CICERO'S SPEECHES
THE CRITIC IN ACTION

Stephen Usher

Aris & Phillips
is an imprint of
Oxbow Books, Oxford

ISBN 978-0-85668-874-4

A CIP record for this book is available from the British Library

Printed and bound by
Printed and bound by Athenaeum Press, Gateshead, Tyne & Wear

CONTENTS

PREFACE

Cicero intended that his speeches should not only demonstrate to his readers how he won his cases, but also display a range of his other literary and cultural interests. This book examines the speeches with particular attention to the influence of these interests on his style, and on the presentation of his evidence and arguments. The historical context of each speech provides the basic material to which the orator applies his rhetorical skills, but Cicero also aims to show by example that oratory is the supreme medium of literary expression, embracing all its forms. In this study, I try to show how successfully he does this, by observing the incidence in his speeches of the refinements which he requires his ideal orator to deploy.

This is the first systematic attempt to draw a comparison between performance and aspiration in Cicero's speeches. Again, its primary focus on his oratory rather than his place in Roman political and legal history and philosophy distinguishes it from most of the books on Cicero that have appeared in recent years. It contains a chronological examination of all the complete speeches (chs. 2–4), giving the historical and forensic setting of each, and an outline of its structure, drawing attention to some of the salient features of its style and to the effectiveness of its rhetoric; and to any particular emphasis (or 'spin') which Cicero imparts to it in response to the needs of the case. Students will find this discussion a useful general companion to their study of the speeches. We then turn to consider the refinements individually (chs. 5–6 (culture and eloquence)). They appear in various forms, each serving a particular purpose, but they combine to give Cicero's oratory its peculiar richness. The different categories into which they fall are defined, and passages which illustrate them are quoted, often at length. Some refinements are seen to be more frequent than others, and these chapters show how this difference is related to Cicero's own interests and strengths. The final chapter begins with Cicero's few statements about his own oratory, some of which are equivocal and even contradictory. Next comes his assessment of other orators, which is a subtle exercise in disparagement. Then we look at the jejune remains of the texts of Roman oratory before Cicero. Finally, the figures for the refinements in all the speeches are brought together, and a list showing the relative incidence of the eight refinements throughout the corpus of speeches is drawn up,

followed by a table locating all the occurrences. These results will surprise some readers.

Earlier drafts of the book benefited from the scrutiny of two anonymous Ciceronian scholars, after Jonathan Powell had encouraged me to embark on the project. He also kindly read a later draft in spite of heavy departmental commitments. I have been most fortunate that the main burden of the editorial work has been assumed by Christopher Collard, who suggested a number of presentational improvements, clarifications, and corrections. Finally, my warm thanks to Tara Evans for her efficiency in preparing my text for publication.

CHAPTER ONE

INTRODUCTION

Cicero made a multiple bid for literary acclaim with his oratory and his writings on rhetoric, together with his works on politics, religion, and philosophy. Present interest focuses on the first two of these groups. His efficiency in preserving written versions of these,[1] and the kindness of posterity, have left us with an abundance of material for the comparison of theory with practice. But before making that comparison, it is necessary to have a picture of the historical background against which Cicero viewed oratory, and which influenced the formation of his ideal. In his *Brutus*, a dialogue in which he sets out to show to what degree his Roman predecessors realized his ideal of effective oratory, it is difficult to estimate how much of the criticism is based on surviving texts. The terms in which he describes their status vary in precision: [*orationes*] *feruntur* ('are in circulation' (205)), *habitae sunt* (strictly, no more than 'were delivered' (169, 170)), or the simple use of the present tense (81, 94, 104, 177) have to be considered alongside *exstant* (82), and instances of analytical stylistic criticism which strongly suggest that Cicero has a copy of the original speech in front of him (126, 167); whereas other orators are described in general terms of the effect of their performance in court (89–90) . Some who circulated their speeches may have done so because, as *litterati* and *diserti*, they had wider literary interests (81); while we are told of one (Lucius Aelius Stilo) who assisted others in writing speeches for the courts, and even wrote complete speeches for them, like an Athenian *logographos* (205–6). In other cases, the medium of preservation was history, the most famous exemplar of this being the elder Cato, who incorporated his own speeches into his *Origines*, whence they acquired an afterlife of their own, aided by proud descendants (61–2), who ensured that a substantial corpus survived until Cicero's time, but could not sustain their popularity among readers (65). This fate was not

[1] Initially, largely by his own efforts, and those of his secretary Tiro. He sent some of his speeches to Atticus, who shared his interest in literature and had a staff of copyists. Of the relationship, Shackleton-Bailey writes: 'Later he became in a certain sense Cicero's publisher' (*Cicero's Letters to Atticus* Vol. 1, 13), a qualified statement necessitated by lack of firm evidence that Atticus undertook the circulation of Cicero's speeches. Indeed, as a firm fence-sitter, Atticus would have been discomfited by being associated too closely with the more politically contentious speeches.

shared by the finest orator of the following generation, Gaius Gracchus, whose speeches were circulated to publicize his programme of reform, and are seen as worthy models for students in Cicero's time (126). But the urge to publish was not universal, and the exceptions include some of the most distinguished orators. Of these Servius Galba feared that he could not match his performance with the written word (93–4), while the much more famous Antonius saw publication as an undesirable commitment to opinions which he might later wish to disown (*Pro Cluent.* 140; *De Orat.* 2.8).

The tradition of earlier oratory that Cicero inherited was thus extremely varied as to quality and indeterminate in quantity. The fullness and accuracy of his presentation of it must also be questioned, because he has an obvious motive for understating the achievement of his predecessors. His treatment of his most formidable rival Hortensius supplies the clearest indications that he did not necessarily evaluate them according to their true stature. Instead of examining specific examples of his oratory,[2] he discusses aspects of his performance, such as his good memory, his assiduous practice of declamation, and mastery of division (301–2); after which (and still concerned mainly with delivery), he turns to Hortensius' Asianism,[3] In brief, Hortensius receives short shrift. In spite of the fact that their forensic rivalry was long dead,[4] Cicero would not explicitly grant him the place of close second behind himself.

This general and often subtle depreciation of his predecessors was a logical component of the quest for the ideal orator which is the unifying theme of *De Oratore, Orator,* and *Brutus.* Of course, if such a paragon already existed, that quest would be superfluous. So what is missing from all this oratory, past and present? What special features or refinements turn run-of-the-mill oratory into great oratory? Fortunately, a single passage in the *Brutus* encompasses them all (322):

> I shall say nothing of myself, but speak only of others. None of them appeared

[2] Copies of them were available in Cicero's time (*Orator* 132), and these perhaps included his opening defence of Verres. See M. Alexander, 'Hortensius' Defence of Verres', *Phoenix* 30 (1976) 46–7, 53, who accepts the suggestion of Von der Mühll, 'Hortensius' (*RE* 16 (1911) 2480), that Hortensius published his speech after Cicero published his, in order to regain some of the prestige he had lost at the trial. It could still be read in Quintilian's time (10.1.23), along with some of his other speeches (11.3.8).
[3] I return to this in ch.7.
[4] They appeared on the same side in several trials – those of Murena, Sulla, Flaccus, Sestius, Scaurus, and Milo – and the *Brutus* begins with a tribute to the recently dead Hortensius, which has the ring of sincerity, but falls short of fulsome praise of his oratory.

to have read more deeply than the common man; and literature is the source of perfect eloquence. None of them had embraced philosophy, the mother of all good deeds and words. Nor had any of them learnt civil law, a subject absolutely necessary for the conduct of private lawsuits and an essential part of an advocate's intellectual equipment. None had a knowledge of Roman history, from which he could, as the occasion demanded, summon up, as it were from the dead, the most reliable witnesses. There was none who, with a short and pointed jibe at his opponent, could relax the minds of the jury, and pass momentarily from the serious subject in hand to humour and laughter; likewise, none who could broaden his speech from a particular issue, limited to a single person and a single time, to embrace a general question of universal interest; and none who knew how to charm the jury with a brief digression; none who could make him feel deep anger, or reduce him to tears, or in short (and this is the orator's supreme characteristic), drive his emotions in any direction that the case demanded.

Already in *De Oratore* (1.17–18) Cicero has listed the qualities which his ideal orator needs to possess: 'knowledge of a very great number of things', 'a thorough acquaintance with all the emotions with which nature has endowed the human race', 'a certain humour and flashes of wit, combined with a delicate charm and urbanity', 'the complete history of the past and a store of precedents', 'a knowledge of statute law and our national law in general'; and he must 'read poetry and writers of the noble arts'(1.157–8). In that earlier treatise he has been content to say that the difficulty of possessing of all these faculties explains the rarity of good orators (*eloquentium* (1.19)). Now he denies that any of his contemporaries has attained his ideal in any of the eight faculties that he has desiderated. This outrageous hyperbole is explained by the context: in spite of his initial denial, Cicero *is* here talking about himself. It is therefore wholly natural that we should expect his own oratory to contain all the faculties and refinements which he has found wanting in others. They may be summarized under the following heads:

1. Literary Knowledge and Culture.
2. Knowledge and Understanding of Philosophy.
3. Knowledge of the Law.
4. Knowledge of History.
5. Wit and Humour.
6. Emotional Appeal.
7. Digression.
8. Dilatation.

4 *CICERO'S SPEECHES*

The arrangement of these topics allows a natural dichotomy into 'culture' (1–4) and 'style', or more accurately, 'eloquence' (5–8), an arrangement which could have been envisaged by Cicero himself when he presented them in this order in *Brutus*. They reveal the individual elements which come together to produce the ideal orator, the subject which he elaborates in *De Oratore*,[5] where oratory is seen as the starting-point and the medium for all other literary, intellectual and humane subjects of study. In *Orator*, he makes reciprocal demands of his subject: the orator must be a polymath in addition to being a master of style. In *Brutus*, reviewing the performance of orators of the past, he credits many early orators with possessing some of the desired qualities. He praises some for being cultured and learned (114), and versed in Greek and Latin literature (175); others have had philosophical training (94, 114, 116, 117–21, 175, 306, 315); many are credited with a legal education, both general and specialized (81, 98, 102, 145, 150, 175, 179, 195, 214, 267, 306); fewer with knowledge of history (81, 205, 214, 237, 247); and ability to generate wit and humour is granted to several of his predecessors (105, 128, 143, 158, 164, 173, 177). The contrast between this generosity towards earlier orators, and the total denial of any of these refinements to his contemporaries, exposes the intensity of the rivalry which underlies much of Cicero's rhetorical writing. This in turn gives added interest and impetus to the examination of Cicero's own performance in his speeches. How effectively, and how frequently, does he deploy those refinements in them? In the following three chapters (2–4), each speech will be set in its historical and forensic context, in chronological order, and the eight refinements will be noted as they occur, so that their bearing on the surrounding argument can be judged. Other rhetorical and stylistic features will also be observed where appropriate. In the subsequent two chapters (5–6) the refinements will be considered separately, so that the different forms which they take and the different rhetorical purposes they serve can be identified and compared. From this examination it will become apparent why some refinements find greater favour with our orator than others. In the final chapter, after brief consideration of Cicero's self-assessment and his assessment of other orators, a short objective account of Roman oratory before Cicero completes the background to presentation of the numerical results. These are corroborated with a table locating the refinements in each speech.

[5] Published in 55 BC. Hence one of the concerns of E. Fantham, *The Roman World of Cicero's De Oratore*, (Oxford, 2004) is the role of the political orator in a new, more challenging environment, which Cicero had experienced to his own detriment.

CHAPTER TWO

ASCENT TO THE SUMMIT

Pro Quinctio

Cicero gives his earliest extant speech the character of a defence, though he is actually appearing for the plaintiff. The speech adheres closely to the classical division laid down in Greek rhetorical teaching, which he had himself faithfully reproduced in his youthful treatise *On Invention,* written a few years earlier than the present trial, which took place probably in 81 BC. His statement in *Brutus* 312 that he trained himself thoroughly in theory before entering the courts is confirmed by the clearly defined exordium (1–10), which is full of conventional topics: complaints about the dangers he faces, due to expert opponents, his own lack of time for preparation, and the illegality of the pre-trial procedure. All this would have been familiar to the first Attic orators Antiphon and Lysias. What is interesting, however, and potentially predictive of future development, is the intensity of expression of the personally involved advocate. The extended metaphor from hunting and medicine which he weaves into the concluding sentences of the exordium (8: *Ita fit ut ego qui tela depellere et volneribus mederi debeam...*), give it a colour and a literary flavour to which his early models rarely aspired ; and the received wisdom that exordia should be mainly low-key seems to have passed him by. This is the more remarkable when it is noted that Cicero is speaking before a single magistrate (C. Aquilius), not a more pliable jury.

The narrative (13–32) has a preparatory introduction *(prodiegesis)* (11–12), and even here the first reference to his opponent Naevius is a forthright characterization, laced with irony ('fine fellow' (11, 16, 19) where he underlines the irony by saying 'I fear he may think I am making fun of him when I call him 'fine' again... a by no means unhumorous buffoon... not unkindly auctioneer'(11). Narrative was always the natural home for characterization, but action rather than direct description had previously been the usual medium in which it was created. As the narrative proceeds, we are never allowed to lose sight of the characters of the main actors. The venality of Naevius is contrasted with the trusting nature of the young Quinctius, who formed a family connection with him (13–16). and partly entrusted to him his financial affairs, which were complicated by a debt which Naevius

seems to have magnified in his own favour. Cicero, apparently unable to prove that Naevius had acted illegally, injects emotion into the narrative (22, 26, 30). At the point of transition to proof (33), he broadens the issue: 'You see your judgement, C. Aquilius, to be not about a matter of money, but about the good name and the fortunes of P. Quinctius'.

Cicero divides the proof under three heads: (1) That Naevius had no case for demanding the possession of Quinctius' property (37–41); (2) That no law or edict existed that allowed him to do so (42–59); (3) That he had not in fact taken possession of it (60–85). To prove (1), Naevius' character is called to the aid of probability, at some risk of circular argument: the greedy, arrogant Naevius had refrained from making his claim to the property for a period of two years, so surely no valid claim existed. The rhetoric is florid and forceful here, as Cicero apostrophizes Naevius, using sarcasm as he suggests that Naevius' 'virginal sense of decorum' prevented him initially from pursuing his claim. (2) is actually concerned with the allegation that Quinctius failed to appear in court after promising to do so under bail (*vadimonium*): an offence which would enable his opponent to obtain an edict against him. Cicero begins by deploring the use of such a hostile and demeaning procedure as bail against one who was supposed to be a friend (48–9). The tone continues to be highly charged, but the effect on a discerning listener is one of suspicion that Quinctius' failure to answer bail constituted a central weakness of his case. This suspicion is not allayed as Cicero makes the same complaint again in a different form (55–6). Then he turns to a factual argument (57–8) which proves that no bail had been posted for the date stipulated by Naevius, since it would have been physically impossible for Quinctius to have reached Rome from Gaul by that date; all of which is attested by witnesses. One would have thought that this physical proof would have stood up on its own without the accompanying vituperation against Naevius. Does Cicero 'protest too much', or is this an example of his 'youthful exuberance' (*Orator* 108)?

The final section of the proof (3) (60–85) is concerned mainly with showing how Naevius was prevented from taking possession of the estate. Quinctius' agent Alfenus, acting legally at every stage, prevented Quinctius' condemnation *in absentia*. There is a pointed contrast between Alfenus and Naevius in respect of both character and methods (70). But of even more concern are Naevius' direct dealings with Quinctius. The dramatic dialogue which Cicero uses here (71–2) succinctly contrasts the arrogance and intractability of Naevius with the reasonableness of Quinctius. This may be

compared with the recommendation of dialogue (*sermocinatio*) to portray character in *Ad Herennium* 4.51.65, where the examples are more diffuse and there is no emphasis on contrast. Cicero's practice thus represents an advance on this, and moreover the swift exchanges may have given him the opportunity to demonstrate his vocal technique by assuming different tones for the two speakers. This may be related to his statement that he consulted the actor Q. Roscius as he was preparing this speech (77).[1] But later he says that eloquence is not needed to present such obvious truths (80).

In the epilogue, where the standard recapitulation (86–90) is followed by an equally standard emotional appeal, in which the advantages enjoyed by the opponents are restated, the only distinctive feature is the presence of some of the amplest periods in the speech (93, 95–9).

Kennedy (*ARRW* 142–8) has argued the futility of attempts to conform Cicero's earliest published speech to the theory he had propounded in the *De Inventione*. Before him, Solmsen[2] had listed passages in the treatise which give the theoretical basis for arguments about motivation, character, and opportunity which feature in both this speech and the *Pro Roscio Amerino*. As to the eight refinements with which we are concerned, the only ones that are present are legal knowledge (30–1), emotional appeal, dilatation (33), and ironic humour.

Pro Roscio Amerino

Looking back on his career, Cicero saw this as the speech that established his reputation (*Brutus* 312). The case was more important than the previous one. His client was accused of the most heinous of crimes, patricide, and his opponents include one of the most powerful and unscrupulous men in Rome, Sulla's favourite L. Cornelius Chrysogonus.[3] The charge against the young Sextus Roscius was, of course, manifestly false: he had not been in Rome when his father was murdered. After the murder, two of his relatives, T. Roscius Magnus and T. Roscius Capito, had acted quickly. They had the murdered man's name retrospectively put on the list of those proscribed. For Chrysogonus, who had been Sulla's chief agent in the murders and confiscations that arose from the main proscriptions, conducted early in

[1] On this section, see J. C. Davies, *Latomus* 38 (1969) 156–7.
[2] F. Solmsen, 'Cicero's First Speeches: A Rhetorical Analysis', *TAPA* 69 (1938) 546.
[3] See V. Buchheit, 'Chrysogonus als Tyrann in Ciceros Rede für Roscius aus Ameria', *Chiron* 5 (1975) 193–211.

81 BC, this was an opportunity for further aggrandizement. But the three miscreants had not counted on the reaction of the young Sextus' fellow-townsmen to this outrage.[4] After they had carved up the property, hostility towards them in Ameria grew strong enough to make them feel insecure, especially as it was known, perhaps to Sulla himself, that Roscius himself was not opposed to the dictator.[5] They decided to get rid of young Roscius, and to do so through the courts.

Cicero's decision to take the case required courage, but perhaps circumstances were on his side. The proscriptions had by this time served their main purpose for Sulla: opposition to him had been removed, or at any rate silenced, and in the present case none could be shown to have existed.

In the exordium (1–13), Cicero is more inventive than in the *Pro Quinctio* in face of the difficult situation in which he finds himself. Whereas in the earlier speech he had used the topos of the inexperienced speaker conventionally to elicit sympathy, here he explains that his youthful obscurity and unimportance have given him the courage to say things which might have spelt danger for an established advocate, whose words would be heeded by many, included those wielding power and influence. It is an interesting political twist to an old commonplace; and he follows it with a bold frontal attack on Chrysogonus and his two confederates, preceded judiciously by praise of Sulla (6; cf. 21–2). He urges the jury passionately not to make themselves complicit in their evil plan to remove the one obstacle to their greed – the life of Sextus Roscius – and to show their own mettle (*animus*) by resisting their demands. A striking double anaphora concludes the section, focusing as it does on the truly guilty men in this case (13):

> The accusers are the men who have usurped the property; the defendant is the man to whom they have left nothing but ruin. The accusers are the men who have stood to gain by the murder of Sextus Roscius; the defendant is the man whose father's death has brought not only grief but poverty. The accusers are the men who have had the strongest desire to murder my client; the defendant is the man who has had to bring a bodyguard with him to this very trial, to avoid being killed in this court before your very eyes. Finally, the accusers are the men whom the people demand to be tried; the defendant is the sole survivor from their wicked slaughter.

[4] See W. B. Sedgwick, 'Cicero's Conduct of the Case Pro Roscio Amerino', *CR* 48 (1934) 13.

[5] On the contrary, he was 'clearly a Sullan partisan' (K. Lomas, 'A Volscian Mafia? Cicero and his Italian Clients', in Powell and Paterson (eds) *CA* 105).

This foreshadows Cicero's plan for the defence. It is to hinge round a central section (83–123), in which he presents arguments and evidence that the murderer of the elder Roscius was Magnus, and Capito was his accomplice.

Even while recounting the events surrounding the murder of Sextus Roscius senior, Cicero provides a revealing account of the activities of Magnus and Capito,[6] who swiftly occupied his property after adding his name to the proscription list. The reaction of the people of Ameria to this is described in emotional terms, and a high temperature is maintained throughout this section (24–32). In particular, the plight of the defendant is constantly deplored – that he is at once stricken with grief at the death of his father and with dismay at the false calumny of the accusation of murder. A recent example of unjust accusation, that brought against Scaevola by the rabid Marian Fimbria in 82 BC (after he had failed in an attempt at murder), provides an historical parallel, although the relative importance of the eminent jurist and the obscure countryman makes the parallel somewhat forced.

Closer examination of the charge of patricide follows familiar lines: the character of the defendant (37–9), his lack of motive (40–68). The latter section contains a reference to a play by the comic poet Caecilius (2nd Century) (46), and adds to the cultural flavour of the passage by praising the devotion and honour accorded to agriculture by earlier generations (50–1). In 55–7 a combination of digression and philosophical argument arises in a discussion of the role of accusers in society, where it is useful that they should ply their trade. They not only secure the conviction of the guilty, under a legal system which has no place for state prosecution, but also enable those who are falsely accused to prove their innocence. Here Cicero introduces an extended simile, or parable. Accusers are like the geese that guard the Capitol, who cannot distinguish between friend and enemy, but raise the alarm when anyone approaches at night, erring on the side of caution. But this caution must be qualified, and this requirement is illustrated in the second part of the parable by the behaviour of other animal sentinels. Dogs guard the Capitol also, but if they bark in the daytime when worshippers approach the temple, they are ruthlessly put down. This double parable is more complex than its Attic models (Demosthenes, *On the Crown* 194, 243, *Phillipic III* 69).

[6] See T. E. Kinsey, 'Cicero's Case against Magnus, Capito and Chrysogonus in the Pro Roscio Amerino and its Use to the Historian', *L'Antiquité Classique* 49 (1980) 173–90; 54 (1985) 188–96; 57 (1988) 296–7.

The atrocity of the crime of patricide elicits further literary, historical, and legal thematic invention. The Furies that pursue patricides in myth are nothing more than their own consciences (67–8; cf. Aeschin.*Tim.* 190), but their effect is terrifying. Terrible too is the punishment for patricide: the condemned man is tied in a sack with a dog, a chicken, a monkey, and a viper, and thrown into the sea. Cicero later quoted this passage as an example of his youthful exuberance (*iuvenilis redundantia*) (*Orator* 107–8). His purpose in this digressive passage is to express outrage that T. Roscius was exposing Sextus to such a fate without adducing a motive for his alleged act. But he had to weigh this aim against the danger that dwelling on the enormity of the crime might somehow cause the jury to associate his client with it. This gave extra importance to the portrayal of his character, which receives added point by being contrasted with that of his accuser (88):

> It remains for us to consider which of the two is more likely to have killed Sextus Roscius: the man who was enriched by his death, or the man who was made a pauper; the man whose means were modest before, or the one who was reduced to the extremes of poverty after it; the man who, inflamed by greed, wages war on his relatives, or the man who, because he was unfamiliar with the forum or the lawcourts, was a frightened stranger not only to the court benches but to the city in general. Finally, jurors – the question most relevant to the case in my opinion – was Sextus his father's enemy rather than his son?

This is a terse piece of characterization based on probability, and a turning-point in the speech, as Cicero has begun (84) to place T. Roscius in the dock (*remotio criminis* (*De Inv.* 2. 86–90)). The evidence against him unfolds at a leisurely pace, interrupted at the outset by a description of the carnage wrought by the proscriptions, coloured by a quotation from Ennius and a historical comparison (90): more men were slain in it than at the Battle of Lake Trasimene, and the number of accusers exceeded those slain at Cannae. This fantasy is followed by some solid evidence on the case: the news of the murder of Sextus Roscius senior reached T. Roscius' confederates Capito and Chrysogonus before young Sextus had heard of it; and their swift seizure of the property argues prior planning. Their subsequent actions confirm this, and serve to blacken their character. In the course of this narrative he discusses the law for breach of commission (*mandatum*), and its implication for society as a whole (111–12), using *a fortiori* argument:

A man who has reneged on a commission in the smallest matter must be condemned by the harshest verdict. So when someone has had committed and entrusted to him a dead man's reputation and a living man's fate, and has brought ignominy on the first and poverty on the second, is that person to be numbered among men of honour, or indeed among the living?

Here, in striving for rhetorical effect, and perhaps prompted by a desire to show his knowledge of the law, Cicero sacrifices logical coherence. Sextus' villainous relatives were under no 'commission' to him other than that of a general obligation imposed by ties of kinship. But once again the fanciful is followed by the more substantial: a 'textbook' argument drawn from T. Roscius' refusal to surrender his slaves for examination (119–20).

The actions of Chrysogonus are the subject of the next section (124–42). The illegal confiscation is represented as a matter of public concern (129: *ad omnes, nisi providemus, pertinere*). But Sulla could not have been expected to be aware of all that was done by his satellites, any more than Jupiter could be held responsible for the worst results of the natural disasters which he visited on mankind. This comparison would have served the function of flattery, in that it makes the mortal ruler appear to enjoy a higher degree of power than the king of the gods, who seems unable to control the consequences of his own actions. It is also in tune with the literary creativity of the speech. Cicero then widens the attack on Chrysogonus by representing him as a menace to all men of property, not just the defendant, and in doing so asserts his own support of the nobility, and of Sulla's re-establishment of their pre-eminence.[7]

In the concluding sections (there is a transition at 143, which seems to mark the beginning of the epilogue), Cicero himself pleads first with Chrysogonus in an *apostrophe* (144): 'Roscius has taken the very ring from his finger and handed it over to you'; then makes Sextus himself address him: 'You possess my farms, I am living off the sympathy of others'. Finally, he calls directly upon the jury (150) to save his client, reminding them emotionally, by mentioning the possible fate of the children of the proscribed, of the bad precedent that an adverse verdict would establish (152–3).

[7] E. Badian, 'Waiting for Sulla', *JRS* 52 (1962) 47–61 describes Cicero's political position in the late eighties as favourable to Sulla's return (49); and J. Paterson, 'Self-Reference in Cicero's Forensic Oratory' (*CA* 88), quotes §136, in which Cicero warmly applauds the outcome of Sulla's reforms; and he notes that Cicero had 'not left Rome at any point'. Further on the speech as a whole, see A. R. Dyck, 'Evidence and Rhetoric in Cicero's Pro Roscio Amerino', *CQ* 53 (2003) 235–46; A. Vasaly, 'The Masks of Rhetoric: Cicero's Pro Roscio Amerino', *Rhetorica* 3 (1985) 1–20.

The transformation from the *Pro Quinctio* could hardly be more pronounced. They share only a high incidence of emotional oratory. The present speech has all eight of the refinements. But, as has been shown, their use is sometimes forced and unnatural.

Divinatio in Caecilium

A decade (80–70 BC) separates the successful defence of Roscius of Ameria from the next speeches that have survived. Of that time Cicero spent some two years touring Greece and Asia Minor (79–77(?)) and studying under various teachers (*Brutus* 314–16) of whom the most influential was Apollonius Molon of Rhodes.[8] He returned after adding to the knowledge of philosophy, history, literature, and rhetoric that he had acquired from his early education. Notwithstanding this, his return to the lawcourts did not produce oratory that he or his friends deemed worthy of publication. But he took the earliest opportunity to advance his public career by securing election to the quaestorship in his thirtieth year (76 BC). He served in Western Sicily in the following year. Rome's oldest province and her main external source of grain, Sicily was also the home of Greek colonial civilization and a former extension of the Carthaginian empire. In addition to seeing that the corn supply to Rome was maintained, and enjoying the cultural spectacles of the island (he took especial pride in personally discovering the tomb of the famous scientist Archimedes (*Tusc. Disp.* 5.64–6)), he devoted much energy to cultivating the friendship and patronage of resident Roman and local men of influence. All this left him ideally placed to play a prominent part in the major provincial scandal of the decade.

Gaius Verres served as governor of Sicily from 73 to 71, and during that time he plundered the province so thoroughly as to make prosecution for extortion inevitable, even allowing for the levels of corruption tolerated by the Senate, many of whom counted on enrichment when their tenure of overseas posts came round. Later Cicero himself returned from his governorship of Cilicia in 50 BC considerably enriched, though he was regarded as a moderate governor. The evidence of Verres' extortion was widespread and overwhelming, but he had the support of some senatorial friends, who tried to raise his chances of acquittal by appointing a collusive prosecutor from among their own ranks, one Q. Caecilius, who had been Verres' quaestor. In order to contest this, Cicero had to defeat Caecilius in a preliminary hearing,

8 See J. C. Davies, 'Molon's Influence on Cicero', *CQ* 18 (1968), 303–314.

the sole purpose of which was to decide who should be the chief prosecutor. This procedure was known as a *divinatio* (Quint. 3.10.3). Its narrow terms of reference make the speech unique, since it is focused on character and motivation, not on events, their interpretation, and the conclusions to be drawn from them. Cicero's self-portrayal is an important and interesting feature of the speech as a measure of his self-esteem at this comparatively early stage of his career, when his senatorial audience would have regarded him still as a *novus homo*.

He represents himself (1–9) as a defender by preference, who has been forced by a sense of duty and a feeling of pity to become a prosecutor. The graphic yet economical description of the plight of the Sicilians, who no longer have their gods to defend them because Verres has plundered their images (3), strengthens his own emotional expression as he represents the Sicilians as his suppliants (*...rogare et orare...*) while he recalls his felicitous quaestorship. Then he broadens the issue to include the universal issues raised by the trial. Any impediments to the punishment of men like Verres would have damaging consequences for the republic and the safety of its citizens (8–9).

A transitional section (10–27) consists of two parts. The first (10–16), linking naturally with the opening section, works around the proposition that the choice of prosecutor should be decided by the preference of the Sicilians who had been Verres' victims. Cicero wins easily by that criterion, even though Caecilius had also served as quaestor in Sicily (4). In the more colourful second section (17–26 (note the *prosopopoiia* in 19)), the inverse proposition, that the prosecutor should be the man whom the defendant and his advocate would least wish to face, is considered (22–6), and this affords Cicero the opportunity to show what an effective prosecutor he will be, before turning to a closer examination of Caecilius' credentials.

Caecilius is now confronted with the size and difficulty of the task of this prosecution (27–47). Cicero is at his most patronising here (27): 'Let me instruct you, since this is the first opportunity you have had of learning the qualifications a prosecutor must possess'. But he also gives some telling specifics of the required abilities: 'You must set forth in detail the whole history of another man's life. You must not only make it clear to the understanding of the court: you must draw the picture so vividly that the whole of the audience

can see it with their own eyes'.[9] Next, the prosecutor must be seen through his past actions to possess an upright character.[10] Certain actions of Caecilius would seem to disqualify him on that criterion. Cicero feigns reluctance to specify these (*occultatio* (29)): 'I do not allege certain facts which you could not refute...'), but reels them off just the same; and Caecilius is made to appear almost as unscrupulous as Verres himself. Soon they are seen together as partners in iniquity (31–3), making inevitable Caecilius' collusive approach to his task as prosecutor. Cicero, by contrast, emphasizes his own awe and respect for the courts (40–2, cf, *De Orat.* 1.116), describing his trepidation as he faces the charged atmosphere of a trial. The contrast between the two is elaborated further: Caecilius thinks he can carry the day by some desultory book-learning (43, cf. 52): a disastrous underestimation of the task, especially as his opponent will be Hortensius, then at the height of his powers.[11]

Cicero selects from the armoury of rhetorical weapons which Hortensius will deploy against Caecilius: he will pose a *dilemma*[12] (*complexio* (*De. Inv.* 1.45)), where either option chosen will tell against his hapless opponent (45, cf. 31, 58, 60).; he will divide up the prosecution's case and demolish it piecemeal; he will ruthlessly exploit emotional appeal. Here Cicero adds rhetorical colour by expressing mock sympathetic fear on Caecilius' behalf (46):

> Take care, take care: consider the danger, I beg and implore you. I cannot but feel the risk that he will not only overwhelm you with his arguments, but even take the edge off your senses with his very gestures and physical movements, until he has made you abandon your planned line of action.

The speakers Caecilius has chosen to support him (*subscriptores*) are not much good either (48–51), one being a tiro and another coming from the back benches, good only at barracking and capable only of pandering to him (*lenocinabitur* (48)). They can be summarily discounted, so Cicero returns to his task of discrediting Caecilius, who has furnished himself with a motive which Cicero could not match: that Verres had wronged him in some

[9] The quality of *energeia* in Aristot. *Rhet.* 3.11.1–2 becomes *enargeia* in Dion. *Hal. Lys.* 7 and Quint. 8.3.61. In *Ad Herenn.* 4.55.68 it is *demonstratio*. The four passages have in common the description 'before the eyes'.

[10] *Ad Herenn.* 1.5.8, Cicero *De Inv.*1.16.22.

[11] Described as a 'friend' of Verres by the author of the *Argumentum in Cic. Div. In Caec.* 185.11. The same source says that Verres had the support of the Metelli Scipiones, to whom Caecilius was related.

[12] See C. Craig, 'Dilemma in Cicero's Divinatio in Caecilium', *AJP* 106 (1985) 442–6.

way when he was serving under him as quaestor in Sicily. To this Cicero retorts that Verres has wronged everyone in Sicily, so that a comprehensive avenger rather than a man with a purely personal grievance is required, and this in turn demands ability (52–3). Moreover, as Cicero's description of the alleged wrong unfolds, Verres is shown to have acted with propriety for once, reversing an injustice done by Caecilius (56); though he soon reverted to his normal character, when 'as though he had drunk of Circe's goblet, he returned forthwith into being the hog which his name suggests' ('*verres*' – 'hog', 'boar') (57). The logic is pursued relentlessly: how can Verres' isolated act of justice serve as a reason for prosecuting him? (60: that is a simplification of Cicero's argument). Moreover, as Verres' quaestor, has not Caecilius been complicit in his crimes? Praetors and quaestors have traditionally been regarded as like father and son (61). Historical examples of this relationship and the obligations imposed by it are given (62–3); and historical figures are made to illustrate the duty of avenging the wrongs done to provincial communities and individuals (66–9). Then the argument widens to contemplate the cure of a pervasive malady (*remedium aegrotae reipublicae* (70, cf. Dem. *Phil. III* 39, *Emb.* 259, *Cor.* 45)). And that duty falls to all patriotic men: 'I think that the prosecution of bad men, and the defence of those in misery and distress, is a worthy occupation for men of my age, for men far older than I am, and for those holding the highest office' (70). This summary prospectus for Cicero's own public career lies at the heart of the personal bid for office with which this speech ends. Of Ciceronian refinements it has six: philosophical (logic – *dilemma*), legal knowledge (18, 35), ironic humour, emotion, historical allusion, and dilatation (9).

In Verrem: Actio Prima

Following his appointment as Verres' sole prosecutor, Cicero toured Sicily to collect evidence, and returned to deliver the present speech early in August 70 BC. We do not know precisely when Verres decided to abandon his defence and leave Rome, though Hortensius may have delivered a speech in his defence (so M. Alexander, *Phoenix* 30 (1976, 46–53); but it is natural to suppose that the preliminary picture Cicero drew of his governorship in the *Divinatio* was damning enough to convince him that he would lose.

The early statement (2) that Verres was already condemned by popular opinion may indeed reflect Verres' political standing, but it also defines the rhetorical parameters which Cicero could allow himself at this stage of the

trial. In a normal trial, such a statement would be regarded as a *petitio principii* (representing as agreed fact that which had yet to be proved). Here a wider purpose – the rehabilitation of the Senate's reputation and authority – can be brought to bear. This enables him to state Verres' crimes without proof for the time being ('he has robbed the treasury and plundered Asia and Pamphylia; he has behaved like a pirate in his office as urban praetor, and like a consuming plague in his governorship of Sicily' (2)); and his character, illustrated by his actions, is portrayed in general terms. Emphasis is laid upon his audacity (5–7), which led him to suppose that he could get away with the most atrocious crimes by bribery (9, 16) and influence. A concentrated outline of his Sicilian depredations (12–15) both serves the immediate purpose and heightens the expression of outrage, but the most important area of concern is the influence Verres might be able to exert in high places. His chief advocate Hortensius had just been elected consul for 69 BC. Cicero articulates the implications of this for Verres, when he tells the jury how, after the result of the election was known, a recent consul, Gaius Curio congratulated Verres, saying that 'today's election means your acquittal' (19). But the political danger posed by this needed further emphasis, and Cicero supplies this in a markedly emotional narrative (20–1):

> This state of affairs disturbed me profoundly. Everywhere the best men were saying, 'Verres will certainly escape your grasp, but the lawcourts will no longer be in our keeping.[13] For who can possibly decline to transfer the courts to another power, if Verres is acquitted? Everyone was troubled, though their distress was less about this scoundrel's sudden joy than about the novel congratulation by such an eminent man. I tried hard to pretend that I did not feel troubled; I tried hard to conceal my anguish behind a calm expression and a still tongue.

However, the sequel suggests that Cicero has overstated the intention and indeed the power of Hortensius to save Verres, since the latter proceeds as if he faces real danger of condemnation. He plans to cause the trial to be delayed until others of his supporters were in positions of power (26ff.) Here Cicero adopts the emotional approach once more, turning first to the jury and asking them what he should do in order to ensure that all his careful preparations are not set at nought, then challenging Hortensius directly to begin the trial forthwith.

[13] Senatorial control of the courts was curtailed or removed by the *Lex Aurelia* around this time.

What follows is a good example of Cicero's technique of broadening the issue (34–40). After noting that his appointed task was the cause of the Sicilian people (34), he sees a greater task arising from it – to serve the Roman people by challenging the exercise of despotic power over the courts (35) by Hortensius and other influential senators. In this excursus, Cicero poses as the champion of the oppressed poor against the extortioners, and this becomes an election manifesto for his aedileship, which he promises to use to wipe out the evils of judicial corruption (36). For a time sight is completely lost of the accused and his crimes (38):

> The people of Rome shall learn from me how it is that, so long as the lawcourts were in the hands of the Equestrian Order, for almost fifty unbroken years, not even the slightest suspicion fell on one single Roman knight sitting as judge, of accepting a bribe to give a particular verdict; how it is that, when the courts had been transferred to the Senatorial Order, and the power of the people over you as individuals had been taken away, Quintus Calidius observed, on being convicted, that a man of praetorian rank could not be decently convicted for less than three million sesterces...

Other examples of the scale of bribery that was rife under senatorial judicial administration are added to form a very long period (to 39...*damnaret*), magnifying the task Cicero had set himself. But he knew that reform had popular support (45), and shows his own support for it by mixing the first with the second person when addressing his fellow senators (*contemnimur, despicimur...*(43)...*observant [homines] quem ad modum sese unus quisquis vestrum gerat* (46).

The speech has thus become progressively more political, with Cicero in tune with the sentiments expressed by Pompey (45), who had realized them by sponsoring Aurelius' law (n. 13). The new powers given to the equites also accorded with Cicero's political tendency at this time, which reflected his own affiliations. As to the present trial, his immediate concern was to thwart the opponents' efforts to delay proceedings (53–5). The speech has five refinements, emotional appeal and dilatation being the most notable, the others being literary and historical allusion, and legal knowledge.

In Verrem Actio Secunda I

Throughout the five speeches which Cicero circulated after Verres' departure and conviction, he maintains the fiction of a real trial: 'He is here before us,

he is making his reply, his defence continues' (2, cf. 35). In 32 he mentions the time that has been allotted to his speech. Before that (6) he tells us that the trial continues because Verres has been driven insane with guilt for his crimes, like a character in a Greek tragedy. Cicero is engaged in a literary creation, and hopes his readers will enter into its spirit. The material which he had industriously collected for the trial was rich enough to accommodate the refinements that are being examined, especially dilatation and digression. But the speeches contain more varied fare than that.

Cicero has taken as his broad subject the whole of Verres' political career, so the first speech covers his wrongdoing during his year as urban praetor before he assumed his pro-praetorship as governor of Sicily. But the opening section (to 31) is a review of the ground covered in the *Actio Prima*, suggesting that he intended the *Actio Secunda* pentalogy to be read as a separate whole. But it also has the features of a conventional exordium: the speaker's expression of confidence in the jury (10), challenges to the opponent (12), and criticism of his delaying tactics (30–1). To this is added his own exertions in collecting evidence and dealing with the judicial preliminaries, contributing to the self-portrayal which exordia often contain. Elements of the political struggle continue to surface (23); and in 26 we have an example of Cicero's legal expertise as he explains the type of treatment which the case requires. No doubt this will have been noted by prospective clients.

It is important to establish the character of Verres, and Cicero does this with a classic example of *occultatio* (32–3), in which enough of a summary of the allegedly omitted material is given to provide the information, and hence the effect, that he wishes to convey. The listener receives a clear intimation of Verres' scandalously misspent youth in a short space; and the extra touch 'I shall pass over all that I cannot refer to without indecency' is exquisitely mischievous.

Verres' quaestorship, in Cisalpine Gaul (83 BC), followed a predictable pattern of embezzlement and treachery against his superior, the proconsul Gnaeus Carbo, who knew about his bad reputation. Cicero, who appears to have tried to audit Verres' accounts from this part of his career, finds them wanting, and goes on to reach more general conclusions about his behaviour. 'The man who has acted like a public enemy to his friends is everyone's personal enemy'. This paradoxical play on *hostis* and *inimicus,* and the gnomic sentence 'No wise man ever thought a betrayer should be trusted' (38), give the passage a mildly philosophical flavour, as does the

generalization (39): *communis est hoc malum, communis metus, communis periculum.* And it is all made even more impressive by the exclamation '*O scelus, o portentum in ultimas terras exportandum!*'

Verres gave a repeat performance of those misdeeds when he went east to the Aegean, as Gn. Dolabella's second-in-command in Cilicia (41–102). His depredations on Delos draw from Cicero a digression on the sacred island (47–8), including a pointed comparison: not even the Persians, who had declared outright war on the Greeks, went so far as to profane her religion. But Verres was insatiable, plundering works of art from the whole area – Chios, Erythrae, Samos, and Aspendos (which was completely stripped of its statuary). History provides more recent contrasts than the Persians – Romans who actually won her provinces like Marcellus, L.Scipio and Flamininus, but whose own private houses remained empty of plunder (55). His claims that the stolen pieces were for the adornment of the city and that he bought some of them are dismissed.

Conscious that the dolorous catalogue of pillage and rapine could become monotonous, Cicero chooses a particularly unpleasant incident and expands it into a detailed narrative (63–9). Like a Thucydides or a Xenophon, he sets the scene for his story, describing its location and the general character of its inhabitants. He also ominously foreshadows (like Herodotus (5.97.3)) the ruinous consequences of Verres' visit (63), and contrasts the characters of the obnoxious Verres and his subordinates with the hospitable and unsuspecting humanity of the local leaders, and the blameless character of his intended victim, the lovely daughter of Philodamus. The creation of this 'beauty and the beast' scenario through strongly drawn contrasts of character encourages readers to assume Verres' participation in the main event, the banquet staged by Philodamus (65–6). But it is curious that his name does not occur in the narrative of the actual feast. Cicero, whose main task is to denigrate Verres by any means at his disposal, would surely have said what he did during it, if he had been there.[14] However that may be, there is no reason to doubt the uproar that followed, and its wider repercussions in the town of Lampsacus, not least for its Roman residents. Cicero makes sure that excesses sanctioned

[14] C. E. W. Steel, 'What Really Happened at Lampsacus?', in *CA* 233–51 argues that Cicero would have made the most of any of Verres' misbehaviour if Verres had been present, and that it is the name of his subordinate Rubrius that features in the story (237–40). She also notes that Cicero invests his description of the trial and execution of Philodamus and his son (§75–60) with deep pathos (247–80). On the Verrine II speeches, see esp. S. Butler, *The Hand of Cicero* (London and New York (Routledge), 2002).

by Verres, not necessary military or administrative actions, are seen to have caused the riots. And if the reader accepts that, he will probably go along with Cicero's view that Verres was undeservedly fortunate in the subsequent conviction of Philodamus, not to mention his own escape with his life. A political message is extracted from this. The governor Dolabella saved his skin. This example of senatorial misrule of the provinces elicits condemnation from Cicero (77), as he turns on Dolabella, and then on Verres in a series of apostrophes charged with emotion (78–80) giving further details of the riot and the mentality of the desperate Lampsacenes.

When Roman rule had driven her subjects to preferring death to life under it, an intolerable, not to say dangerous situation had been reached (81). The only way to reverse this was to stop the abuse of power practised by Verres and others. Cicero wants this proposition to remain firmly in his readers' minds as he continues the account of his crimes. Among these, the one that stands out is his guardianship of the children of his dead colleague Malleolus, and it draws two rhetorical felicities from Cicero: a comparative argument; 'with all Asia offering itself to you to ravage and plunder, you still could not withhold your hands from violating your guardianship' (93); and *eidolopoiia:* 'Shall Malleolus himself rise up from the underworld and demand...? ... I imagine him here in person'(94).

In introducing Verres' urban praetorship (103), Cicero uses characteristic hyperbole: 'Since Verres never let one moment go by without doing something wicked, I have been unable to acquaint myself with all his crimes'. This section (103–21) contains further narrative illustrating Verres' greed, and audacity in pursuing it. But the material also enables Cicero to show his detailed knowledge of the law of inheritance (106–9). He also indulges in cutting sarcasm, expressing feigned surprise that Verres had acted against a woman when he was so fond of their sex, and pretending to accept his claim that he was acting against greed ('who was more fit to do so, in our own time, or when our forebears were alive?' (106)). Later (121), the continuing account of Verres' dispensation of justice turns to bitter humour, the last resort of desperately unhappy people. *ius verrinum*, 'Verres' justice', also meant 'pork broth', which was deemed to be poor fare. Cicero remarks that this illustrates how 'Verres' offences against morality and justice became at the time the subject of common talk and popular catchwords'.

Cicero's knowledge of the law comes into play again as he selects further examples of Verres' disregard for precedent and equity. Cases of inheritance (125–7), and embezzlement of public money (129–53) are

laced with sarcasm, usually references to the praetor as 'fine', 'excellent', etc.; and further evidence of Cicero's legal expertise comes as he analyses the text of a building contract (143–8) drawn up by Verres. The speech ends with summary examples of further injustices. It has the qualities of a speech delivered at an actual trial: emotional appeal, with an abundance of apostrophe, pathos and wit. This would have enhanced the enjoyment of readers, who would have declaimed the speech in the normal manner. But it would also have made them aware of Cicero's capacity for hard preparatory work, a necessary virtue for a career-advocate. In 70 BC was still making his way in the courts, and it is his abilities to master a brief and handle difficult legal issues that are most prominently on show. The speech also has literary (53) and historical allusion (48, 55, 70) and philosophical flavour (38), giving it six of the refinements.

In Verrem Actio Secunda II

The subject of this speech is Verres' general conduct as propraetor of Sicily. This gives it a potentially broad sweep, with scope for the exercise of the Ciceronian characteristics of expatiation, historical perspective provided by examples, and universalization; and it begins with the latter. The 'cause of Sicily' is yoked firmly to championship of 'the whole Senatorial order and the republic itself' (1). In 2–8 historical facts about Sicily invite rhetorical treatment initially because of her venerable seniority: 'the first of all foreign nations to receive the title of 'province'...the first which made our ancestors realize how splendid external empire is' (2). Subsequently the choice of topics serves the function of giving maximum impact to the main subject of the speech: the provincial misdeeds of Verres. Thus the Sicilians have for the most part been loyal to Rome, and this has been acknowledged through the lenient treatment of those cities which have stood against her (Marcus Marcellus, the conqueror of Syracuse, provides the prime historical example of this (4)). The island became Rome's base for the conquest of Carthage, and the unfailing supply of corn from Demeter's birthplace sustained the Republic through perilous times. The Sicilians have accepted the occasional minor abuses of imperial power, and have come to regard Roman rule as generally beneficial; that is, until Verres arrived on the scene. The historical backdrop against which his readers will now view his propraetorship is designed to draw the strongest contrasts and hence the greatest condemnation.

The introduction of Verres (9) soon brings a new vehemence (11ff.), with

sarcasm (13), which Cicero justifies by the necessity to counteract the support which Verres can expect from an array of supporters and others. We have already learnt (*Act. Prim. 40*) that he had taken the practical step of earmarking a portion of his plunder for the bribery of those who had witnessed his crimes. After all, he was already a seasoned plunderer (17–18), and was already on landing preparing 'to sweep the province out' (*ad everrendam provinciam* (19, see 52 (below)) . A major source of enrichment was through the use of his overriding powers to dispute legacies. But it was necessary to employ agents and informers. Cicero seizes on this weakness (26):

> But, we are told, the money did not reach Verres. What kind of defence is this? A serious plea, or is he just trying it on? I ask, because it is something new in my experience. Verres put up a false claimant. Verres summoned the defendants, Verres tried the case, Verres pronounced judgement. A large sum of money was paid; the payers won the case. Is my opponent to reply: 'The cash was not paid to Verres'?

The anaphora buttresses the underlying probability-argument. Verres' counsel is being punctiliously dishonest in claiming that one Volcatius was the recipient: he was one of Verres' many minions. Cicero quickly points to the universal consequence (27): if this defence is accepted all investigations into extortion are doomed to failure, and the good name of the Senate, as the ultimate source of justice in these matters, will be grievously damaged.

The case of Heraclius of Syracuse (35–50) affords a good illustration of Cicero's method of magnifying, dramatizing, and emotionally charging his evidence. As the recipient of a large legacy, he attracted the attention of the governor, who sued him on a technicality in the will, and overrode the Rupilian law concerning the timing of trials. This evokes the first ourburst of indignation (40): 'How are you to deal with such a man? What fit punishment can be found for such outrageous behaviour? You barefaced ruffian...' He had let all laws, customs, and precedents count for nothing when balanced against the prospect of plunder for himself. With his 'audience' aroused to anger over this, Cicero maintains the temperature by describing the distress of Heraclius and the duplicity of Verres in securing his conviction (42). In these hard-hitting passages the style is characterized by short, paratactic clauses, *e.g.* (46) *eripe hereditatem propinquis, da palaestritis, praedare in bonis alienis nomine civitatis, everte leges, testamenta, voluntates mortuorum, iura vivorum* ('Rob the next-of-kin of the legacy, give it to the wrestling-masters; pounce upon another man's property in the name of his fellow-citizens; overthrow

the sanctions of the law and the rights of bequest, the wishes of the dead and the just claims of the living'). Here Cicero seems to be encouraging Verres to be lawless and cruel, but this tactic only adds to the effect of the indignant outburst that follows; and short passages of narrative provide further evidence of Verres' wickedness as the action moves on (46–7).

The 'Verres Festival' (52) is a creature of Ciceronian wit that revisits an etymology already exploited (19): Verres conducted his own 'Sweep-Up Festival'(*Verria*) not only on a specified calendar day but every day (52). Cicero says (1, 68, 82) that he can draw on an abundance of cases of Verrine greed and rapacity, and this enables him to choose examples which have distinguishing features and consequently contribute to a varied and entertaining picture. But they must also be extreme examples of these vices, because they had to shock a jury which was inured to the extortion which was rife in the provinces at this time. Detail was necessary to bring out their full wickedness. The case of Epicrates of Bidis (53–63), another legatee, requires a long narrative to explain Verres' devious method of acquiring the money, using local laws to sequester Epicrates' legacy. Even Cicero's hostile account would have impressed his readers with Verres' ingenuity. His presidency of the courts provided him with another source of money. In the criminal trial of Sopater of Halycae (68–81), the accused was acquitted, but Verres staged a retrial, and seems to have conducted a kind of auction between the prosecution and the defence (69–70). The story includes portrayal of changing emotions as fortunes are suddenly reversed (70): 'When the case came to court, all those on Sopater's side were without fear, without anxiety: the charge was groundless, the case had been judged. Verres had taken his money. What doubt could anyone have of the result?' But the trial becomes a farce, as the principal counsel on each side leaves it and Verres conducts it on his own, and pronounces Sopater guilty. His flagrant abuse of his judicial powers draws a very sarcastic outburst from Cicero (76):

> Save Verres, gentlemen! Save him for Rome! Your need such a man on the Bench! You need him in the Senate, so that he may advise you dispassionately on matters of peace and war.

But this sarcasm gives point to the following serious thought: that if he is acquitted and restored to a position of influence in the Senate, he will tarnish its good name (77).

The story of Sthenius of Thermae (83–118) has a different set of attractive

features. It involves some earlier history, has literary interest in the form of the famous Greek lyric poet Stesichorus, and recounts a rare failure by Verres to purloin the statues he wanted. It also provides Cicero with good opportunities to display the more urbane side of his wit (115–6), as he suggests some kind of symbolism behind Verres' choice of plunder (a statue of Cupid: was it a token of his rapacity, or of his guest-friendship with his victim?). Then an interesting stylistic coincidence may be noted. The elaborately constructed period *Hic... defenderem* (117), which does not complete its sense until the final word, is a personal pronouncement by the orator, to the effect that he would have supported Sthenius under any circumstances because he was his personal friend since his Sicilian quaestorship. (The occurrence of another, even more complex period embodying a personal pronouncement in *Pro Archia* 3, suggests a connection of style-type and subject-matter which could be worth further investigation).

A turning-point in the speech may be noted as we move across the province, and encounter other sources of enrichment for Verres, such as payment in return for honours, preferment or franchise (119–122). At Agrigentum he violated ancient Scipionic laws controlling election to its Senate (123–4). The account is in danger of becoming a mere catalogue, but it is saved from this by a shaft of Cicero's favourite punning wit (129: *qui non tam caeli rationem quam caelati argenti duceret* ('who was thinking more of the silver plate than of the silvery sky'), and when he describes the personality and methods of Verres' chief agent Timarchides (134–6), who mirrored his master's tastes and fed his greed. One of Verres' extortionary devices was a fund for the erection of a statue of himself (137). The practice of raising money for statues of provincial governors was normal, but the amount that Verres raised far exceeded the cost. Cicero ingeniously complains (141) that, if all that money had been expended on statues of the pirate Verres, his grim presence would have threatened innocent citizens from every street-corner in Syracuse. Animism, ironic humour, and even a touch of drama, are thus enlisted in support of rhetoric. Another useful rhetorical argument, *dilemma*, follows (142): if condemned, Verres will be unable to spend money on statues of himself; if acquitted, he is unlikely to be pursued again on the whole matter: either way, he will keep the money. This argument shows how Verres had envisaged just such a win-win scenario, having intended the money for his own private use, and for no other purpose, from the beginning. The further point that Cicero stresses is that the Sicilians gave Verres this money under duresse. As elsewhere, he has to contend with

the special case of Syracuse, where Verres seems to have enjoyed support. But here humour comes to his rescue. Confronted with the fact that Verres was styled *Soter* ('Saviour') by the Syracusans, who honoured him with an eponymous festival, Cicero observes that in that city Verres had almost as many statues erected to him as the number he stole (154). But the main conclusion is summarized in 165: 'no single statue was voluntarily given to you by anyone'. Verres has contrived to make enemies of both Sicilian and Roman residents, and the statues were a device to avoid adding visiting outsiders to the list of his enemies (167–8).

A return from states and institutions to private individuals affords more welcome variety by being mainly narrative again. L. Carpinatius was one of Verres' rent-collectors and a thoroughly disreputable character; but, more importantly, he serves as a prime exemplar of a major practical difficulty facing Cicero. He should have been a main source of evidence against Verres, but he and his confederates gained so much from the malversation of tax revenues and the removal of records, that they were unwilling to testify against their master and benefactor. Against this Cicero deploys a subtle probability-argument (176): if the records had been found intact, they alone would have served as evidence. By both removing them and making themselves unavailable as witnesses, Verres' friends were virtually admitting his guilt and leaving the field of accusation wide open, giving credibility to any charge Cicero might choose to make. But he assures the jury that he will not fabricate anything (179–80), and that he has amassed enough to convict Verres without the lost evidence.

The speech ends with an interesting moral postscript (191–2). He says that advocates in the past, like his heroes Antonius and Crassus, were not only cleverer than their modern counterparts but luckier, in that their clients' misdeeds were not so heinous as to pose problems of conscience for those hired to defend them. He wisely does not expand this into a detailed historical example, like the six noted in the speech, as the idea he is expressing seems decidedly utopian. The other refinements are wit (sarcastic and ironic humour), literary allusion (5), and emotional appeal.

In Verrem Actio Secunda III

The subject of the third speech is corn, and the division is more clearly defined than that of the first two speeches. An exordium *a sua persona,* vehement at times (1–11), returns to the subject of the morality of prosecutors touched

on at the end of the last speech, then gives way to an outline of the different taxation arrangements made by Rome with the several cities of Sicily, and the degree of autonomy they were accorded (12–16). He accuses Verres of violating these privileges in spite of their recent revalidation (18–19). He describes and deplores the changes made by Verres, dwelling on their distressing consequences (22–39). The statutory requisition had always been a tithe (*decumanum*), but Verres gave his collectors the power to decide the amount, thereby leading to extortion and the ruin of many farmers. As before, Cicero generates indignation by highlighting a particular individual, in this case one Apronius, who is vividly characterized (22):

> Look at the expression on the man's face, gentlemen; and from the arrogance that it retains even in a lost cause, imagine what malign energy he displayed in those Sicilian days. This is Apronius, the man Verres finally settled upon, after scouring the whole province for its wickedest denizen as well as bringing with him plenty who were like himself, judging him to be his closest match in villainy, profligacy, and recklessness.

It is easy to forget for a moment that we are not in court. In 43–63 the visible consequences of Verres' extortionate exactions – the fields abandoned by desperate farmers no longer able to make a living from the soil (47) – are the most effective rebuff to his apparent pride at providing Rome with extra revenue (48). But again he gives it point by introducing the sufferings of individual victims of them, each affording examples of different types of injustice (53). Nympho and Xeno failed to provide the required returns of acreage, and were fined. Other farmers were subjected to physical violence, or forced to flee because they were told to pay 'tithes' which exceeded their total produce (57). Cicero, realizing that many of his readers shared Verres' contempt for Sicilians, adds Roman citizens to his list of victims (59):

> But of course, while he treated Sicilians badly, he cultivated the Roman citizens there, was indulgent towards them, was dedicated to securing their good will and favour? Was he indeed? Why, he hated and persecuted them more than all the others.

Now the treatment of the Roman citizens Matrinus and Lollius really was something to make his readers sit up and take notice, especially as the latter was 'nearly ninety' when he was humiliated in front of the noisome Apronius (62). This puts his readers in a more receptive frame of mind for the technically more demanding charges to come. At this point the main three

sections of the speech may be discerned. 67–162 deals with the collection of the tithe, a tenth of the crop paid as tax (*frumentum decumanum*); 163–87 with the purchase of corn (*frumentum emptum*); 188–220 with the payment of money in lieu of corn (*frumentum aestimatum*).

In the first of these sections successive narratives tell of the outrageous demands of Verres' villainous tithe-gatherers and the reactions of the various communities to them. In 81 a telling historical comparison is made, as Cicero notes that the dictator Sulla, notwithstanding the power which he had arrogated to himself, was unable to divert money designated for the state treasury to his own coffers; whereas Verres and his agents, including the *alter Verres* Apronius (84) and others of even lower pedigree, did this routinely, using the money thereby acquired (on selling off the corn at inflated prices) to satisfy the importunities of their mistresses. The smallest communities suffered along with the rest, and the very status of the farmers was degraded (87):

> Thus did you confer equity on your governorship, by making temple slaves the masters of Sicily; thus were class distinctions observed, when you were governor of Sicily, by counting farmers as slaves, and slaves as farmers of taxes.

This description of the topsy-turvy world created by Verres may have its origins in comedy, whence it found its way into oratory.[15] Its humour is grimly ironic, with exorbitant tithes exacted by low-life criminals like Publius Naevius Turpio rather than by properly appointed officials (90).

Cicero pauses for a moment to draw attention to the wider implications of what Verres has done (94–6). In an apostrophe, he accuses him of attacking the authority of the Senate by ensuring that none of its members resident in Sicily should be appointed to the jury (95), while failing to realize that this would not save him from a damning verdict. This item is calculated to keep the reader's interest alive amid the seemingly endless (103) catalogue of abuses. So too is the recital of actual figures for the amounts of corn extorted (106–7, 110–11, 116–17), and the numbers of farmers driven from their land by Verres' exactions (120–1). But Cicero remains acutely aware that the fate of Sicilian farmers may not move his readers, so he reminds them that the spoliation of 'the province'(*i.e. our* province) should concern them (122).

[15] For this lineage, see P. Harding, 'Comedy and Rhetoric', in Worthington (ed.) *Persuasion* (London and New York, 1994) 196–221. Preposterousness combines with paradox. Harding offers as examples the Invalid as characterized by Lysias (Sp. 24).

An historical comparison (125) contrasts the devastation suffered in Sicily during the wars with Carthage and the slave uprisings, from which the land was able to recover, with the crippling systemic effect of the regime of Verres and Apronius. This prompts a rise in temperature as Cicero repeatedly goes on the attack (126: 'You utterly reckless madman...130: 'I must strain every sinew, spare no kind of effort, to persuade all of you ...), exposing the full extent of Verres' greed and its impact on Sicilian agriculture and society. Satisfied that he has convinced the jury of his guilt (42), Cicero tries briefly to persuade Verres to abandon his defence (144) before ending the section on tithes by showing how Verres prepared his subordinates for the arrival of his sucessor Metellus. The moral tone is sharpened as Cicero upbraids Verres for exposing his own son to his excesses (161–2).

In the section on the purchase of corn (*frumentum emptum* (163–87)) Cicero is able to cite the *Lex Terentia et Cassia frumentaria* (73 BC), which laid down clear rules and limits. Here the victim of Verres' embezzlement was the Roman treasury, and this fact elicits some predictable rhetorical pyrotechnics from Cicero (176–8):

> How agreeable does the habit of wrongdoing become for wicked and audacious men, when they go unpunished! This is not the first time that Verres has been found defrauding the state, but it is only now that his guilt has been proved... His guilt is being brought home to him at last, the guilt of deeds as monstrous as they are manifest. And I see him as driven to this deception by divine will, so that he may not only pay the just penalty for his most recent crimes, but also atone for his former misdeeds against Carbo and Dolabella.

But it becomes clear from what follows that hard evidence is not easy to establish, because key witnesses are also interested parties. He approaches this difficulty in a relatively cool and analytical way, asking the relevant questions and explaining the convoluted procedures used by Verres and his agents to bypass the rules. These procedures even appear to have involved exacting money from farmers whom he should have been paying, thus mulcting both them and the Treasury. The section ends memorably. Instead of invoking a specific historical example, Cicero draws (185) a devastating comparison by recalling a general practice in the past, whereby the commanders of earlier Roman armies would, after a great victory, publicly present their clerks with golden rings; whereas Verres had won no victories and no spoils, yet was more lavish in his largesse to his officials and to influential Sicilians, because he wanted to buy off their future testimony against him. In 187 he composes

an imaginary dedication for Verres to make for these men, which begins thus: 'Inasmuch as you have never failed me in any matter of greed and vile practice...', a device sure to draw at least a grim smile from his readers.

Payment of money in lieu of corn involved valuation (hence *frumentum aestimatum*) (188–220). Originally instituted for the benefit of Sicilian farmers, who might have various reasons for wanting to keep their corn, for unscrupulous Roman officials it afforded a ready means of self-enrichment, while enabling them to pose as generous and public-spirited. Cicero makes the most of this, but also shows his legal knowledge by explaining how the purpose and meaning of the laws of extortion, which Lucius Piso introduced when he set up the first *quaestio rerum repetendarum* in 149 BC., had been flouted under Verres' administration (193–5). The fraud is graphically described through an imaginary dialogue between a Sicilian farmer and the governor. We learn from their negotiations that Verres not only pocketed the money assigned to him by the Senate to purchase corn by buying it for less than its value, but also exacted money from the farmers as cash payment in lieu of corn. This double fraud was, of course, ruinous to the farmers, and Cicero's rhetoric here rises to their plight (198–200). The introduction of individual victims, who thus become his witnesses, enhances its impact – Sositheus of Entella and Sosippus of Agrigentum. From their testimony he passes naturally to a hyperbolic *dilatatio*, which begins (207);

> All our provinces are in mourning, all our free communities are complaining, and even foreign kingdoms are protesting, at our greed and injustice. No place within the bounds of Ocean is so remote or hidden that the wanton wickedness of our people has not reached it in these times.

This develops into a discussion of precedent and *auctoritas* in the 'good old days' of sound morality, to be contrasted with more recent practice in the governance of the provinces. There is some danger that too many of these modern parallels might cause the reader to join Hortensius in asking why, if this form of baseness is universal, Verres should be singled out. But Cicero makes sure that his misdeeds are seen to cap the worst of all the others (210–17). The idea of acquitting Verres is too dreadful to contemplate, since it would set a benchmark for the level of extortion that would be permitted in the future (218–220); and the commutation of corn to money would provide many opportunities for future governors to enrich themselves and ruin their victims with impunity.

The tone of the epilogue is unusually combative (221–8). Using

imperatives, Cicero challenges the jury to return an acquittal, and describes the likely consequences; and he challenges his opponent Hortensius, who will be tarred with the same brush as his client, and will be expected to behave like him when he becomes a provincial governor after his imminent consulship. The usual summary (226–7) assumes Verres' guilt and warns once again against his acquittal, which would complete the ruination of the farmers in a country which depends entirely upon their prosperity ('For what is Sicily, if you take away its agriculture, if you blot out the farming population and the very name of farming?'). Finally, Cicero pledges himself to lead the recovery – a significant marker of his own political ambition. The speech contains all eight of the refinements.

In Verrem Actio Secunda IV

As he approached the subject of this speech, Verres' wholesale theft (*latrocinium* (1)) of works of art, Cicero faced the difficulty that he had previously encountered, but to a greater degree.[16] Whereas his Senatorial jury might respond to his arguments relating frumentary irregularities to potential political and economic instability, no such connections could be made with art theft, which had a long history among Roman provincial officials, and had even acquired a certain cultural cachet among the Philhellenic aristocracy. Cicero therefore had to show that Verres was not merely an art thief, but an egregious art plunderer who operated on a scale unequalled in the past. This set a major rhetorical hurdle, and hyperbole had to be called into service, accompanied by reassurance. He says that Verres sought out 'all the towns and all the wealthy houses in all Sicily...to examine them, and if he liked them, to appropriate them'(2); then he adds:

> This may seem a bold statement, but let me ask you to note what I mean by making it. Its unqualified terms are not an oratorical exaggeration, not an attempt to magnify the accusation against the defendant. When I assert that he has left no object of this description anywhere in Sicily, you are to understand that I am not speaking in the usual manner of the prosecutor, but in our common language.

This deft feint warns us to prepare for an outright assault. Hyperbole occurs

[16] On the problems raised by this speech, see E. Thomas, *De Signis* (Paris, 1894); P. Cayrel, 'Autour du De Signis', *MEFR* 50 (1933) 125–55; A. Desmouliez, 'L'interpretation du De Signis', *RU* 58 (1949) 155–66.

throughout, but most notably in 49, 67–8, and 71. Alongside this hostility, Cicero rightly felt that he must not appear to be too much of a connoisseur of art himself, as this might annoy those of his jury who did not share his knowledge, and cause some of them to ask how he came by it, if not through being a collector. This necessary pretence, sometimes even amounting to excuse, no doubt pained him somewhat, as he laid claim to broad artistic tastes. In 4, he says of one statue: 'One was a marble Cupid by Praxiteles – I learnt the artists' names in the course of my investigations as prosecutor'. Another was 'an admirable bronze, said to be the work of Myron, I believe – yes, it was so' (5). Cicero also felt it useful sarcastically to toy with the idea that Verres was so used to luxury (*delicatus*) he was better able to appreciate art like the Sappho of Silanio, which he stole from the town hall in Syracuse, than 'the rest of us' (126). But he soon returns to the reality of Verres' greedy ignorance (127–8).

As we turn to an examination of Ciceronian refinements, historical examples are adduced to compare Verres' depredations unfavourably with those of past officials in 7 and 9 (where the existence of a law denying the power of provincial governors to make private purchases is noted); and in 56, which concerns a recent governor of Spain, the aptly named L. Piso Frugi, who replaced his broken ring with another made by a local goldsmith from a half-ounce of the metal. This example illustrates the principle (*Orator* 71ff.; Quint.5.11.5ff.) that *antiquitas* is less important than *decorum* ('appropriateness') for the choice of *exempla* from the past. In 103–4, the Numidian king Massinissa is said to have plundered the Temple of Juno on Malta, but had second thoughts and returned his spoils, whereas Verres stripped the sanctuary bare and had no such feelings of remorse. Finally, 120–1 is an extended comparison of Verres' treatment of Syracuse as governor with that of Marcellus, its conqueror.

There are many passages of heightened emotion in the speech: 7 (with rhetorical questions); 17–18 (with apostrophe); 47, 52, 71, 74, 77, 86–7, 110–11. The latter is noteworthy:

I think of that sanctuary, that sacred spot, that solemn worship: before my eyes arises the picture of the day when I visited Henna, my reception by the priests of Ceres wearing their fillets and carrying their sacred boughs; my address to the assembled townsfolk, in which my words were heard amid groans and weeping which showed the whole town to be in the throes of the bitterest distress. They were bewailing not the cruel exaction of tithes, not the plundering of their goods, not the injustice of the courts, not this man's savage

lust, not his violence and his insolent outrages: what they wanted was the expiation of this utterly unscrupulous criminal's sacrilege against the divine person of Ceres, her ancient worship and her venerated shrine. So extreme was their distress that one might imagine that the King of Hades had come again to Henna, and had abducted not Proserpina, but Ceres herself. For indeed the town of Henna is thought of as no mere town, but as Ceres' sanctuary: its people believe that Ceres dwells in their midst.

Cicero's own vivid recollection of the atmosphere of the place amounts almost to a *prosopopoiia*; while the unfavourable comparison of Verres, who stole the goddess, with Pluto, who merely abducted her daughter, may have seemed to test the boundaries of taste.

Wit, much of it in the form of sarcasm, is less pervasive: 8, where Cicero ridicules Verres' claim that he bought his plunder; 51; 53–4 (word-play on Verres' name ('broom' and 'hog')); 59 (Verres' extravagance); 95 (Verres = 'hog' again); 102 (Verres and a woman of doubtful virtue).

The speech contains two digressions. In 33–4, he tells a story illustrating how Verres' behaviour on one occasion showed him to be a potential art thief. In 106–8, the temple of Ceres at Henna contains material for a substantial digression. With its mythological background it provides a welcome diversion from the sins of the accused.[17] More integral to its surrounding narrative, and therefore to be seen as a dilatation[18] is the description of Syracuse (117–9).

Two passages have a literary flavour: 39 (the story of Eriphyle, who betrayed her husband Amphiaraus (Graves, *Greek Myths* II 16, 21); 106–8 (the myth of Ceres). This leaves philosophy as the only Ciceronian refinement missing from this speech.

In Verrem Actio Secunda V [19]

After enjoying many opportunities to display his more robust and aggressive rhetorical skills when reviewing Verres' crimes in the earlier speeches, Cicero faces a more exacting task when he comes to assess his performance in the military sphere. It is clear that Verres' friends have defended his

[17] For its function of 'entertaining the reader (*delectare*)', see Von Albrecht *CS* 206.
[18] It is listed by Canter (1931) 352 as a digression.
[19] See R. G. M. Nisbet, 'The Orator and the Reader: Manipulation and Response in Cicero's Fifth Verrine', in Woodman and Powell (eds), *Author and Audience in Latin Literature* (Cambridge, 1992) 1–17.

record of protecting his province from the dangers of war (1). Cicero meets this difficulty by feigning awe at his achievements, expressing mock-fear and apprehension. He sarcastically turns to the old device of *aporia*, incorporating *hypophora*, a combination used by earlier orators when they were deploring the dangerous or pathetic situation in which they found themselves (Andocides *Myst.* 148; and esp. C. Gracchus, quoted by Cicero *De Or.* 3. 214, imitated by him in *Pro Mur.* 88, and also cited by Quintilian (11.3.115)). Anticipating that Verres' counsel Hortensius will remind them of the threatening situation which confronted him, Cicero reminds the jury how in an earlier trial the famous orator Marcus Antonius had given physical illustration of his client's bravery on the field by exposing the wounds he had received on the front of his body (cf. Sall. *Jug.* 85.29). But he maintains his ironic sarcasm (3 'I must be honest with you, gentlemen. I fear that the outstanding merit of Gaius Verres in the military sphere may gain him impunity for all the other things he has done') (so later, 14, 18). Only then does he go on to question the historicity of his claims and the existence of the alleged threats to Sicily's security. Slaves were not allowed to carry arms there, though Verres did not enforce that rule strictly, even allowing the release of some conspiring slaves when they were about to be executed ('bound to the stake, they were suddenly unbound' (11)). Someone must have bribed him – there is no other possible explanation. Subsequent passages are suffused with irony and sarcasm, as the realities of Verres' life-style are revisited. Not a proper field-commander, the only wounds he received on his body were love-bites (32). Military imagery for his amatory exploits (33) provides an artistic touch (cf. Horace, *Odes* 3.26, 4.1).

 Before resuming his examination of Verres' military record, Cicero inserts an interlude in which he reminds the jury of his own ambitions and credentials for further promotion after his aedileship (35–7). This insertion serves a dual purpose: the obvious one of self-advertisement, and the rhetorical one of sharpening the following invective against Verres by contrast. Whereas Cicero discharged all his duties as quaestor conscientiously, and promises to exercise the same qualities as aedile, Verres has never had any conception of the sheer dedication that his office required. After this interlude, Cicero's case develops further into the thesis that each of Verres' provisions for defence had the motive of personal profit behind it. In some cases this led to a weakening of Roman authority, as when Verres excused certain cities from their obligations to provide ships for defence on receipt of a bribe. (As before, when he has made this kind of accusation, Cicero is unable to

furnish clear proof, only inference from events (*ut res indicat* (50 cf. 65 (*suspicio*)). But he gives his account authority by showing his knowledge of the relevant laws (52–3), and multiplies examples of the granting of favours and exemptions, which undermined the military administration and weakened the fleet, leading to a recrudescence of the perennial scourge of piracy. The 'empty' ships were 'better fitted to put gold in the governor's purse than to put fear into the pirates' hearts' (63). The campaign of Servilius Isauricus against the pirates of Asia Minor in 77–4 BC provides a recent example of how such campaigns should be conducted. Servilius paraded their leader at his triumph and executed him; Verres spirited his captives away into obscure retirement or even his personal service (68–71), even substituting Roman citizens to face punishment in their place (72–3). This outrage receives appropriately emotional treatment (74–7).

Verres' pursuit of a life of debauchery led him to make decisions which damaged the authority of Rome. He appointed a Syracusan, Cleomenes, rather than a Roman, to the command of the fleet in order to keep him out of the way while he enjoyed the company of Cleomenes' wife. The historical comparison with Marcellus, conqueror of Syracuse, contrasts the latter's understanding of that city's unreliability with Verres' complete insouciance as he followed his own pleasures, 'standing on the shore in slippers, wearing a Greek cloak and a long-skirted tunic, and leaning on one of his women' (86: Quintilian admired this description for its *enargeia* (8.3.64)). The incompetence of Cleomenes and other commanders led to a disastrous sequence of naval defeats and the growth of piracy. Meanwhile, Verres continued to be a semi-detached spectator, and the reputation of Rome was degraded. This prompts a passionate outburst (100). Next, we hear how Verres planned to deflect blame from himself by charging and executing the captains of the ships, while exonerating Cleomenes. The agony of these men and their relatives is the subject of an extended emotional passage (108–21) which includes a lamentation on the plight of Sicily's leading citizens (122, 128). A broad summary of Verres' organization of the fleet (131–8) unifies this middle section of the speech before Cicero begins a wide-ranging *dilatatio* on topics already raised: Verres' treating of Roman citizens like slaves, behaving now like a pirate (145), now like a tyrant (149) in his quest for plunder; all amounting to the general charge that he declared a private war on the common cause of liberty (*causae communi libertatis inimicus fuisti* (169)), with constant emphasis on the atrocities Verres committed against Roman citizens, the jury's fellow-countrymen.

This thought now develops into an issue of domestic politics. Turning to Hortensius, Cicero warns him of the possible damage to his reputation if he perseveres in defending a man such as Verres (174). There is no doubt that he will be condemned in spite of his confidence in senatorial support; but those supporters are also in a sense on trial, and their behaviour could accelerate the transfer of judicial powers from the present juries to 'a new type and class of men' (177), under the *Lex Aurelia*.[20] Cicero can now enjoy the luxury of promoting his own career while claiming to champion the cause of justice for Rome's oppressed citizens and provincials. History is recruited (180–1) to evoke earlier *novi homines*, on whose careers he proposed to model his own: the Elder Cato and Q. Pompeius Rufus, who had, as he himself set out to do, braved the dangers which self-promotion entailed. Enmities must be faced, toil undertaken (*Inimicitiae sunt, subeantur; labor, suscipiatur* (182)). The speech has momentarily become a statement of a personal programme. He says that he wants to make this his last prosecution, an ambition largely fulfilled, but warns others intending to follow Verres' example to expect him to pursue them. The *Verrines* end with an imprecation which invokes some of the gods whose shrines Verres has profaned, but the reader comes away with a strong taste of the politics of the late 70s.[21] and of Cicero's part in shaping them through this trial.

The *Fifth Verrine* contains five of the refinements: literary allusion, wit, emotional appeal, dilatation, and historical example.

Pro Fonteio

M. Fonteius served as praetor in Gaul, perhaps between 75 and 73, and was subsequently accused of financial corruption and mismanagement under the *Lex Cornelia De Repetundis*. The trial took place probably not long after the enactment of the *Lex Aurelia*. Cicero, no doubt realizing that his career could not be advanced solely through prosecuting men with friends in high places like Verres, here appears in his preferred role of advocate for the defence, and his client is a Senator.

The speech survives in fragmentary form, and we join it towards the

[20] Drafted, as Cicero says (178), as the present trial was being staged (in 70 BC). It was part of Pompey's programme of dismantling the Sullan constitution, and giving more power to his own constituency, the knights and the populace.

[21] For a balanced critique of Verres himself, see F. H. Cowles, *Gaius Verres: an Historical Study*, Cornell Studies in Classical Philology 20 (1917).

end of the exordium. Cicero is upbraiding the prosecutor Plaetorius for bringing an action, without credible witnesses, against a man whose financial practices have shown no irregularities and been no different from those of other administrators (2). The subject of lack of credible witnesses is developed against the background of Fonteius' service in Gaul, a province exactingly administered by Rome because of its proximity and the heterogeneous character of its peoples, which led to instability. These conditions necessitated high taxation and expenditure, but also made it unlikely that irregularities would go unrecorded or unwitnessed (12–15). On the other hand, there were plenty of witnesses to Fonteius' efficient administration (16–7); while Cicero is able to refute individual charges of corruption that alleged profiteering from road-building and the imposition of transit charges on wine. In dealing with the latter, Cicero applies irony to the evaluation of Gauls as witnesses (21) (later styling them 'upright and punctilious oath-keepers' in similar vein (30)):

> If indeed Marcus Fonteius must be assumed to be guilty because the Gauls assert him to be so, what need, pray, is there for a wise jury, an impartial president, an advocate who is not stupid? The Gauls assert it; we cannot contradict them.

The question of the quality of witnesses is pursued further. In the past, juries did not regard all of them as equally reliable. Three historical examples follow of distinguished witnesses who were not believed because they were known to be prejudiced by greed and private enmity (23–4). The argument assumes *a fortiori* form when applied to the Gauls: if distinguished Romans were sometimes not believed, what was to be made of the testimony of Gauls, barbarians who had good reason to hate Fonteius, because of his efficient levying of taxes and other impositions (26–7)? The comparison is reinforced by generalizations about the character of the Gauls (28), who could not possibly understand the probity inherent in Roman forensic procedures. Gallic witnesses could not be expected to admit to uncertainty when giving evidence (29), or respect the sanctity of oaths they had sworn (30), since they were the same people who had despoiled the shrines of the gods .The portrait of the Gauls broadens as appearance is linked to character (33):

> Do you think that as they stand here, with their cloaks and trousers, theirs is the meek, submissive manner of the victims of outrage who, as humble

subjects, appeal for aid to a jury? Far from it! With confident and proud expression, they stroll from end to end of the forum, mouthing vague menaces and uncouth barbarian threats. Contrasted with this is Fonteius, who is the target of these menaces, but is encouraged by his own blameless character and the applause of those who have been affected by his administration (34–5).

The dilatation moves on to consequences (36): if Gallic threats, previously resisted successfully on the battlefields of Arausio and Vercellae, are allowed to influence the outcome of this trial, what precedent would that create for future relations between the two nations? A dramatic touch is added by the idea of summoning the victorious generals Marius, Domitius, and Fabius Maximus from the shades.

Cicero now expatiates on another theme, the frequency in past history of the laying of false charges by and against famous men, in cases of extortion. He chooses his historical examples for their recognized probity, in order to draw the desired parallel with Fonteius and represent him as the victim of wanton litigiousness, and also as the sort of provincial administrator that Rome could ill afford to do without (42–3). At this stage the speech is building up to an emotional climax. This begins with a metaphor of decidedly poetical flavour.[22] The libellous Gauls are 'mustering their batallions' against Fonteius, but are confronted by Macedonians and Spaniards, Massiliotes and Narbonese, who are girding themselves up to 'repel their assaults' with their 'testimonies and panegyrics' of his governorship (44–5). This elevated tone is raised further by the unusual introduction of the defendant's mother and sister, a Vestal Virgin (46–8), and Cicero implores the jury to show sympathy for them, and to 'place more confidence in the evidence of our fellow-countrymen than in that of foreigners, that you have greater regard for the welfare of our citizens than for the caprice of our enemies, that you set more store by the entreaties of her who presides over your sacrifices than by the effrontery of those who have waged war against the sacrifices and the shrines of all the world' (49).

Apart from limited historical allusion, the refinements are those of eloquence (humour, emotional appeal, and digression), and these give the speech its exuberance. It may have done much to affirm Cicero's reputation

[22] The best of Cicero's own poetry belongs to this early period. For bibliography, see G. B. Townend, in *Cicero* (ed. T. A. Dorey (London, 1964) 132. Further on this speech, see P. Jouanique, 'Sur l'interprétation du Pro Fonteio', *REL* 38 (1960) 107–12.

as an advocate in the eyes of potential senatorial clients after the prosecution of Verres.

Pro Caecina

Of all Cicero's speeches, this one most comprehensively exhibits the third refinement, knowledge of the law, and in particular, mastery in the adaptation and manipulation of legal terminology and technicalities. The case concerns inheritance of an estate. Aulus Caecina, scion of an important family in Volterrae, which Cicero was still befriending as late as 46 or 45 BC[23] inherited an estate from his wife Caesennia, but this inheritance was disputed by the present plaintiff, Aebutius who had physically prevented Caecina from entering the property to formalize his claim to it.

Aebutius dictated the legalistic course of the trial by arguing that, because he had no lien on it, Caecina's forcible removal from the estate was not 'ejectment', but 'exclusion'. Witnesses will naturally have their part to play (3), but the case will be decided primarily on the interpretation of the law (5), involving a rigorous process (8) commensurate with the seriousness of the case, in which the advocate requests the cooperation and indulgence of the jury, as he ends his exordium(9–10).

A clear narrative, including the essential details (10–23), is very necessary in an inheritance case. In addition to the facts, this narrative contains a characterization of the litigious opportunist Aebutius, and it is dramatized by dialogue. Aebutius has argued that the charge of 'ejectment' could not hold when the complainant had not taken physical possession of the property, but he has overplayed his hand by using force for the exclusion of Caecina from it. Cicero is able to ask:what is forcible removal from the environs of estate if it is not 'ejectment'? (32). The point is expanded in 33–5, where Cicero considers one legal remedy in face of wrongful ejectment – an action for assault – but points out that this would lead only to mitigation of the grief caused by the ejectment, not restitution. He skilfully shows how the simple application of the text of the law may not give the desired result, but the law can be freely applied in order to embrace its spirit.[24] The tenor

[23] He was involved in seeking Caesar's pardon for this Caecina's son after he had been on the wrong side in the Civil War (*Ad Fam.* 13.66). Further on the Caecinae, see K. Lomas, 'A Volscian Mafia? Cicero and his Italian Clients', in Powell and Patterson (eds) *CA* 106–7.

[24] The real issue of the case, downplayed by Cicero. See L. Fotheringham, 'Repetition and Unity in the *Pro Caecina*', in Powell and Patterson (eds) *CA* 259–60. Further on the speech,

of the following passage (one of suppressed exasperation (40–2)) suggests that Cicero may even be suggesting that the terms of the law should be more clearly defined, and its scope thereby widened, because it makes no provision for redress in the case of unlawful exclusion backed by force or the threat of force. The relentless search for definitions becomes a feature of the speech (*Orator* 102): here the concept of 'force' is extended to include 'being frightened by the sight of it' (47).

In the following sections both concepts are pursued further. In 53–5 he shows how the text of a law cannot be expected to include all its possible applications, as most of his audience will know from their own experience, and as an example from recent history illustrates. Failure to observe the spirit of the law rather than its mere letter smacks of verbal quibbling, a favourite pastime of jurists (cf. *Pro Mur.* 27), but in the present instance it could even damage his opponent's case (67–8). On the other hand, in the humane, liberal form Cicero outlines, the law is to be revered (73):

How splendid a thing is the law, gentlemen, and how worthy of your protection! How may we describe it? The law is something which favour cannot deflect, nor power break, nor wealth subvert.

Conscious that his strictures on the difficulties which can arise from punctilious application of legal texts might lead the jury to think that he undervalues the law itself, Cicero spends some time on affirming his total belief in its central role in society, as the guarantor of a secure life for both the individual and the Roman people in general (70–5). But if the definition of ejectment devised by the defence is allowed to stand in the present case, and they are allowed to deny that force was used purely by showing that no blood had flowed (76), the intention of the law has been thwarted. It will also be seen to have failed the plaintiff, and thrown doubt upon all future claims on property.

Cicero now tells the jury that he has discussed a related aspect of the present case with a fellow-advocate (80), and that he 'quoted many instances, including ancient precedents', to show that the actual wording of the law was often in conflict with the principles of right and equity, so that verdicts were reached on the basis of interpretations which accorded with those principles. By applying them to the present case, Cicero claims to catch the opponent in a *dilemma* (82–3), and to show that the use of force in any form of ejectment

see W. Stroh, *Taxis und Taktik: Die Advokatische Dispositionskunst in Ciceros Gerichtsreden.* (Stuttgart: Teubner, 1975; B. Frier, *The Rise of the Roman Jurists* (Princeton, 1996).

cannot be justified (84). He admits that his argument here is somewhat cerebral, and this forms part of the general picture he draws of himself in this speech, as an advocate who has the legal knowledge and expertise to handle the most difficult cases – a more technically accomplished performer than the defender of Sextus Roscius, who used passion and a degree of wit and culture in a legally much more straightforward case. Here he shows how earlier legislators deliberately chose words for their texts which could be interpreted in the widest possible way (87), and takes advantage of this for his own purposes.[25]

In (95), Cicero shows further legal knowledge, this time about the laws of citizenship, when he answers the prosecutor's argument that Caecina could not inherit the estate because he is a Volterran. This disqualification was nominally imposed by a law of Sulla because Volterrae had sided with Marius,[26] but Cicero argues that Sulla's law was 'so framed as not to deprive them of their rights of contract and inheritance' (102).

In the short epilogue (103–4), the contrasting characters of the two antagonists, Aebutius and Caecina, are summarily described, and attention is drawn to the former's admitted use of force, which puts him in the wrong according to both the letter and the spirit of the law.

The speech contains only two Ciceronian refinements apart from the pervasive manifestation of legal knowledge and expertise. Some of the arguments seem to have the character of logical exercises (48–9, 88–9), while there may be ironic humour in the imaginary scenario of the Gauls demanding reinstatement in the Capitol after they had been expelled (87–8) because of confusion in the wording of the terms of their expulsion (though the speech has been seen to be lacking in humour (Haury *IHC* 123–4)).

Pro Cluentio

This complicated case is set in Larinum, a provincial town not far from Cicero's birthplace of Arpinum. He held the praetorship in 66 BC, the year of the trial, and he owned a villa near Alatrium, which made him a neighbour of some of the principals (49, 117–18). By this time he had a formidable forensic reputation (he was 40 years old), and his cases had included several

[25] He 'dissociates himself from the quibbling in which he is indulging' (L. Fotheringham (n. 24) 273).
[26] See K. Lomas (n. 23) 107.

ASCENT TO THE SUMMIT

clients in the Italian municipia, a connection which he fostered throughout his career.[27]

Aulus Cluentius had been charged with poisoning his step-father Oppianicus, but that alleged event seems to have marked merely the highpoint in a long-standing conflict between two families, which had been punctuated by accusations from both sides. The son and namesake of that Oppianicus accused Cluentius of two other poisonings beside that of his father, and of bribing the jury in an earlier case: serious charges, which had made him vulnerable for the present trial. So Cicero saw it as his priority to undermine the credibility of the prosecutor and his family. He does so by means of a vivid narrative, peppered with comment and asides, through which he paints a lurid and destructive picture of the character of the elder Oppianicus. This comes after an exordium which contains a larger than normal array of the textbook topoi: apologies for the complexities of the case (appropriate here) (2),[28] aporia (4), plea for no prejudgement (6), and *captatio benevolentiae* (7–8). The tenor of the narrative is set in a preparatory narrative (*prodiegesis* (12–16)), where emotion colours the introduction of one of the main characters, Sassia, Cluentius' mother, who married the elder Oppianicus on being widowed. She is portrayed as a cruel and unnatural parent. In the following narrative (21–47), the background to the earlier trial of Oppianicus (74 BC), also for poisoning, attention is concentrated on characterizing him – his unscrupulous opportunism (25), effrontery (26), and selfish impetuosity (27), matched only by that of Sassia (28). Cicero says that he regrets that bare narrative cannot do justice to the events retold (29), but his narrative is anything but bare, as when he describes the death-throes of Oppianicus' poison-victims (30–1), which prove to be mere episodes in a long sequence of crimes (36–45).

The most important of these episodes was a plan by Oppianicus to poison Cluentius, using a slave. This plan was exposed. There was enough evidence to stage a trial, and Cicero at this point was induced to appear for the defence (49–50), accepting the brief out of a sense of obligation, without being fully apprised of its seriousness and all the principals involved. He describes his unease as he began the defence (*qua cura, di immortales! qua sollicitudine animi! quo timore!* (51)); and he even tells how the prosecutor dismantled it, answering his standard questions about motive (enmity and gain (52)), and

[27] On the significance of these ties, see Lomas (n. 22) 110–16.

[28] Cicero may have contributed to those complexities. See J. Humbert, 'Comment Cicéron mystifia les juges de Cluentius', *REL* 16 (1938) 275–96. Cf. Quint.2.17.21.

posing the unanswerable question of why the slave Scamander had brought
money to a secret rendezvous (53). Now Cicero follows this rare admission
of a defeat with an entertaining account of the performance of the defence
counsel in the subsequent trial of Oppianicus' confederate Fabricius (58):

> Thus he thought he was pleading very cleverly when he had produced from
> his secret thesaurus these weighty words: 'Look back, gentlemen, upon the
> lot of mortal man; look back upon its changes and chances; look back upon
> the old age of G. Fabricius!'; after frequent repetitions of the phrase 'look
> back' by way of adorning his speech, he finally looked back himself: and
> lo! G. Fabricius had left his seat with hanging head. Thereupon the court
> burst out laughing; counsel lost his temper, in annoyance that his case was
> slipping through his fingers, and that he could not complete his stock passage
> beginning 'Look back...'; and he was near as possible to pursuing his client
> and dragging him back to his seat by the scruff of his neck, so that he could
> complete his peroration.

The humour aroused in that court scene was no doubt replicated in the
present hearing. Cicero, now on the other side, felt that he could afford the
luxury of enjoying a fellow-advocate's discomfiture in a second defeat for
the cause of Oppianicus, which reinforced his characterization of the villain
of the story.

So Oppianicus was himself brought to trial, and inevitably convicted,
since the same evidence applied to his case as to that of Fabricius; and it was
heard before the same jury. Cicero rehearses some of the main charges of
that trial in order to refute an allegation that the jury was bribed to convict
him, but points out that in any case Fabricius was only acting to promote
Oppianicus' plans (62). There is perhaps deliberate confusion as to who
bribed whom, and in whose interest, but the story passes on to another
disreputable character, G. Aelius Staienus, one of the jurors in the pay of
Oppianicus, who double-crossed him. Cicero portrays him thinking aloud
as he weighs the possibilities (69–70) – a rare form of *oratio recta* in a
part of the speech where there are several instances of other kinds of this
animating device. Ciceronian wit abounds in the narrative as a whole (note
the elaborate culinary imagery in a conversation playing on the meaning
of the proper name Bulbus (71–2)), and further imagery in the passages
leading up to the present trial (79 and the transitional section 80).

The defence of Cluentius begins with a backward glance to the previous
trial, the aftermath of which was a degree of popular sympathy for

Oppianicus, encouraged by the tribune L Quinctius. The powers that had
accrued to that office had since then diminished slightly, enough to make
Cicero more comfortable in the present trial (79–80). The charge of bribing
the jury in the trial of Oppianicus is summarily refuted. There is no proof
against Cluentius, and probability-argument is adduced in his support. A
certain philosophical or gnomic flavour informs the oratory (84): 'Wisest,
they say, is he whose own mind suggests the appropriate idea: next comes
the man who accepts the good ideas of another',[29] and he develops this idea.
Proof of Cluentius' non-involvement in bribing the jury is convincingly
furnished. Then the speech takes a political turn, as he further develops
the question of tribunician power, and how miscarriages of justice can be
induced through excessive exercise of it. Historical comparison is supplied,
showing how, in the time of the Gracchi, when morality was stronger than it
is now, tribunician power could yet destroy even the best men (95).

Knowledge of legal history provides the material for a well-informed
discussion (117, 119–34) of the practical limits which were in practice set
on one of the key powers of the censors, their imposition of the 'stigma'
(*nota, animadversio*), by which they proposed to demote offending senators
or knights. Cicero shows that this and other censorial powers were curtailed
in the actual conduct of cases by judges and jurors. This prepares for the
argument that any capricious censorial pronouncements regarding Cluentius
can be justly ignored (125). In the following criticism that Cicero makes of
the censors' behaviour in relation to the present trial, he likens the arbitrary
visitation of punishment by the censors to the ancient military punishment
of *decimatio*, whereby breaches of military discipline were met with the
killing of one man in ten, chosen by lot (128). He argues that *all* wrongdoers
should be punished, and makes further criticism of the censors for their abuse
of power. The point is driven home with the historical example of Scipio
Africanus, who as censor in 142 BC thoroughly investigated the cases on
which he was called to pass judgement (134).

An interesting digression is made in 139–40, when Cicero says, of
forensic speeches, that they reflect, not the opinions of the advocate, but the
exigencies of the case:

> In my capacity as prosecutor I have made it my first objective to work on the
> feelings both of the public and the jurors; and I was quoting, not from my own

[29] The adage is found first in Hesiod *Op*. 293; later in Soph. *Ant*. 720–3, Aristot. *Eth*. 1.4.7,
Livy 22.29.7.

opinion, but from current rumour, every case that told against the courts, and
was therefore unable to pass over the case of which you speak, as it was then
a matter of great notoriety.

It was for this reason that M. Antonius, one of Cicero's models from the
previous generation of orators, never wrote out his speeches – that he did
not wish to be associated permanently with an opinion (140). It was part of
an advocate's equipment to be able to argue opposite viewpoints, choosing
whatever arguments and evidence could assist his client's case, and also to
use his own personal authority to add weight to it.[30]

A dilatation (146–50), on the subject of the sovereignty of the law, the
significance of its trappings, and the wording of its statutes, leads to some
recent history (151–6), in which the abuse of the law during the conflict of
the orders in the time of Sulla is recalled. This leads to a more comprehensive
discussion of the law, including the definition of its scope, and insistence on
its scrupulous observance, whereby freedom is secured and the ambitions of
its agents are controlled. This and other material in the speech mark it as a
clear step in Cicero's development as an orator, and even an indicator of the
theoretical turn which his writings will later take.

As to the defence of Cluentius, he rounds this off by denying and
refuting further allegations made by the prosecutor against him (162–8).
In a discussion and dismissal of possible motive, Cicero uses a sophistical
argument: 'Would not the enemy of such a wretched man as Oppianicus
have wished his wretchedness to be prolonged in life, not terminated in
death?' (170–1). Silly stories about retribution in hell should not make men
think that there is anything worse awaiting him after death than the torment
he is experiencing now. Secondly and finally, he produces a narrative which
purports to show where the blame for Oppianicus' death should be laid
(174–94). Oppianicus died after falling from a horse, yet his evil wife Sassia
began an enquiry aimed at finding her own son, the defendant Cluentius,
guilty of his murder. She was forced to abandon this for three years, and on
resuming it, conducted it incompetently, using slaves' evidence, extracted

[30] Cf. *De Off.* 2.51: 'An advocate should sometimes defend what looks like the truth, even
if it is not strictly true'. The nature and scope of a Roman advocate's function is investigated
in greater depth by C. Burnand, 'The Advocate as a Professional: the Role of the Patronus in
Cicero's *Pro Cluentio*', in Powell and Paterson (eds) *CA* 277–89. He argues that the advocate's
role in this speech marks an advance on the traditional role of the patronus, whose auctoritas
is almost his only weapon, and who might lack great professional expertise. Further on this
passage, see C. Craig, *Cicero as Orator*, Dominik and Hall *CRR*, 273–4.

under the cruellest torture, but to no avail. Cicero injects emotion into his reaction to the fate of Strato, one of Sassia's slaves who was implicated in her nefarious plans. He was crucified after having his tongue cut out (187–8). Emotion is sustained: it serves the practical purpose of blackening the character of Sassia and strengthening the jury's resentment against her. The importance of Sassia's part in the whole story is such that every means must be found to achieve this; and emotional appeal is the main weapon. After the initial assault, the tone becomes more measured and elevated. An inventive variant to the plea to the gods, often found in epilogues and occasionally in exordia, is introduced here, as Cicero raises the jury to the status of gods, to whom he appeals as a *supplex* (195).[31] He begs for pity for his client, and reminds them that the whole community of Larinum will be affected by their verdict (196). The good character of Cluentius is confirmed by his fellow-citizens' show of sympathy for him; and these include men of some standing (198–9). His mother Sassia, by contrast, with her cruelty, unnatural relationships (*uxor generi, noverca filii, filiae paelex),* must be condemned by their verdict. Her all-round malignity is visualized (*...videtis...* (199)), while Cluentius, a hapless figure, tearfully implores them (201). Only the most callous of jurymen could fail to be moved.

The *Pro Cluentio* is one of only four speeches that contain all eight of the Ciceronian refinements. Quintilian quotes from it more frequently than from any of Cicero's other speeches, and it has attracted considerable interest in modern times.[32]

[31] The beginning of the peroration (Petersen, Fausset, Grose-Hodge): M. Winterbottom (in 'Perorations' (Powell and Paterson (eds) *CA* 218) suggests 188, because 188–94 contain a summary of Sassia's misdeeds, which recapitulates earlier material.

[32] W. Kroll, 'Ciceros Rede für Cluentius', *NJA* 53 (1924) 174–84; E. C. Woodley, 'Cicero's *Pro Cluentio*: an Ancient Cause Célèbre', *CJ* 42 (1946–7) 415–8; G. Honigswald, 'The Murder Charges in Cicero's *Pro Cluentio*', *TAPA* 93 (1962) 109–23. The latter provides a timely reminder that the advocate's function is to present his client's character in a favourable light, if necessary in defiance of the truth. She sets out to show that Cluentius was 'no less a criminal than Oppianicus' (113); that he had motives for poisoning him (121–2); and that Cicero's damning portrait of Sassia was one of the devices with which he 'threw dust in the eyes of the jury' (123). Further on this speech, see Stroh, op. cit. n. 23; C. J. Classen, *Recht – Rhetorik – Politik*. Darmstadt: Wissenschaftliche Buchgesellschaft, 1985; A. M. Riggsby, *Crime and Community in Ciceronian Rome* (Austin, 1999); M. C. Alexander, *The Case for the Prosecution in the Ciceronian Era* (Ann Arbor, 2002); J. Kirby, *The Rhetoric of Cicero's* Pro Cluentio, (Amsterdam (Gieben), 1990.

Pro Lege Manilia

Addressed to the popular assembly on a current political subject by a recently elected praetor, this is the first extant speech which stakes Cicero's claims to be a statesman of stature in the mid-sixties. Recently elected praetor (66 BC), he speaks in favour of the appointment of Pompey to the command of Rome's army in the campaign against Mithridates, King of Pontus. His reasons for backing this appointment were Pompey's growing influence, especially since his consulship in 70 BC, and his success against the pirates; hope of reciprocated support from Pompey in the promotion of his own career; and the security which Pompey's pacification of the province of Asia would bring to the Roman tax-collectors there, who were mostly *equites*, the class on which Cicero depended for support.[33] However, the rapid rise of Pompey through extraordinary commands was a matter of concern, even alarm, in the senatorial circles where Cicero hoped to realize his highest ambitions. So no feathers must be ruffled in this speech. The style required in this set of circumstances was not antagonistic or adversarial, but epideictic, conciliatory, and laudatory – the Middle Style, as it was described by critics. This style was characterized by balanced clauses within a periodic framework, and smoothness in the order of words. The model for this would have been Isocrates rather than Demosthenes. The part to be played by Ciceronian refinements in this kind of oratory is to some extent circumscribed by its nature. It is not a medium for humour, high emotion or the display of specialized knowledge; and the studied deployment of its different topics allows limited scope for digression or dilatation.

The main subject invites epideictic treatment: 'the unique and outstanding merits of Gnaeus Pompeius' (3), but first the reasons for employing his talents in the defence of the province of Asia must be given. They are: the glory of the Roman people (7–8); the safety of her allies (12–14); the protection of sources of tax (15–16), and of the property of Roman citizens (17–18). All these are threatened by a restless, bellicose king who has so far withstood attempts to unseat him. Here Cicero faced a potentially awkward situation. Recent hostilities against Mithridates had been conducted by L. Lucullus, who was competent as a general and able as an administrator, but unlucky in both capacities; more importantly for Cicero, he was a leading senatorial

[33] Pompey would be expected to promote the interests of the equites. See Tenney Frank, 'The Background of the *Lex Manilia*', *CP* 9 (1914) 191–3; E. J. Jonkers, *Social and Political Commentary on Cicero's* De Imperio Gnaei Pompei (Leiden, 1959).

figure, whose replacement would be resisted by many on that side of the political spectrum. Cicero did not wish to alienate anyone, and therefore delivers a fulsome encomium of Lucullus (20–2), colouring it with an extended literary allusion, in which the first flight of Mithridates, jettisoning his treasure on the way, is likened to the flight of Medea from the same land, 'dropping the bones of her brother along the track which her father would follow in pursuit, in order that his progress might be checked by a father's grief as he collected the scattered remains'. Purists may note that the parallel is not perfect.

Cicero has to argue diplomatically that the war now facing Lucullus' successor requires a general of even greater ability than him: hence a section on the magnitude of the task against Mithridates (22–6), followed by a longer section (27–50) on the qualities needed in the general chosen to conduct it – knowledge of military matters, ability, prestige and luck (28).[34] Pompey qualified on all counts: he had acquired military knowledge at an early age (28); shown ability in many campaigns, the forms of it being manifold, including not merely military efficiency, but also incorruptibility, prudence, moderation, approachability, good faith, and humanity (29–42). He had acquired prestige through his successful campaigns (43–6), and had enjoyed luck – a blessing which all the most distinguished generals in the past – men like Quintus Fabius Maximus, Marcellus, Scipio Africanus, and Marius – had had (47–8). (Curiously Sulla ('Felix') is not included in this list, perhaps because many of Cicero's audience would have thought his later career to have been decidedly unlucky for many of them or their relatives, and hence made him a bad model for Pompey to emulate.)

After compiling an impressive dossier of Pompey's qualifications for the sole command in a difficult and dangerous campaign, Cicero turns to examine the objections of those who oppose it (51–62). Foremost among these objections is the argument that extraordinary supreme command should not be conferred on one man. The objectors will have pointed to recent history, and the careers of Marius and Sulla, which ended in tyranny as unchallenged power was converted into dictatorship. Cicero's answer to this is the argument of successful outcome: a single commander had delivered victory and a satisfactory settlement on many occasions in the past. The historical examples of single commands leading to successful outcomes are introduced through *occultatio* ('I shall refrain from mentioning that...'). The examples are briefly listed – campaigns in Spain and against Carthage

[34] See Steel *CRE* 130–5.

(Scipio Africanus Minor) – and against Jugurtha, the Cimbri, and the Teutones (Marius). They may owe their presentation in this form to the fact that the latter, at least, might prompt a knowledgeable audience to question its appositeness.[35] The section ends relevantly to the main argument with the example of Pompey's own early career, which was marked by so many extraordinary commands that Cicero can cap the section with hyperbole, a favourite epideictic figure (62): 'All the departures from precedent which, since history began, have been made in the cases of individuals, are fewer in number than these which our own eyes have seen in the career of this one man'. Thus the argument against constitutional innovation falls.[36]

It now remains to call upon the people to assert their sovereignty over the senatorial grandees (63–5), some of whom actually promoted Pompey's earlier appointments. He uses the epilogue to articulate his formal support for Manilius' proposal, asserting that it represents the popular will. In accordance with the measured tone of the speech, there is no emotional appeal. Indeed, it contains only two Ciceronian refinements, literary and historical allusion; but devices of style and rhetoric, which a popular audience would have enjoyed no less than his well-educated readers, are present in abundance.

Pro Rabirio Perduellionis Reo

Rabirius was accused of involvement in the killing of the popular leader Saturninus, an event which took place some thirty-six years before this trial, which was held in the year of Cicero's consulship (63 BC). *Perduellio* ('treason') was a political crime, and the reasons for the staging of this trial lay in contemporary politics.[37] The *populares*, noting an erosion of the powers they had won through the reforms of 70 BC, chose the case of an aged senator, who may or may not have killed one of their leaders, to test the Senate's authority. The appearance of Labienus as prosecutor strongly

[35] Further on Cicero's use of *occultatio* to introduce material which he does not wish to be examined too closely, see S. Usher, '*Occultatio* in Cicero's Speeches', *AJP* 86 (1965) 175–192.

[36] Steel *CRE* 122, using a version of Catulus' spech preserved by Dio Cassius, shows how Cicero has oversimplified the arguments for and against conferring extraordinary commands. For further remarks on the structure of the speech, see Steel 125–35; and for its panegyric character, see R. Rees, *Panegyric*, in Dominik and Hall *CRR* 139–41.

[37] See E. G. Hardy, 'Political and Legal Aspects of the Trial of Rabirius', *JPh* 34 (1915) 12–39.

suggests the involvement of his patron, Julius Caesar,[38] though his name does not appear in our lacunose text. Cicero felt obliged to defend a man who had upheld senatorial government under which he now held the highest office. It is with an explanation of this that he begins his speech. Brevity is its governing feature: he has been given only half an hour in which to deliver it (6, cf. 17, 38). This restriction inevitably curtails the use of embellishment, and also deprives him of the opportunity to broaden the discussion so as to include the death of Saturninus (9). The main charge has been summarily rebutted by reference to the length of time during which attempts to bring Rabirius to trial on various charges had all either failed or been aborted (8), so Cicero is able to focus on the cruelty of the punishment which conviction for treason would entail. How would that accord with Labienus' *popularis* pretensions (15)? He is tellingly contrasted with the proto-*popularis* Gaius Gracchus, and also with the present speaker, both authors of humane penal reforms.

He tackles the main charge more fully, about half way through the speech (18). He says that his preferred line would have been the *status iuridicialis* (Rabirius killed Saturninus, but justifiably); but that bold admission would have contradicted the facts. But he is happy to admit that his client was armed with the full intention of killing Saturninus, and this intention made him subject to judgement. A brief narrative recounts the relevant events of 100 BC (20), establishing that Saturninus was in armed possession of the Capitol, arrayed against the legitimate forces of the Republic. What was Rabirius to do but to add his support to their patriotic cause? Labienus, however, admitted that his own uncle was with Saturninus (22), a confession which Cicero represents as shameful (23), backing this assertion with a number of examples of other men who were publicly condemned at the time for such an admission (24–5). Cicero attacks him for his ignorance of history, in not understanding those events which took place before he was born, or gauging the stature of the men who opposed Saturninus (26–7), in whose ranks Rabirius took his place. Cicero magnifies the achievement of those men in a short dilatation on man's desire for immortal fame (29–30).

Only fragments of rest of the speech survive. They apparently link the historical defence of the Republic by the Senate with its contemporary role, guided by Cicero's counsel, in opposing populist legislation and the machinations of Catiline. There is paradox and emotional appeal as Rabirius

[38] Rawson, *CAP* 66–7, describes the somewhat theatrical preliminaries to the trial, in which Caesar was involved.

is characterized as the doughty soldier, who never feared the enemy, from whom he had received wounds on the front of his body (*i.e.* facing them, not fleeing from them, matching Marius' claim in Sallust *Jugurtha* 85.29), but now fears his own people (36). But Ciceronian refinements are generally scarce – only four of the eight (sarcasm in 12–14, historical allusion in 15 and 24–5. and the dilatation and emotional appeal noted above) . The Grand Style of the speech (see Albrecht *CS* 24) is not matched by the argument. Cicero seems content to be stating the senatorial side without denigrating or disparaging those opposing it. Perhaps the impending danger from Catiline is foremost in his mind, both as a practical issue and as a potentially recurrent threat to peace that was unrelated to party politics, but which could be extinguished only by a strong coalition of all the orders of the Roman state.

In Catilinam

The Catilinarian speeches were delivered in 63 BC, in the last months of Cicero's consulship:

> *In Catilinam I*: Ad Senatum 8 November
> *In Catilinam II*: Ad Populum 9 November
> *In Catilinam III* Ad Populum 3 December
> *In Catilinam IV* Ad Senatum 5 December (?)

In Catilinam I

Cicero marks the highpoint of his career as a politician more with his purely rhetorical powers than with the eight refinements he recommends. His frontal attack on Catiline, who is present in the curia, begins without preliminaries with a direct apostrophic question:

> How much longer, Catiline, are you going to abuse our patience? When will that madness of yours cease to make us your playthings? When will your unbridled insolence put an end to its display?

This insolence (*audacia*) is the more blatant because Catiline knows that his plans have been laid bare, and his movements are being constantly watched. Sallust adverts to this several times in his *Catiline* (26.2–3; 28.1–2; 29.1; 31.6; 41.5; 43.1; 44.1; 48.8–9): Cicero had many informants, so that he was always a move ahead of Catiline, and cognisant of his plans.[39] He returns to this point in 6–7, where he advises him to abandon his mad enterprise:

Take my advice: abandon your scheme and forget your murder and arson. You are trapped on every side; all your plans are as clear as daylight to us.

This reflects the consul's confidence, which will have had its desired effect on his senatorial audience, strengthening the resolve of the majority, while implanting doubt and fear in the minds of those who were involved in Catiline's conspiracy. But before this (2), more concentrated rhetoric has been applied to dramatizing the general atmosphere and the danger:

What an age we live in! The Senate knows what is going on, the consul sees it, and yet the man is still alive. Alive, did I say? Not only is he alive, but he is present in the Senate, participates in our debates, picks each of us out with his gaze, and marks us down for death. We, however, brave men as we are, think that we are doing our duty to the Republic if only we avoid the frenzy of his cold steel.

To rhetorical question, apostrophe and anaphora is added *correctio*. These figures are succeeded by historical examples (3–4), the first used in an *a fortiori* framework, ending in hyperbole:

Publius Scipio, a man of distinction and the chief pontiff, was a private citizen when he killed Tiberius Gracchus even though he was not seriously undermining the Republic. Shall we, then, the consuls, tolerate Catiline, whose aim is to carry fire and the sword through the whole world?

The apostrophe to Catiline continues, as Cicero describes his own danger

[39] T. R. S. Broughton, 'Was Sallust Fair to Cicero', *TAPA* 67 (1936) 34–46, argues convincingly that 'alleged instances of irony, malice and sly refutation do not stand the test of criticism' (42), and interprets *Cat.* 46.2 as a testament to Cicero's sincerity and courage. But he also says that Sallust gave Cicero 'his due by stealth' (45), a necessary concealment because he was writing under the Second Triumvirate (46). See further W. W. Batstone, 'Cicero's Construction of Consular Ethos in the *First Catilinarian*', *TAPA* 124 (1994) 211–66; J. J. Price, '*The Failure of Cicero's First Catilinarian*', *Studies in Latin Literature and Roman History* 9 (1998) 106–28.

and the vigilance with which he overcame it, contrasting this with the only practical course now available to Catiline – to leave Rome, abject and friendless, with his life in ruins after his plans had been thwarted (15–16). This is a passage of heightened emotion (note the striking *prosopopoiia* in 18), an effect which he may have thought necessary to mask the fact that he had no legal means of attacking Catiline through the Senate, an opinion apparently shared by his senatorial audience, who respond only with 'silent consent' (20), not vocal agreement, to his call to Catiline to leave Rome. Then (22) he expresses apprehension that, if Catiline should go into exile at his unsupported bidding, 'a storm of unpopularity would break over my head...It may not come immediately, while the memory of your crimes is still fresh, but in the future'. Prophetic? That depends on when the speech was circulated.

What follows, a lurid description of Catiline's likely activities when he goes away to join his fellow-conspirators (25–6), would certainly have been helpful material in an apologia answering the critics of Cicero's conduct as consul.

Catiline would no doubt have been slightly relieved when Cicero turned at last to address the curia at large. He animates a dilatation (27) by making them ask him why he refrains from arresting and executing Catiline out of hand. His argument in reply (29–30) begins tentatively: while claiming to have no fear of unpopularity, he appears anxious about the opinions of 'some in this order (*i.e.* senators)... who would have influenced many, the merely naïve as well as those of ill-will, into saying that my action was cruel and tyrannical, if I had punished Catiline'. This points once more to Catiline's shadowy supporters. Cicero is now opposing them openly, saying that Catiline's death would remove '*this* plague upon the Republic'; but he further broadens the argument by introducing the spectre of a 'danger deep-seated in the veins and vital parts of the State'. This imagery of disease, much favoured by his Athenian mentor Demosthenes, is elaborated in a parable (31):

> Men who are seriously ill often toss and turn in the heat of their fever and, if they drink cold water, seem to get relief at first, but then are much more gravely and acutely distressed. In the same way, this disease from which the Republic is suffering will be temporarily relieved by his punishment, but so long as the others remain alive will grow more serious.

The high emotional temperature of this part of the speech, which is sustained to its end as Cicero calls on Jupiter, in whose temple this meeting

is taking place, to visit eternal punishment on Catiline and his henchmen (33), receives added significance when viewed as apologetic, a *post eventum* justification of the execution without trial of the leading conspirators who stayed in Rome after Catiline's departure.

Thus emotional writing has a special purpose here. Otherwise, of Ciceronian refinements, only historical example and dilatation are to be noted.

In Catilinam II

The day after this speech to the Senate, Catiline has gone (*Abiit, excessit, evasit, erupit* (1)), and now Cicero addresses the people. A just war can be waged against a man who has made himself into a *hostis*. Victory of a kind has already been won, since his departure has left the city safe and intact. This triumphant announcement is designed to dispel the fears and doubts of the citizen body, but he still feels that he needs to restate his previously expressed compunction (I. 29–30). This time there is more emphasis on his own part in Catiline's withdrawal, but this seems to be corroborated by Sallust, who has him rushing out of the curia immediately after Cicero had spoken (*Cat.* 31.6–9).

The invective of the first speech is replaced by themes of deliberative oratory, in which narrative plays the necessary part of supplying the relevant facts. A military campaign must be fought, and therefore the character of the enemy must be analysed. The description of the opposing army is in two parts. The army already gathered with Manlius in Etruria (5–6) is more to be feared than the motley farrago of reprobates and dissolutes which Catiline would be taking with him from Rome (4), though the intention of both to go through with their plans in spite of their exposure suggests that they are equally determined. Cicero has to convince the people, some of whom will have been attracted by Catiline's popular programme, that they should be ready to put their own lives on the line in order to stop him. Cicero seeks to negate their idealism about him by portraying his utter dissoluteness, but it has dangerous aspects: he has been 'trained by his life of debauchery to endure cold, hunger, thirst, and lack of sleep'(9) (cf. Sall. *Cat.* 5.3), and this paradox extends to his associates, who are just as depraved, but also equally ready to resort to violence, which makes them desperate, suicidal opponents.

A deeper analysis of the five classes of men who had joined Catiline's

army (18–23) serves to distance the people from their new enemy. These were insolvent men who, however, owned first class properties which they did not want to lose; men who, because of their rank and family connections, still had political ambitions in spite of their debts; ex-Sullans, older men, who had many dependents whom they could summon to their aid if they could promise new proscriptions; an assorted group of malcontents, mainly small-scale debtors; and criminals, like Catiline himself, whom Cicero describes in his most colourful terms (' ...with their carefully combed hair, dripping with oil, some smooth as girls, others with shaggy beards, with tunics down to their ankles, and wearing frocks not togas' (22)). There is humour here: but how different are all these types from his audience! They are men alienated from the mainstream of society, and therefore useless to it. Sarcasm is added to this lurid description (24):

> What a truly terrifying war if Catiline is going to have this élite force of ponces! Now, citizens, marshal your garrisons and your field forces against these brilliant troops of Catiline!

This rallying cry is made more effective by the irony that underlies it, adding to the idea that victory should be assured against such an enemy, in spite of the determination of part of Catiline's army. This part of the speech (23–7) reads like one of the hortatory speeches penned by the historians, with its twin themes of justice and possibility, and its audience including men who will fight the enemy. In the concluding section he reminds the people of the provisions he has himself made to guard the city against the impending danger. In a speech charged with urgency, there is little room for the studied artistry of Ciceronian refinements: there are only two, historical reference (20) and humour.

In Catilinam III

Reference to the gods and to the city's founding hero Romulus gives this speech to the people a celebratory flavour.[40] Cicero does not stint on self-congratulation: he saw this day as the pinnacle of his career (28). Yet otherwise the speech is more conventional than the previous two, with a narrative (4–15) giving a step-by-step account of the events leading up to the arrests of the

[40] Albrecht *CS* characterizes it as 'a largely epideictic piece of self-praise' (122). Further on this speech, see A. Vasaly, *Representations: Images of the World in Ciceronian Oratory* (Los Angeles and London, 1993); S. Butler, op. cit. n. 14

resident conspirators, Lentulus, Cethegus, Statilius, and Caeparius. It contains an important point of reference for future readers, namely his insistence that he has consulted and informed the Senate at every stage. His account is essentially. the same as that given by Sallust (*Cat.* 39.6 –41–5). In it are revealed Lentulus' dealings with the Allobroges aimed at starting a diversionary Transalpine war, and the exposure of the plan through the interception of a letter from Lentulus to Catiline. It is a gripping story as told by Cicero: an ambush at the dead of night, a short confrontation, the messengers brought before the consul at dawn, the conspirators roused and summoned, and the contents of the letters revealed to the Senate. Faced with the evidence, Lentulus had to acknowledge his family seal, and broke down. Cicero adds an ironic note by mentioning that Lentulus' grandfather had 'loved his native land and its citizens more than any other man' (10). Then he describes the demeanour of each conspirator – downcast, confounded, and guilty (13) – which was more convincing than the physical evidence of the letter and the seal.

Cicero now increases his efforts to get the people on his side, as he is aware both of senatorial opposition and of Catiline's popular following. That is why he insists that the initiative for the arrest of the conspirators came from the Senate, not from him alone (13). Historical comparison with recent wars (24) is introduced to make the point that they had been waged in order to change the Republic, whereas the present one, which he describes in terms that suggest it has already been fought to a finish, had its destruction as its aim (25). This is one of several statements which raise questions as to the date of the speech's publication. His anxiety about his own vulnerability also seems to anticipate events that led to his exile. The speech draws to its conclusion against this background (29):

> Have no doubt, citizens, I shall ensure that upon my return to private life I shall uphold and consolidate the work of my consulship, and see that any hatred I have incurred in saving the Republic injures those who hate me and redounds to my own glory.

The speech has an emotional tone almost throughout, but specific passages are difficult to highlight. Its only other Ciceronian refinement is historical allusion (18, 20, 24)

In Catilinam IV

There has been a debate in the Senate following the arraignment of the
conspirators. This speech is Cicero's contribution to it. Decimus Silanus
has proposed the death penalty, Caesar confinement for life in separate
municipalities. (As Cicero does not mention the speech of M. Porcius Cato
which according to Sallust (*Cat.* 53.1) finally swayed the Senate towards the
extreme sentence, we must either reject Sallust or assume that it was delivered
later, perhaps in another debate; or we must ask why Cicero omits it).[41] In the
present discussion, it is the speech of Caesar that commands most interest,
since it seems to have influenced Cicero's treatment of the issue. There is a
philosophical tone to some passages (3: 'A brave man's death cannot bring
dishonour, a consul's cannot be before its time (*i.e.* he has reached a climactic
moment in his life (cf. Herod. 1.30.4–31–5)), a philosopher's cannot bring
sorrow'). Caesar, according to Sallust,[42] has argued that, whereas no cruelty
was too great for the crimes which the conspirators had committed, to
propose cruel punishments was *aliena a republica* (*Cat.* 51.17). From this
a cynic might suggest that he meant such cruel punishments were sure to
have political repercussions. Cicero attributes similar reasoning to him, but
argues cruel necessity, and questions the logic of Caesar's position: 'What
cruelty can there be in the punishment of a crime of such enormity?' (11);
and later frames the problem as a paradox: 'when our fatherland and our
citizens have been destroyed, our desire to be lenient will be condemned as
extreme cruelty'(12). But he also admits that emotion plays a strong part in
shaping his opinion (12):

> Whenever I have pictured Lentulus wielding power, which he hoped the fates
> would grant him, with Gabinius wearing the purple at his side, and Catiline
> there with his army, I shudder when I think of the mothers weeping, the boys
> and girls fleeing, and the Vestal Virgins being violated.

After this memorable visualization, Cicero elaborates the terrible
consequences of a Catilinarian takeover of Rome. The purpose of this

[41] When Cicero sent copies of the *Catilinarians* to Atticus (June, 60 BC (*Ad Att.* II 1, 3)) he
had come to regard Cato as a political liability (id.9), and may also have been at odds with
him since his portrayal of him in *Pro Murena*. But perhaps the chief reason for this omission
was a desire not to share the glory for saving the Republic. He later acknowledges Cato's
motion (*Ad Att.* XII 21).

[42] *Cat.* 51.15.Sallust, aged 23, could not have been present.

is clearly to dispel the doubts of those Senators who were opposing the execution without trial of their guilty colleagues. Now he seeks to win over the doubters by quoting the opinion of one of their number who was actually Lentulus' brother-in-law, Lucius Caesar, and through him reaches back into the past to compare two grandfathers, those of Lentulus and Caesar (13), respectively opponent and supporter of Gaius Gracchus, who both suffered for a cause. There is an *a fortiori* element, as often in historical comparisons, but it is applied only to the two Lentuli.

To doubts about legality are added those of practicality: Cicero has to convince his colleagues that the means and the unanimous will are in place to destroy the enemy and banish internal strife (14–15). This has the effect of isolating the waverers even more . It is a picture of Cicero's cherished *concordia* in action (16), not to be undermined by rumour (17). Everyone wants it to prevail (18):

> Beset by the brands and weapons of this vile conspiracy, the fatherland we all share extends to you the hands of a suppliant. To you she commends herself, the lives of all her citizens, the citadel and the Capitol, the altars of her household gods...You have as your leader a man who is heedless of himself and thinks only of you... you have the support of all classes, of all men, of the whole Roman people.

The *prosopopoiia* contributes to the emotional tone of this passage, and prepares the audience for the singular claims he is about to make. He compares himself to great historical heroes of the Republic, the Scipiones Africanus and Aemilianus, Aemilius Paulus, Marius, and Pompey, who served it abroad but did not save it at home, as he had done (20–1). He rescues this flawed argument by narrowing it down to a distinction between *externae* and *domesticae victoriae* (22), victories over 'the enemy within', and thereby at least makes clear his main purpose in this speech, and perhaps in all four *Catilinarians,* which is to justify all his actions as consul, and to secure his future safety and that of his family. Not being a military man, he chose the best line of eloquence available to him.[43]

The incidence of Ciceronian refinements is again low (three: philosophical (3), historical (4, 21) and emotional passages (11–12, 18)), but the *Fourth Catilinarian* conveys a more complex message than its predecessors.[44]

[43] Steel *CRE* 168–70 develops this point, noting that Cicero's career had not followed the traditional republican course *domi militiaeque.*

[44] R. W. Cape, 'The Rhetoric of Politics in Cicero's Fourth Catilinarian', *AJP* 116 (1995)

In these early speeches, Cicero sets out his store of refinements comprehensively. The chapter contains three of the four speeches that have all of them, *Pro Roscio Amerino, Verrine II* 3, and *Pro Cluentio. Verrines II* 4–5 are distinctive for their concentration of both emotional and humorous passages. Some of Cicero's most impressive displays of legal knowledge are found in *Verrine I, Pro Cluentio,* and *Pro Caecina.* In his political speeches, however, deployment of refinements is more limited because the persuasive techniques required in them were of a different order. *Pro Lege Manilia* was a speech to the converted, designed to affirm an already popular policy. His senatorial audiences for the *Catilinarians* generally favoured his stand in a situation demanding decisive action. In neither situation was there place or time for digression or displays of erudition.Development at this stage was consequently uneven; and there are clear signs that the panoply of refinements will find its place in Cicero's forensic rather than his political oratory.

255–77, sees it as 'a prime example of Roman politics in action' (256), propounding a political programme (257). Cape also notes that his chief task was to consult the Senate, and this affects the interpretation of the speech (259–60, 271–2), while the passionate tone suits the tenor of the debate (263). This thorough study also reviews other (conflicting) scholarly opinion (257), examines the rhetoric (264–8), and finds Cicero's treatment of Caesar reserved and ironic (269).

CHAPTER THREE

CONSULSHIP, EXILE, AND RETURN

Pro Murena

The most accomplished speech that Cicero delivered during his consulship, this is of especial interest in the present study, because it is possible to identify all eight of the refinements which he sought in his ideal orator.

Lucius Licinius Murena was one of four candidates for the consulship of 62 BC, the others being Decimus Junius Silanus, Servius Sulpicius Rufus and Lucius Sergius Catilina. The election had been postponed from its normal time in July, to late October, so that it took place against a background of impending internecine war, as Catiline's confederate, Gaius Manlius, was reported to be raising an army in Etruria. In these circumstances the qualities required in the incoming consuls were starkly clear: unflinching resolve, and the means and ability to stop Catiline and his revolutionary designs. Silanus led the debate on the fate of the arrested conspirators (*Cat.* IV 7, 11; Sall.*Cat.* 50.4, 51.16). No doubt his hard-line views were known before the election, and helped to secure his appointment. Murena was a seasoned, if not particularly distinguished, military campaigner, who had retained close ties with Lucullus, whose returning army could provide the operational force that would be needed to crush Catiline. Cicero thus had complementary reasons for backing these two candidates; and when Sulpicius arraigned Murena for electoral bribery (*ambitus*), and was supported by Marcus Porcius Cato and Gaius Postumus, it was logical that he should appear in his defence.

The prayer for Murena's acquittal which begins the exordium (1–10) may derive ultimately from the one with which Demosthenes begins his greatest speech, *On the Crown.* Like Demosthenes, Cicero prays that the gods may implant the right state of mind in the jury. At the time of this trial – November 63, only weeks before the battle which would save or destroy the city – the reassurance of having an experienced general as consul was well worth praying for. The dignified and solemn effect of his words is reinforced by the four periodic sentences with which the speech begins (1–2)

Having put the jury in the right state of mind, Cicero has to deal with a moral dilemma posed by one of the prosecutors. Cato has criticized him for inconsistency, in that he has both legislated against electoral bribery

and defended a man credibly accused of it. The concept of moral rectitude
(*rectum*), a tenet of Stoicism, a philosophy which governed Cato's life, was
familiar to Cicero, as he shows later (61–6), when he is happy to measure
his knowledge of the subject against that of his opponent. At this stage his
main need is to challenge its rigid application to the present case, so he
substitutes for morality a kind of practical logic: who better to defend an
incoming consul than his outgoing colleague? (3) A parable of returning
sailors passing on information about possible dangers to those about to take
to the high seas (4) serves to mask the weaknesses of this argument.

Cicero's approach to the other prosecutor, Sulpicius, required some degree
of tact, as they were friends who had studied rhetoric together at Rhodes,
and Sulpicius was now evoking the claims of *amicitia* and *familiaritas* (7).
Cicero points out that he had actually backed him, but would not be his
'aide' against Murena (*adiutor*, often used in a military context ('adjutant'),
hence apposite here). Mild wit achieved through play on two meanings of
the verb *petere* ('seek the consulship' and 'attack') serves to summarize
Cicero's attitude.

The division of the speech after the exordium is clear. In a reply to the
prosecutor's attack on Murena's private life (11–14), Cicero upbraids Cato
for makings unsubstantiated charges; and this is followed by a more detailed
section comparing the merits of the candidates Murena and Sulpicius. It falls
into two distinct parts: in 15–42 the comparison is based on events; in 43–53
the comparison is psychological, examining abilities. Ciceronian wit is applied
to Sulpicius, who depreciated his opponent in terms that were extreme enough
to trigger a new popular revolution (*plebes in Aventinum sevocanda* (15)), and
was insensitive in parading his snobbery before 'the son of a Roman knight'
who was currently the consul (himself). The divergence of the two candidates'
careers serves to show how Murena's fitted him for the present emergency.
Sulpicius' 'service' (*militia*) was in Rome, occupied with legal matters (19);
Murena served on campaigns with Lucullus, adding to his military experience
(20). Cicero rhetoricizes the contrast in a summarizing anaphoric antithesis
(22, cf. Dem. *Cor.* 265, a famous antecedent):

> You spend sleepless nights preparing opinions for your clients, he to bring his
> army to its destination in time. You are woken by the call of cocks, he by the
> call of trumpets. You draw up a lawsuit, he a line of battle. You protect your
> clients against surprise, he his cities or camps. He understands how to keep
> off the enemy's forces, you how to ward off rain-water. He has been engaged
> in extending boundaries, you in defining them.

In each antithesis, the lawyer's action is made to appear petty compared with the general's, and the order is climactic, with the last two pairings reversing the order as minor domestic litigation is forced into second place in a comparison with major decisions in the field, as the gap in importance between the pairs of action widens futher.

Further wit is added to this rhetoric as Cicero apostrophizes Sulpicius prior to a more practical examination of the legal profession.[1] 'And since you seem to me to be embracing your knowledge of jurisprudence as if it were your darling daughter...' (23). His argument is directed towards the disparagement and marginalization of that profession, and it is wittily animated with imaginary exchanges between lawyers in a property suit, and their courtroom antics. The more serious criticism of them, that they sometimes perverted ancestral laws by hair-splitting subtleties and adherence to the letter rather than the spirit of the law (27), is obviously more directly relevant to candidacy for the consulship, since a man with these faults lacks *dignitas* (28). Embedded alongside this argument is comparison with the career of orator/statesman, which unsurprisingly is seen as far more useful and worthy for the would-be contender for high office (24, 29, 30). But he is interested not in comparing personalities, but careers which lead to the consulship (30); and at this time the consul needs the qualities that are best evoked by the great patriotic poet Ennius – those of the *horridus miles* rather than the *orator bonus*.

Cato has concentrated on downplaying Murena's military achievement. The war against Mithridates, he said, was 'fought against a lot of women' (31). Cicero meets this with historical comparisons. Past wars against Greeks and Asiatics have been the toughest fought by Rome, and those against Mithridates were no different (31–4). Cicero magnifies the recent successes of Lucullus and Pompey (though not to the extent of furnishing a detailed narrative), while making only brief mention of Murena's part in the latter's campaign.[2] Historical comparison comes to his aid again in his reply to Cato's curious argument that Sulpicius should be preferred to Murena because his name had been returned first in the election for the praetorships (35). This makes wholly unwarranted assumptions about the choice of the electorate, which is in fact as fickle as the varying currents of the Euripus channel. Examples of electoral upsets between 116 and 93

[1] Fantham, *RWCO* 202, notes that Cicero studiously avoids attacking either man personally, directing his humour and irony against Servius' profession and Cato's philosophical sect.
[2] Steel *CRE* 135–6 notes that Cicero represents Murena merely as an 'ordinary general', whose accomplishments are subordinated to those of others.

BC provide illustration of this, but Murena's election to the consulship can be objectively explained: his troops backed him because he had led them well (37–8). This objective argument now broadens. Murena's defeat of Sulpicius had been made inevitable by his good fortune in drawing the lot for the urban praetorship, which placed him in charge of civil jurisdiction, and concluded in public games; whereas Sulpicius was appointed to preside over the courts of embezzlement and extortion, which were attended by informers prosecuting men in rags, and reluctant jurors (42). Success, for politicians no less than for generals, depends heavily on luck.

Sulpicius, by contrast, did not even make his own luck. He refused a province (42), and subsequently revealed psychological flaws in his campaign for the consulship (43–53). By behaving like a litigant rather than a candidate, 'collecting witnesses rather than voters, uttering threats rather than compliments' (44), thereby appearing to anticipate defeat, he had alienated potential supporters. Cicero enjoys speaking as a successful candidate himself (46), and is also here implicitly criticizing Sulpicius for invoking the law on electoral bribery on which the present trial had been based. He even manages to imply that his mismanagement of his election campaign emboldened the fourth candidate, Catiline (49), and this provides Cicero with another opportunity to remind the jury of the fear that was rife in those days of his own glory. In a time which required a fearless leader, Sulpicius showed himself to be a diffident and passive candidate (*remissiorem in petendo* (52)).

The main charge against Murena, that of electoral bribery, is considered in 54–83, but by that time Cicero could have hoped that the jury would have come to regard it as irrelevant. Yet his handling of it is thorough and methodical. Historical examples provide necessary parallels. At the trial of L. Cotta (c. 132–29 BC), the defendant was acquitted because the jury did not want the prestige of his prosecutor, P. Scipio Africanus (cos. 147, 134), to influence the outcome excessively. The parallel is with the present august prosecutor, Cato. It is a nice paradox, which in the earlier case led to a perversion of justice. Another example of miscarriage of justice involved Cato's own ancestor a few years earlier, when the jury acquitted Servius Galba on similar grounds.

Cato subscribed to Stoic doctrines, which included uncompromising and draconian tenets about human behaviour and punishment, and assertion of the infallibility of the Stoic sage. Cicero shows by examples that he is as well versed in the doctrines as Cato, but argues that they should be used

merely as topics for debate, not as rules to live by (62), because they are too extreme to be practical. He prefers the more relativistic position assumed by the Platonic and Aristotelian schools (63), but is careful all the time to confine his criticisms to the philosophy and not to extend them to the man, although later (66) he points out that others have interpreted Stoic doctrine more liberally.[3] While still maintaining a flattering tone, Cicero has been subtly undermining any sympathy the jury may have for Cato, and he pursues this a little further by addressing him as his junior, who may mellow with time (*dies leniet, aetas mitigabit* (65)). The section is further coloured by a literary quotation, in which Achilles' mentor Phoenix says that he can guide him from error (60).[3]

More Ciceronian refinements appear in the following pages. In 74–5, a brief digression introduces the customs and character of the Spartans and Cretans in order to argue that the extremes of austerity and self-indulgence do not enable a people to defend themselves as well as Rome has done by adopting both ways of living at diferent times. Her people, while condemning private luxury, delight in public splendour. In 78 there is a broadening of the discussion (*dilatatio*) as he argues that he is defending Murena not only for personal reasons but also for protection from the Trojan Horse within (*Intus, intus inquam equus Troianus*). (Lentulus, Cethegus, and the rest of Catiline's leading supporters were still at large in Rome (cf. *Cat.* 2.11)). This excursus widens still further into a review of the so-called First Catilinarian Conspiracy (81), a description of the present perilous state of affairs in Rome, and a preview of the political turmoil ahead. Plots are still being hatched, and the energies and courage of men like Cato are needed to counter them (82). Cicero is now stoking the fears of the jury, and in increasingly urgent terms. Their verdict will be crucial for their own survival: *non solum de L. Murenae verum etiam de vestra salute sententiam feretis...in discrimen extremum venimus...versabitur in urbe furor, in foro coniuratio, in curia timor, in campo exercitus, in agris vastitas* (84). One of the most emotionally charged of Cicero's epilogues includes a pathetic picture of the suppliant Murena's dejection on being condemned to exile after winning the highest office, a tragic *peripeteia* (86–9). But the final period exudes a consul's authority, and contains a personal guarantee that the new consul will keep the Republic safe and destroy her enemies.

[3] See C. P. Craig, 'Cato's Stoicism and the Understanding of Cicero's Speech *Pro Murena*', *TAPA* 116 (1986) 231–2, 236. Craig follows Kennedy (*ARRW* 185) in finding humour in this section. In particular he finds it in the literary quotation, which seems questionable.

Pro Murena is frequently quoted by Quintilian on matters of stylistic detail, but he also praises Cicero's handling of Cato for its tact (11.1.71–2). His pupils would have been familiar with the speech; and Cicero would have approved, since it contains all his eight refinements: literature (60), philosophy (3, 8, 15, 31, 61, 77); law (9, 27, 35, 36), history (31–4, 36, 58, 59, 66), humour (8, 19–29, 60–1), emotion (1, 49, 55–6, 85–7), digression (75), dilatation (24, 78). As one of his more difficult defence cases, it continues to attract interest.[4]

Pro Sulla

Whereas Cicero could argue that Murena's election to the consulship was essential for the safety of the Republic, his defence of one of the Dictator's nephews on a charge of political violence in the following year (62 BC) could afford no such patriotic sentiments. P. Sulla already had a track record. He had been convicted of electoral bribery after winning the consulship in 66, and, like a number of frustrated or disillusioned aspirants to office from optimate families, was linked by some with the Catilinarian Conspiracy. Cicero's reasons for defending such an uncongenial client become apparent in the opening pages. The exordium (1–14) is an extreme example of a *principium a sua persona* ('opening focused on the speaker's person') *(Ad Herenn.* 1.5.8; *De Inv.* 1.22). It serves two purposes: to remind the jury (and subsequent readers of the speech) of his part in the suppression of Catiline, and to portray the other side of his character, his clemency towards those less intimately involved in Catiline's plans. Cicero could justify putting himself centre-stage by the action of the prosecutor, Torquatus, who had singled him out for criticism (3), apparently arguing that, as Catiline's exposer, he should not have defended one of his supporters. He could represent this as a serious attempt to undermine his *auctoritas*, and as such it gave him the excuse, which he grasped with both hands, to reassert it by spending about one third of the speech on his own actions and behaviour.[5] Related to this is his desire to consolidate his ties of *amicitia* with the men from whom he hoped to receive support in the future. It is to this that he is referring when

[4] See esp. J. Adamietz, *M. Tullius Cicero Pro Murena* (Darmstadt: Wissenschaftliche Buchgesellschaft, 1989); A. D. Leeman, 'The Technique of Persuasion in Cicero's *Pro Murena*', in W. Ludwig (ed.), *Rhétorique et éloquence chez Cicéron* (Geneva: Entretiens Hardt 28, 1982) 193–228; C. P. Craig, 'Cicero as Orator', in Dominik and Hall *CRR* 276–7.

[5] See J. Paterson, 'Self-Reference in Cicero's Forensic Speeches', in Powell and Paterson (eds) *CA* 91.

he speaks of the 'ornaments and luminaries of the Republic' with whom he is pleased to appear (5), and who, he hoped, would help him keep his political career on an even keel.

The question of Sulla's involvement in Catiline's designs is effectively answered by comparing him with Autronius, one of Catiline's closest adherents (14–18), and the argument is rounded off with the decisive fact that Sulla was in Naples during the climactic months of the conspiracy (17). An emotional passage (19) expressing feelings of sympathy with its victims only serves to point up the dilemma Cicero faced, but his decision to defend Sulla also helped him to reject the label of 'tyrant' which Torquatus had taken up from the new tribunes, Metellus Nepos and Calpurnius Bestia. Cicero combines this here with another insult which he had suffered, apparently from Catiline himself, who had called him (Sall. *Cat.* 31.7) a 'citizen-foreigner' (*inquilinus civis*). These two insults are interwoven, and historical examples of illustrious 'foreigners', including the Elder Cato and Marius, Cicero's fellow-townsman, show the hollowness of that reproach. The implications of the charge of tyranny are then explored, with Cicero himself firmly at the centre, with his steadfast patriotism providing the strongest evidence that he, of all people, would not defend a man whom he knew to have participated in Catiline's crimes.

The main item of evidence offered by the prosecution was that Sulla was named by the Allobroges, but the source for this does not stand up to scrutiny (37–8). On the other hand, Torquatus has a good personal reason for attacking Sulla: both were candidates for the consulship. Once again the discussion widens, as Cicero describes the care with which he sifted the evidence against all those accused of supporting Catiline, and continues to express exasperation at Torquatus' criticism of his defence of Sulla (46–50). The facts of the case have to wait until 53–68, where Sulla's alibi is cast in rhetorical form, with questions and *sermocinatio* (live conversation). This section includes the application of probability-argument to the activities of an associate of Sulla, P. Sittius (56–9), who was wrongly thought by some to be a Catilinarian. This is a useful exercise in obfuscation, as it illustrates how difficult it is to identify Catiline's supporters. Probability-argument is used again with evidence more germane to the case in 69–79, examining Sulla's life and character. This would have required judicious selectivity, not to mention tact.[6] Sulla emerges as kinder and more compassionate than the

[6] In *De Officiis* 2. 29, this P. Sulla is one of the *homines perditi* who profited from civil wars through the auction of the property of the proscribed.

rest of those involved in the proscriptions, even saving some of its victims from death. Sulla's gentle character is underlined by contrasting it with those of the condemned conspirators (76). Sulla had even shown sensitivity by the shame he had expressed on being convicted for electoral bribery, which led him to withdraw from public life; Lentulus, Cethegus, and Autronius were 'driven on by the Furies' to plan the destruction of the Republic, and paid the penalty. The section ends with the reassertion of the principle with which it began: that, whereas the testimony of witnesses was unreliable, a man's whole life was the best guide for a jury (78–9).

Before concluding, Cicero must answer a serious challenge to his *auctoritas* which has been mounted by Torquatus, who has reminded the jury of the support which Cicero had given Catiline in the extortion court before the conspiracy. Cicero pointedly remarks that Torquatus' own father had done the same, and he was consul at the time (65 BC). In a contemporary letter (*Ad Att.* 1. 2. 1) he writes that he is thinking of defending Catiline, because his co-operation in Cicero's his own electoral plans would be useful. All this was quite recent, and therefore embarrassing. He could only reaffirm his singlemindedness in defending the Republic when the danger had been exposed, while repudiating any claim that this gave him special authority as Sulla's defender (83–5).

This sentiment takes the form of an oath as the epilogue begins (86). The emotional build-up, which began as early as (69),[7] reaches its climax in these concluding sections. Sulla's young son has witnessed the 'death' of his father (89) after his earlier loss of the consulship in the courts after winning it handsomely at the polls (91). The final image is one of a tragic figure, whose gentle character belies the charge of violence that has been brought against him, and who deserves sympathy rather than vindictive condemnation.

The trial of Sulla had a favourable outcome for both the defendant and his counsel, although it is impossible to measure the influence of the latter's *auctoritas,* since the patrician Sulla had other powerful friends. As to the speech itself, concentration on a few topics deprives it of the cultural range that characterizes *Pro Murena*, so that it displays only four Ciceronian refinements: philosophy (logic) (24,31,81), historical allusion (23), emotional appeal (see above), and dilatation (78). The emotional peroration also reads better than it may have sounded to the jury, who were thoroughly inured to pleas of pity[8] for undeserving defendants.

[7]　So D. H. Berry, *Cicero Pro P. Sulla Oratio* (Cambridge, 1996) 48.

[8]　On the topos of pity in perorations, see M. Winterbottom, 'Perorations', in Powell and Paterson (eds) *CA* 219–26.

Pro Archia Poeta

This minor case arose from political skirmishing. Supporters of Pompey, who was still absent in Asia (62 BC), sought to embarrass Lucullus by questioning the citizenship of one of his clients, the Greek poet Archias. Cicero's interest in the case may, as he claims, have stemmed mainly from a belief that poets are desirable members of a civilized society. But his motivation may have been more complex than that. By defending Archias he appeared to be placing himself firmly in the Senatorial/Lucullan camp, but his ambitions for a *concordia ordinum* required that he should not alienate Pompey and his adherents. Part of his solution to this dilemma is to divest the case of its political clothing, and to seek common ground with the jury through the medium of culture.

This choice of main theme dictates the style of the speech from the outset. The exordium ends (3) in a single period in classical form, with the sense completed only with the last word *dicendi*. The next section deals practically with the question of Archias' citizenship, tracking his progress from being an immigrant to becoming a citizen of Heraclea (4–8). This is followed (9–11) by a refutation of the prosecutor's claim that the burgess-roll on which his citizenship was recorded was suspect. Since, under the *Lex Plautia Papiria* of 89 BC, citizens of Heraclea, in common with those of other towns which had treaty relations with Rome, qualified for Roman citizenship, the case for the defence ended with this refutation.If, however, the statutory or documentary basis for Archias' citizenship was questionable,[9] this gave Cicero a second reason for generalizing the issue.

Almost the whole of the rest of the speech is a digression, with literature as its central theme, so that two Ciceronian refinements are combined. The celebration of literature would have appealed to philhellenes like Lucullus and Catulus, but perhaps not all the jury would have shared their enthusiasm for it. Hence the emphasis Cicero places on the service literature can perform for society. He does this by referring to men like Scipio Aemilianus, Laelius, and the Elder Cato, who recognized the value of literature as a source of guidance for their political actions (16). There is good reason to suppose that Cicero was thinking of a particular relationship to which this alliance

[9] Albrecht, *CS* 204 questions both. But see D. H. Berry, 'Literature and Persuasion in the *Pro Archia*' in Powell and Paterson *CA* 301. Berry's chapter examines all the important aspects of the speech.

of counsel with executive power might apply: that of himself and Pompey.[10] Certainly, with his own power beginning to decline, it was vital for Cicero to remain as close as possible to Pompey. Moreover, Pompey, like other great men before him, had imitated Alexander the Great by having a historian, Theophanes of Mitylene, with him on his campaigns (24), a sure indication that he acknowledged the value of the fame that he could bring him: another reason for cultivating men of letters, and one close to Cicero's heart.

But poets and their importance are the chief subject, as the digression includes the theme of their divine inspiration and superhuman powers, which have prompted numerous places to claim them as their own (19). Homer was claimed posthumously by Colophon, Chios, Salamis, and Smyrna: shall Rome repudiate the living Archias, whose citizenship has been affirmed by law? (19). Historical examples follow of the patronage and acclaim accorded to poets, and Cicero also makes the telling point that Archias has made recent wars the subject of his poetry (21–2),[11] thereby trumpeting abroad the glory of Rome. Cicero was also hoping that Archias would trumpet his own (Cicero's) glory, but later seems to have abandoned that hope (*Ad Att.* 1.16). By the end of the speech, where he apologizes for his unconventional handling of the case (32), the digression has developed into the even more general theme of the universal human desire for fame, in which he personally had a share (28–9). Such emotion as he conveys is thus largely self-centred. Nor is the speech notable for its wit, or for the use of metaphor and other rhetorical devices.[12] But it contains one of his most famous – and outrageous – digressions,[13] giving it five refinements: literary (12, 18) and historical (16, 19, 20, 21, 22, 24, 26, 27, 28) allusion, legal knowledge (7), digression (13–30), and dilatation (12).The speech is in the richly periodic mode of the Middle Style, like *Pro Lege Manilia,* but has some of the character of a *jeu d'esprit,* a parody of a court case like Lysias 24 *For the Invalid,* but without the burlesque elements of that speech.[14]

[10] See J. H. Taylor, 'Political Motives in Cicero's Defence of Archias', *AJP* 73 (1952) 62–70. Taylor refers (64) to *Ad Fam.* 5.7 (to Pompey), which concludes with the hope that he might become a Laelius to Pompey's Scipio.
[11] On Archias' poetry, see E. Fantham, *The Roman World of Cicero's De Oratore,* 155.
[12] So McKendrick, *SCCLR* 122.
[13] For the latest arguments that the digressions are 'central to the case', see Berry (n. 9 above, *passim,* esp. 307–11).
[14] On which see S. Usher, *Greek Oratory: Tradition and Originality* (Oxford, 1999) 106–110.

Pro Flacco

L. Valerius Flaccus, who was on trial for extortion during his service as propraetor of Asia in 62BC, was a more congenial client for Cicero than P. Sulla, because, as praetor during his consulship, he was a stalwart and effective lieutenant (1). Flaccus is thus a suitable subject for the application of the well-tried technique of setting a client's character and past career in the foreground, inviting the jury to think about it more positively than the charges and the witnesses' testimony that he faces.

In the long and loosely constructed exordium (1–26) Cicero reproves the prosecutors for accusing of greed a man who has shown himself to be free of that vice on numerous occasions. They are themselves witnesses to these examples of his upright character, whereas the witnesses on whose testimony they are basing their charges are wholly unreliable, because they are Greeks (9). There are passages in other speeches in which the whole argument is founded on the assumption that provincials are untrustworthy witnesses, which is a useful line to take in extortion cases (e.g. *Pro Font.* 21–3 (Gauls), *Pro Scauro* 17–21 (Sardinians), 42–5 (Phoenicians and Sardinians)), but Cicero treads quite carefully here.[15] While insisting on his criticism of their dishonesty, even contrasting their disregard for the truth with Roman honesty (11–12), he concedes that they are owed a debt for their contribution to the arts of civilization (9). Nevertheless this attitude to the Greeks shows a degree of inconsistency, (perhaps hard to avoid in the face of the different demands of different clients), when the case of Archias has evoked such ringing praise for them from the same advocate. Criticism of them extends to the indiscipline and irregularity of their institutions (16–24), and again contrast is drawn with those of Rome. The section is rounded off with the theme of Flaccus' character, and that of his family, the *gens Valeria,* which gave the Republic its first consul (25).

Far from relying only on general arguments like those above, Cicero now examines and refutes individually the charges that the Greeks and others have brought against Flaccus (34–92). This part of the speech contains an assortment of Ciceronian refinements. Sayings and *bons mots* enliven 46, 65, 72; Greek and Roman history are touched upon in 64, 98; Ciceronian acerbic wit is displayed in 47, 66, 76, 92; emotional passages occur in their usual place, towards the end (102–3, 106); and there is a brief digression on

[15] So May *TC* 81. On the ethnic stereotyping in this speech and elsewhere, see Vassaly, op. cit. n. 38, ch.2.

epideictic themes in 62–3. The speech has a nice balance between narrative, much of which serves to illustrate the fair dealing and reasonableness of Flaccus, and argument, much of it hard-hitting, with apostrophic questioning and live speech. It is one of Cicero's more animated orations, attuned to the dangerous times in which Rome, and he himself, were living. The condemnation of his consular colleague Antonius was to him an omen of the recrudescence of revolution (94–5). Now he directs the jury to thoughts of those days of terror in December 63, and to Flaccus' patriotic spirit (103–4) which played its part in averting the impending threat. With seven refinements, the speech supplies almost all Cicero's desiderata. The refinements are literary allusion (46, 65, 72), philosophy (logic) (17,39), historical example (64, 98), humour (39, 47, 65, 76, 92), emotional appeal (102–3, 106), digression (62–3), and dilatation (64–5, 94).

Post Reditum in Senatu

Cicero's refusal to co-operate with the Triumvirs led to his exile to Thessalonika in May 58 BC, but he was recalled in the following year, and entered Rome amid popular acclaim on 4th September 57 BC (*Ad Att.* 4.1). In his absence Clodius had intensified his programme of civic disruption, and the return of Cicero was seen by some as offering a focus for responsible popular leadership. Pompey had come to see him as a possible ally against any or all of his colleagues, and especially against Clodius. Cicero's cause was helped by the fact that, of the consuls for 57 BC, Lentulus Spinther was actively supportive, and moved the bill which called for his return; and the other consul, Metellus Nepos, was persuaded to bury past differences. Thus when Cicero delivered his speech of thanks to the Senate on September 5th, he could be sure of a favourable reception. But one essential duty must be meticulously performed: to thank those individuals who had worked effectively for his recall. It may be for this reason that he delivered this speech, alone of those preserved, from a prepared script (*Pro Planc.* 74). No doubt this enabled him to navigate the huge period in §2 (*quod si... recuperarimus*) without losing his way.

In fact much of the speech is epideictic in style, a formal medium which suits the quasi-ceremonial subject-matter: thanks to the Senate collectively (1–2), to the original proposer of his recall, the tribune L. Ninnius (who was prompted by Pompey) (3–4), and to the consuls Lentulus and Metellus (5–9). The theme is a suitably lofty one because Cicero identifies the recovery

of the Republic's fortunes with his own (5), and the elements of praise (for his sponsors) and blame (for those whom he saw as his enemies) find their natural home in this style of oratory. There is more animation in the latter than the former. He inveighs against the consuls for 58 BC, Piso and Gabinius (10–18), who 'had bargained away his well-being (*salus*)' (3), and were now ensconced in their provinces. The standard ingredients of invective are deployed against Gabinius: dissolute youth, foppish self-indulgence, extravagance, irresponsiblity, suspicion of treasonous association with Catiline. Against Piso there is even greater bitterness, as Cicero had thought him to be his friend, who shared his cultural interests. With recent memory of Piso's treachery, his invective against him here lacks the humour (as distinct from pure sarcasm) of his later attack (in *In Pisonem*), even though much of the material is the same. The bestowal of further praise on fifteen men who worked for his recall, including Milo (19) and Sestius (20), gains added force by contrast with this. There is more emotion in his gratitude to Lentulus, who when he 'lay prostrate in the dust, was the first to extend the right hand of his consular protection'(24); and his colleague Metellus set aside past enmity and 'stood forth not merely as the defender of [Cicero's] safety, but as witness to his merits'(25). These men led the people's massive movement for his restoration, but two of his most important benefactors had still to be acknowledged. Without Pompey's advocacy, Cicero could not have won his recall, but the great man had been obliged to operate behind the scenes for reasons of personal safety (29). A more celebratory tone returns with Cicero's thanks to his other great benefactor, the Senate at large (31–2). A backward glance at the events leading to his exile seems curiously out of place, until it is realized that its function is to provide the contrast necessary to underline the speaker's joy and relief at his restoration (31–3). A list of historical examples of restored leaders, indicating the various circumstances of their recall (38–9), would have struck an agreeable chord with those present, some of whom were their descendants. These and emotional appeal (1–2, 8) are the only Ciceronian refinements.

Post Reditum ad Quirites

Addressing the people very soon after he had thanked the Senate,[16] Cicero

[16] Possibly on the same day. The present speech could hardly have been the one described in *Ad Att.* 4.1, delivered on 7 September, which was Cicero's contribution to the debate, apparently held in the Senate, on the current shortage of corn in the city.

had a simpler message to deliver: one of thanks and joy at the people's support in restoring him to his family and friends, an expression of those feelings which all people share (1–4). But there is no concession to the ordinary man's tastes in the matter of style. The speech is even more formal and elaborate than its predecessor, its opening period (*Quod... laetor* (1)) being even longer than its earlier counterpart, and bristling with amplifications. It is also more emotionally charged, as Cicero, testing the limits of decorum, luxuriates in the people's goodwill (6). The historical comparisons are carefully chosen to illustrate how, unlike those restored before him, he had the people and their representatives to thank for his recall (11). The failure of the consuls for 58BC to come to his aid is mentioned only in passing: invective against them would not have interested a popular audience, and would have marred the positive tone of the speech. His thanks to Lentulus and Pompey are recorded once more, but this time briefly (18). More attention is paid to a comparison between himself and that *popularis* hero, his fellow-townsman Gaius Marius, who met adversity similar to his own with indomitable courage (19–20). But whereas Marius took vengeance on his enemies through arms, Cicero will take it by the power of speech, while promoting the interests of the Republic (21–3). His revenge on his four classes of enemies will take a constructive form: 'unpatriotic citizens I shall punish by a wise administration of the state; my treacherous friends by believing nothing and suspecting everything; the envious by a devotion to glory and virtue; and the traffickers in provinces by recalling them home, and holding them responsible for their provincial administration'. But most of his energies will be directed towards repaying kindnesses, especially to his audience, his fellow-citizens. A passage of generalizations on the nature of requital would have sat comfortably in one of his philosophical works (22–3). The brief epilogue (24) is a summary promise to repay the people's *beneficia* with unremitting labours for the public good, affirming that his ideal of a *concordia ordinum* was unrealizable without the participation of the largest component of the state, the common people. The speech contains three refinements: philosophical (22–3), historical (6,7,11,19–20), and emotional (5,18–19).

De Domo Sua

While Cicero was in exile, Clodius destroyed his house on the Palatine hill and consecrated the ground, which would prevent him from rebuilding there.

On 29th September 57BC, Cicero, three weeks after his return, delivered the present speech. It was addressed to the college of *pontifices*. The august nature of this audience set this speech aside from all his others, and influenced the choice of both style and content. Moreover, it was the only speech which solely concerned Cicero's life and his political future. Legal argument and emotional appeal are two salient features of the speech, the latter necessary because he rightly felt that he could not rely on the former. Clodius had invoked two laws, one which deprived 'of water and light' anyone who had executed a Roman citizen without trial, and a subsequent one which applied this penalty to Cicero personally. Cicero could not deny the fact that he had thus treated the Catilinarians, and could only plead that he had Senatorial backing. But Clodius and the *populares* had been able to replace the feeling of terror which Cicero had stirred up during the emergency with one of outrage at infringement of citizens' constitutional rights. There is a measure of agreement that Cicero was on insecure legal ground in this speech:[17] which may explain the intensity of emotion which characterizes the whole of it.

The beginning includes violent invective, with Clodius the target: 'that plague-spot and devouring flame of the republic (2)...that madman (3)... you deadly scourge of the state' (5). After this initial fury abates, contrast of character takes over, (an essential ingredient of artful invectives). Here Cicero contrasts Clodius, who fomented riots over the present shortage of corn, with himself, who dutifully attended the Senate and contributed constructively to the debate. The popular consensus was that Pompey should be made steward of the grain-supply: by supporting this Cicero affirmed his gratitude both to Pompey and to the people for their help in his recall. He also laid claim to the role of protagonist on the political stage, and it was this that gave him the confidence to attack Clodius, so recently the popular hero, who had used his tribunician power to deprive the Senate of its authority to make proconsular appointments: a step towards extreme democracy which had been beyond the ambitions of even that arch-democrat, Gaius Gracchus (24). This effective use of historical example involving *a fortiori* comparison, is followed by a passage of apostrophic invective which, through its elaborate nautical imagery, has an almost poetical flavour:

[17] See W. Stroh, '*De Domo Sua*: Legal Problem and Structure', in Powell and Paterson *CA* 316, n. 15. This chapter is essential reading for understanding of the speech.

Had you been able, amid all the gloom and blinding clouds and storms that then enveloped the state, when you had hurled the Senate from the helm, cast the democracy overboard, and yourself, like a captain of pirates, with your disgusting band of cut-throats, sailed forth with every stitch of canvas filled – had you then been able to carry out your proposals, decisions, promises, and bargainings, what spot in the world would have been untroubled by the usurped power and command of Clodius?

This *extra causam* digression, which he recognizes as such (32), finally gives way to legal matters. While careful to deny expertise in pontifical law, in deference to his audience, he actually brings considerable knowledge of it into play, as he argues that Clodius had flouted several laws: by destroying Cicero's house when he had not undergone a trial (33); when he had arranged his own adoption into a plebeian family in order to secure election to the tribunate (36–8); and when, in violation of that most ancient of Roman legal codes, the Twelve Tables, he created a *privilegium* (legislation directed towards an individual) in order to impose exile on Cicero, and the appropriation of his property. Cicero's careful explanation of the intention of the original laws (45), and quotation from them (47), makes this a good example of the orator's display of legal knowledge, more of which is to be found in 51–3. Wit and ironic sarcasm ('I ask your kind pardon, my good Sextus, since you have lately become a logician...'(47, for further examples, see 105, 127), is interlarded with more fierce invective (47–9). The argument about laws is rounded off by a statement of the principle that all measures carried by force are by definition illegal; and a catalogue, infused with emotion, of the acts of violence which Clodius had perpetrated against him, his family, his friends, and his property (59–63).

It is likely that Cicero's display of legal knowledge conjoined with vehemence was necessitated by the preparation and attention to detail that Clodius had put into his own case against him.[18] Structural variety is provided by chronological treatment, and by more straightforward narrative, as the steps that led to Cicero's return are traced (68–71). The following sections are rich in historical examples, as he reminds the pontifices of men in the past whose houses were razed to the ground, all for being thought to have aimed at tyranny, whereas he had suffered the same treatment for saving the Republic (100–2). Again, this distinction needed to be affirmed, because Clodius' dedication of a shrine to Libertas near the site of Cicero's house had symbolic significance.

[18] See Stroh (n. 17) 334–6.

Indeed, the frequent claim that he had saved the Republic (by withdrawing from it rather than becoming the focal point of a savage war between the forces of mindless destruction, marshalled by Clodius, and those of peace and civil order), colours large parts of the speech and is responsible for some of the rhetorical excesses that disfigure it.[19]

Ammunition with which to go on the attack against Clodius included the scandal of the Bona Dea, for which Clodius had been put on trial in 62 BC. The fact that Cicero does not allude to this until 104–5 reminds us that Clodius had been acquitted. Some members of his audience might also remember that Cicero, while outwardly expressing outrage, had not been foremost among those pressing for his trial,[20] though he gave damaging evidence at it.. Now, five years later, there may not have been much mileage left in the story of a young man's prank (his appearance in 'drag' at a women-only religious ceremony), so Cicero now makes it a mere component of a general picture of the reckless career of a man who should never have held an office of state. In particular, Clodius is singularly unqualified to initiate a religious sanction like the dedication of a temple to Libertas, which is the final subject of Cicero's case (107–141).

The whole subject of Cicero's house on the Palatine Hill had been invested with political significance.[21] To him it was a visible symbol of his final acceptance into high Roman society, but some of his aristocratic enemies and critics saw his occupation of it as the presumptuous self-elevation of a *parvenu.* Clodius' destruction of it was thus not universally condemned. The dedication of the temple to Libertas would also have attracted supporters, though most of these would have been *populares,* some of whom regarded Cicero as a spokesman for the aristocrats.[22] Against these various opponents, Cicero had to resort to legal technicalities. But he was quite adept at this.[23]

[19] A view not shared by Cicero himself, who regarded it as his supreme essay in impassioned eloquence (*Ad Att.* 4.2.2) at the time (*i.e.* Sept. 29 57BC). For modern opinions of it, see Stroh 314–5 .

[20] *Ad Att.*1.16.2. See also W. J. Tatum, 'Cicero and the Bona Dea Scandal', *CP* 85 (1990) 204. But Tatum also thinks that the outrage he expressed was genuine (207), although he was more concerned about the challenge to the Senate's authority implied by Clodius' acquittal (205, 208). It may also be noted that Cicero owed a debt of gratitude to Clodius for his support during the Catilinarian Conspiracy.

[21] W. Allen, 'Cicero's House and Libertas', *TAPA* 75 (1944) 2–3.

[22] Allen 6.

[23] W. J. Tatum, 'The *Lex Papiria de Dedicationibus*', *CP* 88 (1993) 319–328, has a bibliographical note listing examples of Cicero's distortions of laws to suit his immediate rhetorical purpose (n. 9).

The relevant law, the *Lex Papiria de Dedicationibus,* did not precisely cover his case. Seeing this, and using earlier precedents, he guides the argument towards the application of the spirit rather than the letter of the law (128–30).[24] The complicated argument that follows seems to show that other legislation had superseded the *Lex Papiria* of 304 BC, amending its simple provision that a dedication had to be authorized by the people to include the nomination of the person to make it.[25] But Cicero's arguments did not resolve the question of whether a valid dedication had been made.

Officials of earlier times, much more distinguished and venerable than the impious novice Clodius, had encountered difficulties with dedications. It was hardly surprising, therefore, that he found himself out of his depth as he tried to find the right formulation (139–140):

> '...with mind and tongue that wavered...that polluted and unnatural foe of all things holy, who had shocked propriety by often behaving as a woman among men and a man among women, was managing the business with such feverish and disorderly haste, that neither his mind nor his voice nor his tongue could hold themselves ...later... constantly correcting himself, with a fearful and faltering hesitation, pronounced phrases and performed rites entirely different from those contained in your treatises of ritual.

Rhetorically compelling as a description of Clodius' state of mind, with the hint of a guilty conscience at work, this amounted, if true, to a damaging challenge to the legality of the whole proceedings.

The peroration (142–7) begins with a dilatation: 'divert your minds at last from the details of my argument to a broad survey of the Republic's position'. The restoration of Cicero's 'house, home, and household gods' would be a paradigm of the restored Republic (143). This universalizing idea is extended to Clodius' vengeful act itself: Cicero says that it is not his personal loss that grieves him, but the lawlessness of the destruction and the precedent it would set (146). His concluding appeal to the pontifices is elevated by an invocation of the gods (144). He has applied six of his refinements to this uniquely personal speech, literary allusion and digression being the only two absent. 'Effusive in tone, extravagant in verbal richness, powerful in passion' (Stroh 367): the high place of the speech in Cicro's esteem is understandable, as is his eagerness to make it available to his young admirers (*Ad Att.*4.2.2); but it departs in many respects from the text-

[24] See Tatum, 320–2.
[25] For further discussion of the problems posed by this section, see Stroh 327–331.

books.[26] The idea that its publication prompted the counterblast by critics styling themselves Atticists (Stroh 367 n. 218 for bibliography), is attractive, not least because the speech projects a personality which many now found bombastic and over-assertive.

De Haruspicum Responsis

Following Cicero's representations to the pontifices, the Senate rejected Clodius' attempt to have the site of Cicero's house consecrated, but in 56 BC he persevered in his pursuit of his enemy by other means. Early in that year a strange, unpropitious noise was reported from the Ager Laterensis, in the suburbs of Rome. The senate turned to the soothsayers (*haruspices*) for an explanation, and they pronounced that the gods were demanding expiation for, among a number of other transgressions, the profanation of hallowed sites. Clodius evidently had influence with the priesthood; and Cicero was forced to answer the soothsayers' pronouncements.[27]

The subject of this enquiry is not broached until (9). Before that, the scene is set with another invective characterizing Clodius, with the same material as that used in earlier invectives, though here Cicero is able to exploit, with liberally applied ironic humour (with paradox), the spectacle of Clodius, of all people, complaining of desecration and violation of religious rites (8–9). Before that he has portrayed Clodius' manic behaviour, and, more importantly, dissociated himself from personal enmity (5), even after describing how he had frustrated some of Clodius' extravagant antics in the Senate (1–4). Cicero knew that he must show that he did not rank his personal grievances above the needs of the state.

Turning at last to the central question, the interpretation of the reported prodigies, Cicero is able to exploit their unspecific nature and impose his own summary interpretation at the outset: that they represented 'the voice of Jupiter the Best and Greatest, concerning Clodius' madness and wickedness and the terrible dangers that threaten us' (10). In the next sections (11–17)

[26] The departures noted by Stroh include the absence of a *propositio* and a comprehensive *narratio* (368), but in his analysis (338–70) Stroh also notes the many felicities and examples of virtuosity which qualify it as a model for Cicero's readers to emulate.

[27] Writing some ten years later, Cicero divided Roman religion into two essential parts, worship and divination (*De Natura Deorum* 3.5). While the validity of divination was questioned in intellectual circles (see esp. ibid. 14–15), because of its power to play on popular hopes and fears it could be used effectively as an instrument of political leverage, a fact as well known to Cicero as to Clodius.

the prodigies themselves are sidestepped, and it is the authority of the Senate, not considerations of religion, that prevails. He could expect this to go down well with his audience, especially as religious officials are included among the nineteen Senators whom he names, including the consul (12). He could even expect them to tolerate his self-glorification (17). But the question of interpretation of the prodigies was still to be answered.

Cicero begins this section (19–39) with a revealing insight into his own attitude to the practice of religion. He looks to ancestral authority for primary guidance on religious observance, noting that they followed the priesthood in their profound belief in the existence of divine power. It is the latter who thus become the chief source of wisdom in religious matters, even for academic writers on the subject (19). The collective piety thus engendered was the main cause of Rome's imperial success.

But the present examination requires not so much unquestioning piety, as critical enquiry. The soothsayers' interpretation is not the only one possible. 'Cannot we ourselves be our own soothsayers?' (20). Cicero sets out to show that the interpretations given misrepresent known facts and events by attributing the ominous signs to faults in ritual procedures (23), whereas the games have been subject to much more flagrant desecration through the attendance at them of unruly slaves, for which Clodius was responsible. Hence the sounds heard were the protests of the Goddess herself (Cybele) at the pollution of her games (24); and the alarm posed by the slaves was urgent enough to require action, without prompting by portents, like, for example, a swarm of bees (25). With this reinterpretation Cicero tries to show that he has a greater sensitivity to religion than its official practitioners. This also strengthens his authority as he attacks Clodius as a living paradox, the slave-leader, a modern Athenio or Spartacus (26), who comes from a family long associated with the establishment of religious rites (27), and yet has been guilty of heinous acts of sacrilege at shrines in Asia (28–9).

This is a good preface to an emotional introduction of Clodius as an inquisitor into the matter of consecration ('What amazing shamelessness! Have you the audacity to speak about my house?' (30)). The violation of sacred land by Clodius and others in order to build houses in Rome has been commonplace in recent times (32–3), even though it is contrary to the unwritten law of nature. As to Cicero's house, the paradox persists: how should Clodius, the agent of its destruction, be allowed to maintain the sanctity of the land in the face of the Senate's expressed will? (33) Thereafter

(34–9), Cicero deals with each of the violations and refers each to some action which relates them to Clodius, adding to suspicion of his complicity in the soothsayers' pronouncements.

The speech has by this time become a full-frontal attack on Clodius. A review of his career (40–52) contains a historical comparison between earlier revolutionaries – the Gracchi, Saturninus, and Sulpicius Rufus – who were worthy opponents for conservative men of state, and Clodius, who receives a Rake's Progress biographical sketch (41–4), which contains a witty description of his metamorphosis from an effeminate fop to a fully-fledged demagogue (44), a fomenter of dissension, targeting even Pompey. In the past, such a career has led to revolution and despotism. The examples of Marius, Sulla, and Cinna illustrate this (55), and their present counterpart is described as a serpent lurking within society itself, which should be trapped and destroyed. These pages are rich in this sort of heady rhetoric, as Cicero reaffirms the argument that the soothsayers' pronouncements point unequivocally to the reckless actions of Clodius as the cause of divine wrath (esp. 53). He puts the finishing touches to his portrayal of Clodius with a literary comparison of the destructive powers of Scylla and Charybdis with the damage Clodius has done to the body politic. This provides a transition to the epilogue, in which the subject of the speech gives way to a more urgent demand: that Clodius must be stopped. Five out of the eight refinements are present: literary allusion (39, 59), legal knowledge (32), historical example (6, 16, 41, 43, 54–5), humour (6, 8–9, 10–11, 44), emotion (25).

Pro Sestio

The trial of Sestius, in February 56 BC, was for his use of armed force during his tribunate in the previous year. Cicero became involved in it because Sestius had both supported him against Catiline and worked for his recall from exile. He thus had a debt of gratitude to discharge. But the trial seems to have become a major opportunity for other public figures to register their opinions and affinities, if the numbers and distinction of those who spoke in Sestius'defence offer any guidance: Hortensius, Crassus, Pompey, Cicero, and Licinius Calvus. Their advocacy was matched by great popular interest (36). Add to this the fact that Cicero spoke second (after Hortensius (3)), and the scene is set for an extraordinary speech, in which the immediate issue is subordinate to that of the current state of politics, and the future course which they may take. Consequently, Sestius and his defence feature

only briefly (6–13, 71–84, 124, 144), and Cicero himself takes centre stage throughout.[28]

The opening periods foreshadow the broader theme, describing as they do a state of endemic demoralization and despair which affects all, but gives satisfaction only to those who have brought it about – men of violence, who 'bustle about brisk and joyful, but also devise danger for the bravest of our citizens, while they have no fear for themselves' (1). Before engaging that theme, he gives a short laudatory resumé of Sestius' early career, stressing his patriotism as quaestor (6–13). Then, before turning to 57 BC, the year immediately relevant to the trial, Cicero reviews 58 BC at length and in an elevated and emotional tone. It was the year of his exile, one of 'great disturbance and fear to many, when a bow was levelled ostensibly against me alone, but in reality at the whole state' (15). At one point (31) he feels it necessary to explain why he dwells so long on 58 BC, and answers possible critics by arguing that 'the purpose of Sestius' tribuneship was to heal the wounds of that year'. But it is a digression on a truly large scale (6–71), a dramatic narrative encompassing almost a half of the long speech. It is more or less chronological, but admits division into three parts. In 6–35, the events and circumstances that led up to his exile include the election of Clodius to the tribunate which enabled him to legislate against Cicero, but much of the venom is directed against the consuls Gabinius and Piso, especially the latter, because he deceived the people as to his intentions, and failed to protect Cicero, to whom he was related. Two sub-themes colour the narrative: the illegality of the actions of the principals, especially the consuls; and the emotional involvement of the people, who protest and dress themselves in the garb of mourning. The story of Cicero's departure into exile (36–52) begins with a historical comparison deliberately chosen because it is *not* an exact parallel: Metellus Numidicus went into exile at the behest of the Senate, whereas Cicero did so while enjoying wide support, in order not to inflame a volatile situation (37). This piece of history also serves partially to overlie the reality of his position, which was that those with the power to protect him connived at the measures set in train to remove him. But the line of argument which he follows enables him to represent his departure as an act of altruistic self-sacrifice. This is made to

[28] See J. Paterson, 'Self-Reference in Cicero's Forensic Speeches', in *CA* 92 ('Sestius is reduced to a bit-part'). Paterson also notes that the violence that Sestius used was 'to counter opposition to Cicero's recall from exile'. Further on this speech, see Riggsby, op. cit. p. 45 n. 32, pp. 79–84, 89–97.

assume allegorical form as he imagines a hypothetical situation (45):[29]

> If it had happened to me, gentlemen, when sailing in a ship with my friends, that pirates coming in numbers from many quarters threatened to sink that ship with their fleets, unless my friends surrendered me alone to them, if the passengers *refused to do so, and preferred death with me to handing me over to the enemy*, I would rather have cast myself into the deep to save the others, than I would bring those loving friends, I will not say to certain death, but into great danger of losing their lives.

The italicized words prevent the allegory from corresponding with the actual situation, but it serves its purpose of highlighting Cicero's self-sacrifice. A little later this is coloured with a philosophical/ literary sentiment with historical associations (48):

> Lastly, as I had always made honour the rule of my life, and thought that nothing in life was to be sought for by a man without it, should I, a man of consular rank, after I had accomplished such great deeds, be afraid of death, which even young Athenian maidens, the daughters, I think, of king Erechtheus, are said to have despised for the sake of their country, especially as I was the citizen of that same city from which Gaius Mucius came when he entered the camp of Porsenna alone, and with death staring him in the face, attempted to kill him.

Other historical figures follow. But Cicero differs from all of them in that they sacrificed their lives, but since his death might mean the death of the Republic, that course of action would have been self-defeating (49). Cicero never tires of saying that he saved the Republic by quitting it.

The third part of this digression (53–71) narrates other disasters which afflicted the year 58 BC after his departure both at home and abroad: laws designed to undermine the constitution, the granting of power and dominion to unworthy foreign potentates in place of the friends of Rome. The gathering gloom was lightened, and hopes raised, by the first steps towards his return (68–9), at the beginning of June. And these were followed by the election of Sestius to the tribunate (71). Bearing in mind that Cicero was defending him on a charge of violence, it is natural that his part in the story is not a particularly active one. Yet the story itself is violent enough (76–7):

[29] May, *TC* 96, notes this passage as one of several examples of Cicero's use of nautical imagery in this speech.

You remember, gentlemen, how that day the Tiber was filled with the bodies of citizens, how the sewers were choked, how blood was mopped up from the Forum with sponges.

The charge which Cicero has to answer is that Sestius provoked the violence by surrounding himself with armed guards (78–9). Against this he argues that Sestius was the victim, not the author of the violence from which he barely escaped with his life (83), and his recourse to arms was vindicated by the actions of another of Cicero's supporters, Annius Milo (86–90), whose only function in this speech is to show the inconsistency of the prosecutor, who had praised his resistance to Clodius' violence while condemning that of Sestius.

By this time those individuals immediately responsible for the present turmoil have been as clearly identified as possible. It now remains to examine the origins of the state of disorder. The transition is surprisingly abrupt (90–1), as Cicero launches upon one of his most celebrated digressions. It begins in anthropological vein, and its subject is the gradual evolution of human society (91–2):

For which of us, gentlemen, does not know the course of human history – how there was once a time, before either natural or civil law had been formulated, when men roamed, spread and dispersed over the country, and had no other possessions than just so much as they had been able either to seize by strength and violence, or keep at the cost of slaughter and wounds? So then, those who at first showed that they had most ability and wisdom, seeing that human beings could be taught, gathered into one place people who had been scattered abroad, and converted them from that state of savagery to one of justice and humanity. Then things serving common use, which we call public, then associations of men, which were afterwards called states, then connected dwelling places, which we call cities, they enclosed with walls, after divine and human law had been introduced.

Uncontroversial, objective, and familiar to readers interested in political matters,[30] this provides an agreed background, and quiet reassurance in preparation for the more contentious arguments that lie ahead. The establishment of the rule of law to replace violence and savagery fits the immediate context, since Sestius and Milo had upheld law and order against

[30] Of whom some will have read, or would know about, Polybius' account of the origins of human society (6.5–6), which leads to his theory of the cycle of constitutions.

the lawlessness of Clodius and the *populares*. But the excursus that follows (96–143),[31] in which he tries to refine currently held views on the political groupings that compete for power in contemporary Rome, will have raised many questions among Cicero's contemporaries, as it has among modern scholars. It is concerned mainly with the examination of the character of that group who called themselves 'the best men' (*optimates*). Cicero argues that it was not a finite or narrow party, and was defined not by wealth or family connections, but in terms of the morality and behaviour of individuals (97):'All are optimates who are neither criminal nor vicious in disposition, nor frantic, nor harassed by troubles in their households'. The leaders who emerge from this large group are those who are the active promoters of the ideal aim of statesmanship, 'peace with dignity' (*otium cum dignitate* (98)),[32] which was to be achieved through 'religious observances, the auspices, the powers of the magistrates, the authority of the Senate, the laws, ancestral custom, criminal and civil jurisdiction, credit, our provinces, our allies, respect for our rule, the army, the treasury'. While *otium* ensured that the people were not stirred up into sedition, perhaps not even being involved in politics at all, the *optimates* earned their *dignitas* by conducting the government in an upright and constitutional way. (This passage is revisited on p. 240).

But these men must contend with their opposites, the men of violence, whose aim was to destroy all that they had achieved (99–100). It is only the

[31] 'the core of the speech, and not a mere digression' (McKendrick *SCCLR* 206). I agree that another word must be found for it.

[32] This slogan in practice meant something like 'tranquillity for the people and honour for the senators' (Rawson *CP* 127). It lies at the centre of much discussion of the excursus. C. Wirszubski, 'Cicero's *Cum Dignitate Otium*: a Reconsideration', *JRS* 44 (1954) 1–13, reviews previous bibliography, and opines that the phrase applies primarily to individuals (2). He challenges the view that Cicero is 'dreaming' of an ideal concept of political philosophy with no Roman connections. On that thesis, *otium* is the opposite of *bellum, seditio,* or *novae res,* and upholds the maintenance of the *status quo* (4). W. concludes that it was a vague phrase which lends itself to different interpretations (13). J. P. V. D. Balsdon, 'Auctoritas, Dignitas, Otium', *CQ* 10 (1960) 34–50 argues that Cicero misapplies the words to his own time, as he 'hides under an ornamental profusion of fine oratory the barrenness of his own thoughts and the thoughts of his political friends' (46–7). But W. C. Lacey, 'Cicero, *Pro Sestio* 96–143', *CQ* 12 (1962) 67–71, in a searching analysis, finds contemporary relevance in the passage and acute perception of the current situation, making it a real attempt to rally support for a restoration of political stability. 'Cicero's sermon is not basically a defence of the *status quo*, but a call to defend *lex* against *vis*, and to urge the young to take the optimate way of courage and energy' (71).

most resolute of the good leaders who persevere in their careers: history supplies examples of such men in the persons of M. Scaurus and Q. Metellus Numidicus, who curbed the excesses of popular leaders in the face of opposition from the mob (101). To add to his illustration of the difficulties that confront good statesmen, Cicero turns to the tragic poet Accius (102). A longer historical example (103–5) serves to differentiate between dissension in former days, when the popular legislation of the Gracchi was opposed by the optimates, but that opposition did not turn to violence, from that witnessed in his own times, when 'rent-a-mob' violence is a natural adjunct to all political debate. Occasional emotional passages are a feature of this part of the speech (102, 111).

The manipulation of the popular will is still the primary aim of politicians in Cicero's day. He describes how that process has operated in his own case. He begins with the assumption that the people now want a quiet life (*otium* (104)). This contrasts with the situation in the days of the Gracchi and Saturninus, when the people perceived the need for radical reform. Those advocating it did not have to persuade them with bribes or tub-thumping oratory: their popularity was assured. Present-day demagogues must work harder, but the worst of them enjoyed some success because he was prepared to use bribery and force as well as histrionics (106). Clodius used these same methods both when legislating for Cicero's exile and when trying to prevent his return. In the debate about this the side of moderation and responsiblity, represented by the 'good men' (i.e. those advocating Cicero's return), was ranged against that of violence and sedition, and Cicero asks (109):

> Which cause, then, should be considered the popular one? that in which all the respectable men of the State, men of all ages and all classes, are of one mind and opinion, or that in which frenzied furies flock together, as it were to the funeral of the Republic?

Cicero is applying his political theory to his own case. A good *popularis* represents not one class, but the state and its well-being as a whole. Clodius and his kind are not true 'friends of the people', but represent only anarchy and disorder (110–12).

Sensing the need for a change of mood after a long discussion of matters of moment,[33] Cicero introduces some of his own brand of mordant humour. His target is, of course, Clodius (116):

[33] Note the illusion of extempore speaking here (115), curious in the revised version of the actual speech (see n. 36 below).

That arch-comedian himself, not a mere spectator, but an actor and a virtuoso, who knows all the pantomime turns of his sister, who is admitted into a party of women in the guise of a female harpist, neither visited your[34] shows during his fiery tribunate, nor any others, except one, when he barely escaped with his life.

So much for Clodius' claim to be a friend of the people. They customarily expressed their opinions of public figures at games and festivals. It seems that Clodius limited his appearances at these, and with good reason, as on this occasion, when 'the Roman people could scarcely restrain themselves from venting their hatred upon his foul and unspeakable person' (117). This reception is contrasted with that accorded Sestius (124), on whose arrival 'at once from all the spectators' seats right down from the Capitol, and from all the barriers of the Forum, there were heard such shouts of applause, that it was said that the whole of the Roman people had never shown greater nor more manifest unanimity in any cause'.

The best poets and playwrights reflected popular opinion quite as effectively as did politicians. Cicero acknowledges this in the *Pro Sestio* on several occasions. Here (118–23) he quotes them ten times, showing how a poet could arouse an audience's feeling with sentiments which they readily associated with contemporary events and personalities. Thus it could be hazardous for a public figure to attend a dramatic performance, as he could find himself applauded or attacked, both when he arrived at the theatre and during a performance. Cicero enjoys comparing his own experience on his return with that of Clodius, described earlier, and uses it to create the impression of an overwhelming and spontaneous popular will to celebrate his restoration to the Roman scene. This leads to a retelling of the story of his return (129–31), introduced archly by the formula of *occultatio* (*quid ego...commemorem...?*).

The restored self-confidence that Cicero has shown in these passages goes a step further when he attacks Caesar's man, Vatinius, the principal witness against Sestius.[35] Vatinius is cast in the same mould as Clodius – as a wild despiser of the law, ambitious, exhibitionistic, and a ready victim of Cicero's wit (134–5). After this he returns to what must now be recognized as his main theme, the definition of *optimates*, as those who earn that name

[34] M. Aemilius Scaurus, praetor.
[35] The significance of this attack will be examined in detail during the discussion of *In Vatinium*. For the present, Cicero needs only to discredit him in general terms.

by their achievements and adherence to certain principles, not by their birth
(138–9). His choice from among Romans reflects his political sympathies:
not the revolutionary Gaius Gracchus, but the man who deposed him, Lucius
Opimius (consul 121). Alien historical figures who meet his definition
include the Athenians Themistocles and Miltiades, and Rome's old arch-foe
Hannibal (141–2). These are joined by a roll of honour of Rome's 'grand old
men', some of whose descendants are present. From these illustrious names
he turns to his supporters, Milo and Sestius (144), who no doubt gained
from the association with them, and whose silently pleading relatives add
emotion to the scene. Thence to the peroration, in which Cicero himself and
his recent ordeal are the main subjects, confirmimg the central theme of the
speech: Cicero's fears and hopes for the Republic, and for his own part in
its future.

No Ciceronian speech contains clearer evidence of a purpose behind his
oratory which transcends the immediate needs of the case under trial, or
even those of his personal advancement or protection. Although he says
so explicitly on only a few occasions, as when (136) he exhorts young
men (*adulescentes*) to imitate the example of their ancestors, much of the
speech, and especially the excursus, is educative and protreptic in purpose.[36]
Propaganda, a cynic might say; but at least designed to provoke thought. It
may have been more provocative in the form in which it was delivered.[37]
Seven out of the eight refinements are present in *Pro Sestio*: literary allusion
(102, 118, 120–1, 122,123, philosophy (23), history (37–9, 101–2, 107, 127,
141–2), humour (116, 135), emotion (1, 3, 52–3, 76–7, 117–24, 144–7),
digression (91–2, 96–101), dilatation (138–9)

In Vatinium

Cicero's attack on Vatinius in *Pro Sestio* (132–5) is hardly more than a
brief report. But when he refers to the trial in a letter to his brother Quintus
(*Ad Quint. Fratr.* 2.4.1), he writes: 'I cut up his [sc. Sestius'] professed
adversary Vatinius just as I pleased, to the applause of Gods and men'. This
is a description of a comprehensive assault on the character and past career
of the main witness. The practice of writing up and circulating such attacks
was actuated partly by the existence of a ready readership for them among

[36] The precedent for this purpose of oratory was established by Isocrates, and followed by
Demosthenes, on whose didacticism see Usher (n. 14 above) 277–8.
[37] So Stockton *CPB* 213; Rawson *CP* 127. The possibility that *Pro Sestio* and *In Vatinium*
alarmed the triumvirs, especially Caesar, is considered below.

students of rhetoric:[38] they provided live material with which to expand and animate the academic syllabus. But they were clearly not intended for students alone: they became the life blood of political pamphlets, and Cicero himself was the victim of at least one of these.[39] It is in its latter function that *In Vatinium* raises an interesting question. Circulated at a time when the Triumvirate was in crisis,[40] did this invective against the prime enabler of Caesar's legislation precipitate the renewal of their concord at Luca? Perhaps: at any rate, it certainly accounts for the rigour with which they muzzled Cicero after it.

The title transmitted in the manuscripts is *In P. Vatinium Interrogatio,* but the witness is not on trial and the speaker is not expecting any answers; hence it is misleading to translate *interrogatio* as 'cross-examination'. It was a vehicle for the expression of indignation through *apostrophe*[41] (*Ad Herenn.* 4.15.22). This does not begin until §14. Before that Cicero tries to disparage Vatinius' importance (1) while accusing him of violence (2, 4), and false witness (3). The element of comparison often plays an important part in invective.[42] Here it is woven into the fabric of the speech, with Cicero's own actions providing most of the antithesis, but in the first comparison C. Cornelius' legislation is contrasted with that of Vatinius (5–6) Cicero's exile, which saved the Republic but left its citizens in a state of mourning, is then contrasted with Vatinius' legislation, which would bring about its ruin (7):

> And I beg you to pardon me, Vatinius, for having spared that country which I had preserved; and if I bear with you for wanting to damage it and throw it into chaos, will you bear with me for preserving and standing guard over it?

The mordant sarcasm is maintained as Cicero and his patriotism are the

[38] In his discussion of *vituperatio*, Quintilian (3.7.19) observes its traditional antithesis to *laus*, which is derived from the Greek antithesis between *psogos* and *encomium* (Aristot. *Rhet.* 1.3.3). These are the two primary forms of epideictic ('display') oratory, an essential component of the rhetorical curriculum.

[39] The *Invectiva in Ciceronem*: See R. G. M. Nisbet, *M. Tulli Ciceronis In Calpurnium Pisonem Oratio* (Oxford, 1961) 197–8.

[40] See esp. Stockton, 'Cicero and the Ager Campanus', *TAPA* 93 (1962) 471–89. He observes (478) how Cicero noted the tension between the three, and that this emboldened him to attack the legislation of 59 BC (479), raising the question of the Campanian land. These developments alarmed Caesar and Crassus rather than Pompey.

[41] Caplan's (Loeb) translation of *exclamatio*.

[42] See S. F. Bonner, *Education in Ancient Rome*, (London, 1977) 264, drawing on later Greek sources (Second Sophistic). Roman critics are disappointingly uninformative on invective and vituperatio. But see n. 38 (above)

leading topics. (10) is transitional, containing references to both men. At (11) Vatinius' career takes centre-stage, beginning with his quaestorship, during which he is alleged to have committed various acts of extortion. In a brief excursion into philosophy, Cicero remarks that Vatinius' ludicrous pretensions to Pythagoreanism ('hiding your ferocious and barbarous manners behind the name of a profound scholar'(14)), are linked to the more serious charge of misusing and perverting the auspices, which he flouted when they were invoked by the consul Bibulus in order to thwart Caesar's legislative programme. Caesar would not have been pleased to read (or received a report of) this, but Cicero tries hard not to antagonize him, taking care to separate the two (15, 22). Irony comes into play again when Cicero comments on Vatinius' bid for the augurship after his tribunate (20):

> At this point I ask you, if you had been elected augur as you desired (and what an idea that was!)...after all those other wounds by which you thought the state was being destroyed, if you had inflicted this mortal blow through your augurate as well, did you propose to decree, as all augurs since Romulus have decreed, that when Jupiter's lightning flashes it is sacrilegious to conduct public business, or, because you had always conducted it in this way (i.e. ignoring these auspices), did you propose as augur to make a complete end of the auspices?

Continuing with the theme of Vatinius' illegalities, Cicero says that laws which had survived the Republic's most turbulent times ('the vehemence of the Gracchi, the audacity of Saturninus, the turmoil under Drusus, the carnage under Cinna, and even the warfare under Sulla' (23)), had been destroyed by Vatinius. Coincident with his nullification of the laws were attacks on prominent citizens, including Pompey himself. Cicero may have thought that such a catalogue of influential senators would damage Vatinius' prospects of future office; if so, he was reckoning without his most powerful backer, who secured the praetorship for him in 54 BC. Again, Caesar would not have appreciated the disclosure that his man had planned to attack his fellow-triumvir, especially if this was true.

As the account of Vatinius' arbitrary actions continues, their political purpose unfolds. L. Vettius enters the story. Prompted by Vatinius, he informed the Senate that certain optimates were plotting to murder Pompey. Caesar was behind this:[43] all the alleged plotters were optimates, and included the most vehement opponents of Caesar and his popular programme. This was

[43] *Ad Att.* 2.24.2.

the class to which Cicero was increasingly turning for his own rehabilitation: hence his hostility to the authors of this accusation and his indignant defence of each of the accused men (24–5). Vatinius was particularly dangerous because he was prepared to use his tribunate to promulgate radical and potentially unjust laws, using them to attack opponents and to enrich himself (26–9). Having flouted custom and standard procedures during office (30–2), he tried to subvert them when out of it (33–36), including Cicero's own law on bribery (the *Lex Tullia de Ambitu),* on which Cicero is able to speak with authority (37).

As a major part of his final demolition of Vatinius (the speech does not have a formal peroration), Cicero tells him that even his sponsor Caesar has a low opinion of him, and has publicly said so (38–9), pronouncing him to be incurably venal and unworthy of any office, and adding his name to a long list of those who cordially loathe him. The words are comprehensively vitriolic, even by Cicero's standards:

> If no one sees you without a groan; if no one mentions your name without a curse; if everyone avoids you, shuns you, does not wish to hear about you, and when they see you, show their detestation of you as of a bird of ill-omen; if your kinsmen are sickened by you, your fellow-tribesmen curse you, your neighbours fear you, and your relatives blush for you; lastly, if boils have left your nasty face and now take up residence in other parts of your body, if you are publicly hated by People, Senate, and country folk to a man; – why ever do you prefer the praetorship to death, especially since you wish to be a Friend of the People, yet by no other means can you please the people more?

Invective could hardly reach greater heights than this.[44] It would not be surprising if it alarmed Caesar, who was Vatinius' backer for the praetorship. Nor would Caesar have been pleased at the praise which Cicero, in the final pages, accorded Milo, who was Pompey's man, not his. Thus it seems quite probable that *In Vatinium,* and to a lesser extent *Pro Sestio,* played a significant part in shaping the events, in that they brought the triumvirs together at Luca. But *In Vatinium* contains only three of Cicero's eight refinements: literary allusion (14), law (37) and humour (1–9).

[44] Description of a subject's physical appearance (see also 4, 10–11, 13) could certainly sharpen an invective (see Nisbet, n. 39 (above) 194), but it could also be used in routine exchanges in the courtroom (*De Or.* 2. 266). See A. Corbeill, *Controlling Laughter: Political Humour in the Late Roman Republic* (Princeton, 1996) 43–55.

Pro Caelio

This was Cicero's last speech as a free agent until he delivered the *Philippics*. Less than a fortnight after it the triumvirs recemented their alliance at Luca (mid-April 56 BC), and his opposition to them was ended. None of these politics enter the speech. Caelius was 26 years old, and had been Cicero's pupil and friend until 63 BC, when he became one of a number of footloose young men who were attracted to Catiline. Three years after Catiline's defeat, Caelius re-entered public life conventionally with an appearance in the courts as prosecutor of C. Antonius Hybrida for provincial maladministration (59 BC). Cicero's training had obviously equipped him well, as he was successful. But his appearance four years later, this time as defendant, arose from his private life, although the actual charge was for a public crime, violence (*vis*).

The perceptive reader is prepared for something special when Cicero expresses sympathy with the jury for having to sit during a public holiday, to hear a case which should never have come to trial under existing law (1). He is initially very cordial, though also rather condescending, towards his young opponent Atratinus.[45] Indeed, the indulgence due to young men, an old commonplace ('boys will be boys'),[46] is a recurrent theme, subordinating the technicalities of the case.[47] This, and the fact that the trial was staged not because of any indictable offence committed by Caelius, but because of the fury of a woman scorned, provided perfect material for Cicero to regale the long-suffering jury with an urbane diplay of oratorical virtuosity, containing elements of tragedy and comedy, humour and pathos, erudition and moral persuasiveness.

Clodia, the *fons et origo* of the trial, makes an early appearance, with 'the wealth of a courtesan'(1), a phrase which neatly encapsulates the character and the capacity of Caelius' real opponent. He had had a two-year affair with her, which began soon after the death of her husband Metellus Celer in 59 BC, and had ended acrimoniously. Her trying to gain revenge indirectly through the courts was a likely prospect, because Caelius had been active there as a prosecutor mainly, it seems, with a view to preempting prosecution

[45] 2, 8. He manages to avoid the open condescension of, say, the *Divinatio in Caecilium*.
[46] On the characteristics of youth, see Aristot. *Rhet.* 2. 12. 3–16.
[47] H. C. Gotoff, 'Cicero's Analysis of the Prosecution Speeches in the *Pro Caelio*', *CP* 81 (1986) 124, describes the speech as 'more a defense of Caelius' character than an argument against specific charges'.

himself. His colourful career, both before and after his involvement with Catiline, had left him vulnerable to such assaults. So Cicero's first task was to establish a good character for him; and one of the chief functions of the *praemunitio* (3–50) was to strip away the adverse material from the portrayal of Caelius, after representing the charges against him as vaguely conceived – intimacy with Catiline (10–14), bribery (15–16), and violence at elections (19–22). Clodia and her advisers had chosen to prosecute Caelius under the *Lex de Vi* for two reasons: because such charges took precedence over others, and because their scope had been widened in the recent turbulent times, a fact which Cicero himself deplored. They brought five charges against him under the umbrella of this law,[48] having abused this new latitude on a previous occasions (71). Crassus, who spoke second (after Caelius himself) dealt with the first three charges (23), leaving the murder of Dio, an ambassador from Alexandria, and the attempted poisoning of Clodia, for Cicero to handle. The former charge is dismissed briefly (23–4). Cicero quickly returns to his characterization of Caelius. This must have seemed necessary because Atratinus and his assistant (*subscriptor*) had made his dissoluteness (*intemperantia, incontinentia* (25)) into a major issue; but it does suggest a lack of compelling evidence against him (29). But he was keen to move on to what he saw as the cynosure of the whole story.

Cicero proposes to handle the charges laid by Clodia – that Caelius took gold from her to finance the murder of Dio, and tried to poison her – by using the same methodology that he has applied to the rest of the case, namely, by subordinating or discounting witnesses and other concrete evidence, and relying on argument and logic.[49] He concentrates on Clodia's character, contrasting it with the character he has given to Caelius, and alternating humour skifully with pathos. She is a mock-tragic figure, 'the Medea of the Palatine' (18), but she is also 'everyone's friend' (32), like any other *meretrix*. We are still very much on the stage when Cicero introduces the portentous persona of Appius Claudius, her venerated ancestor, no doubt exercising his lungs in the delivery (*Orat.* 85). Appius upbraids Clodia for her licentious behaviour, which shamed the memory of her illustrious ancestors and husband. Then he utters an historically-coloured call to virtue (34):

[48] See R. G. Austin's edition of the *Pro Caelio* (1933, rev. 1960), Appendix V (114–16).

[49] 22. Of these two types of proof, the first was described by Aristotle (*Rhet*, 1.2.2.) as 'artless' (*atechnos*), the second as 'artificial'('technical') (*entechnos*). He also argued that the second type was more reliable than the first because because both witnesses and evidence could be tampered with, whereas a juryman's common sense could not (ibid. 15.17).

Why did your brother's vices move you rather than the virtues of your father
and your ancestors, kept alive since my day not only by the men but also the
women of our family? Was it for this that I tore up the peace with Pyrrhus
that you might daily strike bargains about your infamous amours? Was it for
this that I brought water to Rome, that you might use it after your incestuous
debauches? Was it for this that I built a road, so that you might parade along it
with a procession of other women's husbands?

This *eidolopoiia*[50] thus ends by uniting history with drama, underlining
Clodia's immorality, which Cicero wants to identify as the sole factor that
made the charges of theft and poisoning possible. But at the same time the
character which she has fashioned for herself makes them incredible (35).

Cicero's treatment of the courtroom like a stage continues with another
adviser[51] for Clodia (36). With a salacious hint at his relationship with
his sister, Clodius is introduced counselling her to make light of Caelius'
rejection, and to turn to her many other admirers. This is a piquant way of
reminding the jury of the real motive of the woman scorned. Finally, Cicero
himself assumes a persona, suited to his relationship with Caelius, that of a
father-figure, and turns to literature for a suitable character – to the comic
poet Caecilius for the severe parent (37) (a speciality of his (*Pro Rosc Amer.*
46)) who would upbraid Caelius; and to Terence for the mild and indulgent
father, who would promise reparation to the complainant (38).

The argument takes a philosophical turn with the broad topic of the
training of young men, which arises naturally from his own relationship with
Caelius (39–42). The personification of nature and virtue gives the passage
a certain literary polish, as the modern interpretations of both Stoicism and
Epicureanism are found to be deficient in guidance for young men. The
relaxation of the severity of the old Stoics was an inevitable concession
to modern *mores,* but limits must still be set. A young man may pursue
pleasure ('let some allowance be made to age' (42)), but not to the degree
that damages his reputation, or for a length of time which delays a start
to a normal career. Caelius has met these requirements, having avoided
youthful excesses; and his performance in the present trial is proof of the
self-discipline he brought to his training as an orator (45–6). This gives rise
to a brief dilatation on a topic which features in the opening of *De Oratore,*

[50] The term applied to the introduction of speaking dead persons. *Prosopopoiia (conformatio)*
is used of living, absent persons.
[51] The tragic warner or adviser was a stock figure of Greek drama (Tiresias, Cassandra).
Appius fitted this parallel: Clodius is a semi-humorous parody of it.

on which Cicero may have been working when he delivered this speech – the rarity of good orators. It is only a temporary diversion here, because Cicero still feels that Caelius' character, or at least his behaviour, needs to be defended further, and this need prompts him to re-focus, in the concluding sections of the extra-evidential *praemunitio*, on the *meretrix* who caused all the trouble. That word shapes the whole argument. Immorality cannot logically be imputed to a young man who merely makes use of services freely available.

We come at last to the charges themselves: that Caelius obtained gold from Clodia, and attempted to poison her (51). Cicero chooses not to tackle these charges in the text-book way, by questioning motive, opportunity, the existence of accomplices, and the prospects of success (53), turning instead to rhetorical means, notably *dilemma*, using it to destroy probability on three occasions.[52] He also relies on the character of one good man, Lucius Lucceius, whose slaves were alleged to have been used by Caelius to pass Clodia's gold to Dio's intending assassin(s). Cicero asks whether such an upright man would have allowed himself to become party to the murder of one who had been his guest (54). There is some emotion in this cameo defence of Lucceius (on whom see ch.5: History), but much more when he touches on the death of Metellus Celer, Clodia's husband, which Cicero himself witnessed (59):

> At that moment, at the point of death, when in all other ways his mind had by then become enfeebled, he remembered the Republic with his last thoughts, and fixing his gaze upon me, amid my tears, he strove in broken and dying words to tell how great a storm was hanging over me, and how great a tempest threatened the state. Then, knocking several times on the wall which stood between him and Quintus Catulus, he repeatedly called on the name of Catulus,[53] often on mine, and most often on that of the Republic; so that his grief was not so much at his own dying, as at the prospect of his country and myself being bereft of his aid.

[52] 'If he did not tell her, why did she hand it over? If he did tell her, she made herself his accomplice in this crime (52).......If he was as intimate with Clodia as you claim, he would certainly have told her why he wanted the gold; if he was not so intimate, she did not give it...if Caelius told you the truth, she (sc. Clodia) knowingly gave him the gold to commit a crime; if he did not venture to tell you, you did not give it' (53). See C. P. Craig, *Form as Argument in Cicero's Speeches: a Study of Dilemma* (Atlanta. 1993) 113–5, 118–9; and ch.5 n. 7.

[53] Catulus, one of the leading optimates, had died in 61 or early 60 BC, after which Cicero saw himself as the champion of the optimate cause; or so he writes to Atticus (*Ad Att.* 1. 20.3).

This digression may have an ulterior purpose. Rumours had circulated that Clodia had poisoned her husband, so Cicero may here be conflating the theme of poisoning in general with that of the turmoil fomented by Clodia's brother, which caused Metellus to express his fears for the Republic, and for Cicero's immediate future.

By contrast, the examination of the alleged circumstances of the delivery of the poison (61–9) is suffused with sarcastic humour (62–3, 66, 67, 69), leavened with live speech (*sermocinatio*), in which the opponents' version of events is directly challenged, and the jury is reminded that the 'mini-play'(*fabella* (64)) ending in a 'mime'(*mimus* (65)) was concocted by Clodia herself. Humour at this point will have been a tonic for the jury, animating the complicated story. But it seems likely that Cicero has made the sequence of events even more complicated than it actually was.[54]

Seriousness returns, quite abruptly, for the epilogue (70–80). The two most important points of the defence are recapitulated: that the law under which Caelius was arraigned had been misapplied through the use of false precedents, and that Caelius' character had been misrepresented. The latter point requires some elaboration, necessitating a selective review of Caelius' early career which emphasized his industry and sobriety (72–4). His association with Clodia is blamed for the subsequent set-back in his progress (75). Now the jury have just heard all about this, so Cicero has to change from a tone of vindication to one of pleading for indulgence to youth, and recognition of worth (77). The emotion of this comes to a climax in 79–80, matching but not exceeding similar passages in Cicero's speeches from this period.

He has fulfilled his pledge to give the jury a show to remember. Indeed, his has been a stage performance to rival those which some of the jury have been obliged to miss.[55] An obvious ingredient of this has been the liberal quotation from the dramatic poets. But a more pervasive manifestation of it is the striking characterizations of the leading persons in the drama, conveyed in a seductive and memorable style. As to Ciceronian refinements, seven are to be found: literature (36, 37, 38), philosophy (6, 30, 41, 42, 52,

[54] See Austin (n. 48) 98–9.

[55] H. C. Gotoff, 'Cicero's Analysis of the Prosecution Speeches in the *Pro Caelio*', *CP* 81 (1986) draws attention to the significance of the coincidence of these two events (125): 'it [sc. the trial] invited a theatrical setting, and Cicero's reference to the games in the exordium is designed to establish that connection And hence the dramatic allusion; which the prosecutor Atratinus had also done'.

53), history (34), humour (34, 36, 61–9), emotion (59, 79–80), digression (4, 6), dilatation (39–42, 46). Their number and variety adds to the colour and bravura of the speech on the written page, but one suspects that they played an even more compelling and enjoyable part in the live performance.

Pro Caelio marks an important stage in Cicero's career as an orator. After it his appearances in court and in the Senate were mostly monitored and even controlled by the men who were gradually turning the Republic into an autocracy.

In this middle period of his career, Cicero treated the high and the low points of fortune which he encountered in the years 63–56 BC with almost equal oratorical resource. When at the height of his prestige as consul, he delivered one of the speeches that most completely met his own demaands as a critic – *Pro Murena,* in which he deployed all eight refinements in a case in which success was vital for Rome's security. Throughout this period, he fulfilled obligations to his friends or supporters by defending them with a similar degree of virtuosity (*Pro Flacco, Pro Sestio, Pro Caelio*), but was slightly less generous in this respect towards other clients (*Pro Sulla, Pro Archia).* As to his own affairs, he once more uses almost his full range of refinements in speeches *Pro Domo Sua* and *De Haruspicum Responsis,* but fewer of them in his politcal addresses. Thus the period as a whole is more variable than its predecessor in its content of his ideal features.

CHAPTER FOUR

ADVOCATE OF THE REPUBLIC

De Provinciis Consularibus

Julius Caesar, Crassus, and Pompey met at Luca in April 56 BC, after Caesar had become more and more concerned at the activities of the leading optimates, who had detected fissures in the edifice of their triumvirate, and were threatening to undermine Caesar's popular legislation and unseat him from his provincial command. As to Cicero, there was a certain ambiguity in his position: he still had hopes of influencing Pompey to uphold the authority of the Senate, but had become increasingly alarmed at Caesar's ambitions. But there was nothing ambiguous about the purpose and outcome of the meeting at Luca. There the Triumvirs affirmed their alliance, and immediately initiated measures to strengthen their power and to crush opposition. Cicero, who had played a part in the attacks on Caesar's legislation, was now obliged to exercise his persuasive powers in support of the Triumvirs' new measures, not being given the option this time of patriotic withdrawal.[1]

The senatorial debate at which this speech was made, around the middle of June 56, was about the second part of the Triumvirs' settlement . It had already been decided that Pompey and Crassus should be the consuls for 55, and should follow this with provincial commands. It remained to decide which provinces they would have. Caesar wanted his Gallic command prolonged for a further five years, ostensibly in order to complete the pacification of that large and turbulent country. Four provinces came under consideration in the debate: the two Gauls, governed by Caesar, Macedonia, then governed by Piso, and Syria, governed by Gabinius. Before considering Cicero's handling of this material, it is worth observing that the early removal of Piso and Gabinius from their commands was advocated in the first instance not by Cicero, but by a very senior senator, Servilius Isauricus (cos. 79 BC)

[1] His letter to Lentulus (*Ad Fam.* 1 9.11–12) is a partial attempt to explain his position. He writes that he had supported Pompey since his sponsorship of the *Lex Manilia*, and Caesar's 'interest and prestige were bound up with Pompey's'. Of course this is a disingenuous attempt to hide his embarrassment at the situation in which he found himself, since his re-opening of the question of the Campanian land could not have been seen as anything other than opposition to Caesar.

(§1). Thus when Cicero opens his speech with attacks on these two, he was probably amplifying opinions which had already been expressed. This is not to say that he did not do so with great enthusiasm, but Servilius' initiative deprives statements that Cicero was settling a personal score[2] of some of their validity. It would be more apposite to characterize the invectives which Cicero deploys against these egregiously bad governors[3] as manifestations of a now politically impotent politician re-creating himself in the most memorable way he can.[4]

The attack is launched almost at the outset, beginning with Piso (1–8). His disastrous military exploits have destabilized the province, and his plunderings and extortions have alienated the inhabitants. Gabinius (9–12) has sabotaged the work of the tax-collectors (who were Roman citizens, and members of the Equestrian Order from which Cicero drew much of his support).[5] All this was relatively easy for Cicero to argue and for his senatorial audience to stomach. Both men had enemies in their ranks, and no influential constituency. But when he came to argue for the satisfaction of Caesar's demands, his role of spokesman for the triumvirs was blatantly exposed, and his peculiar oratorical skills called into service. It was the time not for passionate advocacy, however, but cool logic. He hastens to assure his audience that his judgement is dictated by the public good, not personal favour or grievance, and in this he is following the lead of the great statesmen of the past. The precedents are drawn from over a century of history (18–23), making this one of the longest examples of this Ciceronian refinement. The closest precedent to the present case is that of the *popularis* Marius, a relative of Caesar, whose patrician enemies refrained from recalling him from Gaul, even actually appointing him to an extraordinary command (19). Cicero's choice of optimates acting with dignity and patriotic restraint was calculated to go down well with this audience; and he rightly

² So for example, Fantham *RWCE* 214.
³ For a more favourable view of these governorships, see R. G. M. Nisbet's edition of *In Pisonem* (Oxford, 1961) 172–9, 190–2; followed by McKendrick *SC* 292. On Gabinius' governorship, E. M. Sanford, 'The Career of Aulus Gabinius', *TAPA* 70 (1939) 64–92, gives a generally favourable account of it (see esp. 80–9). She notes his family connections with the area (80), and the fact that the narrative of the historian Josephus gives the lie to Cicero's description of the province as *pacatissima* at this time.
⁴ Cf. Steel *CRE* 183: 'The invective is an essential part of the recreation of M. T. Cicero as a political force'.
⁵ R. S. Williams, 'The Role of "Amicitia" in the Career of Aulus Gabinius', *Phoenix* 32 (1978) 195–210, argues that Gabinius' treatment of the tax-collectors arose from his concern for the provincials (201, 204) (cf. Sanford (n. 3) 82), and ends (210) by noting that Gabinius 'remained a *popularis*'. He fought on Caesar's side in the Civil War.

felt that he must try to identify himself with them. Like them, he had opposed Caesar's domestic policies, but when Caesar became a patriot by defending Rome's northern borders, Cicero found it impossible not to be the friend of one who had rendered good service to the state (24). He can even argue that Caesar is being unselfish (29–30):

> What reason is there for Caesar to wish to linger in the province, except in order to hand over to the State fully completed the settlement that he has undertaken? I suppose that it is the pleasantness of the country, the beauty of the cities, the culture and refinement of the inhabitants, the desire for victory, the extension of the boundaries of the empire, that detain him? What lands can be found more savage than these, what towns more uncivilized, what peoples more ferocious? What is more desirable than all those victories, what more distant than the Ocean? Will his return to his country be in any way unwelcome either to the People who sent him, or the Senate who honoured him? Does the passage of time increase our longing for him, or make us forget his existence more and more? And do those laurels, won at the cost of great dangers, lose their freshness after so long a time? And so, if there are some who do not love the man, there is no reason why they should recall him from his province; for that means to recall him to glory, to a triumph, to congratulation, to the highest honours the Senate can confer, to the favour of the Equestrian Order, to the affection of the People. But if, for the sake of the State's advantage, he is in no hurry to enjoy such brilliant fortune, because he wants to finish all the work he has begun, what ought I, a senator, to do who, even if I wished otherwise, should be bound to consult the interests of the State?

The change of mood from one of initial sarcasm to one of frank admiration of the subject, then back to the cool logic of his and Caesar's patriotism, is a masterly piece of rhetoric. It also cleverly addresses both Caesar's enemies and his partisans.[6] Cicero falls short of the sustained adulation that he showed towards Pompey in *Pro Lege Manilia*, making only a brief tribute here (31). His acknowledgement of Caesar's achievements focuses on his actions ('crushed in battle...terrified...checked and subdued...taught them to submit to the rule of the Roman People' (33)), rather than directly characterizing the man himself. By contrast, in historical examples of earlier conquering generals (32), we read of Marius' 'divine and outstanding bravery', and Gaius Pomptinus as 'that

[6] If in *Ad Att.* 4.5.2 he is describing this speech when he writes that he has 'observed moderation', that seems an accurate self-critique. Steel's opinion that 'his praise of Caesar is lavish' (*CRE* 181) needs some qualification.

gallant man'; and heights of rhetoric are reserved for mountains: 'Let the Alps now sink to the earth' (34). Far from delivering an encomium of Caesar, he sets out to explain his relationship with him (40), beginning with an early friendship which Caesar tried to convert into a political alliance, which Cicero rejected (41). But both parties behaved reasonably. Certainly Caesar reacted harshly to his non-cooperation, but Cicero accepts this as wholly understandable: 'I have more reason to fear blame for my presumption in refusing his generous offers than he has for the harm he did notwithstanding our friendship' (41). The most important point to emerge from a very intricate argument is that, whereas his support from the optimates has at times been equivocal (44–5), the goodwill of Caesar towards him, affirmed by Pompey (43), has been constant. He complains especially that there had been no effective effort in the Senate to attack the law which sent him into exile (45). Hence, while pronouncing it to have been 'the funeral of the State', they had deemed it 'a regular funeral announced in all due form'. Thus Pompey and Caesar have done more to secure his restoration than his awowed allies. He deploys his legal knowledge to show the inapplicability of the laws that had been invoked(46).

The brief peroration (47) is a good example of 'summary under heads'. Private enmities should be shelved in the interests of the State, and *a fortiori*, since there is no enmity, and any imaginary enmity has been effaced, there should be no impediment to the advocation of the best policy, which is the reappointment of Caesar to the command that will enable him to complete the conquest of Gaul. Opponents of that reappointment should ask themselves whether their attitude is consistent with becoming reconciled with Clodius, who is now as much their enemy as his. The tone of the speech has remained dispassionate, balanced, and conciliatory to the end. Only three Ciceronian refinements find a place in it: legal knowledge (46), historical examples (18–23, 27, 32), and humour (29).

The question of the relation of the speech to the *palinodia* ('recantation') mentioned in *Ad Att.* 4.5.1 is not unimportant,[7] as it may cast light on Cicero's opinion of his own work. In that letter he refers to another letter which he had sent to Pompey soon after Luca, after Pompey had warned him not to

[7] Most modern commentators have considered it; and since Butler and Cary (Cambridge, 1924 104–6) firmly identified it with the letter which Cicero sent to Pompey, the majority have endorsed that view. Fantham (*RWCO* 214 n. 9) seems to fall short of outright endorsement, writing: 'it is generally thought that this speech [*i.e. Prov. Cons.*] was the Palinodia explained by Cicero in his letter to Atticus (4.5) of April or May 56'. Her analysis of the speech (214–9) places it securely in its historical context.

proceed further against Caesar's Campanian Land Law (*Ad Fam.* 1.9.9). It is natural to identify that letter with his *palinodia*, as they are mentioned almost in the same breath. However, the Triumvirs would certainly have demanded a public statement from Cicero of his new position, though abject submission or apology would have been embarrassing to all parties. Hence the measured, statesmanlike tones of *De Provinciis Consularibus*.

Pro Balbo

The trial of Cornelius Balbus took place in 56 BC, very soon after *De Provinciis Consularibus,* and saw Cicero in his new role as a spokesman in the interests of the Triumvirs. Balbus, a native of Gades (mod. Cadiz), served in the Sertorian War (79–82 BC) under Pompey, who rewarded his efficiency with Roman citizenship. After his enrolment in one of the four city tribes, he spent much of his time in Rome, where he acquired wealth and property. He also became a close friend of Caesar, and was involved in the negotiations that led to the formation of the Triumvirate. These covert activities placed Balbus at the centre of Roman politics, an achievement which did not go unnoticed by men who regarded that position as theirs by right. These optimates grew jealous of the wealth and influence enjoyed, through the patronage of their political enemy Caesar, by this foreign upstart. Balbus was also active in the courts, thereby adding to the ranks of his enemies as he advanced his career. Now he found himself the target of litigation, with matters of law central to the case against him. But the trial was also about politics, in that it was an indirect attack on Balbus' sponsors Caesar (who had returned to Gaul) and Pompey. The appearance of Pompey and Crassus, speaking before Cicero, reflects this.

In referring to Pompey's performance at this trial, Cicero pays remarkable tribute to his deep knowledge of laws and precedents (2–3), following this with more general praise of the wide influence he has deservedly acquired (11–13). This leads to an emotional passage (13–16) which emphasizes Pompey's understanding of 'treaties, agreements, terms imposed upon peoples, kings, and foreign races' (15). This may be not mere courtesy, but an invocation of the *auctoritas* of Rome's most powerful citizen in this particular case, which was necessary because legal authority is difficult to establish.[8] For good measure, Cicero rounds off the section with a dilatation on the subject of worthy ambition (16).

[8] So J. Harries, 'Cicero and the Law', in Powell and Paterson *CA* 162.

The prosecutors have disputed Pompey's granting of Roman citizenship to Balbus on the ground that Gades had not 'given consent' to it.[9] In his reply, Cicero shows his legal knowledge, citing the *Lex Gellia Cornelia*, which validated the granting of citizenship by Pompey (19), presumably superseding the old law invoked by the prosecutors. By further quoting precedents which involved early negotiations between Rome and her Latin neighbours, and the different principles and intention that actuated them, he tries to remove the old law from the discussion. However, it seems that the precise nature of Roman citizenship was a subject of keen debate at this time, and Cicero's handling of it betrays anxiety about the interpretation of the relevant texts.[10]

But Cicero had another line of argument. The original treaty with Gades in 206 BC had been informal (Livy 28.37), and had been consolidated in 78 BC, but even then was not ratified by the People in the *comitia*. Consequently, Cicero contends, any Gaditane veto on the conferment of Roman citizenship on one of its citizens would have been invalid, though he scrupulously avoids attacking any other aspects of the treaty (32–5). And he follows this with supplementary arguments designed to show (i) that the enfranchisement of Balbus did not violate the treaty, and (ii) that the wording of the treaty placed Gades in an inferior position to Rome.[11]

Throughout the legal discussions which are central to the speech Cicero draws advantage from texts which are so imprecise as to invite amendment, which he conducts using the principle of equity, with the assistance of analogy which his knowledge of history, as well as law, enables him to draw. He also makes logical deductions from other laws and treaties (32), and shows that the prosecutors have drawn false conclusions from the misinterpretation of the text of the law (35). Probability argument comes into play when he answers the claim that the citizens of Gades did not want Balbus to receive Roman citizenship: it ran against their past behaviour, and they would know that their interests demanded that they should maintain and strengthen their friendship with Rome. Their past friendship has been attested on many occasions and by many distinguished witnesses (38–40), and their present interest in both Balbus and their relationship with Rome is

[9] *fundus factus est* – an archaic term, apparently derived from an ancient law made to meet different conditions.

[10] See Harries (n. 8) 161–2.

[11] Further on these arguments, see P. A. Brunt, 'The Legal Issue in Cicero *Pro Balbo*', *CQ* 32 (1982) 141–3. In explaining them, Brunt adds that they are 'obviously technicalities', but that those of the prosecution could be similarly described (143).

shown by the presence of their envoys at his trial. Further examples of the conferment of citizenship without the consent of the recipient's state add to a long list of historical examples (48–55). In 56–63 the focus is upon the defendant and his friends. Balbus has suffered the fate of most successful men: envy, and hence slander. By contrast, he has always shown respect for worthy citizens. This section serves as a bridge to the more vehement plea for pity in the peroration (64–5).

Biting sarcasm is present in 20, 25, 27–35; so that the speech has five of the eight refinements, with emotional writing in 13. In its display of legal knowledge it is comparable with *Pro Caecina*, and it illustrates the fluid state of Roman law, especially that concerned with *ius commune*, the laws affecting Rome's relationship with other states.

In Pisonem

'Heaven has no rage like love to hatred turned
Nor hell a fury like a woman scorned.'

Of these two verses by Congreve, perhaps the second is the more famous; but the first describes the background to the invective *In Pisonem* very well. It is conceived on an altogether larger scale, and shows a deeper intensity, than its predecessor *In Vatinium*. Whereas he had had no reason to expect anything but hostility from Vatinius, Cicero's previous relationship with Piso, up till the latter's consulship in 58 BC, had been cordial, and he had supported his candidature. But when Piso failed to use the paramount position which that office conferred to save Cicero from the pain and ignominy of exile, that failure seemed to Cicero the ultimate act of treachery. But behind the extreme hatred that he displayed in the invective lay also the frustration that he felt at the situation in which he found himself at the time of its delivery, which was probably some time between July and September 55 BC, just over a year after the Triumvirs had recemented their alliance at Luca, when the muzzling of Cicero was near the top of their agenda. Piso returned from his proconsular post in Macedonia around that time, and the occasion of the speech may have been the Senate's debate on his tenure of that office.[12] Unlike a prosecution speech,[13] an invective was not required to prove or substantiate charges. The

[12] See R. G. M. Nisbet's edition (Oxford, 1961), Appendix VIII (199–202)
[13] The reasons Cicero gives for not prosecuting Piso (95) are very unconvincing. Paradoxically, Cicero's attack on him is a tribute to Piso's independence: if he had been tied to any of the triumvirs, Cicero would not have dared to attack him.

genre had a long parliamentary history, but enjoyed increasing vogue in the First Century BC.[14] Cicero took this opportunity to develop his skills in it. The fragmentary opening of the extant speech contains disparaging references to Piso's birth, one of the standard *loci* of invective. The continuous text opens with a description of his appearance, superficially impressive enough to counterbalance his unattractive features, and to trick men into supposing that he was someone to be respected (1):

> We were not deceived by your slavish complexion, your hairy cheeks, your discoloured teeth; it was your eyes, eyebrows, forehead, in a word your whole countenance, which is a kind of dumb interpreter of the mind, which pushed your fellow men into delusion; it was this that tricked, betrayed, and inveigled those who were unacquainted with you.

The personal detail is almost embarrassing to hear. Comparison immediately comes into the argument, and remains a constant ingredient, another standard feature of invective. Cicero, who had risen through the *cursus honorum*, Piso had climbed the ladder from obscurity, personally unknown to the electorate, who only knew his family name (2):

> You were made an aedile; it was a Piso, not you who bear that name, who was elected by the Roman people. So it was upon your ancestors that the praetorship was conferred. They were dead, but all men knew them; you were alive, but as yet not a single man knew you.

The comparison continues in greater detail, as Cicero gives selected highlights of his own consulship (4–7). Piso's administration, by contrast, was weak, allowing Cicero's enemies, particularly Clodius, to encompass his destruction. The attempt to convert Piso from a passive bystander to a prime mover of it focuses on his statement that he disapproved of cruelty, which referred to the execution of the Catilinarians without trial. Cicero says that Piso made that statement 'with one eyebrow soaring into your forehead and the other tucked down to the level of your chin' (14), a characteristically abrupt introduction of burlesque into a serious indictment. The statement itself must have stung Cicero, in view of the cruelty Piso was allowing to be inflicted on him, his friend.

Historical comparison also plays a part: the presence of this refinement in Cicero's type of invective has come to seem natural and inevitable. In 100

[14] See Nisbet (n. 11), Appendix VI (193).

BC Metellus retired in order to avoid conflict with Marius: Cicero did so in fear not of obvious enemies, but of less easily identifiable dangers – the consuls, and also those influencing them – and their threat is made more vivid by imagery (21):

> Other gales I saw upon the horizon, other squalls I had anticipated; other tempests threatened which I did not give way to, but made myself a solitary sacrifice to ensure the safety of all.

Piso has been portrayed as an incompetent consul, then a complicit one, and now one wholly indulgent in unbridled licence and debauchery after he has abandoned his authority to Clodius. Cicero's picture of his behaviour would no doubt strike a chord with later readers in the reigns of Nero, Commodus, and Caracalla. But his purpose at the time was to blacken Piso's reputation, and to achieve this he even allows Gabinius some virtues (27–8) to compare with the anarchic irresponsibility that Piso brought to the consulship, never consulting the Senate, making legislative proposals, or observing existing laws (30–1).

The comparison between Cicero's and Piso's careers resumes: Cicero's triumphant return, publicly celebrated by all orders (34–6), and Piso's inglorious governorship of his province of Macedonia, characterized by a suspicion of fiscal malpractice and widespread plundering because of his failure to send despatches (37–9). (But see n. 3 (above).) Cicero now applies Epicurean doctrine to Piso's situation. His behaviour proves that he is interested only in the indulgence in pleasure that he thought central to it; but Cicero shows that there is more to the authentic doctrine than that. The wise man was less interested in questions of physical pleasure and pain than in the pursuit of honour and the avoidance of shame. He defined evil as pain, and good as pleasure, so that 'even if he were to be shut up in the bull of Phalaris and roasted above a fire, he would assert that he was perfectly happy and calm in his mind'(42) By this distinction Cicero is asserting that he has a better understanding of this crucial aspect of Epicurean philosophy than the self-styled connoisseur himself.[15] Historical examples illustrate this philosophical point. Marcus Regulus suffered torture at the hands of the Carthaginians, but was content, because he had acted honourably; while the

[15] P. De Lacy, 'Cicero's Invective against Piso', *TAPA* 72 (1941) 49–58, notes that Cicero's 'failure to substantiate arguments by specific evidence arouses suspicion that they do not give an accurate picture of Piso's conduct and character'. On pp. 57–8 De Lacy goes further than Nisbet in showing how Cicero misrepresents Epicurean teaching.

fate of Gaius Marius, as of Marcellus before him, were to be accepted as fortune's dispensation, not the consequence of wrongdoing (43). A quotation from poetry serves here, unusually, to colour the wrong view (the poet 'appeals to the sentiment of the uninstructed, and not of the philosopher'). The balance is then restored, reaffirming the authority of the poet, as Cicero alludes to the role in tragedy of avenging powers (46–7), who had surely vented their wrath on Piso by driving him to the mad deeds that he had committed on his province.

A digression into Gabinius' command in Syria offers a more straightforward catalogue of maladministration (48–52). This is more reminiscent of Verres, with the emphasis laid on his extortions, perhaps because his military operations were probably quite successful. Just over a year later (Oct. 54 BC) Cicero, under some duress, defended Gabinius for extortion, and lost. Now, however, he returned to mainstream material, comparing his return (again) (51–2) with that of Piso (53–6). This section ends in bitter recrimination, and also deep irony:

> You are the first governor on record who, having been invested with consular authority [sc. in Macedonia], did not gain a triumph on your return. But, conscript fathers, a philosopher has spoken in your midst: he has said that he never cared for a triumph.... (58) Gnaeus Pompeius cannot now adopt your policy. He has blundered, he never had a taste for the philosophical outlook: the poor fellow has already had three triumphs. Crassus, I am ashamed of you! What can have been your motive in bringing a formidable war to its conclusion and showing such eagerness to have that laurel wreath decreed to you by the Senate? Publius Servilius, Quintus Metellus, Gaius Curio, Lucius Afranius, why did you not sit at the feet of this sage, this learned man, and so avoid the error into which you have been led? Fie upon you, Camillus, Curius Fabricius, Calatinus, Scipio, Marcellus, Maximus – fools, all of you! Paulus was out of his mind, Marius a simpleton! How misguided were the fathers of both these consuls! And why? Because they celebrated triumphs!

Sustained irony of such intensity is a feature of this invective. Here, in the sequel, he moves into potentially risky territory (59):

> But since we cannot alter the past, why does not this fiction of a man, this Epicurus of mud and clay, hasten to instil these sublime philosophical doctrines into that great and illustrious commander, his son-in-law [Julius Caesar]? Believe me, it is fame that bids this great man soar; he burns with a

desire for a well-earned triumph. He has not learnt the lessons you have learnt. Send him a tract; nay, if at this stage you can contrive to meet him in person, meditate what phrases you can use to quench and stifle the flames of his desire. A man of such restraint and strength of will as you are cannot fail to exert an influence over the giddy victim of ambition; the learning of the father-in-law will surely work upon the ignorance of the son-in-law. You will say to him, consummate proselytiser that you are, the elegant and accomplished product of the School:...

Piso's lecture is made to broaden into a disquisition on the subject of triumphs, viewed through his Epicurean eyes – 'Vanity, mere vanity' (60). This is contrasted with his own return from his province, which resembled that of an obscure private citizen, without the trappings of his proconsular rank. It was remarkable only for the skill with which he presented his accounts to the treasury, concealing his peculations to the bafflement of its clerk, who quotes from Plautus ('The account is indeed plain, but the money has gone.' (*Trinummus*, 414).) But this section is remarkable mostly for its portrayal of Caesar, which hinted at his ambition only enough to show that Cicero sympathized with his enemies, while not wishing to annoy his friends.

After returning to invective mode as he compared Piso's life with his own (63–7), Cicero once more tries to show that he understands Epicureanism more profoundly than Piso, who was attracted to its sensual side and missed its true spirit. In the course of his long association with the Epicurean philosopher Philodemus, Piso had selected and adopted those parts of his teaching which suited his own voluptuary tastes, while the 'Greek in a strange land' (70) had little option but to be complicit.

Piso's interest in literature had led him to ridicule certain verses in Cicero's poem *On his Consulship*, to the excruciating fatuities of which he had attributed Cicero's exile. Cicero rejects the charge that they had caused offence to Pompey, and thence broadens the discussion into his general relationship with with Pompey (76–7) and Caesar (79–82). He uses this as an opportunity to deny accusations of conspiracy against both, and so to consolidate his own political position. Certainly in this section of the speech he seems to be trying to ingratiate himself to them, especially the absent Caesar, to whom he is almost apologetic for not supporting his reforms, while he praises his conquests. Historians are wise to handle this eulogy with care: the longer Caesar was away, the closer Cicero came to Pompey. His personal friendship with Caesar would wither as the danger to the Republic grew.

A summary of Piso's crimes in Macedonia begins in 83, making that point the beginning of a long and loosely-constructed peroration: his *crudelitas* (83–5) and *avaritia* (86–8), and the concluding events of his proconsulship (88–93). The invective even intensifies, and the reason for this becomes apparent: his desire to proceed to a full prosecution cannot be fulfilled (see n. 13). A year later, however, he wrote to his brother that the speech was being read and learnt by heart in the schools (*Ad Quint. Fratr.* 3.1.8.). It contains six of the Ciceronian refinements: literary, philosophical, historical; humour, digression, and dilatation.

Pro Plancio

Gnaeus Plancius was quaestor in Macedonia when Cicero arrived there in exile in 58 BC, and did much to make his sojourn there as bearable as possible. Three years later he was elected to the aedileship, but was prosecuted by one of his defeated opponents, M. Juventius Laterensis, for *ambitus*. Cicero gladly grasped the opportunity to repay his kindness by defending him, and was successful. The trial took place in 54 BC.

In the exordium (1–4) it becomes clear that he is going to make the case into an issue of character, not one of material guilt or innocence (3: 'If I fail to show the honesty of his way of life...'). Proof that Plancius has the virtues of incorruptibility, self-control, and loyalty, and has exercised them throughout his life, will be enough. But Cicero's task will not be easy, because both defendant and prosecutor have been his friends:[16] by praising the one, he risked slighting the other. His line is to represent the electoral process itself as a lottery, in which the merits of the candidates are irrelevant, because the people decide the outcome, and their choice is liable to be based not on an assessment of a candidates' integrity or ability, but on the success of his importunities; and since the people's choice has the force of law, the candidate has no recourse other than to court its favour. Hence the election process is a turbulent business (15):

> If, like the deep and vast ocean, those billowing waters of the voting-place and the popular assemblies seethe as if with some boiling tide, so that they flow over some places, but withdraw from others, shall we be disappointed

[16] Plancius was an eques from Atina, a few miles from Cicero's birthplace of Arpinum. Further on his background, see K. Lomas, 'A Volscian Mafia? Cicero and his Italian Clients', in Powell and Paterson *CA* 102–4, 112. On the other side, Laterensis also had a claim on Cicero: he had been among those who worked for his return from exile and protected his family in his absence (73). This dilemma (6) pervades the speech

at the onset of rash partisan enthusiasm, when we meet no moderation, no
deliberation, no logic?

The discussion moves on to the subject of local supporters versus the mere
claims of rank. Here Cicero and Plancius share a common experience.
Plancius received strong backing from his fellow citizens. Knights from the
countryside were often so supported, as was Cicero himself in his candidacies;
and he cited his own example when he canvassed for Plancius (24). Then
he goes back into recent history for an example of townsfolk helping one
of their benefactors: the rescue of Gaius Marius from his enemies by the
colonists of Minturnae (26). The language he uses for this is almost poetic.

There now follows a brief review of Plancius' career (27–30), which
begins with the impressions he left with the superiors under whom he served,
and even the good impression he made on the provincials. It then turns to
private relationships with kinsmen (29), summarily broached with *occultatio*.
The prosecutor Laterensis has sought in vain for material unfavourable
to Plancius, and has tried to fall back on trumped-up, outrageous charges
involving Plancius' father. He has even tried to curb the freedom of speech
which has long been enjoyed by Roman knights – a freedom confirmed by
examples from the past.

Cicero now complains that Laterensis, while nominally conducting
his prosecution under the *Lex Licinia*, which is aimed at curbing illegal
associations (*sodalicia*), has extended its application to include all measures
bearing upon corrupt practices (36–40). Cicero shows knowledge of the law,
and can demonstrate that the prosecutor has 'evaded its spirit' (42–3). On
the other side, Plancius' popularity made it unnecessary to use the bribery
of which he was now accused; and in any case there was no time for him to
organize it (44–8). Then Cicero dwells on Laterensis' noble background, and
urges him not to act in a way which would have disappointed his ancestors.
Previous candidates for the aedileship had not been daunted by failure, but
had gone on to win high office. In the previous generation, there was one
spectacular example of resilience: Marius, who, after suffering two defeats
in his candidature for the aedileship, went on to be elected consul seven
times (51).

The following sections of dilatation broaden from a statement that jealousy
(*invidia*) is commonly felt by those aiming above their station, into actions
which arise from that jealousy – slander, the invention of false rumour and
false evidence. Some aptly chosen verses from the poet Accius summarize

the argument (59). Then he answers an argument used by slanderers, who try to give their obloquy maximum effect by comparing the object of their jealousy with the most illustrious consuls of the past, pointing out that the mere attainment of high office is less praiseworthy than the acclaim that is won after it by the exercise of *virtus*.

But fame can be transient: Cicero illustrates this from his own experience (64–6). On returning from his quaestorship in Sicily, he found, to his chagrin, that people did not know that he had been away: 'out of sight, out of mind'. After that experience, he made sure, through his writings no less than through his actions, that people would not forget him so easily. He amplifies this with a passage from the Elder Cato.

The speech assumes the tone of a treatise on ethics (68), as Cicero distinguishes between monetary and moral debt:

And yet a monetary and a moral debt are two different things. He who discharges a debt in money ceases to possess that which he has paid; while he who remains a debtor keeps what does not belong to him. But in a moral debt, when I pay I keep, and when I keep, I pay by the act of keeping.

Historical examples of past statesmen who were condemned in spite of the support of eminent men have been adduced by the prosecutors, but Cicero argues here that they were inappropriately chosen. At this point the reader will have become perplexed by the plethora of material which is irrelevant to the main charge against Plancius (72–82). Indeed, the prosecutor Laterensis clearly shares this perplexity, and Cicero compounds it by answering at length on the subject of his obligation to the defendant. In 76 there is a reference to his criticism of Cicero's lukewarm defence of Cispius, who had supported him. Cicero rebuts this, claiming that he had shed 'floods of tears, sighs, and weeping commingled'. Even more remote from meeting the charges is the answer to Laterensis' argument that Plancius had done little during his tribuneship to further Cicero's cause. Is the whole of this line of argument to be explained as material for the published speech, with Cicero's main object the setting of his own image,[17] as a man who handsomely repays his benefactors, and was therefore a potentially valuable political *amicus*?

Of two philosophical passages, the first, on gratitude, follows naturally. The focus is even more firmly on Cicero himself. He deals with another of

[17] On Cicero's use of his speeches for this purpose, see J. Paterson, 'Self-Reference in Cicero's Forensic Speeches', in Powell and Paterson *CA* (on *Pro Plancio*, pp. 93–4). On the rhetorical problems facing Cicero in this speech, see Craig, *Dilemma* (ch. 5, n. 7) 123–45.

Laterensis' criticisms, that Cicero liked to appear for the defence because it afforded him the best opportunities to create pathos (83). He goes on to complain that Laterensis had changed from sympathy for his exile to censure for not enlisting the aid of his friends and fighting for his political career. But he was not able to call on the support of such powerful men as those of the past – Marius, Publius Mucius, and Lucius Flaccus. The theme of the second philosophical passage is immortality, and is linked to a dilemma faced by Cicero himself (90): dying for one's country would achieve a form of it, but would defeat its purpose if the country were thereby endangered.

In answer to his opponents' criticism, Cicero claims that he enjoys as much freedom of action still as they do, especially as he has become reconciled to his previous adversaries (*i.e.* the Triumvirs, whose relationship with him he prefers to characterize (93) in political rather than pesonal terms), without sacrificing his patriotism. Most men would urge him to continue in this line of conduct, as would indeed The State herself, introduced (92) in a *prosopopoiia*:

> Since you have always served me, and never yourself, and since the gain from that service has been, not joy and wealth...as it should have been, but a cup of bitter grief, serve yourself now for once, and think of your own people. My fear is not that your services to me have been insufficient, but that the return I have made to you has been meagre compared with the extent of your service to me.

The enhanced rhetorical tone of this passage is maintained in another of Cicero's nautical images (94), but the argument to which it leads seems casuistical: by going along with the beneficial policies dictated by Pompey and Caesar, he was showing the adaptability enjoined by history, literature, and wisdom upon a man who sought success. But the image he creates makes him seem more like a tourist than a man bound on a serious journey.

Using his opponent's wit as a means of pointing to exaggeration, he quotes Laterensis' words as he complains of Cicero's overblown praise of Plancius' services to himself, 'making a triumphal arch out of a sewer, and conferring divine powers upon a piece of sepulchral masonry' (95). The peroration (98–104) begins soon afterwards. The length of the pathetic *narratio* which traces Cicero's peregrinations via Sicily and Brundisium to Dyrracchium and Macedonia, where he was met by Plancius, seems disproportionate, but proves to be an emotional build-up (see esp. 99, 101) to an extraordinary climax, in which he begs the jury to look favourably upon a defendant who

has gone through such mental agony on his behalf, rather than recall to mind and pass judgement on the charge on which he has been arraigned. Cicero's personal prominence in the speech may be explained by the fact that Laterensis had decided to make the trial a contest of *auctoritas* and *dignitas* between himself and Cicero. This prominence may also account for the presence of seven out of the eight Ciceronian refinements, with only digression absent. The underlying reason for the great assembly of rhetorical material in this speech is Cicero's embarrassment at his opponent's exposure and exploitation of his abject submission to the Triumvirs.

Pro Scauro

M. Scaurus was prosecuted in 54 BC for malfeasance, mainly extortion, during his governorshp of Sardinia.[18] As an adherent of Pompey, and the son of a former *princeps senatus*, he attracted the support of Cicero, who at that time was keen to affirm his alignment with both Pompey and the Senatorial leadership. The speech survives in mutilated fragments, but a search for Ciceronian refinements in it is not unrewarding.

The continuous text begins in the middle of the proof, after Cicero has refuted charges against Scaurus concerning the poisoning of a certain Sardinian named Bostar, whose property he is alleged to have coveted; and he deals with further charges of lustful importunities to the wife of another Sardinian, Aris (I 1–7), which led to her suicide. This event leads to the adduction of historical examples of famous persons who embraced suicide in the face of dishonour. Examples include the mythical figure of Ajax (III 3); Themistocles, and the less well-known Cleombrotus of Ambracia, who was prompted to do so by his misreading of Plato's *Phaedo*. The theme takes a philosophical turn at this point (III 5), but concludes on a note of humour (6) when he tells the jury that the suicidal wife had another reason for her act – that she was old and ugly. Other characteristics make her like a figure of comedy: 'He [Aris] was afraid of his wife, who was old, wealthy, and ill-tempered; but though her ugliness made him unwilling to keep her as his wife, her dowry made him unwilling to divorce her'. There is more in a similar vein, with a description of a plot to kill her, feigning suicide (10–11).

Cicero's purpose in telling these stories is to contrast the nastiness of

[18] See E. Courtney, 'The Prosecution of Scaurus in 54 BC', *Philologus* 105 (1961) 151–6. For the ethnic stereotyping, see Vasaly, op. cit. (ch.2 n. 40).

these Sardinian families with the nobility and uprightness of his client; and the broader contrast between mendacious Sardinians and estimable Romans is developed in the background (VIII 17, IX 20–1). In the meantime, Cicero criticizes the prosecutor Triarius for his perfunctory preparation of his case, illustrating this with a short digression (23), and comparing his slipshod methods with his own travels and laborious compilation of evidence for the trial of Verres (XI 25–6).

Insight into the political rivalries of the time is given in XI 31–6, but this section fits rather awkwardly into the structure of the speech. The section on the reliability of witness seems more relevant (XVIII 38–41), and that theme is amplified in a dilatation (XIX 42–5) on the perfidiousness of the Phoenicians (the race from which most Sardinians were derived), which was an ancient theme in Roman literature and lore – to which Cicero appends a moderating note, admitting exceptions to the general indictment. The concluding fragments contain the peroration almost intact, in which there is an emotional final defence of Scaurus (XXIII 46–50), but otherwise no further Ciceronian refinements, of which there are five (philosophy, law, history, emotional appeal, and dilatation).

Pro Rabirio Postumo[19]

As governor of Syria, in 58 BC Aulus Gabinius invaded Egypt in order to restore Ptolemy Auletes to the throne from which his subjects had expelled him. A bribe of 10000 talents from the king was Gabinius' inducement, but Ptolemy had had to borrow that money from Roman lenders, of whom one was Rabirius. On his return from his province Gabinius was prosecuted and exiled, and when his estate was found to be too small to meet the fine that had been imposed, the *Lex Julia de Repetundis* was invoked. Under this law the shortfall in any fine payments could be sought from any person who had been involved in the condemned man's financial dealings. As such a person, Rabirius was summoned before the court of enquiry in 54 BC.

In the exordium (1–2) Cicero seeks sympathy for Rabirius for having been deceived by the plausible and importunate Ptolemy: a misfortune rather than a crime. Moreover, Rabirius was only following his own father's worthy example, as had famous men in the past such as Scipio Aemilianus and Publius Decius. Rabirius' father, Gaius Curtius, was a wealthy tax-farmer and *princeps ordinis equestris,* an order from which Cicero drew

[19] See M. Siani Davies' edition 'Cicero's Speech *Pro Rabirio Postumo*' (Oxford, 2001).

much of his support (15). But he was induced to defend Rabirius primarily by Pompey's desire that he should do so, rather than any attachment to him. Rabirius' poor judgement is made to appear understandable, and it was Ptolemy who was to blame for the misuse of the loan (6–7).

Cicero uses his practical knowledge of the law to advert to a lack of precedent in this case (9–10), where the defendant had been brought to court on tenuous evidence. He also invokes a general judicial principle, that a senatorial jury should consider not only what a law allowed (*quantum liceat*), but also what its own moral standards required (*quid deceat vos*) (11–12). In the present case, they had general powers to summon Rabirius, but before doing so they should consider the lack of evidence against him and his good character, and, most seriously of all, the fact that they were technically wrong to summon him under the *Lex Julia*, since that law was framed to deal with provincial governors, not Roman knights. Cicero expresses concern about the serious politically destabilizing consequences which this legal error could have: it could cause a quarrel between the orders ('the insidious blight will spread, and more widely than you imagine'(15).) Examples are given of recent politicians' concern with the equilibrium of power between the two orders. Glaucia, on legislative powers (14), and Drusus, who was opposed by the equites when he tried to subject them to a form of enquiry already imposed on senators. They complained that this would bring their obligations into line with those of the Senate without granting them its privileges (16–17). This broadening of the argument reflects Cicero's secondary, though important, purpose in this speech. While remaining committed to his ideal of a *concordia ordinum*, he is here putting the case for the parity of the knights with the senior order (13,15).

The prosecutor has tried to involve Rabirius directly in Gabinius' plans and actions in Egypt, which have been discredited at his trial. Cicero is able to show that this accusation is at variance with those used successfully against Gabinius, and employs irony (21). The prosecutor has further alleged that Rabirius served as Ptolemy's treasurer (22), but Cicero qualifies this by saying that he was forced to do so. He accepts repeatedly that Rabirius had acted foolishly in allowing himself to become involved in the king's affairs; but history furnishes examples of such foolishness by men seemingly of superior wisdom who had ignored the injunction 'Put not your trust in princes': Plato, who narrowly escaped with his life from Dionysius, tyrant of Syracuse; the historian Callisthenes, who was killed by Alexander the Great; and Demetrius of Phalerum, who was murdered in Egypt (23). Rabirius had reluctantly worn

a Greek cloak to avoid being conspicuous during his sojourn in Egypt, but the prosecutor has upbraided him for this sensible act of self-protection. Cicero offers examples of similar sartorial adaptability by famous historical figures (26–7). And Postumus had no option of leaving, being under forcible detention. Cicero finds one literary quotation on the necessity to bow to force (28), and another on the arbitrariness of kings (29). This is all intended to elicit sympathy for the gullible but well-intentioned Rabirius. But a serious allegation against him has to be met: that while raising money for Gabinius, he diverted some of it into his own pocket. The difficulty of refuting such a charge leads Cicero to resort to quibbling over detail, criticizing individuals and groups, and questioning whether it was possible to trace the money alleged (30–40). He must ask the jury to review all the rumour and put it to the test of probability. He could also introduce an extraneous source of Rabirius' wealth: the generosity of Caesar (41), who becomes the subject of an encomium,[20] on which he embarks in suitably elevated language, making sure at the same time that sympathy for Rabirius is kept in the foreground. Adding Caesar's name to the list of his supporters would serve to remind the jury of the *auctoritas* of a man who could not defend him in person.

There is an injection of emotion into an idealized portrait of Rabirius, a man unconcerned about wealth, who would happily be condemned to lose it in exchange for the restoration of his honour (45–6). This passage leads to one of even greater feeling, intensified by *prosopopoiia*, as he turns to a personal recollection and apostrophizes his client (47):

> There rises before my eyes the vision of that night so fraught with sorrow for all those I love, when you laid yourself and all your resources unreservedly at my feet, when you comforted my departure with your companions, your protection, and such a weight of gold as the exigency of that time demanded; and during my absence you never failed my children or my wife.

The amount of emotion in the closing sections covers up an absence of summarized charges and evidence. In his questioning of the grounds for making Rabirius liable for the repayment of Gabinius' debt, Cicero's introduction of the *Lex Julia* has probably been irrelevant, since the practice of making a debtor's associates liable lay outside the text of that law, and Rabirius was therefore properly charged. The speech contains seven of the Ciceronian refinements, missing only digression.

[20] Winterbottom, 'Perorations', in Powell and Paterson *CA* 218, marks the beginning of the peroration here (41).

Pro Milone

The year 52 BC was one of tumult: it began without consuls, and by the time Pompey was appointed to a sole consulship the Senate House had been burnt down. The occasion of this wanton act was the return to Rome of the body of Clodius, whose violent death at the hands of a gang led by T. Annius Milo led to the present trial. This took place in a dangerously charged and menacing atmosphere, the court ringed with armed men. Cicero had been keen to defend a man who, more than most, had befriended him in his feud with Clodius, and prepared one of his most admired and classically partitioned and proportioned speeches.[21] But on the day he seems to have been disconcerted by the combination of an oppressive military presence and the baying of the Clodian mob, and delivered it with 'less than his customary assurance', according to his commentator Asconius (11). (Plutarch follows the less credible hostile tradition that he delivered only the opening periods of his speech (*Cic.* 35. 5)).

The central question of the case was that of responsibility, *i.e.* who started the fight. Milo maintained that the killing took place in self-defence. The two men were leading mutually hostile armed parties when they met, apparently by chance, while travelling in opposite directions along the Appian Way. The confrontation took place near Bovillae, about twelve miles from Rome. The facts relating to the event may seem simple enough, but the political circumstances surrounding it made Cicero's handling of the case anything but simple.

In the exordium (1–6) he adverts to his anxiety, contrasting it with the robust character of his client (1), and refers to Pompey, as the guarantor of a fair trial, countervailing 'the brute force' of arms which surrounds the proceedings (2). His opponents are 'men whom the madness of Clodius has sated with plunderings and burnings and every form of disaster to the community' (3). The emphasis on Milo's bravery (rather than his cleverness) will make more credible the defence of spontaneous action, rather than planning, in regard to the battle at Bovillae. The second part of the exordium (4–6) pleads for the jury's favourable attention and stresses the worthiness of his client and his willingness to face danger in the cause of rightness and justice, with only the request that the facts and the proofs should be fairly considered.

[21] Winterbottom, 'Perorations' (see n. 19) 217 writes: 'Cicero took the opportunity to make it, among other things, a model for the aspiring student....' (n. 8)

The category under which Milo's case is to be argued is that of justified homicide, so the narrative is preceded by a long list of historical and literary examples. The carrying of arms for self-defence is also defended ('homicide is surely not merely justifiable but even inevitable when the offer of violence is repelled by violence' (9)... 'the law authorizes self-defence; it forbids not homicide, but the carrying of a weapon with a view to homicide' (11)). A point raised by the prosecution, that the Senate had already pronounced Milo's act illegal, is flatly denied: all it had done was to consider holding an enquiry about the killing, which Cicero himself had voted for, and Pompey approved (15). There are more historical examples of justified homicide, and the discussion assumes a philosophical tone (17):

> In life let there be a distinction between the highest and the lowest; but let death at least, when criminally inflicted, be amenable to both penalties and laws which shall be invariable, unless the death of Clodius is rendered more shocking by the fact that he was slain amid the monuments of his ancestors.

This section furnishes Cicero's readers with an illustration of the handling of *constitutio* (or *status*) *iuridicialis* (*De Inv. 1* 14–15). In 18–19 he dilates on Clodius' designs on Pompey's life, which broadens into a general plea in the interest of public safety, of which, as had been noted, Pompey was seen as the sole guarantor. Few of Cicero's excursions into deep sarcasm match the one that follows (20):

> But how absurd of me to compare Drusus, Africanus [historical figures whose murders were not followed by Senatorial enquiries], Pompeius and myself [targets of Clodius' attacks] with Publius Clodius! Those acts were tolerable; none can with equanimity endure the death of Publius Clodius! The Senate mourns; the equestrian order is inconsolable; the whole community is bowed down with affliction; the municipalities wear mourning dress; the colonies are heartbroken; why, the very fields are pining for a citizen so benificent, so kindly, so gentle!

By way of completing the preliminaries, Cicero indicates a strong motive for Clodius to murder Milo. It was the prospect of Milo's election to the consulship of 51 BC, which would render him impotent in his office of praetor, which he hoped to win in the same year (24–5). When at last the narrative of the facts begins, Milo's side of the action is shown to be natural and unplanned (28):

Milo, on the other hand, after having been in the Senate that day until its dismissal, went home, changed his shoes and clothes, waited for a short time while his wife made such preparation as ladies usually make, and finally started out so late that Clodius might already have returned to Rome, if he had intended to do so. He was confronted by Clodius, unencumbered, on horseback, no coach, no baggage, no customary Greek companions, without his wife (which he scarcely ever was); while our supposed ambush-setter, who, we are told, had planned the expedition with a view to murder, was driving with his wife in a coach, wrapped in his travelling-cloak, with a large, cumbersome, effeminate and dainty retinue of waiting-maids and pages.

Cicero goes on to describe how an organized attack by Clodius' men was repelled, largely through the bravery of Milo, though his slaves actually killed Clodius. The main points to be stressed were, of course, that Clodius' violence was met with violence, effrontery with valour; and that Milo's slaves acted on their own initiative (29). The legal position is restated with clarity (31): the act of killing was justified because the attack was premeditated, and the only question to be decided was who was the planner. The short narrative has already suggested the answer, and the subsidiary question of who stood to gain (*cui bono?*), which had been considered earlier (27), is briefly restated here (32). This leaves the way open for a conclusion drawn from probability arising from character and motivation. Clodius was a danger to the state, with a programme of destructive legislation which Milo, had he become consul, could have thwarted. As to Milo, Clodius posed no great threat to his advancement, which was moreover approved by most Romans, who saw him as a protector against Clodius' excesses (34). Hence, ironically, Milo gained nothing from the death of Clodius who, when alive, was 'food and fuel for his renown' (35, 52). But Milo had a reputation for violence (cf. 66–7), or association with it (36). This is a possible point of comparison between the two characters; but Cicero quickly dismisses it by arguing that the violence wrought or threatened by Clodius has been far the greater, and against worthy men, whereas that of Milo has been against Clodius in defence of his friends (37–8). This portrayal of a restrained, mainly reactive Milo, who even did not take opportunities to kill Clodius when he could have done so legally and with impunity, hardly accords with other accounts, but serves Cicero's purpose of establishing a character from which he could deduce probability, answering the question: Which of the two was more likely to have been intent on violence at that fateful encounter, so soon before the consular elections (43)?

A further piece of evidence of Clodius' intent, his prediction that Milo would be dead within three days (44), is given before the salient points of the narrative are reviewed. A few extra details, and the interpretations put on them by others, are related, mostly tending to confirm Milo's good reputation (53–71), and further to undermine that of Clodius (72–9 (a full-blooded invective describing some of his acts of lawlessness)). Here the taut classical structure of the speech has begun to slacken; and the first Ciceronian refinement for some time appears, allusions to early figures who were slain because they were thought to be aspiring to tyranny (72), and to Hellenic festivals celebrating the slaying of tyrants (80), a deed to which Milo would have admitted, had he done it. Further historical examples illustrate this point, which is reinforced in an elevated passage (83) which also has philosophical content, on the subject of the gods and state religion (84–5), and the retribution which Clodius' abuse of them has brought upon him. Cicero contrives to attribute Clodius fate to superhuman forces, with his killer no more than their agent, and his supporters acting with the same insanity after his death that he had shown in life (86). And interest remains focussed on Clodius' god-inspired downrush to ruin (88), with no summary of Milo's case, and speculation entirely replacing fact and argument: what would have happened if Milo had been killed and Clodius had become praetor, and even consul? (89).

In the long peroration (92–105), beside the standard emotional plea for pity stands an unusual idea: that Milo is too proud and brave to ask for it himself, but it should not for that reason be withheld (92). Now Plutarch records (*Cic.* 35) that Milo's cavalier attitude to his trial was a major reason for his condemnation. It must therefore be uncertain whether the idea of Milo's pride was introduced into the published speech for reasons of historicity, or it is simply an addition to the characterization of Milo, which underlies the whole of this section (see again (101): 'These tears cannot melt Milo; he has a strength of mind beyond belief...he shows the spirit that is natural to him'.) *Prosopopoiia* is often a feature of perorations. Cicero goes one step further in vivid representation by giving Milo a valedictory speech (93–4), and adds his own commentary on a portrayal of a man whose whole career has been devoted to saving the state from her internal enemies. Cicero does Milo's pleading for him, and makes his emotion personal as he expresses dismay at the possibility that his pleas might fail (102), after Milo has done so much for him (104). The contrast between himself and Milo is maintained to the end (105): 'But no more. Indeed, I can no longer speak

for tears, and my client forbids that tears should plead his cause'. Perhaps not surprisingly, this model speech contains as many as seven Ciceronian refinements,[22] which include a passing allusion to Aeschylus *Eumenides* (8); only digression is lacking.

Pro Marcello

The seven years separating this speech from *Pro Milone* contain the final stages of the transition of Rome from a republic to an autocracy. From our point of view, Caesar's victory at Pharsalus in 48 BC ended free speech for all but the boldest or those most compliant with the new order, and introduced a new form of defence-oratory, in which the speaker pleaded on a one-to one basis with the autocrat (here Caesar). Questions of guilt or innocence were decided less on technical legality than on persuading the autocrat that the defendant's offences did not present dangers or threats to his new regime. Marcellus (consul in 51BC), had been one of Caesar's most persistent and outspoken opponents, especially in the recent stages of the latter's career. After Pharsalus, Marcellus remained abroad, on the island of Mitylene, and appears to have made no immediate attempt to return to Rome. The initiative for his recall seems to have come from the Senate, who sought thereby to strengthen their own influence, and perhaps test Caesar's temper, particularly gauging the degree of forgivenesss he would show towards his defeated enemies.

Cicero had been one of these, but two years had passed since Pharsalus, and many of Caesar's enemies had survived through his outward show of moderation and clemency (1). Cicero associates himself more closely with Marcellus than other known facts about their relationship suggest. Two opposite views of his purpose in the speech have been propounded. Taking it literally, one can read it as a piece of counselling, advising Caesar to use his power with wisdom and discretion, and with the ultimate aim of restoring the Republic (23).[23] Or it may be seen as a 'veiled attack rallying

[22] For interesting interpretations of several passages in the speech, see A. R. Dyck, 'Narrative Obfuscation, Philosophical Topoi, and Tragic Patterning in Cicero's Pro Milone,' *HSCP* 98 (1998) 219–41. Albrecht (*CS* 191–3) shows how the narrative broadly follows Cicero's own prescription in *De Orat. II* 326–30. For valuable recent examinations of the speech, see J. M. May, 'Cicero's Pro Milone: An Ideal Speech of an Ideal Orator,' in C. W. Wooten, *Studies in Honor of George A. Kennedy* (Leiden: Brill), 2001) 123–34; C. Steel, Reading Cicero: *Genre and Performance in Late Republican Rome* (London, 2005) 116–131.
[23] Von Albrecht *CS* 172.

Caesar's opponents',[24] directed towards his senatorial colleagues. The influence which Cicero enjoyed after Caesar's death seems to suggest that many contemporaries interpreted it in this ironic way, especially when they considered its moments of extreme unctuousness (*e.g.* 22). But did Caesar himself see through this also? Perhaps he did, but felt secure.

Outwardly, at any rate, Cicero is mostly cooperative and constructive, while trying to steer Caesar towards a future of constitutional peace, dwelling on Caesar's military achievements only in general terms (4–9), highlighting acts of clemency, especially those carried out in the heat of battle (9–10) Later he says that merely conquering enemies is not enough (25–6); peace is the only truly lasting legacy (29). A philosophical flavour is also injected into this argument (27), and the tone becomes progressively more didactic.

It becomes increasingly clear that a defence of Marcellus is a secondary aim for Cicero. After all, Caesar had already shown a predisposition to pardon and readmit him to the Senate, to join others who had fought against him at Pharsalus. A straightforward view would cast Cicero in the role of a respected adviser, who, like Caesar, had always been averse from civil war (14–15), and, amid all the praise lavished on a generous conqueror, and concern for his future safety (21–3, 32) (or is that the acme of irony?), Cicero manages to keep his main message clear: Caesar must restore the republican institutions, especially the lawcourts (23). This message lies behind the argument for constancy in pursuing a cause (30–2), and *haec* in the clause *omnes qui haec salva esse volumus* (32) is to be understood as 'the existing state of things', and he intends it to mean the republic which Caesar is about to restore.

The peroration of this short speech (33–4) recapitulates his opening expression of gratitude, and characterizes Cicero as the mouthpiece for all citizens, making Marcellus the pardigm for all of them: ' I feel that all rejoice at the deliverance not of a single person, but of the community at large'. The personality of Cicero has, as often before, been more prominent than that of his client from beginning to end.Yet it contains only two Ciceronian refinements: philosophical tone and emotional appeal.

[24] So R. R. Dyer, 'Rhetoric and Intention in Cicero's *Pro Marcello*', *JRS* 80 (1990) 26. He finds the speech ironic (26, 29), allegorical (27), and enigmatic (28), posing a dilemma (25) arising from Caesar's need to continue his policy of clementia, which would outrage his senatorial enemies, in order to satisfy his supporters. Further on the nature, purpose and effect of clementia, see Dyer 18, n. 14–16. He concludes that the speech was 'a clear summons to tyrannicide' (30). For an opposing view, see M. Winterbottom, 'Believing the *Pro Marcello*', in *Studies in Honor of Edward Courtney* (Munich; Leipzig: Saur, 2002).

Pro Ligario

A favourable reception for the last speech encouraged Cicero to stage a repeat performance for Q. Ligarius, who had served the Pompeian cause in Africa until he was captured by Caesar after the Battle of Thapsus (46 BC). Ligarius, a relatively insignificant figure, might have won an easy pardon like other Pompeians, but he had offended one of these, Q. Tubero, who decided to retaliate by prosecuting him for treason (*perduellio*), perhaps in the hope of winning favour with Caesar. The speech with which Cicero defended him has some of the routine characteristics of a classical forensic oration, but these are marshalled with the polished skill of a seasoned craftsman. This excited the admiration of both ancient critics (the attention it receives from Quintilian is exceeded only by that paid to *Pro Cluentio* and *Pro Murena*) and modern commentators.[25]

The exordium (1) and narrative (2–5) are clearly and conventionally marked. But in the exordium the topos of the opponent's preparation (Greek *paraskeue*) is refined in a framework of wit (irony) as he says: 'hoping that you knew nothing of the matter at first hand, and that you could have known nothing of it at second hand, I had come prepared to take advantage of your ignorance to save an unfortunate man'. In the sequel he rues his own lack of thorough preparation and pretends that he will have to abandon his intended defence and fall back on a plea for mercy, having, of course, no intention of doing any such thing. The irony extends to the *aporia* that leads to it, and colours the whole passage, as Cicero goes on to say that Tubero has an easy task, in which the defendant pleads guilty, though to the same crime as the prosecutor (*i.e.* being a Pompeian) (2).

The narrative economically describes the career of Ligarius in Africa, showing that he had no foreknowledge of the imminent war and no plans as to his future allegiances, and steered clear of taking sides until Pompey's control of the region obliged him to do so; and he remained in Africa unwillingly (4–5). Faced, however, with the undeniable fact that Ligarius had fought against Caesar two years after Pharsalus, Cicero turns towards

[25] Kennedy *ARRW*, drawing on G. Walser, 'Der Prozess gegen Ligarius im Jahr 46 v. Chr.', *Historia* 8 (1959) 90–6, suggests that Caesar used this trial as an opportunity to parade his clementia in order to encourage more diehards to submit to it. J. P. Johnson, 'The Dilemma of Cicero's Speech for Ligarius', in Powell and Paterson *CA* 371–99, examines modern bibliography. He concludes, against the common view that the speech is a *deprecatio* (a plea for mercy implying admission of guilt), that Cicero's clever advocacy is directed towards establishing Ligarius' clear innocence of any crime.

Caesar emotionally, calling for his *clementia* with surprising confidence (6–7). In the same mood, he turns to Tubero (9):

> When your sword, Tubero, was unsheathed on the field of Pharsalus, what was its object, at whose breast was its blade pointed, what was the significance of your weapons, on what were your thoughts, your eyes, your strong right arm, your fiery spirit directed? I am too insistent; I will return to myself. I fought on the same side.

The apostrophe to Tubero continues in an amplified style. There is an allusion to the practices under the regime of Sulla (12), whose cruelty Tubero is proposing to exceed. Ligarius is already languishing in exile: what punishment is worse than that, except death? And what act is more cruel than to oppose the clemency with which Caesar could restore him? Like Tubero and other restored Pompeians, Ligarius depended far more on that clemency than on the soundness of their cause (*non tam nostrae causae fidentes quam huius humanitati* (13)). But Cicero is looking for double insurance, so he turns to examine the question of whether Ligarius has committed a 'crime'. However Ligarius' action in opposing Caesar is described, its seriousness is diluted by the fact that he was only one of many, and the act of choosing the wrong (*i.e.* losing) side is an unfortunate error rather than a crime (17–18). The nature of the conflict itself underlines this (19):

> At the outset, Caesar, you defined the conflict as a secession,[26] not a war, not an outburst of hatred between enemies, but of dissension between citizens, a dissension in which both parties had the welfare of the state at heart, but in which each, through policy or through passion, diverged from the common interest.

Moreover, the men who had to decide which side to join were subject to unequal forces, with Pompey and his great prestige so close at hand, reinforced by the authority of the Senate (20–1). Tubero obeyed the order to sail for Africa, along with others committed to the republican cause. Ligarius' only 'crime' was to anticipate their journey (22).

Having shown in general terms that Tubero joined Caesar's enemies, Cicero tries to show that his adherence to Pompey was stronger than mere willingness to follow the lead of others. His annoyance with Ligarius was due to the fact that Ligarius' presence in Africa prevented him from waging war

[26] Caesar uses the word *secessio* in *Bell. Civ.* 1.7.5, implying that the situation prior to the war corresponded to that category of conflict.

against Caesar and so winning glory (25). He was quick enough in deserting the Pompeian cause after missing this opportunity of fame. Cicero uses irony and sarcasm to complete his portrayal of the shallowness and inconstancy of Tubero's character (26–8), to be contrasted with his client's consistent straightforwardness. Up to this point he has relied more on this contrast than on pleading. But now he turns to this and to flattery (31–5). He speaks before Caesar not as an advocate in an ordinary case, but (30): 'I plead as before a father: 'He erred, he acted thoughtlessly, he is sorry: I throw myself upon your mercy, I crave your indulgence for his fault, I beg you to forgive him'.' That is the highpoint of this passage of pleading. In general, the tone is cooler and more reasoned than in *Pro Marcello*, and he is able to say that Ligarius has supporters among Caesar's own friends (35). Cicero could have used Caesar's pardoning of Marcellus as an *a fortiori* argument, but he clearly thought that his defence of Ligarius, who became Caesar's enemy almost by accident, could be conducted with elegance rather than with the passion that he had deployed on behalf of Caesar's inveterate political adversary, Marcellus. Thus the peroration lacks the emotion theoretically prescribed for that section. Instead we read a generalization which neatly summarizes the ethics of the case: 'Nothing is so dear to the people as kindness, and none of your many fine qualities excited such admiration and such pleasure as your compassion.' This economy is reflected in the paucity of Ciceronian refinements, of which there are only four: philosophical (logic),historical allusion, humour, and emotional appeal.

Pro Rege Deiotaro

Deiotarus, King of Galatia in Asia Minor, had been one of Rome's most active allies in the east since his accession around 80 BC. But in the following years loyalty to Rome had come to mean, in practical terms, loyalty to successive Roman generals and administrators. He had the misfortune to back the 'wrong' general in the Civil War, and was present in Pompey's camp before Pharsalus. To make matters worse, his kingdom was attacked in his absence, and he was forced to turn for aid to the victor in the war. Caesar pardoned him, but a new danger supervened when Castor, the king's son, accused him of plotting to kill Caesar. This had the mark of a dynastic conspiracy, but there was a case to be answered. Cicero took up Deiotarus' cause because of help he had received from the king during his proconsulship of Cilicia (*Ad Fam.* 15. 2.2–3, 4.4).

The speech completes the trio of orations *apud Caesarem*. In it Cicero has to deal with witnesses who are at once unscrupulous and deeply involved. These include Castor, who was both his grandfather's accuser and the chief beneficiary in the event of his condemnation. This prompts Cicero to make his own apprehension the main subject of his exordium (cf. *In Caec.* 41–2, *Pro Cluent.* 51, *Pro Milone* 1; *De Or.* 1.121). Potentially intimidating also is the fact that the hearing takes place in the house of the very man Deiotarus is accused of plotting against; but Cicero turns this into an opportunity for flattery, by saying (4) '...but your unique and surpassing qualities, Caesar, lessen any such fear on my part'. At the same time, Cicero feels the need to say that the venue of the hearing inhibits oratorical pyrotechics.[27] How does this different requirement manifest itself? In fact, the heart of the speech is a measured portrayal of Deiotarus' character, with particular reference to those actions which show his loyalty (13–16) and establish a clear probability that a man who has displayed his qualities is unlikely to have been capable of the treachery of which he has been accused. The test of probability is also applied to Deiotarus' logical faculty: he must surely know that murdering Caesar would make him a pariah, especially if the circumstances of the killing were as patent as had been described by the prosecution (17). The historical parallel of Deiotarus' entertainment of Caesar with King Attalus' entertainment of Scipio Africanus (19) is part of a colourful and semi-humorous narrative. Both kings wanted to make public show of their regard for their visitor. But perhaps Cicero should not have made so much of this, as it could have been merely a device of concealment. By its very nature, the crime of poisoning, skilfully executed, is difficult to detect and its perpetrator hard to trace. Both sides knew this, so the prosecutor fabricated other plans for Deiotarus to murder Caesar. But Cicero is able to ridicule their improbability (21–2).

Further evidence that Deiotarus had intended to harm Caesar is examined and dismissed with equal dispatch (22–5). Exchange of imaginary dialogue between himself and the prosecutor is a feature of this section, giving it a very animated character. This general charge, that Deiotarus had always been on the lookout for oppportunities to murder Caesar, are belied by instances of the king's help. But Cicero cannot conceal the dilemma that faced Deiotarus when the Pompeian cause, which he had supported, was on the point of collapse. He chooses the death of Domitius at sea *en route* to join Caesar to illustrate Deiotarus' realignment, but this choice is peculiar, because it depends on

[27] See A. Lintott, 'Legal Procedure in Cicero's Time', in Powell and Paterson *CA* 77–8.

flat denial of the evidence it seems to provide. The king was alleged to have quoted a line of verse: 'Let our friends perish, so long as our enemies die with them!' Cicero dismisses the attribution on the ground that it is too barbarous for Deiotarus, who is a civilized man, to have said it. Cicero realized the line's ambiguity, but also had to deal with another story which recorded the king's delight at the death of Domitius: that he danced naked at a party in celebration (26). He can only fall back on character-probabilty; and Caesar knew Deiotarus as well as he did. Cicero brings up reinforcements in the form of praise of Deiotarus (26–8). Historical examples on the proper treatment of members of one's household are used comparatively. But the whole passage contains obscurities, exacerbated by the fact that Cicero apostrophizes Castor and Caesar in close succession. The vehemence of his attack on Castor, calling him a runaway slave who has risen above his station (32–3), is designed totally to discredit him, and enables Cicero to concentrate in the peroration (35–43) on finally reassuring Caesar of Deiotarus' goodwill and constructively reconciling them. An historical parallel is adduced of a monarch accepting defeat at the hands of a Roman general, and counting himself fortunate at the outcome (36). Avoiding the extremes of emotional appeal (40), Cicero places Caesar centre-stage, and affirms the vital part which his power, exercised with clemency (41–3), has played in stabilizing the alliances with the leading figures. The speech contains six of the Ciceronian refinements: literary allusion, philosophy (logic), legal knowledge , historical example, humour, and emotional appeal

The Philippics

The fourteen *Philippics*[28] track the course of events from September 44 to April 43 BC, most of which were disappointing to Cicero's aspirations for a restored Republic. This gave them the character of rhetorical history with strong tragic elements, while their positive approach underlined the fact that their author was, at the time of their composition, enjoying the period of his greatest influence ouside the year of his consulship. They were composed and circulated in immediate reaction to events, and this is reflected in their different moods.

[28] Cicero may have given them this name (*Ep. ad Brut.* 2.4), inviting comparison with those of Demosthenes and similarly combining the deliberative and the invective genres of oratory. For a detailed examination of this comparison, see C. W. Wooten, *Cicero's Philippics and their Demosthenic Model* (Univ. of North Carolina Press, 1983) 50–7, and chs. 4–6 *passim*.

Philippic I

The opening sections have the character of a reporter's narrative, delivered in the first person, and describing and explaining his own movements at the time (1–11). He had abandoned his intention to leave the country when it appeared that Antony might commit himself to the restoration of the Senate's authority. But the departure of Brutus (9) abruptly changed his mood of optimism to one of alarm. He conveys this change of emotion to his audience: 'Then truly I was fired with such eagerness to return that no oars, no winds were swift enough for me... And then, after a rapid passage to Velia, I saw Brutus, and I cannot describe the sorrow I felt at the sight'. From him he learned that a bold attack by Lucius Piso on Antony had not received the support it deserved, indicating the abject spirit of the Senate. It was the urgent need to strengthen its resolve that prompted Cicero to return to the rostrum for his final defence of the Republic.

But his first speech opposing Antony's designs (so far as these could be discerned) was studiedly moderate and contains comparatively few Ciceronian refinements. History momentarily adds colour to a sense of foreboding, though the examples had become stock phrases for an emergency (11): 'Hannibal is at the gates...a peace with Pyrrhus is at issue'. Cicero's fears were real enough, as Antony had threatened to burn down his house if he absented himself from meetings of the Senate. His policy at this stage is to disturb the *status quo* as little as possible. Thus he will support Caesar's *acta* without necessarily approving them, in the interest of peace quite as much as maintaining the integrity of his own programme. Historical parallels justify this policy (18). As he applies his legal expertise to them, Cicero shows that Caesar's legislation is a mixture of good laws and those that are incompatible with existing laws (18–23).

Cicero has not yet abandoned his hope of becoming a counsellor to whoever found himself in an all-powerful position, and as this appears likely to be Antony, it is he who becomes the recipient of his advice. In 27–8, he warns him not to stifle free speech, but also encourages him and his consular colleague Dolabella, (who had been Cicero's son-in-law) by praising their early aspirations (29–32). But he also records regretfully an apparent change of direction in their policies (33):

> Whence suddenly came that great change? I cannot be brought to suspect you had been seduced by greed. Every man may say what he likes: we need not believe him. I have never recognized in you anything sordid, anything

mean. Sometimes, no doubt, those of his household corrupt a man; but I know your strength of will. Would that you had been able to avoid suspicion as succesfully as you had been free of guilt.

The tone is still conciliatory, as Cicero appears to express continued confidence in Antony. But it is now qualified confidence, since he finds it necessary to remind Antony of speeches in which he celebrated unity and freedom. The argument is taken a significant stage further through a literary allusion (34): 'Let them hate, so long as they fear'. This is the pronouncement of a tyrant (Atreus), who seems to have paid for it with his life in Accius' play. Cicero had already abominated the sentiment in a different context (*De Off.* 1.28.97). Later Caligula is said to have quoted it with approval (Suet.*Cal.* 30), but Seneca (*De Ira* 1.20.4) shared Cicero's abhorrence. Here Cicero adds to Antony's annoyance by comparing him with his grandfather, the famous orator (34); and the didactic tone here probably exacerbated it, as Cicero discourses on the importance for a ruler of the true esteem, as distinct from the hollow applause, of his subjects (35–6) – applause which he himself has always despised (!). He stings Antony further as he ends by 'holding himself at call' (39), affirming that his primary audience is not Antony, but the Senate. The speech contains four Ciceronian refinements: literary allusion, knowledge of laws (18, 23), history, and emotional appeal.

Philippic II

Remembering that Antony had threatened him recently (*Phil.* I. 12; Plut. *Cic.* 43.6–7), Cicero would have expected some form of hostile reaction to his *First Philippic*. But its ferocity plainly surprised him, as did its personal nature. Antony accused him of violating the duties of friendship by not returning favours done (5–6), and in his tirade had reviewed Cicero's consulship (12–15), accusing him of complicity in the killing of Clodius (21–2), attempting to disrupt the alliance between Pompey and Caesar (23–5), and planning Caesar's assassination (25–31). Thus Antony appears to have mounted a comprehensive attack on Cicero's career, amounting to a full-blooded invective, containing some of the standard ingredients of that genre, like comparison (15). If Cicero wished to remain a credible force in politics, he had to reply with the same weapons, and to maximum effect.

Antony had reproached Cicero with his general demeanour while in Pompey's camp before Pharsalus. Presumably he pursued this line in order

to represent Cicero as a lugubrious outsider, unsympathetic to both sides in the war. Cicero says that he was only expressing dismay at the prospect of the loss of so many worthy men's lives (37). Antony may have dwelt on those of Cicero's qualities which made him an ineffective poltician in a time of military conflict. Cicero must in turn focus on Antony's deficiencies as a leader in normal times. He is a drunkard and a debauchee, quite different from his venerated grandfather (42); not a good orator, though he was trained in the art (43); and a gambler (57). Character is illustrated by deeds, as invective takes the form of biographical narrative, tracing Antony's moral descent from his childhood (44) and including his lawless immorality (44–6), intimacy with Clodius, and unauthorized travels (48). This scandalous material afforded Cicero several opportunities to display his wit, for example (45):[29]

> You assumed a man's gown, and straightway turned it into a harlot's. At first you were a common prostitute, and the fee for your crimes was fixed – and it was not small. But Curio quickly turned up, took you away from your meretricious trade and, as if he had given you a matron's robe, established you in an enduring marriage.

From this semi-humorous episode on Antony's personal and domestic misdeeds, Cicero turns to more serious charges alleging crimes against the state (50ff.) He blames Antony for providing the pretext for war, in that he was tribune when Caesar made the Senate's disregard of that official's veto as a pretext for opening hostilities (53). Cicero ignores the obvious probability that Antony was acting merely as the agent for Caesar's plans, and makes him personally responsible for the emergency created by his tribunician veto. He also takes no account of the pressure being exerted upon Caesar's supporters at this meeting by Pompey's friends, who were backed by an army stationed close at hand (Caesar *Bell.Civ.*1.2.6). The performance of Antony in office receives the full invective treatment (58):

> The tribune of the people was driven in a Gaulish chariot; lictors crowned with laurel preceded him; in their midst a female mime was carried in an open litter...There followed a travelling coach of pimps, a most iniquitous retinue; a mother set in the rear attended upong her vicious son's mistress as though she was a daughter-in-law. O wretched mother, disastrously fertile! With the imprints of these infamies did that man set his seal on all the boroughs, prefectures, and colonies, in a word on the whole of Italy.

[29] On this passage and 63, see Fantham *RWCO* 206–7.

The invective culminates in a description of Antony's behaviour at an
assembly (63):

> At an assembly of the Roman people, while in conduct of public business, a
> master of the horse, for whom it would be disgraceful to belch, vomited and
> filled his own lap and the whole tribunal with fragments of food reeking with
> wine.

Behind the coarse humour of these and other similar descriptions lies the
serious purpose of discrediting Antony as a political figure and comparing
him unfavourably with Octavian, whom, in spite of his dubious credentials,[30]
Cicero was hoping to groom as the standard-bearer of the restored Republic,
under his own benign guidance. The republican cause could also be
promoted by making full play of the residual popularity of Pompey. Hence
the reference to the sale of the great man's property (64):

> The goods of Gnaeus Pompey the Great were submitted to the harsh
> announcement of the auctioneer. In that one matter forgetful of its slavery, the
> State groaned (*civitas ingemuit*), and though their hearts were enslaved (since
> all things were possessed by fear) yet the groans of the Roman people were
> free (*gemitus tamen populi Romani liber fuit*).

The *prosopopoiia* sets the whole state against the sacrilegious individual
Antony, the sole buyer of these hallowed goods. His act of *hybris* is followed
by one of farcical self-indulgence: the almost equal mixture of grim humour
and strong emotion is reinforced by poetry and myth – a gnomic quotation
from Naevius (or Plautus): 'evil gains come to an evil end'; and allusion
to Charybdis as the archetype of voracity (66). A sarcastic expatiation on
Antony's pseudo-transformation from inebriate to sober citizen rounds off
this section (69–70).

Antony's part in the Civil War, as described by Cicero, casts him clearly as
Caesar's chief backer in his bid for the tyranny. Indeed, he was an even more
enthusiastic slayer of republicans than his master, and expected his due reward,
though he did not expose himself to as much danger as did, for example,
Dolabella, and continued in his dissolute ways even while campaigning in
Gaul (71–6). But in his relations with Caesar, he made sure to keep closer than
his rival (78–84). The notorious occasion when Antony tried to place a diadem
on Caesar's head, signalizing his elevation to the kingship, is highlighted in

[30] 'Consider his name, consider his age' (*Ad Att.* 16.8.2); 'I don't trust his age, and I don't
know what he's after' (id. 16.9.1).

a dramatic narrative, with asydeton and verbs in the historic present tense (85–6). Its significance for the present is clear: Antony is more extreme in his ambition, at least ostensibly, than Caesar: 'What is more shameful than that he should be living who set the diadem on Caesar's head, while all men agree that he was rightly slain who flung it away?'

Cicero's interpretation of Antony's actions following Caesar's murder (88ff.) shows how he turned himself from a tyrant-backer into an aspirant to tyranny. His first actions were those of a man in fear and panic (89); but when events enabled him to take charge, he presided over Caesar's funeral, exploiting to the full the popular feeling that it aroused, even fomenting the inevitable public disorder that it engendered (90–1). Here Cicero is careful not to paint a one-sided picture. He tells how Antony passed moderate legislation, including the abolition of the dictatorship, thereby gaining credibility as a constructive statesman. But he only does this in order to show that its purpose was to disguise Antony's real intention: Cicero was not fooled (92):

> The State seemed to others settled, but by no means to me, who feared shipwreck while you were at the wheel. Did his character escape me? Or could he any longer be unlike himself?

Evidently Antony proved himself adept at keeping the people and allies of Rome happy, and hence loyal to himself, by largesse at the expense of the treasury. But all his acts were those of a tyrant, and he even showed himself more extreme than Caesar in the exercise of power, by arbitrarily adding to Caesar's *acta* (100), especially in the matter of founding colonies. Nevertheless these are instances of adroit politics, so Cicero sets out to minimize them. He does this by giving prominence to instances of Antony's greed and vulgarity, like his illegal acquisition of the farm of M. Varro at Casinum, which Varro had made into a place of culture, but under Antony became a boozing-den (103–5). This is an appropriate place to introduce some culture of his own in the form of a quotation from poetry (104). The subjects which Varro and his friends had discussed correspond with three of our Ciceronian refinements – 'the laws of the Roman people, the memorials of antiquity, every system of philosophy and learning' (105): Cicero makes the most of the contrast with the goings-on under Antony's tenancy:

> But in your tenancy, the whole place rang with the voices of drunken men; the pavements swam with wine; the walls were wet; boys of free birth were consorting with those let out for hire, and harlots with married women.

This striking example of Antony's behaviour outside Rome introduces an account of his travels in Italy, which were intended to consolidate his personal standing but in fact showed that his popularity was not universal, so that he had to resort to intimidation in dealing with those who were less than enthusiastić for his rule. Thus the main thrust of Cicero's account is to make Antony seem to represent force, war and a suppression of senatorial authority which was worse than those of Cinna, Sulla, and Caesar (108–9). But Antony was less skilful than Caesar had been either in legislation or in circumventing opposition (110–17).

After an earnest plea to Antony to 'recover his senses' (118), Cicero promises to resist his excesses to the death:

> I defended the state in my youth, I will not desert it in old age; I despised the swords of Catiline, I will not dread yours. And I will even offer my body if the liberty of the State can be conjured up from my death, so that then the grief of the Roman people can at last give birth to what it has long laboured for.

This close identification of Cicero with Roman liberty may well have been in Antony's mind when the list of those proscribed was drawn up by the Second Triumvirate a year later. His sustained invective in this speech was enough to convince Antony that he was too dangerous to be left alive in such an unstable political situation; and Cicero had labelled him a tyrant so irrevocably that there could be no reconciliation between them. The speech contains five of the refinements: literary and historical allusion, humour (in very large measure), emotional appeal, and dilatation (116).

Philippic III

The rhetoricized narrative resumes on 20 December 44 BC, as the new consuls for 43 BC, Hirtius and Pansa, are about to enter office. Cicero addresses the Senate. The direction of affairs is to be influenced henceforth by the arrival, some eight months before, of Caesar's heir, the young Octavian, whom Cicero met in his villa at Puteoli (see n. 30). Octavian attracted support from both the common people and Caesar's veterans, while Antony's control over the latter, as he approached the end of his consulship, was weakening by the day. In the meeting at which the *Third Philippic* was delivered, Antony is a third party whose fate is under discussion, not the addressee, hence the relatively restrained tone. Octavian is cast as the saviour of the Roman people. and the commonwealth from the cruelty of Antony (4–5).

In this reasoned atmosphere the quieter Ciceronian refinements find a natural place. As on other occasions when the subject is tyranny, historical comparison with the Tarquins is made: (8–9):

> For our ancestors' desire for liberty when Tarquin was expelled was not as great as ours should be to retain it now that Antony has been driven off: they had learned ever since the foundation of the city to obey kings; we after the expulsion of the kings had forgotten our servitude. And whereas Tarquin, whom our ancestors would not tolerate, was considered not merely cruel, and called not merely impious, but 'The Proud', we have often tolerated that vice in a private individual, but our ancestors would not bear it even in a king.

Decimus Brutus had been among the foremost in the opposition to Antony, just as his ancestors had figured largely in the expulsion of Tarquin. This prompts Cicero to broaden the historical parallels, and the passage becomes a fully-fledged dilatation, which is enriched by a detailed comparison of Tarquin to Antony, favourable to the former (10), linked to an attack on the latter, who is characterized as an unworthy consul (12), and contrasted with Octavian ('Who is chaster than this young man? Who more modest? What brighter example among youth of old-world purity?') Antony had inveighed against Octavian's ancestry, probably on a number of occasions. This is Cicero's reply.

Knowledge of the law makes a short but interesting appearance (15–16). Otherwise most attention is given to comparison of family connections, since Antony had also attacked members of Cicero's family (17–18). These attacks appear to have been among the parting shots aimed by Antony at Cicero, who replies with interest, describing instances of Antony's tyrannical and erratic behaviour with strong sarcastic humour (22–6). By contrast, he praises Octavian, waxing lyrical with a literary quotation (27). In the concluding sections he alternates with invective against Antony (28), *hortatio* to the Senate (with timely reference to his own patriotic commitment) (29–36), description of Antony's depredations (31), *hortatio* of the consuls elect, Hirtius and Pansa (36–8), and finally praise of Octavian. Elsewhere (*Ad Fam.* 10.28.2) he writes of the 'intense fervour' with which he delivered this speech. But it falls short of the *Second Philippic*, which was not delivered, in emotional content. However, it contains six of the Ciceronian refinements, digression and emotional appeal being absent.

Philippic IV

Cicero delivered this speech to the people on the same day as he addressed *Philippic III* to the Senate. Among the people Antony would still be enjoying a degree of popularity, if only as Caesar's man, so Cicero has to impress upon them that he has been eliminated as a political force, and is now viewed as a *hostis* (enemy of the state), though he has *not yet (nondum)* been so denounced by the Senate (1). With Antony out of the way, attention once more falls on Octavian. In this speech he is praised again, but from being a *clarissimus adulescens* in III. 7, he has become *vel potius puer* (3). This qualification, while apparently intended to magnify his achievement, on a more subtle level alludes to his youthful inexperience. Octavian has saved the state by levying an army against its enemy Antony (4, 6), while Decimus Brutus has taken practical measures against Antony to loosen his foothold on Gaul (9). But who has the authority to lead the people, with the blessing of the gods (10), to freedom? Cicero applies himself with gusto to whipping up popular emotion, likening himself to a general exhorting his men before battle (11), here against an enemy who has become transformed into a bloodthirsty monster (12). The popular bugbear, Spartacus, makes a natural appearance, but that of Catiline seems gratuitous, until we come to the final link in the argument, Cicero himself (16):[31]

> As for me, so far as by thought, labour, watching, influence, and advice I shall be able to strive for and effect anything, I will leave nothing undone that I think concerns your liberty; for having regard to your generous kindnesses towards myself, it is impossible to do so without committing a crime...We have, for the first time after a long interval, with my counsel, and at my instance, been fired by the hope of liberty.

Certain parallels may be drawn between these two speeches and *Catilinarian I* (to the Senate) and *II* (to the people). Both the popular speeches are *hortationes,* looking forward to a coming conflict, with Cicero leading the cause of the Republic; while the senatorial speeches concentrate on attacking the character and aims of the *hostis.* The present short speech contains three Ciceronian refinements. These are in close proximity: philosophical and historical (13); and emotional appeal (12–14).

[31] Stockton *CPB* 300 writes: 'We are back in the heady days of that other December nineteen years earlier'.

Philippic V

At the end of *Philippic IV* Cicero lists his senatorial allies, a distinguished group; but the necessity to deliver this speech and its two predecessors in close proximity is a salutary reminder of the opposition he faced as he relentlessly conducted his attack on Antony. Events had seemed to justify it, as Antony moved against Decimus Brutus, and was besieging him at Mutina. But there were senatorial voices which counselled diplomacy. Fufius Calenus, supported by L. Piso, proposed that an embassy be sent to Antony, ordering him to abandon the siege. Cicero now argues strongly against any kid-glove treatment of a man who had chosen to wage war against the state, especially as this would involve the Senate's retraction of its previous decision, and withdrawal of plans that had already been drawn up. Negotiation with Antony would imply the possibility of compromise, but 'nothing at all can be granted to a combatant, though there may be something to be conceded to a petitioner' (3). Cicero exposes the logical inconsistencies in his fellow-senators' position. The legions who have chosen to defend the state have been rightly praised, but now the Senate is proposing to repudiate their action by sending an embassy to negotiate with their enemy (4). But this application of logic oversimplifies the tensions in the situation. It seems that Antony's friends were proposing to offer him Further Gaul (5–6), so Cicero can only upbraid these friends, whose action would merely precipitate carnage and lawlessness much closer to home. He reminds them of Antony's recent passing of legislation in total defiance of auspices (8–9), and gives a catalogue of his other irregularities, showing in the process his own knowledge of the law, and sarcastically describing Antony as 'this chaste and upright fellow and supporter of the courts and of the law' (12), who appointed a cosmopolitan array of jurymen:

> What an eminent bench of jurymen! What a wonderfully dignified court! My heart yearns to plead for a defendant in that court!

This is one of the more colourful facets of Antony's civic administration, contributing to a general picture of anarchy and chaos. To this is added the military dimension, beginning with the stationing in the city, and particularly around his own person, of armed men, ready to enforce his will. This broadens into their actions in the field from the time of the *First Philippic*. The destruction wreaked by Antony in his advance on Brundisium, followed by the siege of Mutina, is compared unfavourably with the depredations of

Hannibal (25). This comparison is amplified (27), perhaps because one of his opponents in the debate had used the precedent of sending ambassadors to Hannibal as an *a fortiori* argument, and Cicero has to challenge that precedent's validity.

The pattern of narrative interwoven with argument continues, centring on the *Bellum Mutinense,* which is in progress. The speech's philosophical tone is maintained, with speculation as to Antony's likely response to the Senate's demand. Delay would strengthen his position: 'Every evil is crushed easily at its birth; on reaching maturity, it as a rule gathers strength' (31) In the present case, nothing less than the summary suppression of Antony will suffice, whereas concession will only postpone the inevitable showdown. Therefore the State should move directly into preparations for its preservation by the enactment of the *Senatus consultum ultimum,* followed by an announcement to those serving with Antony that if they left his army before 1 February (*i.e.* within the month) , they would suffer no harm (34).

Having declared war on Antony, Cicero must now rally or consolidate support for it by praising those men on whose patriotism he was relying. He writes a series of lavish *laudationes* of Decimus Brutus, Marcus Lepidus, Sextus Pompeius, and finally (and especially) Octavian (35–53 – a third of the speech). This latter part gives the speech an artistic balance of genres, but this is not matched by an unusual content of Ciceronian refinements, of which there are four: philosophical, legal, and historical; and ironic humour.

Philippic VI

This is Cicero's report to the People, delivered on 4 January 43 BC, of the transactions in the Senate on 1 January where, in spite of apparent general support for the proposals he had outlined in *Philippic V,* in the end diplomacy prevailed, and it was decided to send an embassy to Antony. While it is probable that his popular audience would not have been unduly fazed by this decision, they knew that it meant defeat for Cicero. His sensible reaction to this was to deliver a carefully balanced account of the meeting, avoiding any open expression of dissent from its decision, and ending with a short but memorable statement of his commitment to the cause of the people and their freedom (18–19):

All classes wish the same; to the same purpose are applied the boroughs, the colonies, the whole of Italy... That the Roman people should be slaves is

contrary to divine law; the immortal gods have willed it to rule all nations. You must either win victory, Romans – which you will surely do by your loyalty and by such unanimity [as you are showing] – or do anything rather than be slaves. Other nations can endure slavery; the Roman people regard liberty as theirs by right.

Before reaching this black-and-white statement of the issue, Cicero has had to present it in unconditional terms: under no circumstances will Antony abandon his plans and yield to the will of the Senate (5–7, 10); hence the relief of Decimus Brutus should be prosecuted without waiting for negotiations to begin (8–9). That is Cicero's policy; but he knows that some of the people will oppose it because many of them support Antony and his associates. His brother Lucius is their 'love and darling...the people's patron' (12). Thus, by Cicero's own admission their popularity is deep-rooted, and his effort to undermine it by sarcastically referring to their vanity (13–15) seems less than effective. And this more equivocal position is linked to the realities under which he is addressing the people. The embassy has been sent, war has not been declared. So he can only advise them to await the envoys' return (16), confident that their mission will have been abortive. Only then will his own policy come into operation again. Another very short speech, it contains three Ciceronian refinements: historical allusion, humour, and emotional appeal.

Philippic VII

This speech appears to address a routine debate of the Senate about 'small matters' (*i.e.* routine business). But Antony's friends had taken the opportunity of a lull while the envoys made their way to his camp before Mutina, in order to air evidence that he was prepared to compromise. Cicero sees this as forcing him to widen his attack to include these supporters. But first he examines what he thinks Antony is demanding for his co-operation with the Senate. He says that Antony is demanding the disbandment of all armies, which would leave the whole of Italy open to attack (2), and Rome at his mercy. By supporting him while knowing this, his partisans show that they share his contempt for democracy (4). Cicero confronts them (literally, by apostophizing one of them (5)) with the charge of 'favouring the enemy'. The fact that they included 'consulars' in their number makes his stance particularly uncompromising, and he seeks to avoid becoming isolated by

recruiting to his side an ally of similar standing – the present consul, Vibius Pansa, whom he claims to see as the potential saviour of the Republic (7), an unlikely role (*Ad Fam. XVI* 27.2). At this stage Cicero thought that he could bind Octavian to the Republican cause. Pansa and his colleague Hirtius had both been Caesar's men, so Cicero could have anticipitated that they would soon join Caesar's heir against Antony. But for the present he had to combat Antony's friends in Rome. His approach is more thoroughly analytical than before. He takes the subject of the acceptance of peace, and divides it into three: that it would be disgraceful (*turpis*) (9–15); that it would be dangerous (*periculosa*) (16–20); that it would be impossible (*esse non potest*) (21–5). This corresponds with the traditional division of deliberative oratory into the topoi of just or honourable, expedient, and possible. Negotiation of terms with Antony would be dishonourable because it would show *inconstantia*, a most un-Roman vice, and betray the *constantia* displayed by recent leaders in their prosecution of the war against Antony. It would be dangerous because it would admit his brothers into positions of power (16–17), men whose past record was one of lawlessness, even towards their own men. They would promote his unworthy aims with ruthless efficiency, and intimidate all opposition. Peace made with such men would be war in disguise (19): 'if we wish to enjoy [true] peace, we must wage war; if we reject war, we shall never enjoy peace'. Moreover, the pacifist line is not forced upon them, because there is no dearth of men willing to defend the Republic (20).

In order to support the argument of impossibility, Cicero has to fall back on emotional appeal (21). A string of rhetorical questions containing no argument or evidence have to serve. Are not the Senate, the Knights, the People united in their hatred of Antony? (22). And does not this make war inevitable? As we have seen, the reality of the situation is not so clear-cut and one-sided. But Cicero has here reached the point of no return in his political and personal career. He has single-mindedly set himself on isolating Antony, and now (24–5) says that Antony cannot be reconciled with Octavian, Brutus, or the Senate. Antony has his own agenda, which is still the same as it has been from the start. As the speech owes more to rhetorical theory, especially that concerned with deliberative oratory, as illustrated by the deployment of the topoi of the honourable and the expedient,[32] than to the needs of artistic refinement that Cicero serves in much of his other oratory, only two of those refinements are present: philosophical tone and emotional appeal.

[32] See Cic. *De Inv.* 2.51.157–165; 166–9. Like Aristotle, Cicero does not discuss the possible or impossible as a topos.

Philippic VIII

As Cicero had predicted, the envoys returned not with Antony's acceptance of the Senate's demands, but with a restatement of his own: settlement of his troops, endorsement of decrees outlined in Caesar's papers and of legislation made during his own consulship. In return he was prepared to acknowledge the claims of Marcus Brutus and Cassius to the consulships of 41 BC. Cicero was of course enraged by this, the more so because Antony's friends urged caution in the debate on 2 February, and won. He delivered this speech on the following day.

Cicero and his friends had argued that the State was at war with Antony, while the latter's supporters, led by Lucius Caesar, had preferred to apply the term *tumultus* to the situation, believing that the use of that word would lead to the adoption of less extreme measures. But they were wrong. The declaration of *tumultus* was followed by the emptying of the courts, the assumption of military garb, the holding of a levy, and the suspension of exemptions from service in the city and throughout Italy (*Phil. V* 31). 'There can be a war without tumult; there can be no tumult without war (2,3),' War is a steady, lasting state, but *tumultus* is an extreme manifestation of it at a moment of crisis, requiring urgent action. Cicero's involvement in legal matters had equipped him better than some of his colleagues to deal with the semantics of key words, an important faculty in view of their effect on the choice of action in cases like the present one. In this case he deploys irony as an additional weapon (5):

> Decimus Brutus is being attacked: there is no war; Mutina, an ancient and loyal colony, is being besieged: not even is this war; Gaul is being ravaged: what peace can be more assured? Who can call that a war, to which we have sent a consul, the bravest of men, with an army?... So now they and their armies are engaged in peace! He is not an enemy whose garrison Hirtius has driven out of Claterna. He is not an enemy who is opposing in arms a consul, attacking a consul elect!

The situation thus meets Cicero's definitions of both war and tumult. Now he broadens the discussion into consideration of causes of civil wars. Historical examples point to quarrels between individuals, but he singles out the present war as having no prelude of discord, no concrete issues dividing the combatants. Yet there are two sides in the war: Antony, who has created it through his ambition to destroy all the State's institutions, and who incites

his followers with promises of plunder; and 'our side', who are defending 'the temples of the immortal gods, our walls, our homes, and the tombs of our ancestors...our laws, courts, liberty, wives, children, fatherland' (8). Thus it is a war between good and evil.

The cerebral character of the speech is maintained as Cicero explores the semantics of the term 'peace'. It is a conditional concept, in that it cannot subsist, for example, in a state of slavery, which is the justest cause of war (12). Nor can it be accorded to individuals who disturb it. This view is illustrated from Cicero's favourite period for historical parallels, that of the Gracchi. Peace had to be shattered by the necessary killing of Gaius Gracchus by the consul Opimius in 121 BC (14). More recently, the same necessity imposed on Marius and Valerius the duty of killing Saturninus and Glaucia in 100 BC (15). In both cases, the consuls were loyally assisted by members of the most eminent Roman families. Then there was the case of Catiline: surely he could not be granted 'peace' in which to pursue his evil aims? In fact there are two kinds of peace: the general peace, which depends on the vigilance of good citizens, who take upon themselves the duty of seeing that actively bad citizens do not have the other kind of peace, which leaves the malefactor free from interference in his nefarious activities. Cicero addresses Calenus in amplifying this (13):

> And you say you are one who has always longed for peace, always wished that all citizens should live in safety. Fine sentiments! But only if you mean good and useful and loyal citizens; if you wish for the safety of those who are by nature citizens, but by choice enemies, what difference is there, pray, between you and them?

The semi-philosophical tone of this part of the speech gives way to ferocious irony as he exposes the absurdity of a position which Calenus has assumed here not for the first time (16):

> Let the reprobate, the criminal, the traitor be saved; let the innocent, the honest, the good, all the State, be wiped out. In the case of one man, Quintus Fufius, I confess you saw far farther than I did. I thought Publius Clodius a dangerous citizen. You, on the other hand, thought him incorrupt, reasonable, innocent, moderate, one to be preserved and desired as a citizen. In the case of this one man you were very clear-sighted and I was seriously in error, I concede.

The use of antithesis with *parison* to disguise over-simplification is well illustrated here, and even better illustrated below (17):

Yes, indeed, I do favour Decimus Brutus, you Marcus Antonius; I desire the
preservation of the colony of the Roman people, you are keen that it should
be reduced by storm.

Between these two passages is a reference to Cicero's simulation of outrage
in his oratory, allegedly made by Calenus. Cicero denies 'arguing angrily',
but admits to arguing vehemently in order to emphasize strongly-felt
difference of opinion on important issues. Vehemence was a long-recognized
characteristic of Cicero's delivery (see Plut.*Cic.* 3.7).

Much of the rest of the speech shows the strength of the opposition he
faces. Not only Calenus, but other consulars, prompted by the ambassadors,
have spoken for accommodation with Antony. This elicits sorrow rather
than anger from Cicero (22). Historical examples of earlier embassies
illustrate how these had been conducted with a firmness which would have
discouraged Antony from ignoring their authority (23).

Concluding thoughts return to Antony. His negotiating position is made
to seem the more outrageous by the irony that prefaces it (25):

How modest are his commands! We must be made of iron, conscript fathers,
to deny this man anything!

And so it seems when he says: 'I give up both provinces; I resign my army;
I do not refuse to become a private citizen'. These are his words: he seems to
be coming to his senses. 'I forget everything; I desire reconciliation.' But what
does he add?: '...if you give rewards and land to my six legions, to my cavalry,
and to the praetorian cohort'. The full list of demands is impressive (25–8),
with the beneficiaries including Antony's humblest and most disreputable
underlings. The traffic of concessions has been one-way, and the speech draws
to its end on a note of despair: hopes of freedom have dissolved during six
years of descent into slavery (32), but he ends with a concrete proposal to
offer amnesty to those of Antony's supporters who lay down their arms before
the Ides of March. This was doomed to go the way of his earlier proposals.
The speech contains four Ciceronian refinements: philosophical tone (13) and
logic (definition – 2–4, 16) perhaps overlapping with legal knowledge in the
earlier sections, joined later by historical examples and ironic humour (6, 16,
25).

Philippic IX

The occasion for this speech was the death of Servius Sulpicius Rufus while serving on the embassy to Antony. As an ex-consul and provincial governor he had been a natural choice for such a mission. To Cicero his death was a personal loss, as they had been friends since early manhood, when they had shared the same teachers. Sulpicius had become an eminent jurist and legal innovator of lasting influence. The two men found themselves briefly on the opposite side in the trial of Murena, but their friendship survived this easily, and Sulpicius' letter of consolation to Cicero on the death of Tullia (*Ad Fam.* 4.5) is one of the most memorable of its kind.

The speech is a contribution to a debate, held on the day after that in which the *Eighth Philippic* was delivered, on the form which the honours to Sulpicius should take. A proposal that there should be a public funeral followed by the erection of a gilt statue on the rostra was opposed by P. Servilius. Cicero had to refute Servilius' objection (3–10) before proceeding to his own tribute to Sulpicius. This requires the deployment of both his legal and his historical knowledge.

Evidently the law concerning the circumstances under which statues should be granted was open to interpretation. Servilius had opined (*censuit* (3)) that the conferment was to be made only upon a man who had *been slain by the sword* while serving on an embassy. Presumably Servilius quoted a text, against which, in the standard manner of the handbooks (*Ad Herenn.*1.19, 2.19), Cicero invokes the spirit of the law by appealing to ancestral custom which, he contends, admitted a wider interpretation: that if his death had arisen in the course of the embassy, *i.e.* his simply going on it had caused his death, he should be honoured with a statue. He supports this with the argument that the purpose of such awards as this was to persuade men, 'in dangerous wars, to undertake the office of ambassador with greater boldness' (3) (in the assurance that they need not die under the enemy's sword in order to receive the permanent memorial of a statue and a public tomb). Cicero chooses his historical precedents cunningly. In the first, four Roman ambassadors to Veii are slain in cold blood by the king Lars Tolumnius; in the second an ambassador to king Antiochus is murdered in an incident independent of his mission (4). This shows that the full honours had been awarded in different circumstances. Now Cicero extends the terms even further.He argues that Sulpicius had in fact been 'killed by the mission'; and since Antony had been the cause of it, he was Sulpicius' murderer (7). Thus

Cicero introduces Antony into this debate, determined to keep him in focus, even while paying tribute to his old friend. But while the whole sequence of events starts with him, their progress has a fatalistic inevitability. Sulpicius would have acted out of character if he had refused to serve; his eminence meant that the Senate would call upon him to do so. Now they had a moral obligation to 'restore his life which they have taken away, since the life of the dead is set in the memory of the living'(10).

This leads naturally to a eulogy of Sulpicius' achievements (10–17). Praise is fulsome enough within the limits of his reputation as a jurist, won through his 'almost godlike knowledge of the interpretation of the laws, and the development of the principles of equity. All men of every age in this community who have understood jurisprudence, were they brought to one place, would not be comparable with Servius Sulpicius' (10). A pedestrian statue, together with interment in a public place, would provide a fitting tribute to his civilian virtues (13). The eulogy includes the actual text of Cicero's proposal, but for the rest he has not drawn on the numerous instances of his friend's qualities in action which long acquaintance would have enabled him to recall. Nor has he utilized the conventional divisions and topoi which by this time had been long established. One can only conclude that the consuls had imposed severe restrictions on the time allotted to individual speakers in a debate on what was actually a minor matter. The speech contains two Ciceronian refinements: legal knowledge and historical allusion.

Philippic X

The debate between Cicero and his supporters and those of Antony continues. Julius Caesar had assigned the provinces of Cisalpine Gaul, Macedonia, and Syria to Decimus Brutus, Marcus Brutus, and Cassius respectively. After his assassination, Antony and many other senators did not want the tyrannicides in positions of power, but during the dissension that arose over these appointments, Marcus Brutus assumed control over his province. Cicero, a close friend who regarded Brutus as one of the strongest guarantors of the restoration of the Republic, placed an eulogy of him at the heart of this speech (7–9) as he recommended successfully that he be confirmed in his governorship. But before that he has to deal with determined opposition, from the same source as before. This time in a personal attack Calenus is characterized as wholly prejudiced and irrational (*'Quae est enim ista tua ratio...* (3)) in his hostility to the Bruti and blind allegiance to Antony. As

usual, Cicero represents the issue in absolute terms, concealing the real reservations that many people felt about Brutus the tyrannicide (Note that (4) he says of Brutus that 'we should revere him', not that he is in generally revered). Hence the emotion injected into the eulogy (7):

> And here of the god-like and immortal exploit of Brutus I shall say nothing; it is enshrined in the grateful remembrance of all, though not yet attested by public authority. Good heavens! What patience he showed, what moderation, what calmness and modesty in the face of wrong!

Brutus' withdrawal from the city after the assassination is seen as an unselfish act of statesmanship. But Brutus had an army, so Cicero dwells on his patriotism and sense of responsibility: his opponents would have pointed out the danger posed by his command. Cicero rebuts this through a succinct comparison with Antony (12): 'the one looked for resources to overturn the State, the other to preserve it'. Brutus can be relied upon to hold Macedonia in the State's interest (13–14). Indeed, in another emotional passage, Cicero almost identifies him with her: 'Brutus is and always will be ours, born as he is to serve the State... the State pined for him; he is on everyone's lips, and the theme of everyone's talk' (14). The *virtus* of Brutus – his reliability, moderation, and especially his popular following – is portrayed in order to counterbalance any misgivings about the attitude to Caesar's murder of the people and his veterans (15). Brutus' aims are the same as those of the other men who are resisting Antony: he shares their desire to liberate Decimus Brutus (16–17).

Cicero now sets the debate on a higher plane by concentrating on a unifying theme, rendering it in a suitably philosophical tone (20):

> It is indeed with a great and almost assured hope that we have taken up the cause of liberty; yet though I admit that the outcome of war is uncertain and Mars is inconstant, even so we must fight to the end for liberty, even at the risk of our lives. For life does not consist merely in breath: for a slave it does not exist at all. All other nations can tolerate slavery; our state cannot, and for no other reason than that other nations shun toil and pain, and are prepared to put up with anything in order to be free of them; but we have been so trained, and our minds so imbued by our ancestors, as to refer all our thoughts and deeds to the standard of honour and virtue. So glorious is the recovery of liberty, that in seeking to regain it we should not shun even death. Nay, if immortality were to follow our shrinking from the present danger, yet from that it would seem that

we should shrink even more, as it would mean the perpetuation of slavery. But seeing that, by days and nights, every manner of chance surrounds us on every side, it is not the part of a man, least of all a Roman, to hesitate to surrender the breath he owes to nature, to his fatherland.

From this generalized eulogy of freedom, Cicero slips almost imperceptibly into a general pronouncement about Antony, that he is 'the one enemy of all men'(21), though he adds his brother Lucius for good measure, sarcastically describing him as 'a citizen most dear to the Roman people' before condemning him as worse than Antony. The strength and authority of Marcus Brutus is needed to subdue him and all Antony's other friends. After this argument the speech ends with the text of Cicero's proposal, which expresses approval of all Brutus' actions since his accession to his proconsulship of Macedonia, and authorizes him to use any public moneys needed to conduct military operations. The speech contains two Ciceronian refinements: philosophical tone and emotional appeal.

Philippic XI

The subject of this speech is Dolabella, who had been Antony's consular colleague in 44 BC. He had been given Syria as his province for the following year, replacing Cassius, Caesar's original appointee. Passing through the province of Asia *en route* to Syria, he found his progress barred at Smyrna by the governor Trebonius. After initial negotiations, Dolabella imprisoned Trebonius by a ruse, and had him killed in a peculiarly brutal manner. This sequence of actions is readily explained in partisan terms. Cassius and Trebonius had been tyrannicides, Dolabella, like Antony, one of Caesar's men. But the extreme form which his action took seems to have caused general revulsion, and the Senate, on the motion of Calenus, declared Dolabella a *hostis*. Cicero took the debate as an opportunity to expose and enlarge upon the moral turpitude of his main political enemies.

The first step in Cicero's assault, which is the chief theme of the exordium (1–3), is to associate Antony with Dolabella's action in a general way: they are 'twins in wickedness, unprecedented, unheard of, fierce, barbarous' (2). And Antony has similar atrocities in mind: 'what Dolabella has done where he had the power, Antony threatens to do to many...he contemplates greater punishments against us than against an enemy: death he regards as a penalty due to nature, but anger demands torment and tortures' (2).

The narrative (4–5), as usual in Cicero, is not a mere account of movements and actions. In the story of the meeting and negotiations between Trebonius and Dolabella, prominence is initially given to the expressions of cordiality that they exchanged – intimate conversations, embraces, pledges of faith – which made Trebonius an easy victim of Dolabella's treachery. Cicero spares his audience none of the horrific details of Trebonius' last hours (5): they contribute materially to his picture of the extremes to which Antony and his party would go, and as such are designed to stiffen the resolve of Cicero's own supporters (6). Dolabella is 'the image of the cruelty of Marcus Antonius', so Cicero dwells on the pathos that is to be aroused by what Dolabella has done (7):

> Therefore set before your eyes, Conscript Fathers, that picture, wretched and tearful as it is, yet one necessary to stir our feelings: the night attack on the finest city of Asia [Smyrna]; the irruption of armed men into Trebonius' house, where that unfortunate man saw the brigands' swords before he heard what was happening; the entry of the raging Dolabella, his foul speech and his infamous mouth; the bonds, the lashes, the rack, the torturer and executioner Samiarius; all of which they say Trebonius bore with fortitude and patience. That is great praise, and in my judgement the greatest praise... And Dolabella was so devoid of human feeling – though in that he never had any part – so as to practise his insatiable cruelty not only on the living, but even on the dead; and on the mangling and molestation of the body, as he could not glut his soul, he fed his eyes.

This onslaught is infused with philosophical thoughts: 'It is the part of a wise man to resolve beforehand that whatever can happen to a man should be borne calmly if it should happen to him (7)... For in proportion as the strength of the mind is greater than that of the body, so those ills are more severe that are contracted in the mind than those contracted in the body. More wretched then is he who is compelled to be the victim of another's misdeed' (9). An *a fortiori* comparison is made with an example from history: Regulus was tortured by the Carthaginians. That was considered a cruel act, but it was done against an enemy. Trebonius was tortured by a fellow-citizen: how much more cruel was that?

Whereas Dolabella seemed to have acted alone in this barbarous episode, Antony's other associates presented a collective danger. Cicero turns now to them, relieved perhaps to be leaving Dolabella, who had been his son-in-law (10). He makes short character-assessments of each based on highlights of

their careers. They have prodigality in common, making them dangerously greedy and unscrupulous (10–14).

Cicero now returns to the subject of the debate. Dolabella has been declared a *hostis*, so war must be waged against him. Cicero is satisfied with neither of the opinions expressed so far: that an extraordinary command be established, and that the consuls for the year conduct the campaign. He objects to the former, and cites historical examples where extraordinary commands were not given to private individuals but to a serving consul or proconsul (17–18). The number he supplies of these exceeds those assembled anywhere else in Cicero's speeches, and they span the period of Roman history from the Pyrrhic War to recent times. He quickly disposes of the extraordinary commands granted to Pompey, the second of which, against Mithridates, he had supported in the speech *Pro Lege Manilia*. Disposing of the proposition that the present consuls should conduct the campaign was more difficult, so Cicero falls back on general arguments that they were already engaged in important operations (21, 23–4). His own proposal is to give the command to Cassius (26, 30–1), who can be relied upon to carry out the wishes of the Senate (27–8). This partly reveals Cicero's own opinion: that the consuls Pansa and Hirtius, Caesar's men, were less than fully committed to the republican cause, as indeed proved to be the case.

The text of Cicero's proposal (29–31) sets out the terms and powers by which Cassius will exercise his command. These are to embrace a very wide area, and he is granted the authority to raise ships, men and money, 'making requisitions from whomsoever he thinks good'. It is possible that the conferment of such comprehensive powers upon a man who combined energy with dubious political aims would have alarmed some senators, and Cicero may have made a false tactical move in praising his 'ardour' and 'spirit' (32). It may also have been unproductive to draw the veterans into the discussion, urging that their possible offence at Cassius' appointment should not be taken into account, as they were a spent force (37–9). At all events, Cicero's proposal was unacceptable to the consul Pansa, who secured the command for one of the consuls; and Cicero was equally unsuccessful when he placed his proposal before the People. This may be a case of excessive ingenuity on Cicero's part. The speech contains three of his refinements: philosophical, historical, and ironic humour (14).

Philippic XII

The idea of sending a second embassy to Antony was proposed towards the end of March 43 BC, after his friends had said that he was now receptive to negotiation. But when the proposal was debated, one of the men nominated to serve on it, P. Servilius, spoke against it, and when Cicero added his objections to those of Servilius in this speech their combined authority was enough to cause its abandonment.

In the exordium (1–3) he has to explain how he had been initially deceived by the pleadings of Antony's supporters into believing that he was now prepared for meaningful negotiations. The realities of his position are probed by means of a question-and-answer dialogue: 'Does he then withdraw from Mutina?' 'I do not know.' 'Does he obey the Senate?' 'I believe so', says Calenus, 'but on condition that he maintains his dignity.' This device illustrates strikingly how Antony's attitude cannot be gauged, since his own friends do not know what it is. Cicero then explodes with sarcasm at the absurdity of even starting to treat with him (4):

> By Hercules, Conscript Fathers, you must stoutly strive to lose your own dignity, which is very great, and maintain that of Antony, which neither exists nor can exist, that he may, through your agency, recover what he has lost by his own actions.

This extra vehemence was needed because the decision to send the embassy still stood at this stage of the debate: 'But, they say, the question is not open: the embassy has been appointed' (5). Cicero uses imagery combined with philosophical thought to try to alter this state of mind:

> What is not open to a wise man to correction? Every man is liable to err; it is the part only of a fool to persevere in error; for the later thoughts, it is said, are usually the wiser. That mist just referred to has been dispelled; light has broken through; the case is clear; and not with our own eyes only, but we are warned by our friends... (7) But if there has been an error, Conscript Fathers, induced by a vain and fallacious hope, let us return to the right path; the best harbour for repentance is a change of counsel.

Cicero now ventures out to the broader issue (*dilatatio*). What is the likely psychological effect that sending an embassy will have? It is introduced with the device known as *correctio* (7):

By heaven, what advantage can our embassy bring to the State? Advantage, do I say? What if it is even likely to injure it? Likely to injure? What if it has already injured it? Do you not think that the Roman People's most eager and steadfast longing for the recovery of liberty has been lessened and weakened when they hear of an embassy for peace?

In the meantime, Antony remains the same unreliable negotiator, and Cicero recalls his record of illegalities and atrocities with some of the most graphic language in the *Philippics,* and this powerful visualization (14):

> Set before your eyes Marcus Antonius as consular, add to him Lucius hoping for a consulship; fill up with the rest – and not of our own order only, who look for honours and commands. Do not despise even the Tiros, the Numisii, the Mustelas, the Seii; peace made with them will not be peace, but a pact with slavery.

These disreputable friends of Antony would debase the government. With this harrowing image, Cicero addresses directly the leading sponsors of the embassy, warning them of 'submitting our necks to brigands'(15).

Most of the second part of the speech is less interesting, being taken up with Cicero's personal *apologia* for refusing to accept appointment to the embassy (17–26). Much of the material is familiar, but in dwelling on the personal danger he would face he tries to give this a philosophical colouring by linking his fear to his leading position: 'wise men say that he who professes to be the guardian of many should first of all be the guard of his own life' (25). The self-centredness of the speech persists, but in the end he belatedly offers to serve on the embassy if his safety can be guaranteed (30). This caps an eccentric and strangely irresolute performance. It contains three Ciceronian refinements: philosophical tone, emotional appeal, and dilatation.

Philippic XIII

Matters were coming to a head in early April 43 BC. The Senate was required to assess the strength of the Republic's forces as Antony's stranglehold on Mutina showed no signs of weakening, and Decimus Brutus faced the prospect of being overwhelmed. The Senate's task was difficult, because the leaders of armies in the provinces were in the process of deciding which side to join. (Cicero's portrayal of Antony as an isolated public enemy wholly

misrepresented the true situation.) One of these leaders was L. Munatius Plancus, who as governor of Transalpine Gaul had many men under arms, including cavalry. When the Senate received from him a letter (*Ad Fam. X* 8), assuring them of his continued loyalty to the Republican cause, they were emboldened to renew their demand to Antony to lay down his arms. His reply was insultingly uncompromising; and it provided Cicero with the raw material for one of the longest and cleverest *Philippics, the Thirteenth.* In it he attacks Antony's letter analytically, and includes Antony's followers in his assault. He also recommends Sextus Pompeius offer of assistance.

Philosophical tone (*peace v. discord*) combines with historical comparison in the generalities of the exordium (1–2). Cicero tries to distinguish the present discord from those that arose in the past, suggesting that, whereas compromise might have been reached in the latter cases, peace could not be made with Antony and his followers. The idea that it could be is dismissed with bitter sarcasm (4):

> O trusty hand of Antony, with which he has butchered many citizens! O ratified and sanctified treaty which we shall make with the Antonii! If Marcus shall attempt to violate it, the conscientiousness of Lucius will call him back from the crime!

Cicero follows this with a visualization ('Set before your eyes...') of the disorderly, drunken rabble that follows Antony showing improbable discipline and restraint in the face of the new situation. These passages prefigure a renewed intensity in this speech. But the sequel, in which Wisdom is personified and engaged in debate, has some of the character of a Platonic dialogue. Here she seems to act as the mouthpiece of Stoic doctrine, advocating the endurance of adversity rather than brave resistance (6). He then turns to human opposition to his extreme stance. Marcus Lepidus is foremost among those advocating active pursuit of a peaceful accommodation with Antony. He had had a previous diplomatic success when he had brought Sextus Pompeius over to the Senatorial side (8). But now he would be dealing with a very different subject (10): 'In one of them is modesty, firmness, moderation, integrity; in them [*i.e.* Antony and his friends] lust, crime, and an immeasurable audacity in applying any wickedness'. Next he reminds Lepidus that he is acting in the name of the Senate, notwithstanding the negotiating powers and the army over which he has control. A discussion of the precise nature of legality (14–5) and a quotation from Lucilius add to the Ciceronian refinements, but his admonition

of Lepidus is especially significant. It may even be a later addition. Lepidus ultimately joined Antony, so perhaps Cicero is laying claim to clairvoyance. However that may be, he certainly underlines the evil consequences that such an association would entail (16–17).

The destructive progress of Antony to Mutina, the first embassy and Antony's scornful reaction to it, form a short but emotional narrative (20–1). Then for the rest of the speech a point-by-point analysis of Antony's recent letter of complaint to Hirtius and Octavian provides the material (22–48). No doubt Cicero has been selective. He begins with two of Antony's most outrageous utterances, his expression of joy at the death of Trebonius, and his complaint at the condemnation of Dolabella for the killing. The technique Cicero adopts is to compare Antony with both men, and from there turns the speech into a critique of a range of Antony's faults and weaknesses, adding that his promotion had been due entirely to Caesar's patronage (24), which gave him no entitlement to patronize the young Octavian; and that his siege of Mutina was doomed to failure ('If you retreat, all forces will pursue you; if you remain where you are, you will be ensnared' (25)).

In his letter, Antony had objected to the idea that Brutus and Cassius should be granted more powers. Using his comparative technique, a regular device of invective, Cicero turns on the adherents of Antony and examines their credentials for governmental office, compared with those of the much more worthy men of the past. This broadens into a picture of what kind of rule Rome would suffer under such men. Antony's 'Senate' would include many unprincipled nobodies, and some are described with searing sarcasm (*e.g.* one Decius Mus, who 'nibbled at Caesar's gifts' (*mus* – mouse) (27)).

Antony has chosen to criticize certain legal and administrative changes made by Hirtius. Cicero argues that these objections illustrate Antony's own hostility to progressive government in the state's interest (30–2). Other charges and complaints are dismissed sarcastically as trivial (33–5), and he turns with equal sarcasm to the record of Antony's crimes (36–7). There is little scope for the deployment of Ciceronian refinements in the summary presentation of such a large number of items. But towards the end of the speech Cicero finds the opportunity to comment scathingly on Antony's attempts at philosophizing as he tried to conceal his crimes against the state (45).

Antony stands for nothing but 'the massacre of good men and the partition of the City and of Italy' (47). He is not interested in negotiating with anyone who would not concede all his demands. What, then, of peace with Antony?

In the poet's words, 'Sooner fire with water' (49). They vividly summarize Cicero's chief aim in the speech, which is to drive home the argument that trying to enter into negotiations with Antony is a futile exercise. This leads naturally to his own proposal, which is to encourage Sextus Pompeius, son of the great Pompey, in his moves to join the Republican cause which his father had upheld. The speech contains five Ciceronian refinements: literary allusion (15, 49) and historical allusion (1), philosophy, emotional appeal, and dilatation (7).

Philippic XIV

The occasion of the last surviving *Philippic* oration was the first defeat of Antony at Mutina (15 April 43 BC). The substantive proposals tabled at a meeting of the Senate on 26 April were that a public thanksgiving be proclaimed and that civic dress should be resumed. Cicero set himself the task of persuading his audience that the single defeat of Antony did not remove the threat he posed, as Decimus Brutus was still under siege. The Republic was far from being at peace, so Cicero saw it as his duty to sustain the attack on him with the same intensity that he had established in the *Second Philippic*. He therefore supported the thanksgiving, but opposed the other proposal.

A leading theme of the speech is the on-going character of the war. The forces besieging Mutina had been defeated but not destroyed. 'The completion of this war is the safety of Decimus Brutus' (1). While measures were being taken for his relief, war was being prosecuted and Rome was under arms (4–5). The proposer of the thanksgiving, P. Servilius, has been too indulgent to Antony's side by describing them as 'wicked and audacious men': such terms are applied by private litigants to their opponents, but Antony is a public enemy, not a petty wrongdoer (7). Cicero draws the distinction with sarcasm, and moves on to describe some of the atrocities Antony had committed, comparing them with Hannibal's worst (9). He advocates acceptance of the thanksgiving proposal, but suggests increasing the number of days of celebration and the granting of special honours to the victorious generals, because their victories had not been against barbarians. Cicero cannot resist his last opportunity to compare his victories over Catiline with those of the present generals of the Republic (13–14). It seems that he still harboured hopes of a restored Republic with himself as its leading citizen, which may have been his undoing, as Antony's agents were

spreading rumours that Cicero was aiming at the dictatorship (14). In 17 he claims that he has introduced his actions as an example to other public-spirited citizens, but the effect of this short excursus has been to confirm his ambitions. In 19 he styles himself *principem revocandae libertatis,* who has continued to watch over the state, and consistently regarded Antony as its enemy. But thanksgivings are traditionally celebrated for victories over external enemies, as historical examples show (23). Nevertheless praise must be accorded the Republic's *imperatores,* which include Octavian, and must be the more poignant in the cases of Pansa and Hirtius, because they had given their lives in its cause (26–7). The concluding *prosopopoiia* is memorable (27):

> O what supreme happiness was that of the sun himself, who before setting, while the corpses of murderers were strewn on the field saw Antony in full flight!

The text of his own proposal for a thanksgiving (29–38) provides Cicero with his last opportunity to rally support for himself personally and for his policy. Including the soldiers most notably in his laudations, he lavishes praise on ordinary Romans to a degree rarely seen elsewhere in his oratory. Especial praise is reserved for the Martian legion (31–2, 36), who had broken away from Antony after he had killed some of their number. The concluding sections read like a classical funeral oration (*epitaphios*), which includes the *consolatio* of surviving relatives (34), but with the constant undercurrent of hatred and abomination of 'the enemy'. The wording of the proposal casts Antony and his army in the same mould as Hannibal and the Carthaginians. This ending of Cicero's *Philippics* (36–8) must have seemed to Antony far more wounding than the many slanders against him throughout the other speeches, because in it, more than anywhere else, he appears not as the scion of a distinguished Roman family, but as an outsider and a barbarian, insulted by a 'new man' and a civilian. With these final words, Cicero signed his own death warrant more surely than if he had applied a pen to the actual document. The speech contains only three Ciceronian refinements (history, humour, and emotional appeal), following the general trend of the *Philippics*: their relentlessly attacking mode leaves less scope for the cultural refinements found in the best court-speeches, while their often pungent brevity results in no digression and few dilatations.

The effects of the 'muzzling' suffered by Cicero after the Triumvirs reaffirmed their alliance at Luca are not immediately apparent to the

reader of his speeches. He drew on his ingenuity to compensate for it. In *De Provinciis Consularibus,* where he was obliged to speak for the prolongation of Caesar's Gallic command, he had to praise Caesar in spite of his misgivings, but was able to give vent to his frustration by inveighing against his less potent enemies Piso and Gabinius, and was even allowed to exhibit those formidable invective skills later aagainst Piso, in a speech which became a prime specimen of the genre. He was also able to reminisce memorably and reassert some authority within the judicial system in his speech *Pro Plancio,* which contains seven of his refinements. Again, he could display his knowledge of the law and of history while defending two of Pompey's men, Balbus and Rabirius Postumus, and provide his admirers with a classical model of forensic oratory in his speech *Pro Milone.* Even when he faced the ultimate loss of freedom of speech when he pleaded before Caesar, he produced three highly polished and subtly conciliatory orations which hopefully dwelt upon the dictator's republican credentials while seeming to some to encourage tyrannicides.

In the *Philippics,* Cicero set himself two main tasks: to follow the unfolding of momentous events, and to put the spotlight on Antony as the author of the republic's impending downfall. This pressing dual programme allowed him less scope for the cultural refinements, especially literary allusion and legal knowledge, than he had enjoyed in his early oratory. It is only in *Philippic II, III* and *XIII* that we find as many as five refinements. Remembering that Cicero wrote *Brutus* in 46, we may think of his requirement of all eight of them as retrospective, since the *Philippics* were composed some two years after the dialogue. Their low incidence in those speeches also reminds us that his ideal orator could exercise all his talents only in settled circumstances: the political arena in times of crisis was not the place in which to display them in their full glory,

CHAPTER FIVE

CULTURE

(a) Literature

The four sections of this chapter come together naturally as the core subjects which the well-born Roman encountered in the course of his broader education. This distinguishes them from the purely technical training which he would receive in order to make him into an effective speaker, and which he would obtain from practical manuals on oratory. A man who could display breadth of knowledge was listened to with more respectful attention than one who merely showed that he had learnt a few tricks of the rhetorician's trade. No ancient orator appreciated this fact more thoroughly than Cicero, who moreover saw oratory as an all-embracing cultural discipline, requiring its pupils to read poetry and history (*De Or.* 1.158, 3.48, 100, 102). The study of poetry was also useful to the trainee orator on a practical level, as a medium of voice-training (id. 3.173–181), and it is to this connection that Cicero refers when he initially expresses his indebtedness to his teacher, the poet Archias (*Pro Arch.* 1). But a little later (2) he says that his own literary interests transcend oratory. Elsewhere (*De Or.* 3.27) he opines that poets are akin to orators. Knowledge and appreciation of literature was a part of the education of well-born Roman boys, who read the poets, both Greek and Roman. This knowledge was utilized in the process of literary composition, because it was widely believed that poets say things more memorably, and with greater succinctness and clarity, than ordinary men, because they are imbued with divine fire (*Pro Arch.*18); so that quotation from the disciples of the Muses conferred a higher authority upon the written word.

The use of literary quotation in Cicero's speeches is to be linked to his character as well as to his education. There can be little doubt that he enjoyed regaling his audiences with examples of his erudition. Though he was careful not to do so excessively when addressing popular audiences,[1] he rightly thought that his intellectual peers would be pleased to have their

[1] See D. H. Berry, 'Literature and Persuasion in the *Pro Archia*', in Powell and Paterson *CA* 302, who gives instances of Cicero feigning ignorance.

learning acknowledged.[2] Wide reading and knowledge of literature were attributes which he accorded his best predecessors (*Brutus* 114, 175, 247, 265), and he took the available opportunities to rival them by displaying his own. Again, the recital of verse was congenial to him, as it gave him the best possible chance of exercising the histrionic skills by which he laid great store, as part of the necessary equipment of an orator (*De Or.* 1.18, 114–5, 127–8, 131–2, 156). He may have adapted his delivery to accommodate the verse (Quint. 11.1. 39). Like some of his friends and acquaintances, Cicero wrote a significant amount of poetry himself, especially in his earlier years, though its uneven quality evoked ridicule in his own day (see *Phil.* 2. 21), and famously from the pen of Juvenal (*Sat.* 10. 24).The fact that poetry figured so largely in his training may account for his use of it for illustrative purposes in his rhetorical writings.[3]

In the following discussion, some passages already noted in the previous chapters are revisited as illustrations of the different functions and effects that literary quotation can have in an oration. Thus the quotation from the poet Caecilius in *Pro Rosc.* 46–7, in which a father keeps his legitimate son with him in Rome and relegates his bastard son to the country, has the effect of giving a kind of higher authority to what may have been a standard practice. When he turns to his favourite Roman tragedian Accius in *Pro Sest.* 102, the poet's authority is being invoked for protreptic purposes, and the same poet is quoted in *Pro Planc.* 59, where Cicero describes how he dispensed advice to his own son. In the same speech (66) there is a rare appeal to the authority of a prose author (Cato in his *Origines*). In these cases the literary authority tells us what we should do, sometimes informing our knowledge, as in *Pro Rab. Post.* 29, where the ways and manners of kings are illustrated with a quotation from Ennius, whose words have a cautionary function.

Many quotations illustrate more straightforwardly how the poet 'says things better'. The flavour imparted may be gnomic or proverbial. 'Wisest is he, they say, whose mind suggests the appropriate idea, next comes the

[2] Just such a scenario is envisaged by Shakespeare, *Julius Caesar*, Act 1, Scene 3:
 Cassius: 'Did Cicero say anything?'
 Casca: 'Aye, he spoke Greek.'
 Cassius: 'To what effect?'
 Casca: 'Nay, an I tell you that, I'll ne'er look you in the face again: but those that understood him smiled at one another and shook their heads; but for mine own part, it was Greek to me.'
[3] See Fantham *RWCO* 138–46. Albrecht (*CS* 105) relates the particular frequency of poetical quotation in the speeches of 56–52 BC to the preparation of *De Oratore*.

man who accepts the good idea of another' (*Pro Cluent*. 84, quoting without
acknowledgement ultimately from Hesiod *WD* 293). Such sayings will have
joined the store of collective wisdom accumulated over the years and lost
their authorial identity in the process. Then there are more pithy phrases,
like 'picking out a crow's eye', meaning deceiving the wariest of men (*Pro
Mur.* 25, and *Pro Flacc.* 46), and in the latter speech (65) 'A Phrygian is
improved by beatings' (cf. Old Eng. 'A dog, a woman and a walnut tree
– the more you beat'em the better they be!'). Two other ethnic stereotypes
are introduced proverbially in the same passage: 'If you want to make a
risky experiment, try it first on a Carian'; and 'the farthest of the Mysians',
referring to another depised race. The gnomic utterance of 'a certain poet'
(cf. Plaut.*Poen.* 843), 'evil gain comes to an evil end' glosses the context in
Phil. II 65, and the authority for 'what an excellent guardian of sheep is a
wolf' (*Phil. III* 27) is also unnamed. For some readers and listeners, sayings
like these can give a ring of familiarity to a passage, while to others it shows
the learning and the worldliness of the orator.

 In other quotations ingenuity is added to these qualities. Their free
use in *Pro Caelio* contributes to the entertainment which he promises his
audience at the outset. In 36, quotation assists a comic figment, in which
he imagines Clodius remonstrating with his sister Clodia for her obsession
with the unresponsive Caelius. Clodius quotes a trochaic septenarius from
an unnamed poet: 'Why do you shout so loud? Why do you fuss about a
trifle?' Then Cicero draws another image, that of the stern father (which
he is seeking for himself) from the poet Caecilius, who specializes in
cantankerous old men (37), and even tries to improve on Caecilius when
he writes:'Such a father would say: 'Why have you taken yourself off to
be near that courtesan? Why did you not flee as soon as you found out her
allurements?' Then he characterizes the 'kind father', using a quotation from
Terence (38). In this passage of quotations the full extent of Cicero's part in
its composition is not clear, but they add to the theatrical atmosphere that
characterizes this part of the speech. In *In Pisonem* 43, the poetic language
of Ennius is chosen to heighten the philosophical argument about deserved
and undeserved punishment, and a similar effect is achieved later (82) with
a quotation from Accius.

 The speaker's knowledge of literature is manifested in a more general
way when he uses material derived from his reading without necessarily
quoting from a particular author. In *Pro Rosc.* 131, the rule of Sulla is
compared for its latitude with that of Jupiter. In *In Verr. II* 4.39, the greed

of Verres is compared with that of the legendary Eriphyle, whose story is part of mythical lore (*accepimus in fabulis*). In *Pro Leg. Manil.* 22, the flight of Mithridates of Pontus from his kingdom evokes a detailed comparison with the mythical flight of Medea. Just as Medea scattered the limbs of her brother along the track which her father would follow, to distract him in grief, so Mithridates distracted the pursuing Roman army by leaving his treasure strewn piecemeal in their path. (Here purists might find the comparison unsatisfactory.) Less dramatically, in *Pro Mur.* 60 Cicero casts himself playfully in a tutorial role to his junior Cato, indirectly alluding to that of Phoenix to the young Achilles. Here the story of this relationship would have been told by many authors besides Homer, so Cicero's audience need not have ascribed Phoenix's words to a specific source. In *De Harusp. Resp.* 39 the generalized comparison is between the anguish and pain of madness as portrayed in drama, and that witnessed in real life, where the gods visit these afflictions upon men just as mercilessly. Later in the same speech (59) the dreaded maritime hazards Scylla and Charybdis give colour by comparison with the all-engulfing greed of Clodius. Similes like this can be rather more commonplace, as when Antony, the cause of ruin and destruction to the State, is compared with Helen of Troy (*Phil.II* 55).

In *Pro Sest.* 118 the scene is the stage itself. Cicero describes a dramatic performance in which the actors chanted the words 'This, Titus, is the sequel, the end of your vicious life', seeming to address their words to Clodius, who was seated in one of the front rows. Clodius was understandably disconcerted. This negative reaction between actors and audience is soon matched by a positive one in 120–2, where an actor uses his text and his histrionic powers to generate praise and sympathy – for Cicero himself. In this passage, he may well have used his own acting skills when delivering the quotations.

The authority of revered poets; added clarity through the apt phrase or expression; colouring through comparison; display of learning and sharing the enjoyment of it with like-minded audiences: these are the qualities and effects that Cicero drew from his readings of literature, mainly poetry, and used in his speeches. His other writings contain many references to his devotion to literature. The owner of a good memory and a large library, ably organized by his educated slave Tiro, he could have pursued a full-time literary vocation. As it was, the course of his career dictated otherwise, up to a point. In the *Orator*, published in 46 BC, he writes (148): 'Literature was once my companion in the courts and the Senate-House; now it is my joy at home'. The first clause of this sentence is a clear reference to the ancilllary

role of literature in his speeches, both forensic and deliberative; the second clause points to a change in his life, though when this began is less easy to assess. The greatest concentration of literary quotations occurs in the speeches delivered and published between 56 and 54 BC (see Austin's note on *Pro Cael.* 37 p. 81), which included the publication of *De Oratore* (55 BC). Literary matters began to take up more of his time in these years. He spent much of his time away from Rome in 55 BC, and in a letter from his Tusculan villa he writes to Atticus of 'devouring literature with that amazing man Dionysius' (*Ad Att.* 4.11). The change becomes more pronounced after Pharsalus. Politics became impossible. In 46 BC he wrote: 'We must serve the State in our libraries, if we cannot in the Senate-House and the Forum, and pursue our researches into custom and law'. (*Ad Fam.* 9.2 *sub fin.*) The most fertile period of Cicero's academic writing was around this time.

Steeped in literature in the course of his education, Cicero constantly renewed his acquaintance with it, and returned more concentratedly to it towards the end of his career.[4] It was his constant companion, and he turned naturally to it whenever he needed to add colour or point to what he was saying. In view of the frequency with which he quotes from literature in his letters, it is perhaps even surprising that there is not more literary allusion in the speeches. The more leisurely and contemplative atmosphere of the philosophical writings was more conducive to their regular appearance.

(b) History

Cicero wrote poetry, and wrote extensively about philosophy, but although history played a major part in his life, and allusions to it abound in the speeches, he did not find the time to write a major work in the genre. This failure is the subject of a discussion among his friends in *De Legibus,* at the end of which his brother Quintus suggests the reason for it: that he wanted to write only about events in which he was himself a participant (*I* 8).[5] This is related to his conception of the proper nature of historiography, as revealed earlier (*I* 5): *opus unum hoc oratorium maxime* ('this branch of literature

[4] See Fantham *RWCO* ch.6. On the possible relationship of Cicero's other literary activities to his oratory, see Albrecht *CS*, who (105) remarks on the frequency of poetical quotation in the oratory of 56 to 52 BC (see above), and notes that this coincided with a period of 'Cicero's poetic productivity in the Fifties'.

[5] Cicero's own reason was lack of time. Writing history was considered the most time-consuming of literary activities (Juv. *Sat.* 7. 98–104). But fear of the consequences of writing freely may also have been a factor. On the letter to Lucceius, see Fantham *RWCO* 157–9.

is closer than any other to oratory'). The connections between oratory and history are centred on the part played by personality. Cicero's historian, after providing the necessary factual and logistical background, must give his own judgements of actions and events (*De Orat.* 2.63):

> The nature of the subject demands chronological arrangement and geographical representation; and since men reading about important events expect to be told first the plans of campaign, then their execution and their outcomes, they also expect the author to indicate what he thinks was good about those plans; to show, in his narrative of actions, not only what was done or said, but also how; and in speaking of the consequences, to give an account of all its causes, whether originating in accident, sound judgement, or recklessness; and as for the individual actors, besides an account of their exploits, the historian must give particulars of the lives and characters of those who are outstanding in fame and renown.

It is easy to see why history corresponding to this definition should be attractive to the orator. It is concerned with praise and blame, good and bad character, core subjects of epideictic oratory and often at the centre of cases presented in the courts. That history could also contain material which might play on the emotions, however vicariously, is also suggested in his letter to Lucceius, a historian whom he was trying to persuade to celebrate his consulship (*Ad Fam.* 5. 12.4–5):

> Nothing tends more to the reader's enjoyment than varieties of circumstance and vicissitudes of fortune. For myself, though far from desirable in the living, they will be pleasant in the reading; for there is something agreeable in the secure recollection of bygone unhappiness. For others, who went through no personal distress, and painlessly survey misfortunes not their own, even the emotion of pity is enjoyable... in the doubtful and various fortunes of an outstanding individual we often find surprise and suspense, joy and distress, hope and fear; and if they are rounded off by a notable conclusion, our minds as we read are filled with the liveliest gratification.

Cicero's ideal historian thus needed to draw on practically all the resources that his ideal orator deployed. Like the orator, he should regard his readers as a live audience, reacting to his story like spectators at a tragic performance, or on rarer occasions, at a comedy. The story was shaped by the individual actors, who provided its rational element as well as its human interest. They also introduced features which fell clearly within the province of the orator:

live speech – hortatory or deliberative – the psychological element (how people were motivated and persuaded), and the influence of the characters of leading men on policies and the morale of their people. Indeed, without these ingredients, history is nothing but a dry record of events, as indeed was the earliest Roman historical writing (*De Orat.* 2. 52–3).

Individuals animate history. In oratory historical personages amplify argument by furnishing the orator with examples, through which they become 'witnesses from the past' (*Brutus* 322). They perform a rhetorical function, as they are a species of argument from probability (*De Inv. I* 30,49: 'An example supports or weakens a case by appeal to precedent or experience, citing some person or historical event'). An event in the present could be compared with a parallel case in the past, where the outcome is known and was favourable or adverse, according to the requirements of the argument. Examples serve two main, often related, purposes: to fuel a comparison, and to provide a precedent. Both purposes depend on the respect for antiquity that Roman juries could be assumed to feel. The underlying belief is that the past case should be imitated; but in comparisons, the relationship between past and present is more subtle and variable.

In *Pro Rosc.* 33–4, the present trial is compared with the prosecution of Q. Scaevola by C. Fimbria. Here there are two points of contact: both trials were equally unwarrantable, and both had been mounted after the defendant had escaped assassination. Later in the same speech (70), Roman lawmakers are compared favourably with Solon because, unlike him, they were not discouraged by lack of precedent from legislating most severely for patricide. More rhetorical is the comparison (90) of the killings under the Sullan proscriptions with the slaughter of the Roman armies at Trasimene and Cannae, where the purpose is magnification.

As well as providing parallels, in which the aim might be imitation, or simply the injection of colour, a historical comparison could be negative or positive. In *Pro Rabir. Perd. Reo* 13, the strength of the motive of revenge actuating the prosecutor Labienus, whose uncle had been an associate of Saturninus and died with him some thirty-six years earlier, is compared unfavourably with the grief felt by Gaius Gracchus, whose brother had been slain by his political enemies, but who did not engage in vendettas against them. In political cases like this, the motivation of the two sides could always be profitably explored. In *In Catil. IV* 4, the present revolutionaries are compared negatively with the earlier *populares* Gracchi and Saturninus, whose aims were reform, not widespread murder. In *Pro*

Mur. 31, a negative is answered with a positive comparison: after Cato has
disparaged the Mithridatic Wars, in which Murena fought, Cicero puts them
on a par with some of the fiercest wars fought by Rome in the past, of which
the most memorably difficult were those fought in Asia against Philip V
of Macedonia and Antiochus of Syria. Mithridates had been as worthy an
opponent as either of those kings, as Sulla had acknowledged by leaving
him to continue in power after campaigning successfully against him. In 66
a historical comparison becomes a comparison of character. The younger
Scipio's association with the Stoic philosopher Panaetius made him gentler
and more affable: Cato's intimacy with the contemporary Stoic Athenodorus
might have been expected to have affected him similarly, especially as his
own great-grandfather (Cato the Censor) had been such an amiable man
(a humorous coda to the argument). In a speech (*Pro Sulla*) which is
much concerned with Cicero's own *auctoritas*, he gives a roll-call of men
from Italian towns who, like himself, had enjoyed distinguished political
careers in the service of Rome. He warns the prosecutor Torquatus to avoid
offending their fellow-townsmen, who wielded the franchise (24). On the
literary scene, in *Pro Arch.* 22, the esteem in which the poet Ennius was
held by the Elder Scipio is compared with that enjoyed by Archias in other
states. In this there is an element of precedent, because Cicero is arguing
that Rome, like those other states, should show her gratitude by conferring
citizenship on him.

In *Pro Flacc.* 98, examples are given of men who had been charged, like the
defendant, with extortion, but had been acquitted because of signal services
to the state, either in wars on her behalf (Manius Aquilius, consul in 101BC,
and recently Lucius Murena), or as consul in difficult times (Gaius Piso,
consul in 67 BC and defended by Cicero in 63 BC). The idea that possible
offences by men who have earlier distinguished themselves in some area of
public life should be overlooked is sometimes used,[6] especially in cases of
extortion because their seriousness is notoriously difficult to estimate. In the
Post Reditum speeches, one of the themes is that Cicero's popularity rather
than his connections with influential senators had secured his return. This
had been a remarkable feature of it, and the comparison is strengthened with
another example showing another agency, quiet diplomacy (*Post. Red. In
Sen.* 38):

[6] Especially in early Attic oratory, a defendant's services to the community were routinely
paraded before juries, though evidence is lacking that guilty men were acquitted on this kind
of testimony alone.

In the cases of these [Publius Popilius, Quintus Metellus, and Gaius Marius], there was no unity of action among the magistrates, no rallying of the Roman people to the defence of their constitution, no outbreak in Italy, no decrees passed by municipalities and colonies.

Cicero's return was the result not just of these two forms of sponsorship, but to them must be added a third, popular acclaim, the combined will of the people and the Senate. It was therefore to be celebrated with especial enthusiasm. This argument is repeated and enlarged in *Post Red. Ad Quir.* 6ff.

In *De Dom.* 24, Cicero tells how Clodius forced through the assignment of the consular provinces without senatorial approval, and remarks that even the most *popularis* of previous tribunes, Gaius Gracchus, had not gone as far as this in flouting the senatorial prerogative. Here the historical example serves to highlight an extremity of behaviour. In 65, a comparison between himself and the Decii, who had fought to the death at the battles of Veseri (340 BC) and Sentinum (295 BC) without knowing their outcome, is part of the fabric of a complicated argument, in which he represents himself as the saviour of Rome by withdrawing into exile rather than precipitating a civil war by defying Clodius: Cicero, the civilian, likes to surround himself with military imagery, and linkage with these heroes of the past adds lustre to this self-portrayal. In 91 he compares his position in relation to Clodius with that of Scipio Nasica facing Tiberius Gracchus in 133 BC. The comparison here points up a difference, not a parallel, as does the comparison in 101, where the houses of four historical figures from the fifth and fourth centuries, Spurius Maelius, Spurius Cassius, Marcus Vaccus, and Marcus Manlius, had been burnt to the ground because their owners had aspired to tyranny, and each site had been marked. Cicero uses this to underline the injustice of similar treatment of himself.

It is inevitable that historical comparison should occasionally produce hyperbole. In *Harusp. Respons.* 6, Milo's limited achievements are set beside Scipio Aemilianus' destruction of Carthage. In a more sober comparison (16), Cicero shows how the Senate's decree to restore his house was more favourable to him than the one which it had passed in favour of Publius Valerius, consul in the first year of the Republic (509 BC). In 41–2 there is parallel comparison: Tiberius and Gaius Gracchus are characterized as men who misused their great talents to rouse the mob, and while Saturninus achieved the same result by his very instablility, Sulpicius Rufus by his

eloquence beguiled even the wise and the loyal. Clodius is compared unfavourably with these able *populares*, and portrayed as a mere libertine, whose limited abilities are thereby exposed in the clearest light.

Whereas modern subjects tend to emerge second-best from these contests with men from the past, Cicero often uses them to add to his self-image. In *Pro Sest.* 37–9, his moral superiority over his historical counterpart is not initially clear-cut, but has to be argued in detail. Metellus had gone into exile after refusing to agree to a senatorial decree which had been passed by force – a quixotic and vainglorious gesture, according to Cicero, and unrelated to any unselfish desire to avert civil strife. Cicero's exile, on the other hand, had been imposed because of measures which had had universal approval (the execution of the Catilinarians); and these were still approved by the majority, who would have been prepared to break the peace in his support.

An elaborate double-comparison occurs in *Pro Balb.* 11–12. The theme is jurors' trust of defendants or witnesses. How could the testimony of Pompey be questioned, when that of Metellus, in his own trial for extortion (112 BC) shamed the jury into accepting his evidence without demur? Similarly, many years earlier in Athens, a jury protested in one voice when a famously revered witness (the philosopher Xenocrates) went to take the oath. The comparison of Cicero's exile with that of Metellus has a slightly different interpretation in *In Pis.* 20, where their similarity is made to appear closer, with Metellus, like Cicero, going into exile to avoid civil war. In *Pro Planc.* 26, another example of Cicero's use of history for self-glorification (cf. *Pro Sest.* 37–9 above), he sets his own fame on a par with that of Marius. In *Pro Mil.* 16–20, Cicero lists instances of the murder of prominent men, into which no close enquiries were made, in order to argue that the death of the egregiously wicked Clodius should likewise occasion no special legal process. In *Pro Lig.*12, he deplores the punishment proposed for his client by saying that even under the dictator Sulla, no one had proposed the level of punishment being advocated by the prosecutor. In *Pro Reg. Deiot.* there are three historical comparisons. In 19, the comparison adds colour to the narrative as the hospitality accorded Caesar by the king is compared with the sumptuous reception given to Scipio Africanus by another Asian monarch, King Attalus. In 31–2, Deiotarus' grandson and accuser Castor is compared with Domitius Ahenobarbus, a tribune in 104 BC (and an ancestor of the Emperor Nero). Here the comparison centres on the two men's attitude to the evidence offered by a slave: Domitius sent him back to his master, spurning his testimony; whereas Castor suborned a slave to testify against

his grandfather. In 36, the comparison is closer. Antiochus the Great, after his defeat at Magnesia in 190 BC, recognized that the treatment he received from the Romans was generous, and also that the reduction in the size of his empire made it easier to administer. Deiotarus suffered similarly at the hands of Caesar and reacted in the same way, though whereas Antiochus had been guilty of mad imperial ambitions, Deiotarus had simply miscalculated.

Of the many historical references in the *Philippics,* seven are comparative. In *III* 8–9, the ancient longing for liberty that had led to the expulsion of the proud tyrant Tarquin should be exceeded by present determination to retain it following the expulsion of Antony. There is the happy familial coincidence of the two agents – Lucius and Decimus Brutus – and Tarquin was a less repressive tyrant than Antony. In *IV* 14, Antony comes off second best in a comparison with Catiline: he is 'equal to him in wickedness, but inferior in energy'. In *V* 17, Antony's employment of bodyguards, a symbol of tyrannical repression, is seen to have been excessive and ostentatious when compared with the more discreet protection which previous leaders – Cinna, Sulla, and Julius Caesar – had provided for themselves. Later (24–5), Cicero argues that Antony, who is supposed to be a Roman citizen, has committed the same crimes as Hannibal, an avowed *hostis* of the Roman people, since both have besieged Roman *coloniae.* As often with such comparisons, the side which might be expected to have been the less vicious has turned out to be the more so: 'Hannibal was not guilty of these [sc. widespread depredations], but kept much for his own use; but these men, who lived only for the hour, have not given a thought, I do not say to the fortunes and the property of citizens, but even to their advantage'.

The erection of statues alongside those of past heroes invites comparison which will usually be unfavourable to the newcomer. In *VI* 13, we read of statues of Antony and his brother Lucius provoking predictable ridicule. On a more serious political level, in *VIII* 7–8, in support of his general argument, which Antony's supporters have been trying to undermine, that the state was engaged in civil war, he shows how previous civil conflicts in the first quarter of the century had been over less serious matters – individual differences over specific items of legislation – whereas the present war had arisen 'not amid civil discord and dissension, but amid the greatest possible unanimity and amazing concord'.This striking paradox is forcefully pursued: 'our side' is defending those things which all men hold most sacred; Antony is striving to upset all these things. In *XI* 9, supporting the argument that the man guilty of a crime bears a heavier burden than his victim, the torture and death of

Marcus Regulus, one of Cicero's favourite exemplars, is coupled with the very recent undeserved fate of Trebonius at the hands of Dolabella, which is the main theme of this speech.

The comparisons in the above examples contribute to the argument and to the style by providing extra force, variety, and colour. In the following examples history is invoked in order to provide a precedent for the course of action proposed, making it a direct and practical contribution to the speaker's case. The first example of this type is in *Pro Rosc. Am.* 64, where the collapse of an earlier homicide trial, that of T. Caelius, illustrates how the slightest flaw in the evidence can (and should) be fatal to the prosecution, because of the unique seriousness of homicide charges and the irrevocable consequences of reaching the wrong verdict. In *Div. in Caecil.*, one of the arguments used by Cicero to try to disqualify Caecilius from becoming Verres' prosecutor rather than himself is the fact that Caecilius had been Verres' quaestor. Here the precedent already existed: examples of quaestors not being allowed to prosecute their praetors are readily available (62–3). This had happened because the possibility of collusion between the junior official and his superior had been recognized. A more elaborate example of the use of an historical precedent to support an argument is in *In Verr. II* 2. 109. Sthenius of Thermae was an assiduous art-collector, whose co-operation Verres had sought. But later that had been withheld, so Verres trumped up a capital charge against him of forging documents. Faced with this danger, and on the advice of his friends, Sthenius fled from Thermae to Rome, where he secured a resolution of the Senate that the prosecution of persons in their absence on capital charges should be prohibited in the provinces. Ignoring this, Verres held the trial and pronounced Sthenius guilty, and publicly upheld the view, backing it with precedents, that it was legal to prosecute a person in his absence (102). Cicero contrives a counter-precedent which looks stronger than the recent senatorial judgement, using *a fortiori* argument (109):

> Will you hesitate to follow the precedent set by the court which, upon the conviction of Gnaeus Dolabella, annulled the conviction of Philodamus of Opus because he had been convicted, not in his absence – nothing so unjust and cruel as that – but after being appointed by his fellow-citizens member of a deputation to visit Rome. Equity induced that court to take that decision on grounds comparatively weak: will you hesitate to take a similar decision when the grounds for it are very strong, especially as it is now supported by the authority of a precedent?

Contrasting with this recommendation of action following precedents, in *In Verr. II* 3.207 there is a warning that precedents for evil actions should not be used to justify them. Roman greed and injustice had plunged the provinces into impotent despair, but 'Rome will find herself without hope of escaping doom, if the precedents set by one scoundrel are to secure the acquittal and impunity of another'. But Hortensius has drawn his precedents from the actions of past governors of high reputation, and this is difficult to rebut. So Cicero simply has to argue that Verres has far outstripped them in rapacity, and the comparison becomes primarily one of degree. This question of the rapacity of former governors is raised again in *IV*.7–9, with the same verdict – that Verres' depredations were of an entirely different order to these.

The precedent proposed in *Pro Font.* 23–4 is addressed to the jury, and concerns their own procedure. Examples from the past are given of very distinguished witnesses who have not been given credence, and these include the venerable consul for 123BC, M. Aemilius Scaurus. In *Pro Cluent.* 128, the argument is about a precedent leading to a false analogy. The precedent is the *decimatio*. It had been suggested that this military punishment should be applied to the *nota censoria*, a civil sanction directed against offending cititizens. The objection to this was that the *decimatio,* the execution of every tenth man in a delinquent brigade, was a form of random selection, *pour encourager les autres*, whereas the censor's stigma was directed against a particular transgressing individual. The purpose of applying this false analogy had been to discredit the courts in the eyes of the people in general. In 134–7, still focusing on the censorial exercise of power, Cicero introduces Scipio Africanus Minor, noting that he was scrupulous in obtaining proof to justify his removal of G. Licinius Sacerdos from the equestrian census. The contrast here is with Cicero's client, for whom subjection to this kind of examination would have been preferable, since 'he would easily have held his own, even if he had had the censors as his judges, against the groundless suspicion and prejudice aroused against him by a demagogue'. Another precedent is introduced in 151, where we are told of a law made by the *popularis* Gaius Gracchus, which bound senators while exempting others, but was retained by the anti-democratic L. Sulla.

In the speech *Pro Lege Manilia*, Cicero supports a single command for Pompey for a war against Mithridates. Pompey's accession to the consulship in 70 BC, and his successful command against the pirates in 67, had sounded alarm bells among many senators who were fearful that these instruments of power would encourage him to emulate Marius and Sulla. But the practical

argument was strong – that he had already delivered victory, proving his mettle as a general – and he was popular. Here Cicero shows that he also had history on his side (60):

> But, I am told, 'Let no innovation be made contrary to the usage and the principles of our forefathers'. I shall refrain from mentioning at this point that our forefathers always bowed to precedent in peace but to expediency in war, always meeting new emergencies with new developments of policy; that two mighty wars, those against Carthage and Spain, were brought to an end by a single commander, and that the two most powerful cities, Carthage and Numantia, which more than any others constituted a menace to our empire, were both destroyed by Scipio. I refrain from reminding you that, more recently, you and your fathers decided that the hopes of this empire should be placed in Gaius Marius alone, and that he should direct successive wars against Jugurtha, the Cimbri, and the Teutones. As for Gnaeus Pompeius, in whose cases Quintus Catulus desires that no new precedent should be established, call to mind how many new precedents have been established in his case with the entire approval of Quintus Catulus.

The *occultatio* is one of Cicero's boldest, and suits a context where his listeners will have been acquainted with these precedents, but their familiarity in no way diminishes their importance. They are in fact central to the argument for Pompey's appointment.

In *In Cat. I* 3, the precedent used seems forced, illustrating Cicero's predilection for introducing historical material for its own sake. The killing of Tiberius Gracchus by Scipio Nasica in 132 BC is adduced as an *a fortiori* precedent for the killing of the much more dangerous and lawless Catiline; but the state has already passed sentence on Catiline, so that there is no need for private citizens to follow Scipio Nasica's lead and take the law into their own hands. Again, this part of the speech is addressed to Catiline himself, not the senators. Other more suitable precedents are introduced to illustrate the speed with which the Senate's sentence on revolutionaries had been carried out (4), and Cicero blames himself for his slowness in carrying out its wishes (5).

In *Pro Balb.* 11, the trial of Q. Metellus for extortion in 112 BC is adduced to illustrate the effect which the reputation of an honest man could have on a jury:

> There was not a single man among the jurors who did not avert his gaze and

turn completely away, for fear that anyone might have any doubt as to the truth or falsehood of what he had entered in his public records.

He goes on to argue that the same degree of trust should be accorded Pompey. The precedent is not an exact parallel, as Pompey is not accused of dishonest appropriation when he enacted a law enfranchising Balbus, nor was he submitting to an audit.

The impressiveness of really old precedents, on whose validity Cicero has earlier cast doubts, is vindicated later in the same speech (31):

> Romulus, the first founder of this city, taught us by the treaty he made with the Sabines, that this state ought to be enlarged by the admission even of former enemies as citizens. Through his authority and example our forefathers never ceased to grant and to bestow citizenship.

Following a minor defeat of Antony at Mutina (April 43 BC), a relieved Senate considered the proclamation of a thanksgiving (*supplicatio*). In *Phil. XIV* Cicero supported this, but opposed a supplementary proposal that civilian garb be assumed, symbolizing the complete cessation of hostilities. The historical examples here widen the question: they are of cases where the cessation of serious conflicts was not followed by thanksgiving because they had not been with external enemies (*hostes*) but, like the present war, had been between Romans. But Cicero's main objection had been to the idea that the war had ended. He is raising the question of the thanksgiving in order to make the more general point that it would be premature. These examples support his negative stance (23):

> Sulla as consul waged a civil war; when he had brought his legions into the city, he expelled those whom he chose, and killed those he could: there was no mention of a thanksgiving. A serious war with Octavius followed: no thanksgiving was decreed to Cinna though he was the victor. Sulla as Imperator avenged the victory of Cinna: no thanksgiving was decreed by the Senate.

The victories had not been over *hostes*, but over fellow-citizens after internecine carnage: hence, no thanksgiving. The same is true in the present case.

A feature of the *Verrines*, which were not delivered but prepared for an appreciative circle of literary readers, is the number of examples of ancient historical and semi-historical or mythical stories told, it seems, for purposes of embellishment or entertainment. These include the story of Latona and

her son Apollo on Delos (*In Verr. II* 1.48), and also the famous digression
on the history of Sicily, which will be examined later (pp. 190–1). On a
smaller scale, a summary history of Himera traces Carthaginian occupation
and the city's recovery from it, during which the citizens reasserted their
identity by the creation of many fine works of art. Their patriotism all those
years ago seems to make Verres' plundering of these treasures seem even
more outrageous. Picturesque historical details, in the manner of a Timaeus
or a Herodotus, appear in *In Verr. II* 3.76 (the polygamous practices of the
Persians and Syrians). Elsewhere early Greek history furnishes illustration
of the attachment of writers to the entourages of great men, so that they
could sing their praises with authority (*Pro Arch.* 20, the great man being
Themistocles). Cicero's knowledge of the early history of Greece appears in
Pro Flacc. 64–5, where their ancient ethnic division into Ionians, Dorians,
and Aeolians completes his description of the Greek presence in Asia. In *De
Dom.*139, Cicero takes his audience back to the earliest days of the Republic
to illustrate the steadfastness of a consul in his task of dedicating the Capitol.
Such passages as these give a pleasing patina of antiquity, and hence authority,
to the case being made. A similar effect may be felt, though to a lesser degree,
on encountering the large number of other historical references that appear
throughout the speeches. These seem to make no discernible contribution to
the argument or the rhetoric, but are simply literary embellishments designed
to show the orator's knowledge and superior understanding of the events he
is recounting. Most of them may be treated summarily.

In Verr. I 44:	Pompey's consulship of 70 BC and his restoration of tribunician powers.
In Verr. II 2. 113, 118:	The past careers of Sthenius of Thermae and Gnaeus Domitius.
In Verr. II 3. 81:	The absolutism of Sulla.
In Verr. II 3. 125:	Punic Wars in Sicily.
In Verr. II 3. 185:	The custom of a governor giving a gold ring to a subordinate after a victory.
In Verr. II 4. 21–4:	Histories of Phaselis and Messana.
In Verr. II 4. 56:	L. Piso's recent governorship of Spain
In Verr. II 4. 72:	Segesta and Carthage at war.
In Verr. II 4. 73:	The Bull of Phalaris.
In Verr. II 4. 115–51:	The History of Sicily (see under *Digression*, pp. 190–1).
In Verr. II 5. 7:	Previous governors of Sicily.

In Verr. II 5. 84:	Marcus Marcellus, conqueror of Syracuse.
In Verr. II 5. 180:	The Elder Cato, his ability and ambition.
Pro Font. 38–9:	Instances of false accusation, cited to show how easily mistakes could be made, as they had been in the past.
Pro Cluent. 95:	P. Popilius and Q. Metellus, who found that simply leading an exemplary life was not enough to protect them from violent tribunes.
Pro Cluent. 153:	Courage shown in the past by members of the equestrian order.
Pro Caec. 53:	Recollection of a case in 93 BC involving the famous advocates L. Crassus and M. Scaevola.
In Cat. II 20:	Recent history of resettled Sullan veterans.
In Cat. III 10:	Lentulus briefly reminded of his grandfather's distinguished career.
In Cat. III 19:	Portents of the recent past.
In Cat. III 24:	Recent civil wars illustrating the atrocities which such conflicts bring, and from which the present generation has been saved by his action.
Pro Arch. 21:	Roman conquest of the Pontus.
Pro Arch. 24:	Alexander and Pompey and the value they placed upon historians.
Pro Arch. 25:	Sulla and the poetaster, whom he rewarded for his eulogy on condition that he would write no more verse.
Pro Arch. 26:	Metellus' ambition to be immortalized.
Pro Arch. 27:	Decimus Brutus and Fulvius, and their regard for the poets Accius and Ennius.
Post Red. ad Quir. 20:	Marius' return from exile, and his vengeful spirit.
De Dom. 77–9:	History of Roman citizenship.
De Dom. 86–7:	Instances of popular power exercised against patricians.
De Prov. Cons. 27:	Recent history (Pompey and the Mithridatic War).
Pro Cael. 34:	The Pyrrhic War and Appius Claudius.
Pro Balb. 34:	Gades as a loyal ally of Rome.
In Pis. 43–4:	M. Regulus and M. Marcellus.
Pro Planc. 33:	Granius the lugubrious auctioneer, famous for his caustic wit in the Gracchan period.
Phil. I 11:	Passing reference to the dangers posed by Pyrrhus and Hannibal.

Phil. IV 13:	The conquest of Carthage illustrating Roman valour.
De Leg. Agr.I 5:	Historical background to the acquisition of land in Macedonia.
De Leg. Agr.II 10, 31:	Unfashionable praise of the Gracchi.
De Leg. Agr.II 81:	Attitude of earlier generations to the *Ager Campanus*.
De Leg. Agr.II 83:	The poor productivity of Asia during the Mithridatic War.
De Leg. Agr.II 87:	The destruction of Carthage.

A final category consists of historical material used explicitly for the purpose of amplification, reinforcing an argument while adding extra colour. Some of these examples are close in character to some of the passages listed above.

In *In Verr. II* 1. 55, examples are given of honest, relatively unacquisitive governors, whose 'houses were empty of statues and pictures', but whose standards of probity are not followed in modern times.

In *Pro Mur.* 36, he gives examples of the fickleness of the mob, manifested in unexpected electoral defeats; and in 59, there are examples of juries' reluctance to condemn a man on the strength of the prosecutor's eloquence.

In *Pro Arch.* 16, there are examples of past public figures who have enriched their natural gifts with literary studies, an important part of the argument in this case; and in 19, examples of places whose citizens have claimed famous writers as their own.

In *Pro Sest.* 101–3, there is a discussion of dissension in the Gracchan years about popular reforms and different groups' interpretation of them.

In *Pro Sest.* 127, the Marcus Regulus story has been used by the prosecutor against Cicero, arguing that, whereas Regulus would not stay in Rome while his comrades were imprisoned in Carthage, Cicero had been ready to countenance violence in Rome in order to gain his own return. His reply to this is forthright, but risky:

> Violence! Of course I desired violence, when I did nothing as long as violence ruled, and when nothing would have been able to topple me, if it had not been for violence. Was I to reject that a return of mine, so brilliant that I fear it may be thought that the desire for glory made me go into exile just so that I might return thus triumphantly?

This is Cicero at his most vainglorious and headstrong, and the recalling of Regulus to the argument adds to this impression. There is also a strong streak of sarcasm here.

In *Pro Sest.* 140–2, we are reminded of the speech's wide-ranging and at times almost protreptic character (on the subject of patriotism and life in politics), as the life of L. Opimius is examined in detail. A man of his aims and ideals should have had a glorious end to his career, as he suppressed and finally extinguished the revolution of Gaius Gracchus. But he was unlucky, and finished up in exile at Dyrrachium. The parallel with Cicero's own career reinforces the lesson for the reader: the course of the patriotic politician's life will often be hazardous, because injustice sometimes prevails, at least for a time; but he should not be discouraged. In the same passage, the argument extends to Greek examples (141): 'The great Themistocles was not deterred from defending the State either by the calamity of Miltiades [his prosecution after the failure of his expedition to Paros], who a little before had saved it, or by the exile of Aristides, the one man said to have been the most just of all'.

In *De Prov. Cons.* 18–23, where Cicero is arguing for the continuance of Caesar's Gallic command, he furnishes examples of generals not being recalled after successful campaigns, even by their political enemies, whose patriotism transcended their personal feelings.

In *Pro Balb.* 28, cases of distinguished Roman citizens, mainly from the end of the Second Century, taking up residence abroad, add to the point he is making about the Roman law which forbids citizens to hold the franchise of two states. Later in the same speech (48–53), examples are interwoven with the argument, which is directed towards refuting the contention that the permission of states and cities whose citizens had been offered Roman citizenship must be obtained before it could be taken up. Thus a prosecutor would not resort to this refusal as a point against a defendant, because it was of no value. There is also the broader point that such an impediment would prevent the enrolment of the ablest of Rome's allies (49), and the conferment of deserved honours upon men who had served her well.

In *Pro Planc.* 51–2, there are examples of men who have failed in their candidature for junior state offices going on to become consuls. Cicero uses these to conciliate the prosecutor Laterensis, who has himself stood unsuccessfully for the tribunate, by consoling him, rather cleverly, with the argument that he has done himself no harm by airing his positive views; so that his defeat 'was, in a sense, a recognition of his merits' (52). A rather tortuous

argument in the same speech (69–70) finds Cicero objecting to the misuse of a historical example. His opponent has cited the support given by Q. Metellus Pius (consul 80BC) to Calidius' candidature for the praetorship as a worthy example of the return of *gratia* (Calidius had earlier secured his father's return from exile), but that support was unsuccessful; whereas Cicero had no such clear-cut obligation to support Plancius, and should therefore not expect his intercession on his behalf to meet with any greater success.

The fragmentary speech *Pro Scauro* contains four historical examples, difficult to evaluate because their context is not always clear, but possibly owing their survival to their reference to famous individuals. In III 1, P. Licinius Crassus; in III 2, Manius Aquilius, Marcus Antonius, and unnamed members of the *gens Iulia*: all of whom faced suicide rather than fall into enemy hands. In III 3, the most famous mythical suicide, Ajax; and the historical Athenians Themistocles and Socrates who, along with the Spartan Cleombrotus, heroically met their deaths. Historical examples of unjust convictions for extortion are given in 40.

In *Pro Rab. Post.* 2, there are examples of generals emulating the renown of relatives – Scipio Aemilianus, of his father Aemilius Paulus, Fabius Maximus' son trying to rival him, and Publius Decius being imitated by his son in making the supreme sacrifice. These are followed by similar examples from more recent history, in 3 and 4. In 226–7, examples of Roman generals wearing foppish dress, which was however suited to its time and place, include Sulla and Rutilius Rufus.

In *Pro Mil.* 7–9, where Milo admits killing Clodius, but in an unplanned affray, previous homicide cases in which the accused admits his guilt include some of the earliest and the most recent. The almost legendary Marcus Horatius was freed after killing the three Curiatii and his own sister. The other examples are of the slayers of an aspiring tyrant and of revolutionaries. These precedents unequivocally affirm the principle of justified homicide, which is discussed further.

In *Phil. I* 18, as part of an argument against rescinding previous laws, Cicero contends that even those which their creator, with knowledge of future developments, might have framed differently, should not be altered. In *Phil. II* 87, characterizing Antony as a tyrant, he describes the fates of other would-be tyrants – exile for Lucius Tarquinius, death for Spurius Cassius, Spurius Maelius, and Marcus Manlius. By contrast, in 114, the present-day liberators Brutus and Cassius are honoured even in their absence, examples for others to imitate. By the time Cicero delivered *Phil. V*, the nineteen-year-

old Octavian was on the scene. Cicero has examples (48) from both early and recent history of men who had been made consuls while very young. And there was Alexander the Great, who 'died in his thirty-third year, an age by our laws ten years younger than a consular age'.

In *Phil. VIII* 31, Quintus Scaevola (consul 117 BC) is introduced as an example of public-spiritedness, attending the Senate and the needs of his clients at an advanced age and when in poor health. In *Phil. IX* 4, speaking in favour of a statue for his dead friend Servius Sulpicius Rufus, Cicero gives examples of other men who had been honoured with a statue for services to the State, including four ambassadors killed at Fidenae by Lars Tolumnius in 434 BC. This is a dramatic example of the hazards faced by ambassadors rather than a close parallel with Sulpicius, who died naturally while serving on the embassy to Antony. Finally, in *Phil. XI* 17–18, he gives examples of the conduct of military campaigns being entrusted to the incumbent consuls rather than to commanders with extraordinary powers. Thus they support the opposite argument to that advanced in *Pro Lege Manilia*.

Cicero approached history from a number of angles. As well as being an enthusiastic antiquarian[7] he appreciated its literary qualities, and particularly noticed its links with oratory. His held that history could also add authority and a kind of aesthetic pleasure to the spoken or written word. Of its specific functions, the provision of precedents for proposed action or legislation is of more practical importance than the mere illustration or colour furnished by examples. Cicero's ideal of historiography focuses on morally admirable individuals, and such men (or occasionally their opposites) always figure in the historical material which he deploys in his speeches. In his time, at least until the fifties, history was not much read; but it might have been if there had been historians who could follow Cicero's prescription, though few would have been qualified to do so.[8] The large amount of history in the speeches may be seen as the partial realization of an unfulfilled ambition.

[7] See E. Rawson, 'Cicero the Historian and Cicero the Antiquarian', *JRS* 62 (1972), 34: in a wide-ranging article, she notes Cicero's 'hunger for information about the great individuals of Roman history' (39), and for this reason chooses Brutus as Cicero's 'most sustained, sensitive and successful historical achievement' (41). To illustrate Cicero's potential as a historical writer, Rawson chooses the opening chapters of *De Orat.* 3 (44). Before her, B. L. Ullman, 'History and Tragedy', *TAPA* 73 (1942) 25–53, chose *Cat.* 3 (50), having remarked that Cicero 'wanted the dramatic episodes played up'. Ullman considered that Cicero distinguished between general history and 'particular' history (44).

[8] Rawson, art.cit. 35. Further on the subject, see M. Rambaud, *Cicéron et l'histoire*, (Paris, 1953); M. Fox, *Cicero's Philosophy of History*, (Oxford, 2007).

This section began with passages in which Cicero argued the affinity of history to oratory. But the qualities of good historical writing which he describes in the Letter to Lucceius, (and which he finds wanting in Rome's native historians (*De Orat.* 2. 51–6)), represent the historian's art as more broadly based, occupying the same emotional ground claimed by the epic poet and the tragic dramatist. This ideal historian would seek to stimulate the senses of the same audiences as these, following the example of 'the father of history', Herodotus, who gave live readings of his history in what may have been a deliberate challenge to his literary rivals. We can be sure that, if Cicero had become a full-time historian, he would have thrown down the gauntlet to the poets with equal alacrity.

(c) Philosophy

When we come to examine the philosophical material in the speeches, it soon becomes apparent that we are dealing with two distinct branches of the subject, moral philosophy (or ethics), and dialectic (or logic). It will be taxonomically useful to treat these separately in the following discussion, starting with moral philosophy, because it is a more or less homogeneous subject, whereas the topics of dialectic are clearly definable, and therefore need to be considered individually.

Cicero studied both of these branches of philosophy as part of his early education. During his late adolescence the Stoic philosopher Diodotus lived in his house, and Diodotus' teaching ensured that the contemporary version of that doctrine, including its teaching of logic ('dialectic', *Brutus* 309), became a major influence on Cicero's intellectual and moral development. But Cicero was already acquainted with the main tenets of Epicureanism, which he had gathered from his boyhood teacher Phaedrus; and the authors he encountered in his readings of Greek literature included Plato and Xenophon, who presented complementary accounts of the teachings of Socrates. Equipped with this and other formative material, Cicero's philosophical education was, for most practical purposes, complete by the time he began to write his speeches for the law-courts. He explains which aspects of it he applied to his oratory (*Orator* 16):[9]

[9] Cf. *Brutus* 152 ('necessary for students of the law'). Von Albrecht *CS* 228–232 discusses the schools and aspects of philosophy that influenced the training of the orator. These latter include ethics, psychology, and dialectic. See further A. Michel, *Rhétorique et Philosophie chez Cicéron: Essai sur les fondements philosophiques de l'art de persuader* (Paris, 1960).

Surely without philosophical training we cannot distinguish between the genus
and the species of anything, nor define it nor divide it into subordinate parts,
nor separate truth from falsehood, nor recognize 'consequents', distinguish
'contradictories' or analyse 'ambiguities'.

This choice of 'topics' (see Cicero *Topica* 13–14, 20–1) shows that, at
least in Cicero's mind, the long-standing quarrel between philosophers and
rhetoricians was at an end. An orator needed the tools and techniques of
semantics and dialectic in order to clarify (or occasionally to obfuscate) his
arguments and define his case. Cicero returns to the subject of the affinity of
rhetoric to dialectic, enlisting the authority of Aristotle *Rhet.* 1.1, in *Orator*
113–5. But in the sequel to this passage he broadens the philosophical
compass to embrace ethics (118):

> He should not confine his study to logic, however, but have a theoretical
> acquaintance with all the topics of philosophy and practical training in
> debating them. For no explication of matters concerning religion, death, piety,
> patriotism, good and evil, virtues and vices, duty, pain, pleasure, or mental
> disturbances and errors – subjects which often come up in lawsuits but are
> usually treated inadequately – is possible without philosophy.

The orator's cultivated audience expected him to deal with these subjects in
a morally uplifting manner (119). Earlier in his career, Cicero seems to come
close to the uncompromising position of the Elder Cato, who defined the
orator as 'a good man endowed with eloquence' (*vir bonus dicendi peritus*),
when he affirms (*De Inv.* 1.1) that 'eloquence without wisdom is highly
damaging'. With the passage of time, realism takes over. In *De Oratore* he
makes no sustained attempt to link his orator's skills with morality, confining
himself to a single mention of it (*III* 55). And later, he requires his ideal orator
only to observe 'appropriateness' (*decorum, Orator* 70). This means that a
speech should elicit approval and avoid offence through judicious choice of
subject-matter and style, which could be subsumed under the description of
'what is fitting and agreeable to an occasion or person' (id. 74). The orator
did not necessarily need to be a 'good man' in order to achieve this effect,
but only to appear to be so. But mastery of the techniques of argument and
style could not be feigned: that branch of philosophy must be his constant
companion.

Yet when the orator came to face the stressed and occasionally
tumultuous ambience of the law-courts, his 'knowledge and understanding

of philosophy' manifested itself most noticeably in ethical pronouncements. These took the form of observations, didactic or prescriptive in character, on human behaviour and the human condition. On this level, the thought is not traceable to a particular school or doctrine. An early example of this mundaneness is *Pro Rosc.* 75, where the idea of the innocence of rustic life is adduced as a probability-argument for the defendant's innocence. Its force is derived from observation of normal human behaviour in given conditions: 'Crimes [such as murder] do not usually arise from the country way of life... but in the city luxury is created, and from luxury comes greed, and from greed rashness, and from this are engendered all kinds of misdeeds'. This is how societies have been seen to develop throughout human history, and, for thinking men such observation forms the material from which they must construct the prescriptive theories on which they base their teaching. In Cicero's speeches philosophical thought remains at this practical level for the most part, and its elementary, homespun character is mirrored in the style of the writing.

In *In Verr. II* 1. 38, the general question of the effect of individuals' behaviour on the stability of society arises from an action described in the narrative. It concerns trust: 'No wise man ever felt that a traitor could be trusted...[Sulla] gave him not the trust due to a friend, but the fee due to a traitor'. In other examples the gnomic character of the generalization may be more pronounced. In *Cat. IV* 3: 'A brave man's death cannot bring dishonour, a consul's cannot be before its time, a philosopher's cannot bring sorrow'. On a more prosaic note, in *Post Red. Ad Quir.* 22: 'It is indeed easier to avenge a wrong than repay a kindness'. The thought may take a more rhetorical form, as when in *Pro Marc.* 27 he says: 'For what, in any case, is the significance of the same word 'long'[sc. life], if it involves an idea of finality? When that comes, all past pleasure counts for nothing, because there shall be none thereafter'.

The richest repository of this kind of philosophical thought is the *Philippics*, Cicero's latest oratory, written soon after his major philosophical works when he was in his sixties. Although they do not always achieve the depth of insight found in those treatises, they range over a wide variety of ideas:

IV 13: 'Nature has indeed decreed death for all men, yet against a cruel death and dishonour, bravery, which is a property peculiar to the Roman race and seed, ever affords a defence.'

V 31: 'every evil is easily crushed at birth, but as it ages to maturity, it gathers strength.'

X 20: 'We must struggle for liberty at the risk of life: for life does not consist merely of breath – it does not exist at all in slavery.'

XI 9: 'For in proportion as the strength of the mind is greater than that of the body, so those ills are more severe that are contracted in the mind than those which are contracted in the body. More wretched then is he who incurs the guilt of a crime than he who is compelled to undergo the misdeed of another.'

XI 39: 'For nothing flourishes for long; age follows on age.'

XII 5: 'Every man is prone to error; it is the part of a fool to persevere in error; later thoughts, as the saying is, are the best.'

XII 25: 'Those engaged in public affairs should leave behind them in death a glorious name, not the opportunity to criticize their faults and blame their folly.'

XIII 1: 'The very name of peace is sweet, while peace itself brings not only delight but safety.'

XIII 6: 'But, it may be said, the issues of war are uncertain. It is surely the part of brave men, as you should be, to display courage, and not fear the whims of fortune. But since from men of our class not merely fortitude, but also wisdom is required, fortitude bids us fight, it kindles righteous hatred, it impels us to conflict, it summons us to danger. But what does Wisdom say? She employs more cautious counsels, she looks to the future, she is in every respect more guarded. What then was her opinion? For we must obey, and judge to be the best that conclusion which is most wisely conceived.'

In *XIII* 45 Cicero draws a caricature of Antony speaking like a philosopher (*incipit philosophari*): 'If, as I tread the path of an upright purpose, the immortal gods shall, as I hope, assist me, I will gladly live. But if another fate await me, I anticipate joyfully the punishments that you will suffer. For if, when conquered, the Pompeians are so insolent, what they will be like as conquerors it is for you to discover.' Here the sequel shows that this particular 'philosopher' is misguided, but his tone is clearly recognizable.

To this philosophical portrayal of attitude, behaviour, and morality, is to be added a strong prescriptive element. This is present in *In Verr. II* 3.161–2, where the subject is the purpose of education: 'You begot your children not only for yourself, but for your fatherland, that they might not be merely a pleasure to yourself, but, in due season, do good service to their country'. The prescriptive element is stronger in more extended passages, like *Pro Mil.* 17: 'Was there, then, any special process proposed for enquiry into

Africanus' death? None, assuredly. Why so? Because the guilt of murder does not differ when the victim is renowned and when he is obscure. In life let there be a distinction of standing between the highest and the lowest; but let death at least, when criminally inflicted, be subject to penalties and laws which shall be invariable.'

In certain cases the prescriptive force is implied rather than overtly expressed. In *Pro Planc.* 68: 'A pecuniary obligation is very different from a moral obligation. He who discharges a debt ceases to possess that which he has repaid; while he who remains a debtor keeps what does not belong to him. But in moral debt, when I pay I keep, and when I keep I pay by the very act of keeping.' The argument has its own logical force: exhortation is unnecessary. In the same speech there are discussions of 'gratitude'(81), and (90) on the fear of death he says: 'I have always thought that those who sacrifice their lives for their country have not died so much as achieved immortality'. This is a commonplace sentiment, observing a general truth about what men think, but also expressing a kind of faith in positive human qualities, to which his audience is invited to aspire.

Discussion of the tenets of the different schools of philosophy finds a place in the speeches only where the context requires it. It usually takes the form of criticism of other men's misapplication or misinterpretation of the orthodox doctrines, as part of a wide-ranging attack on their characters. Of these doctrines, Epicureanism had the most obvious allurements, positing, as it was popularly and simplistically thought to do, that the ultimate aim in human life was pleasure. Epicurus founded his school in Athens at the end of the Fourth Century BC, when the failure of the Greek city-state was a matter of observable fact. His reaction to this was to counsel abandonment of the corporate political life and withdrawal to secluded surroundings, where the student could share his life with like-minded people. From this community (the 'Garden') ambition was banished, so that it became free also of material greed, and the love of power. This might be congenial to some, but many Romans in the First Century knew that any decision to opt for the quiet life was fraught with dangers and uncertainties. For Cicero, the *novus homo*, those uncertainties were acute. For him choice of the contemplative or hedonistic life would have led to obscurity, and probably to poverty as well. Moreover, he was ambitious; and at Rome as elsewhere, ambition demanded exposure and participation, especially as he started his career without the advantages of membership of an established senatorial family. The luxury of greater detachment could, however, be afforded by

the patrician L. Calpurnius Piso, Caesar's father-in-law. His version of Epicureanism is the subject of Cicero's severest criticisms of the sect. The first of these is in *Pro Sest.* 23;

> He [Piso] praised most those philosophers who are said to be above all advocates of pleasure; what pleasure, and when and where acquired, he did not question: he had swallowed the single word with all his heart and every part of his body. He added that these same men were quite right in saying that the wise do everything in their own interests; that no sane man should engage in public affairs; that nothing is preferable to a life crammed with pleasures; whereas those who said that men should aim at an honourable position, should consult the public interest, should think of duty throughout their life and not of self-interest, should face danger for their country, receive wounds, welcome death: these he called visionaries and madmen.

Cicero clearly identified himself with these 'visionaries and madmen'. But he also saw himself as the victim of this Epicurean detachment, because Piso's effortless accession to the consulship, followed by passivity, left Clodius with *carte blanche* to pursue his enemy Cicero into exile. The consul's philosophical beliefs had become a matter of vital personal concern to Cicero, who had thought Piso was his friend. Hence the sustained venom of his invective against him, but in the course of it he approaches Epicureanism from a number of angles. One allegedly Epicurean idea is encountered in *Ag. Pis.* 42:

> If I were to see you and Gabinius [Piso's fellow-consul] crucified, should I feel a greater joy at the laceration of your bodies than I feel now at that of your reputations? For nothing should be regarded as a punishment that, by some mischance, good and brave men may find inflicted on themselves.

Here the idea of undeserved punishment being incapable of causing pain or mental distress, a popular tenet of Epicureanism, is approached obliquely, the purpose being to argue that Epicurus could not be invoked in the present case, because Piso would thoroughly have deserved his punishment. In another passage (59–67), Piso is subjecting his son-in-law to an Epicurean tutorial on the vain futility of ambition, It begins:

> 'What, Caesar, is the strong attraction that these dedicated thanksgivings [sc. for military victories] of such frequency have for you? The world is under a deep delusion about them, the gods care nothing for them, for they, as our

godlike Epicurus has said, feel neither kindness nor wrath towards anyone.'
You will scarcely carry conviction with such arguments; for towards you he
will see that they have shown anger, and still do.

This leads to the clever device of making Piso amplify his argument by
describing the under-achievement of his own career, which has earned
him nothing but contempt, according to Cicero, who goes on to contrast
it with those of some of his contemporaries. Piso's avoidance of exertion
and possible pain is in tune with contemporary Epicurean taste, at least as
propounded by Piso's Greek associates, who seem to have indulged his own
eclecticism (70: 'His Greek teacher was far too charming and complaisant
to have any notion of standing up to a senator of the Roman People'). Both
teacher and pupil ignored the more austere side of Epicurus' doctrine, which
rejected the various forms of sensual pleasure as potentially painful, and
the arts as not contributing to happiness. Its Roman critics dwelt on the
extreme consequences of following these tenets: simplicity led to lack of
culture, even crudeness; while freedom and individuality led to licence. The
kind of controversy that could arise from such simplistic definitions of the
conflicting schools is well illustrated in *Pro Cael.* 41:

> Some [the Epicureans] have said that the wise do everything for pleasure, and
> there are learned men who have not recoiled from this disgraceful statement;
> others [the Academics and Perpatetics] have imagined that virtue can be
> combined with pleasure, so as to unite by the wit of words two things which
> are to the highest degree incompatible; and there are those [the Stoics] who
> have shown that the only direct path to glory is the path of toil – and they are
> now almost completely confined to their lecture-rooms.

The central point of interest in this passage is that, while he is in varying
degrees dissatisfied with all the major philosophical doctrines, Stoicism
had the largest number of features that were attractive to him, as it was to
other statesmen in the mainstream of Roman politics. Detailed discussion
of Cicero's philosophical works lies outside the scope of this study. It will
suffice to note their frequently expressed preference for Stoic doctrines.

In the trial of L. Licinius Murena for corrupt electioneering (*ambitus*),
the chief prosecutor was M. Porcius Cato, a sectary of Stoicism. As usual,
Cicero's approach is adapted to suit the needs of the case: whereas elsewhere
(*e.g. Paradoxa Stoicorum* Pref. 4) he praises its doctrines, in this trial he
criticizes its dogmatic inflexibility (61):

For there was a man of genius, Zeno, and the disciples of his teaching are called Stoics. Here are examples of his maxims and precepts: the wise man is never moved by favour, never forgives anyone's misdeed; only the fool or the trifler feels pity; a real man does not yield to entreaty or appeasement; only the wise is handsome, however misshapen, rich however needy, a king however much a slave. We who are not wise are according to them runaways, exiles, enemies, or even madmen. All misdeeds are equal; every disdemeanour is a heinous crime. The casual strangling of a cock is no less a crime than the strangling of one's father. The wise man never 'supposes' anything, never regrets anything, is never wrong, never changes his mind. Marcus Cato, with his outstanding intellectual gifts, was induced by these sages to seize upon this doctrine not just as a topic for discussion, but as a way of life.

Here Cicero deliberately chooses some of the popular travesties of the doctrine, and the Stoic sage here portrayed is an incomplete, inhuman person with whom it is easy to find fault, as his brief in this particular trial requires him to do. But under a different brief (*Pro Balb.* 3), he is even prepared to contradict those who dissent from Stoic doctrine:

I am now convinced of the truth of the saying, which when put forward by some of those who are devoted to literature and the study of philosophy seemed to be incredible, that for a man who has established in his soul a firm grasp of all the virtues, everything that he does turns out well.

This corresponds with the second essay in Cicero's *Paradoxa Stoicorum,* which posits that a man's possession of virtue guarantees his happiness, whatever physical pain he suffers. He seems to have gone out of his way here to make a philosophical point, since the only reason for introducing 'virtue' here is to praise Pompey.

Cicero rarely states philosophical dogma in such clear terms as this in the speeches. We must return to his criticisms of other people's interpretations of it. Avowed Stoics and Epicureans are not his only targets. Addressing Vatinius in his invective (*In Vat.* 14) he says:

You are in the habit of calling yourself a Pythagorean, and of hiding your ferocious and barbarous manners behind the name of a profound scholar. Pray tell me, however much you have engaged in unknown and sacrilegious rites, and become accustomed to call forth spirits from the underworld and to appease the infernal deities with the entrails of boys, what madness led you to show contempt for the auspices under which this city has been founded, upon

which the whole state and its authority depend, and to declare to the Senate, in the first days of your tribunate, that the pronouncements of the augurs and the pretensions of their college would be no obstacle to their undertakings?

Pythagoreanism was associated with mysticism and metempsychosis, and was not primarily concerned with codes of conduct. It was widely misunderstood and misinterpreted, and societies formed by its sectaries were viewed by some with suspicion and even abhorrence. Here Cicero introduces Vatinius' Pythagoreanism to explain his misconduct of his official duties. So this is another example of how misguided addiction to philosophy can adversely affect a statesman's performance.

Whereas he could reject or criticize the tenets of the philosophical schools in his speeches, Cicero expounds and appears to endorse some of them in his academic treatises. The absolutism of the Stoics which he pronounced too extreme in the *Pro Murena* appears in more or less diluted form in the *Paradoxa Stoicorum,* while in the *De Finibus Bonorum et Malorum,* he gives balanced accounts of the main philosophical dogmata and sets out his objections to each.

Cicero displays no such ambivalence in his attitude to the other main branch of philosophy. As has been observed, he knew that one cannot argue properly without knowledge of logic (*dialectica*), so that it is an essential part of an orator's equipment. Earlier speakers, just like Cicero himself (*Brutus* 309), had found training in it, via the philosophical schools, especially those of the Stoics, indispensable (*Brutus* 94, 116, 117–21, 152–3, 175, 306, 315). Examination of his speeches reveals the specific logical topics which he used in them.[10] They may be listed as follows:

(1) Definition: applied to key words in an argument to distinguish meaning, and also genus from species (*De Orat. II* 164, *Topics* 9, 26–9, 83).
(2) Analogy (*De Orat. II* 166, *Topics* 15) and Comparison (*Topics* 23, 41–5).
(3) Contradictories (*De Orat. II* 166, *Topics* 17, 41–9) and
(4) Inconsistencies, leading to Absurdity.
(5) Ambiguities.
(6) Consequence: the process of deduction (*Topica* 23, 53–7).

Turning to examples of these topics, we find definition in action in *Pro*

[10] Cicero saw no boundary between the domains of rhetoric and dialectic. His wide use of dialectic is noted by Powell *CA* 48, with dilemma as 'the most pervasive and spectacular' species. Difficult to classify, it probably falls under the head of Inconsistencies, which Cicero does not explain in his *rhetorica*. For this connection, see Quint. 5.8. 30, 33.

Caec. 48–9, where it is applied to the quibbling argument of the prosecutor Aebutius, who has prevented Caecina from physically laying claim to the property in dispute. The use of force to effect the exclusion would have left him open to the charge of 'ejectment by the force of arms', so he has resorted to two sophistical arguments: that Caecina was not 'ejected', but 'excluded'; and that actual force was not used. Aebutius is induced dialectically to accept the defendant's refutation of this argument (48):

> Come now, Aebutius, you shall yourself pronounce judgement on the question of force. Answer me, if you please. Was Caecina in fact unwilling to enter the estate, or was he unable? In saying that you withstood my client and drove him back you admit that he had the will to enter it. Can you, then, say that it was not force that barred him, when he was prevented from entering by a gathering of men, although he desired to enter, and had come there with that intention? For if he was unable by any means to do what he was very keen to do, then some force must inevitably have prevented him; otherwise you must tell me why, when he desired to enter, he was unable to do so.

With this part of the refutation complete, the argument progresses to its next stage (49):

> Now you cannot deny that force was used: the [next] question is how, since he failed to enter, he was 'driven out'. For if a man is to be driven out, he must necessarily be removed and displaced. But how can he be, if he has never once been in the place from which he claims to have been driven? Well, suppose that he had actually been there and had fled in terror at the sight of armed men, would you say that he had been driven out? I think you would. Will you, then, who deploy such skill and ingenuity to decide disputes by the letter and not the spirit of the law, and who interpret laws in the light rather of their wording than of the general good – will you, I say, bring yourself to state that a man has been driven out without having been touched?

This argument, which develops into one on the spirit and the letter of the law, is carried to absurd lengths in the following passage, in which he finally establishes that his adversary's quibbling manipulation of language should not be allowed to obfuscate and frustrate the purpose of the legislator or the intention of the law. Later in the same speech (88), Cicero explains the intention behind the wording of the law, and illustrates how it would apply in a specific case.

Further examples of the topic of definition occur in *Pro Cael.* 6

(*accusatio, maledictio*) and 30 (*crimina, maledicta*), *Phil. II* 5 ('benefaction' (ironic)), and *Phil. VIII* 2–3 (*bellum* and *tumultus*, where it is central to the discussion).

More numerous are examples of the standard comparative argument, in which the greater is deduced from the lesser, or the lesser from the greater. In *Pro Sulla*, Cicero says:

> If in your eyes we whose names have become familiar to this city and a common topic of men's talk are foreigners, how much more so will be those fellow-candidates of yours who are the élite of the whole of Italy and are now going to contend with you for office and every position of importance? (24)
>
> But if that first piece of information had any substance, ought it to have carried more weight when it was old than when it was fresh? (81)

Likewise, in *Pro Flacc.* 17:

> If behaviour like this used to occur regularly in Athens when she outshone not just the rest of Greece but virtually the whole world, what restraint do you think existed in the public meetings of Phrygians and Mysians?

Further examples of this type of argument are to be found in *De Dom.* 46, 140, *Pro Mil.* 37, *Phil. VII* 18, *XII* 15, *XIV* 11, 12, 13. It will be noted that there is a moral element in some of these examples. This is even more pronounced in *Pro Mur.* 3, where Cicero answers Cato's criticism of him for undertaking Murena's defence:

> I ask you, Marcus Cato, who is more appropriate to defend a consul than another consul? Who in the Republic should be more closely tied to me than the man to whom, after defending it with such efforts and at such peril to myself, I am now handing it over to preserve? If, in a case for the recovery of goods which have been sold under contract, a man has assumed the contractual obligation should incur the risk of a court decision, then it is surely even more appropriate in the trial of the consul-designate, that the consul who has declared his election should, above all, be the guarantor of the office conferred by the Roman People, and defend it from all danger.

Here the comparative argument reinforces the logic, and there is an underlying sense of moral obligation.

Contradictories do not appear to be exemplified as a distinct class in the speeches, but inconsistencies manifest themselves in several forms. In *Pro Cluent.* 61 the inconsistency of two verdicts is exposed by questioning.

In 170–1 of the same speech there is an array of improbabilities designed to destroy the prosecution's contention that Cluentius had clear motivation for murdering Oppianicus. These are arguments that the actions alleged are inconsistent with reason. A similar relationship between inconsistency and improbability is to be noted in *Pro Rab. Post.* 31 and 39. Another illustration of this relationship is *Pro Marc.* 21, where Cicero questions the logicality of Caesar's paranoia:

> Who is the madman who is on your mind? Is it one of your own friends? – and yet who are more truly your friends than those to whom you have restored a security for which they dared not hope? Is it one of those who were once on your side? It is a madness unbelievable in any man that he should not count his own life of less value than that of one under whose leadership he has realized all his highest aspirations?

The sequence of suggestions (*hypophora*) turns now to 'enemies', and these are likewise dismissed. Cicero uses a more complex form of this argument in *Pro Reg. Deiot.* 18–19, where the charge that the king had intended to poison or assassinate Caesar is refuted by showing that both his actions and the sequence of events were incompatible with such a plan. Cicero succeeds in investing the whole episode with a degree of absurdity (21).

The orator's purpose in drawing attention to absurdities might simply be to cast ridicule on the proceedings, as in *Pro Sull.* 31; or it might be designed to suggest that the actions alleged did not take place, as in *Pro Sull.* 57. Or the absurdity may arise purely from the deductive process, as in *Pro Planc.* 8:

> It does not follow that if a candidate has been passed over by the people, who should not have been, he who has not been passed over ought to be condemned by a jury. For if this were so, our juries would virtually possess a power which in the days of our ancestors the patricians were unable to retain, the power of passing their censure upon elections.

In *Phil. II* 18 Cicero summarizes some mutually contradictory statements which Antony has made in a speech, and thereby casts doubt on his credibility in general. It is an effective weapon for this purpose, and it is perhaps surprising that he does not use it more frequently.

By its nature, *dilemma* is the most destructive of logical arguments, because, even in its simpler form, it devises a double trap or defeat for the opponent:

If [the Dorylaeans] had produced the genuine records, there was nothing with which to accuse Flaccus; if the forged records, there was the penalty awaiting them. (*Pro Flacc.* 39)

If the offence lies in the fact that he was the first to vote, do you impute this fact to chance, or to the proposer of the law? If you impute it to chance, then you have nothing with which to charge *him* [Plancius]; if to the consul, you establish that our leading citizen judged Plancius to be the leading man of his order. (*Pro Planc.* 35)

If you assert that Ninnius' proposals, so directly affecting you as they do, should be held invalid, you created in your memorable tribunate a precedent to which you take exception when applied against you, but which you apply against others to their detriment. But if your consecration is legally valid, what part of your own property can be held to be unconsecrated? (*De Dom.* 125)

As it is, what outrage, I ask, are you seeking to avenge, yours or the state's? If the state's, how will you explain your perseverance in that cause? If your own, see that you do not fall into the error of thinking that Caesar will show anger against *your* enemies, when he has pardoned his own. (*Pro Lig.* 29)

If then Caesar [Octavian] was an enemy, why was the matter not raised with the Senate? But if Caesar was not to be thus stigmatized by the Senate, what can Antony say except that, in keeping silent about Caesar, he confessed himself to be an enemy? (*Phil.III* 21)

If in that war he [sc. Deiotarus] made a mistake, that mistake was shared by the Senate; if his judgement was right, we should not abuse even a vanquished cause. (*Phil.XI* 34)

Added complexity confers even greater force upon a *dilemma*:

There is surely one point which no one, however hostile to Cluentius, would fail to concede me: if it is agreed that bribery was used in that case, it was used either by Habitus [Cluentius) or by Oppianicus. If I show you that it was not used by Habitus, I gain my point that it was used by Oppianicus. If I demonstrate that it was used by Oppianicus, I clear Habitus. (*Pro Cluent.* 64)

In the last example Cicero is using *dilemma* to achieve a positive result for himself, though of course the effect is to undermine his opponents' position.

Dilemma can be equally effective in the political sphere, as when

logically destroying the position adopted by an opponent while undermining his moral credibility (*Phil. III* 21–2):

> When Antony does not venture to make a motion about the man who was marching against him with an army, though he was consul, what else is this than to judge himself a public enemy? For necessarily one or the other was an enemy: no other judgement of the opposing leaders was possible. If then Caesar [Octavian] was an enemy, why was the consul not to refer the matter to the Senate? But if Caesar was not to be so censured by the Senate, what can Antony say but that, in keeping silent about Caesar, he confessed himself to be an enemy?

Logic and morality combine again when, in political argument, the charge of inconsistency is being debated. In *Phil. VII,* when Cicero is defending his rejection of peace with Antony, he argues (10):

> But perhaps, when you decreed honours to Caius Caesar [Octavian], honours that were indeed deserved and merited, but were none the less extraordinary and memorable, for the sole reason that he has assembled an army against M. Antonius, you did not then adjudge Antonius an enemy? And Antonius was not then adjudged an enemy when by your authority the veterans that had followed Caius Caesar were commended?

He goes on to cite the instances of other leaders' patriotic acts (11–12), all confirming the thesis that Antony was the prime enemy of the Roman People, and no form of accommodation could be reached with him.

The representation of both the main branches of philosophy, in roughly equal measure, in Cicero's speeches is explained well in his own background and statements. The New Academic Philo of Larisa, one of Cicero's earliest teachers, taught both philosophy and rhetoric (apparently on the same day (*Tusc. Disp.* 2.9)); while the sheer volume of Cicero's writings on the ethical side of philosophy confirms the importance which he accords it. His characterization of philosophy as 'the mother of all good deeds and words' (*Brutus* 322) seems to indicate that, in the choice of subject-matter for his speeches, its teachings in ethics were most important, and were comprehensively influential. But the whole area of philosophy, like other branches of culture, afforded him additional opportunities to show his knowledge and win debating points off his opponents. Hence the discussions of individual doctrines found their way into suitable contexts. At the same time, the branch of philosophy that shaped his technical development as an

orator was logic, and its application in 'the topics of reasoning and argument' (*Orat.* 44, cf. 113), was central to the ideal orator's training. This explains his statement in *Orat.* 12, where he writes: 'Whatever ability I possess as an orator comes, not from the workshops of the rhetoricians, but from the spacious grounds of the Academy'. He notes (15) that the best Greek orators (Pericles and Demosthenes) were trained in philosophy, from which they learnt how to enrich their style and arouse emotions. Later (113) he firmly places the 'science of logic' in his ideal orator's programme of study, before adding other branches of philosophy to it (118–9). This priority corresponds with his deployment of those two branches in the speeches: dialectic is pervasive, whereas discussion of ethics and the philosophical schools is occasional.[11]

(d) Law

In republican Rome, law (*lex*) was the handmaid of justice (*ius*), and *leges* ('statutes') formed the main body of the laws of the state (*ius civile*, defined by Cicero (*Topica* 28) as 'statutes, decrees of the senate, judicial decisions, opinions of those learned in the law, edicts of magistrates, custom, and equity'). Since justice arose from human nature itself (*De Leg. I* 17), the laws that men made had to be interpreted by men, constantly added to in the light of events, and continually tested by the criteria of justice and fairness. Making laws and enforcing them without reference to these criteria is the licence of a tyrant (*De Leg. I* 42). Bad laws could be made at any time, and these should be abolished (*De Leg. II* 13). Literal application of laws through failure to take particular circumstances into account could actually lead to injustice (*De Off. I* 33 (*summum ius summa iniuria* ('[application of]the letter of the law can produce extreme injustice')). Laws were to be seen as organic and flexible, with the result that their application provided much useful employment for jurists, and also factual and rhetorical material for advocates. Hence a thorough grounding in *ius civile* was essential in the

[11] For good modern discussions of Cicero's philosophical writings see J. G. F. Powell (ed.), *Cicero the Philosopher: Twelve Papers* (Oxford, 1995). See also A. E. Douglas, *Cicero the Philosopher*, in T. A. Dorey (ed.), *Cicero* (London,1964) 135–70. On *dilemma*, see C. P. Craig, *Form as Argument in Cicero's Speeches: a Study of Dilemma* (Atlanta, 1993). Craig includes parallel (si...si, aut...aut) arguments in which the 'double-catch' force may not be strong, but which he describes as 'dilemma form', 'dilemma structures', and 'narrative dilemma'. Consequently he cites many more instances of *dilemma* than are recognized in the present study.

latter's training. In his legal studies, Cicero followed the informal method traditionally adopted in Rome. He attached himself to Quintus Scaevola, 'who though he took no pupils, yet by the legal opinions given to his clients taught those who wished to hear him' (*Brutus* 306). By choosing this Scaevola (cos. 95 BC and Pontifex Maximus), Cicero probably obtained the best legal training available.[12] But this training was still unsystematic, and he received it in the company of men like his friend Atticus (*De Leg. I* 4.13), who did not intend to proceed to a career in law. His attitude to the question of the importance of legal training and knowledge is to some extent conditioned by the fact that some of his more learned contemporaries were semi-professional jurisconsults. He does not expect the trainee orator to match their expertise,[13] and considers that he does not need to do so himself, since his profession is superior to theirs (*Orat.* 141: 'Will anyone ever doubt that in a peaceful civil life eloquence has always held the chief place in our state, and jurisprudence has been of secondary importance?'). It is no more than common sense, however, to concede that knowledge of the law at a practical level is essential for an advocate (*Orat.* 120: 'He should understand civil law, which is needed in the daily practice of the courts of law. What is more disgraceful than to attempt to plead in legal and civil disputes when ignorant of the statutes and the civil law?'). This ambivalence has already been foreshadowed in *De Oratore*, where the subject is sufficiently important for its two sides to be investigated.[14] In *I* 185–200, Crassus recommends the study of the law to an orator, but he begins by insisting that it is not a difficult subject. Yet, as its ramifications unfold – its taxonomy, its associations with other disciplines, its influence on them, and the authority which its experts acquire – it becomes increasingly attractive to the student; but the idea of its relative ease fades significantly. When Antonius comes to argue the contrary case (*I* 234–45), he draws attention to the difficulties of interpretation that bedevil the legal statutes,[15] which leave the way open for raw eloquence to triumph; and he

[12] Scaevola was 'the real founding father of civil law', (Fantham, *RWCO* 111), because he assembled the current corpus of it and edited it in eighteen books, providing litigants with authoritative pronouncements and precedents. He also revised the old laws (*De Leg.* II 49– 53).

[13] Fantham, *RWCO* 107 describes Cicero's introduction of 'knowledge of law' in *De Orat.* I 18 as 'somewhat modest'. It appears in the form of a litotes (*neque legum ac iuris scientia neglegenda est* ('nor should the learning of statutes and of the law be neglected').

[14] Fantham, *RWCO* 102–132; J. Harries, 'Cicero and the Law', in Powell and Paterson *CA* ch.5 151–5; and *Cicero and the Jurists*, (London, 2006).

[15] See Harries cap. cit. 151–2; and esp. 156–7, where she writes: 'Advocates worked in the

points out that it is only cases that hinge on such uncertainties that come to court (241). Antonius (Cicero?) concludes with examples from Crassus' own cases in which his opponent's legal subtleties had failed to win against his geniality, wit, and humour (243). Thus both men – Antonius in theory, and Crassus in practice – recognize the primacy of oratorical skill over pure legal knowledge. Cicero's own choice, where possible, of appearing as the last speaker (*Orat.* 130) is also explained by this recognition. By leaving the more technical parts, including the discussion of laws, to previous speakers, he could concentrate on what he did best, arousing the jury's emotions and regaling them with his wit. And he knew that these rhetorical skills would make him more popular and electable than mere legal expertise.

The limited utility of purely juristic knowledge is argued most forcefully in *Pro Murena,* where the defendant's unsuccessful opponent for the consulship is P. Sulpicius Rufus, one of the most distinguished jurists of the time. The arguments are tailored to the case: that legal knowledge is of no use for promoting a political career, and that lawyers, by choosing to make their knowledge and procedures private and recondite, had cut themselves off from the people, even appearing arbitrary and tyrannical (25). Then there are more general criticisms of lawyers: that they had undermined perfectly workable procedures by their subtleties (27), that their learning was of little practical use outside the courts, and that the difficulty of their subject had been greatly exaggerated. Cicero claimed that he could set himself up as a legal expert in three days (28; cf. *De Orat.I.* 191–2). So he appears to have a poor opinion of jurists. But it must be remembered what he is arguing about in these passages.[16] He is comparing, as candidates for the consulship, a man who has served Rome as a general (his client Murena) with one who has been a servant of the law (Sulpicius), and presses his point home by arguing that the only worthy opponent of a general is an orator: the former is supreme when the state is at war, the latter in peacetime (30).

Cicero's ideal orator is fully equipped to explain all legal matters that are likely to occur in trials. While he must steer a course that avoids the appearance of excessive cleverness (*Orat.* 145: 'practical knowledge is pleasing to men, but a clever tongue suspect'),[17] he must have a working

wide disputed space between the limited guidance offered by written authorities and the amorphous provisions of *aequitas* and *consuetudo.*'(For definitions of these, see n. 19).
[16] Paterson makes this general point (*CA* 38): 'any statement by an advocate must be seen in the context of what he was trying to achieve in the speech'.
[17] In *De Orat.* 2.4. both Crassus and Antony are portrayed as trying to avoid this suspicion,

knowledge of the laws or risk defeat. It can be contended that Cicero had more than that.[18] Again and again he shows himself comfortable, and more than competent, in discussing legal procedure, the historical background of individual laws, their texts and their interpretation; as is seen in the following examples

In *Pro Quinct.* 30–1, he shows how the application of a relevant praetorian edict had been 'novel' (*novum*), and how its ambiguity had been exposed by his client and by other observers. In *Pro Rosc.* 62–72, the difficulties of following correct legal procedures in cases of patricide are considered at length, in the light of the terrible punishment ordained for this atrocious crime. In particular, the evidence for it must be completely watertight, as the recent failure of such a case shows. In the same speech (111–5) there is a discussion of the historical background to the laws concerning breach of contract, as a basis for comparison with the present case. Similarly, in *Pro Tullio* 9–11, the scope of the *Lex Aquilia* is defined, and later discussed (41–2). In *In Verr. II* 1. 26–7, he explains a law dealing with the procedure for adjourned and second hearings, which he is proposing to revive for the purposes of the present case. In the same speech (106–7), he tells how Verres misinterpreted and misused a law, pronouncing a will illegal in order to benefit from the estate himself. He then defines the time scale in which laws operate (109–10), and hence how the rules had been infringed by Verres (115). Other examples of the discussion of legal procedure include *Pro Cluent.* 116, where he describes how the procedure for assessing penalties works in practice. He says that, in giving their verdict, jurors tend to pay scant attention to such assessments, and this sometimes results in severer penalties than the original conviction seems to require. In *Pro Cluent.* 146–156, he protests at length against the prosecutor's attempt to apply a law regarding senators to his client, who is an eques. Again on the subject of procedure, in *Pro Mur.* 35 he argues that a precedent set in the earlier election for praetor should not be applied to the present election for the consulship. In *Pro Planc.* 41–2, he criticizes the procedure for selecting juries which the opponents have attempted to introduce in the present trial. In *Pro Rab. Post.* 8–10, laws concerning the recovery of money extorted by provincial officials are under discussion, and Cicero argues that new procedures for

the former by being seen to despise Greek learning, the latter by seeming not to have learnt anything at all.

[18] Harries, cap. cit. n. 14, 153 argues that 'knowledge of law in its most technical and even occasionally pedantic sense was part of his culture'.

tracing the stolen money were unjust. In *De Leg. Agr. III* 6–7, he speaks in graphic terms about the ongoing conflict between contemporary and past legislation over the whole question of land redistribution.

Turning from primarily precedural matters, examples in which Cicero shows his knowledge of the substance, background, and purpose of individual laws may be found in larger numbers. Many of these amount to little more than the simple citing of a law (*In Verr. II* 4, 41, *Pro Caec.* 95, *De Leg. Agr. I* 21, 26–8, *De Dom.* 33, 43, 50, *Prov. Cons.* 46, *Pro Balb.* 19, 20, *Phil. III* 16, *V* 8–10). But there are other more interesting passages in which there is more detailed and critical discussion. The most important of these are in *Pro Caecina, De Domo Sua,* and *Pro Balbo.*

In *Pro Caecina,* the defendant laid claim to an estate, and was opposed by Aebutius. In order to establish that claim formally, Caecina was to meet Aebutius on the land itself and submit to ejectment. Aebutius opposed the enactment of this legal process by posting armed men at the entrance. Against this Cicero has to complain that the law as it stands does not take account of the abuse that could hamper its implementation (33):

> I ask you, is there any legal process available in my case, or is there none? The collecting of men together because of the disputed ownership is not right; the arming of a mob in order to maintain a right is inexpedient; nothing is so inimical to private rights as force, nor anything so hostile to public justice as that men should be collected together and armed.

Unless measures are taken to ensure that the purpose and spirit of the law are observed, the just outcome cannot be achieved. In the meantime, Cicero has to do the best he can by analysing the text of the law, with particular reference to the use of the word 'ejectment', and the distinction (or lack of it, as the wording stands at present) between the threat of force and its actual use. This discussion, and others elsewhere, illustrate the unsatisfactory state of the drafting of Roman legal texts. These usually require verbal explanation in order to arrive at the intention of the legislator (53): '... for if our intention could be made clear without speaking, we should not use words at all; but because it cannot, words have been invented, not to conceal but to reveal intention.' In fact, a law can only define a principle, and the actions and situations to which it applied will require imaginative interpretation of its underlying purpose. In 54–68 Cicero illustrates this with examples, in which the understanding of the meanings of words is the key to the just operation of the law. In 80 he takes this a step further by describing how he discussed

this matter of the letter and spirit of the law with the legal expert who had devised the prosecutor's arguments. This is one of the few occasions when Cicero openly displays his own legal knowledge, saying that he 'quoted many instances, including many ancient precedents, to show that the justice and the principle of right and equity were often at variance with the actual wording of the law, and that decisions had always been based on the interpretation which was the best supported and the most equitable.'[19] In *De Harusp. Resp.* 32 the further issue of laws which are not written or codified, but sanctioned by nature, is raised, but not elaborated. One of these forbids men to assert rights of possession of property belonging to the gods.

In *De Dom.* 34–7 he states the law of adoption, showing how it is available only to those incapable of having natural offspring, and how this and related laws have been flouted by his adversaries. He then refers to the law governing augury, and how Clodius had flouted it or upheld it to suit his purposes (39–41). Clodius is also criticized as a drafter of laws, with his banishment of Cicero being shown to be flawed (51). Later the procedure leading to the dedication of the statue to Liberty on the site of Cicero's house is shown to have been irregular, because the ritual formulae were not observed (138).

In *Prov. Cons.* 46 it is necessary to quote the texts of the Aelian and Fufian laws in order to give a complete account of the precise circumstances under which laws can be passed:

> ...that a law cannot be passed on all days whereon public business is lawful; that when the law is being proposed, the sky can still be watched, that pronouncement of evil omens and veto by intervention is still permissible; that the censors' verdict and power of investigation and their most strict supervision of morals have not been removed from the state by pernicious laws...

Knowledge of these laws, which authorized the observation of auspices, and hence the suspension of state business, was essential for any aspiring legislator, but Cicero does not take for granted such knowledge in his audience of senators.

[19] The relationship between 'equity' (or 'fairness' (*aequitas*)) and law is mentioned only in passing in the surviving books *De Legibus* (I 19, 48), affirming that it is a concept arising from empirical human judgement of individual cases. In *De Off.* II 79 *aequitas* is used to characterize the long-term occupancy of property as giving the right of possession, which is not upheld by the law.

Laws concerning rights of citizenship are pivotal to the speech *Pro Balbo*. Cicero's handling of the legal technicalities that arise from examination of the *Lex Gellia Cornelia* and its antecedents has already been discussed (pp. 101–2). Here it is necessary to observe only that he relied on the sheer number of arguments, precedents, parallel examples, and laws, including some which were irrelevant, like the *Lex Julia* of 90 BC (21), and later examples of the conferment of citizenship by victorious generals and other famous figures of the past (46–55). Parts of the speech become a discussion of the historical origins of legislation on citizenship not only in Rome but elsewhere (30–1). Besides all this legal history Cicero also uses common-sense probability, arguing that the Gaditanes' services to Rome showed them to be staunch friends who were unlikely to reject privileges which other lesser allies had come to enjoy (40–44). It is notable that Cicero appears to admit that some of the legal arguments have been superfluous (56), and explains their deployment as a means of countering the hostility and prejudice which those jealous of Balbus have shown. But in most of his oratory he keeps discussion of the law to the necessary minimum. He explains his reason for doing this in *De Legibus* (*I* 12). There his brother Quintus suggests that, with advancing years, Cicero should become more a 'counsellor of law' and less an active advocate. Cicero rejects this, saying that excessive concentration on the law and its interpretation 'would be irksome to me not because of the labour involved, so much as because it would remove the opportunity of thinking about speaking itself' (*dicendi cogitationem auferat*). He is saying that he prefers to devote his energies to the artistic composition and delivery of his speeches, whose integrity would be disrupted by the lengthy discussion and analysis of laws. It is that undermining of his artistic purpose that he would find 'irksome' (*molesta*). Moreover, the study of law had engaged many minds before and during his lifetime,[20] and he felt neither able nor inclined to rival them. So he had two reasons to set limits upon his incursions into their territory. Exceptionally, in *Pro Balbo,* he expounds the law at length with a rhetorical purpose – in order to overwhelm with science and reason the irrational prejudices of his client's enemies.

[20] See Fantham, *RWCO* 109–10.

CHAPTER SIX

ELOQUENCE

(a) Humour

In the hands of the forensic orator, humour is a weapon,[1] its target is his opponent, and its ammunition is ridicule. Even in its apparently inoffensive form, as a display of wit which, by deploying such devices as verbal conceits and feigned extemporaneity, delights his audience and affords them diversion and relief from the tedious rigours of the case, the speaker is embarrassing his adversary and demonstrating his own intellectual superiority. Cicero acknowledges this essentially hostile purpose of humour in the summary reference to it in *Brutus* 322 : 'with a brief and pointed jest at his opponent's expense he was able to relax the attention of the court and pass for a moment from the seriousness of the business in hand to provoke a smile or open laughter'. But the whole topic of humour and the means of engendering it were difficult to define because of their subjectivity, and even more difficult to teach (*De Orat.* 2.217–8). Cicero does not attempt to deal with humour in *De Inventione,* and it is referred to only briefly in *Ad Herennium* (1.10). In his analysis of it in *De Oratore* (2. 216–8; cf. *Orator* 88), emphasis is laid on restraint, with preference given to gentle banter, because he associated it with good breeding (236). Quintilian confirms and amplifies this, warning against the use of wit to wound (*laedere*) (6. 3.28) because 'we should never make it our aim to lose a friend rather than a jest'. He is, as often, thinking of Cicero, who did not always follow his theory into practice, but made many enemies through embarrassing them with his crueller barbs (Plut. *Cic.* 27–8; Quintilian was aware of Cicero's reputation for this (6.3.3)). His wit could be not merely urbane, but scurrilously destructive. But before investigating this dichotomy further, it is necessary to observe some other distinctions.

In *De Orat.* 2.218, Cicero writes:

> There are, you see, two sorts of wit (*facetiae*), one running with even flow throughout a speech, the other pointed and concise. These are called by the ancient critics, respectively, *cavillatio* and *dicacitas.*

[1] Cf. the title of Fantham's chapter: 'Wit and Humour as Weapons' (*RWCO* 186–208). On humour as a manifestation of aggression, see A. Koestler, *The Act of Creation* (London,1964) 52–6.

These words translate respectively into 'banter', and 'witticism', the distinction being between humour that impregnates and suffuses a whole passage, and sudden, short, concentrated jocosity.[2] The aim of both is to evoke laughter or ridicule, occasionally as a way of expressing the speaker's indignation,[3] but more generally for the reasons outlined above. The strictures that Cicero applies to taste in humour are set out in *De Orat.* 2. 238–9:

> All subjects of ridicule are found among the blemishes noticeable in the conduct of people who are neither objects of general esteem nor yet full of misery, and not apparently fit to be hurried off to execution for their crimes; and these blemishes, if deftly handled, raise laughter. In ugliness, too, and in physical blemishes, there is good enough matter for jesting, but here as elsewhere the limits of licence are the main question. As to this, not only is there a rule excluding remarks made in bad taste, but also, even though you could say something with a highly comical effect, an orator must avoid each of two dangers: he must not let his jesting become buffoonery or mere mimicry.

The dignity of the courtroom and the rostrum must never be flouted, even for a moment, by allowing it to resemble the comic stage. But the orator can observe these restraints and still draw on a rich store of humorous devices. The most fertile of these would have been familiar to him from his studies of rhetoric: irony and sarcasm[4] (which is by far the commonest form of humour of both the instant and the pervasive kinds), and their close relative *para prosdokian* (the unexpected twist); imitation, analogy (especially using simile), double meaning (*double entendre*), ambiguity, altered meaning of words. Cicero's summary of the devices of humour (*De Orat.* 2.289) includes 'dissembling' in both style (delivering funny material with a stern and gloomy expression (cf. Quint.6.3.26) and substance, but the brief reference to these devices in *Ad Herennium* (I 10) is more informative:

> ...a fable, a plausible fiction, a caricature, an ironical inversion of the meaning

[2] 'Extended humour and immediate witticisms' (Fantham, op. cit. 189). In Orator 87 the generic word is *sales* , and the word facetiae has replaced *cavillatio*, joining *dicacitas*. These correspond with the two species described in De Oratore. Other words which, like *sal, sales*, describe 'extended humour', or 'humorous temper', are *lepos* and *urbanitas*.

[3] See *In Verr.* I 121; hence the link with satire (Juv. *Sat.* 1.79).

[4] Sarcasm is the vehicle through which irony is delivered. The word is derived from the shape assumed by the mouth, typically of a dog or other carnivore, when tearing flesh (Gr. *sarkos*), baring the teeth in a sneer.

of a word, an ambiguity, innuendo, banter, (feigned) stupidity, exaggeration, recapitulation (of the opponent's argument, giving it a false twist), an unexpected turn.

Irony puts the opponent at a disadvantage. Socratic irony, whereby the philosopher pretends ignorance or lack of understanding (perhaps the 'stupidity' alluded to above), gives his opponent a temporary false confidence, making his embarrassment, when it comes, the more profound. Socrates was the ultimate *eiron* ('dissembler'), because he pretended to lack all knowledge (*omnium se rerum inscium fingebat* (*Brutus* 292)). But even by Cicero's time the term applied to varieties of saying what you do not mean, ('being mock-serious in your whole manner of speech, while thinking something different from what you are saying' (*De Orat.* 2. 269), including its direct opposite). The mood and style of irony was elegant yet plain.[5]

 The only practical method of examining examples of humour is to consider them as they occur in each speech, not by type or genre. This is simply because the categories are too numerous for meaningful classification. Even the broad division between *cavillatio/facetiae* and *dicacitas* does not always work satisfactorily. This problem manifests itself from the outset. In *Pro Quinct.*, Sextus Naevius, a leading figure in the case, has the witty character required in his profession of auctioneer (11–2) (see below, on *Pro Planc. 33)*, but also the immorality of the *scurra* ('dandy'), while conducting himself with 'virginal modesty'(39): a natural butt for good-natured humour, in an otherwise very serious speech. The passing brief sarcastic reference to him as *vir optimus* (19; cf. *Pro Rosc.23*) is replicated too many times throughout the speeches to record individually. But humour, even of this limited kind, is absent from *In Verr. I, Pro Leg. Man., Post Red. in Sen.* and *ad Quir., Pro Marcell., Phil. IX.*

 Pro Rosc. Amer. is another very serious speech. But the portrayal of the arrogance of the defendant's chief antagonist Chrysogonus contains a certain rather grim, sarcastic humour (6):

> He [sc. Chrysogonus] demands this of you: that since he has openly seized
> upon another man's property, an estate which is conspicuously rich; and since

[5] For its association with the plain style, see H. V. Canter, 'Irony in the Orations of Cicero', *AJP* 57 (1936) 463; on critical opinion that irony is a device of sophistication and refinement, see J. A. Cuddon, *The Penguin Dictionary of Literary Terms and Literary Theory*, (London, 1976) 458–62, whose discussion extends to the idea of 'irony of situation', which includes 'tragic irony'.

the life of Sex. Roscius is barring his way to his enjoyment of this wealth, you should remove all doubt and fear from his mind. He does not think he can take possession of such a large and well-endowed estate while my client is still alive, but thinks he can do so once he has secured his condemnation and ejection from it; and he hopes to squander and waste in luxury what he has acquired in crime. He expects you to relieve his conscience of the compunction that goads and stings him night and day, so that you can present yourselves as his accomplices in the enjoyment of this infamous plunder.

Chrysogonus' whole irrational attitude invites ridicule: he appears to expect the jury to condone his immorality and even participate in his crime. This paradox contributes to his characterization. The only other instances of humour are passing witticisms: three involving words (22: *felix*; 100 *palmas... lemniscatum*; 124 *nomen aureum Chrysogoni*), and one (61) banter with the prosecutor Erucius.

Cicero's patronizing tone in *Div. in Caecil.* has been noted (p. 12) in relation to (27), where the tone is one of mild banter as he offers to 'instruct' his opponent. Perhaps a note of sarcasm is to be detected earlier (22), when he says that the Sicilians whom Caecilius wishes to represent regard him as a target for revenge, not a potential agent of it, because he had been on Verres' staff and complicit in his misdeeds. Caecilius, if appointed as prosecutor, would be supported by one Alienus, and 'worse aliens than Alienus' (50); while of Caecilius himself Cicero says 'you will certainly want watching, or you will not only let out my secrets but go off with my property'. More sustained, and not a little dramatic, is the irony of the following passage (57):

So far, I see you all note with surprise, Verres is not Verres but the perfect Scaevola [the model governor]. Could he have added more gracefully to his reputation, or relieved a poor woman in distress more equitably, or checked his wanton subordinate more energetically? His actions as a whole here seem to deserve the highest commendation. But suddenly, as though he had drunk from Circe's goblet, he turned in one flash from a man into a Verres, became the hog that his name suggests, and resumed his proper character. He appropriated a considerable part of that sum of money, only returning a modest fraction to the woman herself.

Verres' reversion to type after an uncharacteristic sequence of actions is coloured by one of several puns on his name (*verres* – 'hog', 'boar' (cf. *In Verr.*

II 1.121; 4.53, 95)), underlining the transformation. Another uncharacteristic episode is greeted with more straightforward irony in *In Verr. II* 1.106:

> He [Verres] tells us he is taking measures against greed. And who is more fit to do so, in our time, or in any other time in our history? Was ever man so untouched by greed as he? Pray, let us hear the rest: it is really delightful to see the man's high moral tone, and his knowledge of the law, and his impressive personality.

Cicero says that he considers wit to be misplaced in this serious trial (*II* 1.121), but the next speech contains at least nine examples of it, the highest number in the *Verrines*. In 13, there is paradox, as a delegation sent to defend Verres have roundly condemned him. In 52, the 'Verres Festival' is greeted with bitter irony ('The truly glorious Verres festival...the Verres Festival, splendid!' (cf. 154)). But such irony is often in close attendance upon violent vituperation, as here. In 54, Verres became 'more unctuously anointed than the successful athletes' after profiteering from the staging of certain games. In 76 Cicero urges: 'Save Verres, gentlemen! Save him for Rome! Spare him and keep him safe! You need such a man on the Bench. You need him in the Senate, to give his voice for peace or war, uninfluenced by greed'. 115–6 affords a good example of wit (here word-play – *Cupido* (a statue of the god)... *cupiditas* (Verres' greed)) embedded in a passage of violent invective. There is more subtlety and dissimulation in 132, where Cicero appears to accept Verres' pretence of honesty:

> Verres decided that his dealings with this matter should be quite open; he would resort to no dishonest drawing of lots or cutting days out of the calendar. He certainly tried to do nothing underhand or fraudulent here; with the purpose of banishing from all his cities those eager and covetous desires which are the ruin of so many states, he announced that he himself would appoint the censors in every city.

In 141, on the subject of Verres' statue, Cicero says that he had mulcted the Sicilians of enough money to erect statues of him in every alley-way, 'where, one would have thought, it was hardly safe to go': dual-purpose humour, coupling the hyperbolic idea of more statues than are normally erected in open places like city squares, and the brigand-figure adding to the danger faced by passers through the city's by-ways.

Cicero repeatedly argued that Verres' fiscal reforms were made purely for personal gain. Sarcasm expresses his scepticism in 3.16–17:

Did your powerful brain detect some fault in it [sc. the tax-system]? Were your understanding and judgement superior to those of all the able and distinguished men who governed the province before you? This is what we should expect from you, from a mind so profound and active as yours – thus much I am willing to allow you ...I am consequently not surprised that you should have devised a new law for corn-tithes, after showing so much judgement, and gaining so much experience, with praetor's edicts and censor's regulations.

Before a sophisticated jury which included men who had themselves been exposed to the temptations of exploiting the provincials during their own tours of duty, sarcasm, with its often world-weary tenor, was likely to be more effective than outright rage. Such men would nod knowingly when Cicero adverted Verres to the 'Court of Claims presided over no doubt (*videlicet*) impartially by yourself' (3.27). The same preference is given to the treatment of his agent, the egregious Apronius, who becomes an almost comic figure, 'a fine new fashion in tax-gatherers, not shabby and dusty as you would expect tax-gatherers to be, but plastered with perfumes, and flabby with drink and late nights. His first movement, the first breath he uttered, would have filled the place with the smell of wine and perfume and his body-odour' (3.31). (Does Cicero ignore his own strictures on good taste here?) In these long passages, Cicero occasionally pretends to make concessions (*e.g.* 3.34), but he is not really loosening his grip on his victim, even when he is engaging in mock praise (3.155): 'How rich and impressive is this eulogy of Apronius by Timarchides! Whom can I imagine dissatisfied with one whom Timarchides approves so warmly?' Both villains are dispatched with one shaft of sarcasm.

In 4.8, an apparent moment of relief in the attack on Verres turns into a twist of the knife in the wound:

And yet, why this vehement attack on Verres? A single word will ward it off. 'I bought the things', he tells us [cf. 133]. God help us! What a splendid defence! We have given the power and insignia of a governor to a trader, and sent him to our province to buy up all the statues and pictures, all the gold and silver plate, all the gems and ivories, and leave nothing there for anyone!

Part of the irony is in the temporary false retraction of blame, to be succeeded by an even more serious accusation. Cicero likes to alternate between ironical praise and blame. In 4.51 Verres is 'our hardworking and conscientious governor' (cf. 146: 'our prudent and fair-minded governor'), who soon

becomes 'the tyrant himself'; in 53 he is 'a dragnet ('sweeping machine' (*everriculum*)); in 54, on a broader canvas, there is a grimly comic scene, in which Verres has set a large party of skilled men to work on processing his plunder, while he 'sat in his workshop for most of the day, wearing a grey mantle and a Greek tunic', claiming that he was keeping the whole of the province in safety. In 95 his suffering subjects were able to summon up enough humour to observe that 'this monstrous hog (*verres*) ought to be included among the labours of Hercules quite as much as the celebrated Erymanthian boar'.

The *Fifth Verrine* is Cicero's answer to Verres' claims of military efficiency. He begins with a brilliant comic *aporia*, coloured appropriately by military imagery (2):

> What am I to do, gentlemen? To what line of attack am I to resort? Which way shall I turn? The description of him as a great commander in the field rises like a rampart to withstand all my assaults. I see the topics on which Hortensius will wax proudly. He will remind you of the war that threatened, of the crisis facing the state, of the shortage of good generals; and then he will implore you – nay, he will insist, as upon something to which he is himself entitled – that you should not let Rome have so great a general snatched from her through the evidence of Sicilian witnesses, nor allow so great a soldier's shining record to be obliterated through charges of avarice.

Elements of irony and paradox distinguish comic *aporia* from its serious, even tragic counterpart, which is the original form of the figure (and the only form found in Greek oratory). There is also a hyperbolic effect here, as we are momentarily prompted to contemplate Verres' greatness as a general. Cicero maintains this for a while ('I do fear that the outstanding merit of Gaius Verres in the military sphere may gain him impunity for doing all the things that he has done' (3), and defines it further: ' Granted that Verres is a thief...yet he is a great commander, a fortunate commander, a commander we must keep to save our country in the hour of danger'(4).

Humorous narratives are a feature of the *Verrines*.[6] The humour is often diffused, creating an atmosphere rather than provoking immediate and short-lived mirth, but providing essential characterization. In 5.26–7 Cicero describes how Verres used 'his intelligence and good sense' to overcome the rigours of winter travel by spending his time, some of it in bed, confined to

[6] Fantham, *RWCO*, 201, who notes that they occur 'early in each speech, at a certain distance from the main themes'.

his comfortable quarters in Syracuse; and when he finally took to the road in spring, he 'rode in a litter carried by eight bearers' bedecked like one of the old kings of Bithynia. There is similar portrayal of Verres' remoteness and deficiency in the commander's sense of duty later (86–93), but there Cicero's caustic wit is directed towards his peculiar dress (86) and his debauchery in the face of extreme danger ('the Roman governor burning with vile lust, and the Roman fleet with the flames which those pirates kindled' (92)).

Already some of the conditions that favour the incidence of Ciceronian wit and humour may be discerned. Their hostile purpose links them to particular personal targets and, bearing in mind the central role which Cicero's own person plays in his speeches,[7] one can see that the interplay between it and the character of his victims influences the amount and the quality of the humour that he deploys against them. The vehemence of his sarcasm in his attacks on Verres is to be explained in these personal terms. Cicero had seen himself as a moderate and constructive provincial administrator, and had formed a cultural attachment with his Sicilian charges; whereas Verres indulged in all the excesses of imperial power, including personal greed and irresponsibility. And hostility was fuelled by a degree of envy: Verres belonged to the aristocratic establishment, to which Cicero aspired; perhaps he also shared Verres' interest in art, but was not yet a connoisseur. Finally, Cicero was building his reputation as an advocate, and the high-profile Verres case was an ideal milieu in which to raise his standing further. Adversaries who met both these criteria – he could represent them as opposed to all the important principles that he himself held, but they shared some of his interests and perhaps exceeded his knowledge about them – were the natural targets of his humour. Clodius – demagogic, anarchic, but enviably popular; Piso – remote, inert , and aristocratic, but with genuine cultural interests; Cato – oligarchic, inflexible, but an astute politician with some knowledge and practical interest in philosophy. Combinations of opposites with affinities like these made such men the most attractive objects of humour for Cicero.

In *Pro Font.* 21 the first of several of Cicero's ironic ethnic gibes concerns the credence to be accorded witnesses. 'The Gauls assert it: it is no use our denying'. They are the extreme example of the absurdity of expecting a jury to accept the evidence of aliens as fact. The racial divide is deepened later, when Cicero denies that Gauls can have no understanding of the principles governing Roman legal procedure, and irony surfaces again (29) when one

[7] See J. Paterson, 'Self-Reference in Cicero's Forensic Speeches', in Powell and Paterson *CA* 79–95.

of their leaders cannot distinguish between saying 'I think' and 'I know'. The sanctity of an oath is also a concept ignored by 'the upright and punctilious oath-regarders who beset the Capitol' (30).

In the best passage of sustained humour in a legally complex and serious case, the ridiculing of a witness is pursued through the medium of irony (*Pro Caec.* 28):

> The tenth witness to give evidence, anxiously awaited and reserved till the last, a member of the Roman state, the glory of his order, the pride and ornament of the lawcourts, the model of old-time rectitude, was Fidiculanus Falcula; and although he came into the court in so violent and bitter a spirit and not only to attack Caecina with his perjuries, but even to appear enraged against himself, I so far calmed and soothed his feelings that, as you remember, he dared not say a second time how many yards his farm is distant from the city.

Falcula's behaviour, as a bribed juror and as a witness, is described further in the sequel in a similar tone. Before that passage, style contributes to the sharpness of wit in the description of the prosecutor Aebutius, 'a clumsy fool among men and clever lawyer among women' (chiasmus in the Latin: *inepti ac stulti inter viros, inter mulieres periti et callidi*) (14). Style also plays an important part in 23 in an instance of hostile wit: 'What Caecina would have most desired was to have no quarrel with anyone: in the next place to have no quarrel with such a knave; and in the last case, with such a fool'. In 18 there is an example of temporary ironic concession:

> And so I suppose, like a timid and inexperienced man, lacking both in courage and resource, my client did not think it worthwhile, for the sake of an inheritance, to have any doubts cast on his rights as a citizen, and gave way to Aebutius, letting him keep whatever of Caesennia's estate he wanted! No indeed! He acted like a brave and wise man, and crushed this foolish and dishonest claim.

Another variety of irony, ironic self-depreciation,[8] is exemplified in 32: 'I, unskilled as I am in the law and unversed in the business of litigation.... Suppose that I am mistaken... I am anxious to be your pupil in this matter'. And this is in a speech in which he clearly set out to demonstrate his ability in a legally difficult case!

Pro Cluent. was another vexing case, complicated by previous litigation.

[8] A category identified by Canter op. cit. (n. 5) 461–2.

In 40, the grim irony hinges on individual words and phrases. Oppianicus' father tried to employ a doctor, whom Cicero describes as 'so often successful (*victorem*) as to be notorious', to kill his grandmother, but she refused his attentions; whereupon he calls upon a 'travelling quack' (*pharmacopolam circumforaneum)* to do the job, who despatched the old woman with the first draught and moved on to his next assignment. By contrast, in 58–9 Cicero paints a whole comic scene in which counsel for the defence in an earlier trial bungled his brief, using pompous rhetoric in the process and ending up by reducing the court to laughter and his client to despair. In 71–2, dialogue combined with play on personal names provides the humour. Another passage in *Pro Cluent.* (140–2), which does not immediately appear humorous, is nevertheless illustrative of the more urbane side of Cicero's wit. The prosecutor has called attention to arguments in his previous speeches (probably the *First Verrine* and *Pro Caecina*), which appear to disqualify Cicero, on moral or intellectual grounds, from undertaking the present defence. After making the general point that an advocate propounds not his own personal views, but those which his case demands (or 'not the conclusions warranted by our own judgement, but the deductions which can be made from the case' (139)), Cicero recounts the reaction of the great orator Crassus to a similar situation, in which he displayed 'wit and humour' (*lepore et facetiis* (141)) when telling how he embarrassed his opponent Brutus by quoting from a case in which the latter's father had referred to documents which revealed his son's extravagance. Some of the more cultured jurymen would have compared Cicero with Crassus at this point.

In *Pro Rab. Perd. Reo* Cicero makes much of the inhumanity of bringing such an aged man to trial, and this takes the form of irony in 12–13, where he describes the prosecutor Labienus as 'merciful' (*misericors* (12)), and 'kind' (*clemens* (13)). In the *Catilinarians* humour is to be found in only one passage (2. 22–4), where Cicero describes the manners and appearance of Catiline's boon-companions (see p. 54). Their effeminacy and dissipated life-style is comically characterized in order to make them seem ineffectual would-be revolutionaries.

Pro Mur. contains some of Cicero's freshest and most engaging humour, characteristics which his two main victims, Sulpicius and Cato, probably took in good part.[9] After an early piece of word-play directed against the

[9] Plutarch, *Demosthenes and Cicero* 5, reports that Cicero's ridicule of Cato's Stoicism drew laughter from the jury, and a quiet smile from Cato, who remarked: 'What a funny man we have for our consul, gentlemen!'

former (8: *peteres...petas* (in two senses: 'Even though I supported you when you were going for the consulship. I am not obliged to support you in the same way when you are going for Murena'), he is criticized for taking his profession of jurisconsult too seriously with some colourful imagery in 23: 'Since you seem to be hugging your knowledge of jurispudence as if it were your darling daughter, I shall not allow you to be so mistaken as to think that this whatever-it-is that you have taken so much trouble to learn is in any way remarkable'. The ridiculous lengths to which lawyers were prepared to go in order to retain control over procedure after some of the rules had become public knowledge are exposed and explored graphically through live speech (25–6), as lawyers are portrayed as introducing arcane procedural impediments. This humorous criticism of lawyers and their obscurantist pedantry would certainly have struck a chord of sympathy in some of the jury.[10] But the criticism has a serious side, as these legal experts are accused of ruining or spoiling established procedures by their subtleties, and abandoning the spirit of the law by sticking to its letter (27). It is therefore not surprising that lawyers are much less popular than generals, and less potent and influential than orators (29–30).

Sulpicius had been a fellow-candidate with Murena for the consulship. Cicero's arguments and humour had been directed towards showing him to have been inferior in that contest; and he even suggests that Sulpicius decided to prosecute Murena before the election, thereby giving the impression that he expected to lose (43–4). Cato, on the other hand, had no such personal motives, and prosecuted because of a principled desire to put an end to electoral bribery. This makes him the more dangerous adversary ('the root and core of the whole prosecution' (58)), and Cicero expresses fear of his excessive *auctoritas* (58, 67). The irony that he directs at Cato is of the most urbane kind, so that the absurdity of his position dawns very gradually on the listener. After expressing his admiration of Cato's upright character, he sensitively points out how he has tried impractically to apply Stoic doctrine, rigidly and literally, to real-life situations instead of relying on his native common sense (60–6). The effect of this ironic humour is difficult to gauge, and the task of doing so would have been easier if we could have heard the cadences of the spoken word; but it can be identified more clearly when Cicero suggests that Cato should imitate the manner of his great-grandfather

[10] So Fantham *RWCO* 202, adding that lawyers were seen as suffering from a 'relative lack of glamour' compared to, say, army commanders. This made them relatively unattractive consular candidates (28).

the Censor, whom he describes as a paragon of affability, sociability and humanity (66), qualities not associated with that stern, uncompromising figure.

The range of styles in *Pro Flacco* is seen at its upper end by the grandeur of his introduction of his client (1), and at its lower end by the ridicule that he heaps upon the prosecution's witnesses. The latter, trying to support their extortion claims against Flaccus, are sarcastically dismissed as incredible (39), or as swindlers (Heraclides) (45–7); and, as in *Pro Font.*, he characterizes whole races – here Phrygians, Mysians, Carians, and Lydians – as being in one way or another unreliable (65). Later he even tries to undermine one of the prosecutors, Decianus (76) by ridiculing his ambition and susceptibility to empty flattery. Decianus had claimed to have been honoured by the Pergamenes, but Cicero says:

> Did you not realize that you were being ridiculed when you read out phrases like: 'man of exceptional wisdom, of unique ability'? Believe me, they were making fun of you. When they were putting a golden crown at the head of the text, they were really giving you no more gold than they would a jackdaw. Could you not see through their fun and wit?

The use of humour to embarrass and discomfit an adversary is illustrated nowhere better than in *De Dom*. Withering sarcasm is the particular weapon. Apart from the example in 47 (see p. 74), in 60 similarly deep sarcasm arises from a description of a harrowing situation – the victimisation by Clodius of Cicero's wife and family – and provides a foretaste of the sort of invective that was later to be directed towards Piso and Gabinius. Slightly lighter, because the subject was marginally more remote from Cicero's personal affairs, is his treatment of Clodius' plans to dedicate his site to Libertas. Here Clodius is 'a model of religious scrupulosity'(105); and inevitably, the Bona Dea scandal is reintroduced. The two are linked again in 110, and in 111 the absurdity of connecting the concept of liberty, of which Clodius is 'the devout priest', with a man whose policies have repeatedly flouted it, is exposed in all its irony. Indeed, throughout the speech sarcasm lies close to the surface. In particular, Cicero takes every opportunity to ridicule Clodius' attempts at statesmanship (*e.g.* 127 '... the pronouncement of a veritable Numa Pompilius').

The slightly less stressful situation surrounding the speech *De Harusp. Resp.* evoked a more light-hearted treatment of the same absurdities. In 8:

Religious observances and rites, conscript fathers, were matters which Clodius, of all people, laid before his mass meeting. Yes, Publius Clodius complained of the neglect, the violation, the desecration of rites and sanctities! It is not surprising that you should think this a fit subject for laughter; why, his own meeting laughed at the thought of that fellow who, as he so often himself boasts, was paralysed by a hundred decrees of the Senate, all of them pronounced against him for sacrilege, and who made the sacred banquet of the good goddess the scene of his adultery, and who had polluted rites, which is a crime for a man's eyes to gaze upon even inadvertently, not only by his male presence, but by his shocking licentiousness – that such a man should protest at a mass meeting against a lack of religion. So now we look forward with keen anticipation to his next meeting on the subject of chastity.

Clodius, like Verres and Gabinius, had a penchant for outlandish dress, an easy target for Cicero's wit (44):

But Publius Clodius suddenly emerged from his saffron robe, his frontlet, his womanish slippers and purple hose, his breast-band, his lute, and his monstrous debaucheries – a fully-fledged demagogue.

The last word may reveal a political purpose behind this comic description. Many past demagogues had earned respectability: men like Tiberius and Gaius Gracchus were now admired, especially by those with *popularis* sympathies. Cicero wanted to deny Clodius any place in that company of men of the people, and therefore portrays him as a seeker of the wrong sort of popularity.

Cicero continues his vendetta against Clodius and his family in *Pro Cael.* His sister, Caelius' discarded lover, had accused him of trying to poison her, so Cicero attacked her credibility on a wide front; and humour is one of his weapons.[11] Caelius was a difficult client to defend, because he had undoubted connections with Catiline, and had also made many enemies among the men he had prosecuted in the course of advancing his political

[11] T. A. Dorey, 'Cicero, Clodia, and the Pro Caelio', *G and R* 5 (1958) 175–80, ascribes Cicero's particularly bitter hostility towards Clodia, expressed in *Ad Att.* 2.1.5 and elsewhere, to the fact that she participated in the plundering of his house; and, unlike other commentators, he does not reject out of hand the story in Plut. *Cic.* 29.2 that she had earlier tried to persuade Cicero to divorce Terentia and marry her, and, upon his refusal, had tried to frustrate his attempts to climb the social ladder (179–80). Dorey also argues unconvincingly that the prosecution of Caelius arose in the first instance from a family feud with Bestia and Atratinus, and that his affair with Clodia was a 'subsidiary' cause of it (175).

career. In the whole of §36 Cicero applies different types of humour to Clodia, introducing her brother in two roles. It begins in dubious taste:

I will take your younger brother, who is a perfect man of the world; who loves you dearly, and who, because, as a little lad, he was the nervous victim of irrational fears at night, would always bed down with you, his elder sister.

He then amplifies Clodius' role of her counsellor in matters of the heart, as he commends to her his own 'sexual code of a rake':[12]

Sister, why are you making such a fuss? Why have you lost your senses? Your eyes fell on a young neighbour. You took a fancy to his clean-cut features and his tall figure; you wanted to see him often; you wanted to use your wealth and position to tie him to you, but you failed. He is chafing and pushing you away... So take your favours elsewhere. You have those gardens by the Tiber which you acquired for their position there, where the young men come to bathe. From there you may pick up marriage proposals every day. Why do you fret over this man, who rejects your advances?

Part of the humour of this lies in the fact that it would be recognized by the jury as a description of Clodia's normal behaviour, while Clodius fulfils the role of another of the characters of comedy (see p. 92) that colour this part of the speech.

Later (64) Cicero's attempt to surround Clodia's actions with the aura of comedy is openly expressed, when he descibes her as 'the poetess of experience who had already composed many comedies', and soon he devises a comic scene (67):

My mind is agog at the prospect of seeing, firstly, those young dandies, intimate friends of a rich and high-born lady; and then again, these valiant warriors, posted by their commandress in ambush and in garrison at the Baths. I intend to ask them where they concealed themselves – whether it was in a bath-tub, or a 'Trojan Horse', which received and protected so many invincible warriors, waging war for a woman...

The dichotomy between precept and practice which was briefly abumbrated early in this chapter (p. 196) is more pronounced in his invective against Piso than in any previous speech. In his strictures on taste in humour (*De Orat.* 2.236–9), Cicero has implied that there are limits which should exclude

[12] So Fantham *RWCO* 204.

extremes, but accepts 'ugliness and physical blemishes' as suitable subjects for jesting. But he also adds that the orator 'must not let his jesting become buffoonery'. Thus when in an early *apostrophe* (1) he says:

> We were not deceived by your slavish complextion, your hairy cheeks, and your discoloured teeth...

he cannot be accused of failing to follow his own rules. This description might have raised a smile as listeners recognized a familiar face. The purpose of it was to add humour to the portrayal of a man who otherwise looked impressive and grave, but whose performance more closely matched these blemishes. But the detailed scene painted in 13 seems, at least to modern taste, to cross the boundary between urbane humour and scurrility:

> Do you remember, you filth, when I visited you at the fifth hour with Gaius Piso, how you were emerging from some mean hovel with a hood over your head and slippers on your feet? and how, when from your malodorous lips, you had exhaled upon us the fumes from that disgusting tavern, you pleaded your enfeebled health, and alleged that you were in the habit of taking some vinous remedies to support it?

In an actual trial, the sheer ferocity of this invective might have detracted from its humour by arousing some sympathy for its victim, who was not without influential friends. Perhaps in what was to be read as a literary *tour de force* Cicero felt he could give free rein to his hatred of an ally who had become a virtual enemy. Considering Piso's passive attitude as consul to have been a primary cause of his exile, he reserved a special brand of semi-refined burlesque for his description of his behaviour during this time (22):

> Who in those days ever saw you sober, or engaging in any activity befitting a free man? Who indeed ever saw you in public at all? When the house of your colleague [Gabinius] rang with song and cymbals, and when he himself danced naked at a feast at which, when executing those whirling gyrations of his, even then he felt no fear of Fortune and her Wheel, Piso meanwhile, neither so elegant nor so artistic a debauchee, lolled amid his tipsy and malodorous Greeks, while, amid all the miseries of his country, his colleague's feast was called a sort of banquet of Lapiths and Centaurs; and in it none can say whether he spent more time in drinking or in vomiting or in excreting his potations.

Later, humour is confined to brief jibes at Piso's Epicureanism ('my worthy Epicurus, though product of the sty' (37)); to his generalship ('O second

Paulus' (39)) and to the two combined ('Conscript fathers, a philosopher has spoken in your midst: he has said that he never cared about a triumph!'(56)). Piso's use of Epicureanism to justify his own lack of ambition has already been touched upon (p. 105), but he also gives the subject a humorous colouring in 58–61, which begins:

> Gnaeus Pompeius has already committed himself; he cannot act upon the lines you have laid down. He has blundered; he never had any relish for the philosophical outlook: the poor fool has already had three triumphs. Crassus, I am ashamed of you! What can have been your motive in bringing a formidable war to its conclusion, and showing such eagerness to have that laurel wreath decreed to you by the Senate?....Fie upon you, Camillus. Curius, Fabricius, Calatinus, Scipio, Marcellus, Maximus – fools, all of you! What a witless man was Paulus! What a boor was Marius! How misguided were the fathers of both these consuls! And why? They celebrated triumphs!

The irony is carried further as Cicero urges Piso to pursue his son-in-law (Caesar) with lessons on the vanity of ambition (see p. 180–1). Later (73), when ridiculing Piso's attempts to become a literary critic, he adopts the tone of an exasperated teacher whose pupil behaves like a bully rather than a judicious critic ('not an Aristarchus, but a Phalaris'). In 91, Cicero greets Piso, on the disastrous end of one of his military campaigns during his governorship of Macedonia, as 'illustrious commander' (*praeclare Imperator!*).

In the speeches that follow *Harusp. Resp.* and precede *Pro Cael.* serious politics take precedence over the lighter touch of humour. Occasional hints of irony may be detected in several paasages, but the only clear examples of it in *Pro Sest.* are in 116 and 135, directed respectively against Clodius and Vatinius; while the early sections of the invective *In Vat.* (1–9) are suffused with it. The only passage of humour (irony) in *Prov. Cons.* (29) has been quoted on p. 98.

In *Pro Balbo* Cicero attacks the gravamen of the prosecutor's case by ridiculing him personally (20):

> What a brilliant lawyer and antiquarian, what a marvellous reformer and improver of our constitution, since he appends to treaties a penal clause excluding members of states bound to us by treaty from any share in our rewards and favours! How could any greater ignorance be shown than by saying that states bound to us by treaty must 'give consent'.

The irony gains force from the fact that the prosecutor and would-be reformer of Roman law is a Gaditane. He is also addressed or referred to sarcastically in 25, 27, and 32.

Towards the end of *Pro Planc.* (83), Cicero disdainfully criticizes the prosecutor Laterensis for trying to restrict the arguments which he could deploy, complaining ironically: 'if I cannot mention the sacred cars, how shall I be able to make a speech at all?' Laterensis seems to have been prone to this kind of technical sniping at his adversary. In 85 Cicero tells how Laterensis had derided him for missing an opportunity to make a witty pun. In *Pro Rab. Post.* there are two short sarcastic references (21, 24) and a longer passage in an ironic tone (38–9).

In *Pro Mil.* 17, Cicero contrives to introduce a note of absurdity into a serious subject:

> ...unless the death of Publius Clodius is rendered more shocking by the fact that he was slain amid the monuments of his ancestors – for this is what our opponents say again and again – asking us to believe that Appius the Blind constructed a road, not for the use of the people, but as a place wherein his descendants might with impunity play the highwayman.

The prosecutors have tried to be too clever, and Cicero is ridiculing their argument. The introduction of the Claudian patriarch Appius adds to the absurdity of their idea by the fact that he was remembered for his gravity and uprightness.

One of Cicero's boldest excursions into humour comes at a sensitive juncture in *Pro Reg. Deiot.* 21. Cicero described this speech as 'on the light, coarse-spun side' (*Ad Fam.* 9. 12), and the passage quoted below is one in which refinement is not a feature of the humour. Cicero is examining the prosecution's account of the unsuccessful plan to murder Caesar in Deiotarus' palace. (He is, of course addressing Caesar) (21):

> When, we are told, you had expressed a desire to vomit after dinner, they proceeded to conduct you to the bathroom, for there the ambush was posted. But your 'good luck' once again preserved you: you said you preferred to retire to your apartment. Perdition seize you, Mr. Runaway! Not content with being a worthless scoundrel, you must also be a drivelling idiot. They were brazen statues he had placed in ambush, were they, and it was quite out of the question to transfer them from the bathroom to the bedroom?

The prosecution's explanation of why the murder-plot failed is so riddled with

improbabilities that it is easy to argue that it never existed in the first place.

Pro Lig. has been shown to be a very subtle speech,[13] raising as it does the question of the response that Cicero aimed to elicit from his readers. A speech which constantly drew attention to the *clementia* of its addressee also drew attention to his absolute power, which could excite resentment, and even more radical sentiments. Did the three 'Caesarian' speeches, and particularly this one, generally regarded as the most accomplished, actually recruit the tyrannicides? Those who detected the greatest measure of irony in Cicero's words might have regarded him as their spiritual leader and mentor, though he later denied any part in the actual killing or in its preparation (*Phil. II* 25–36). It is therefore necessary to consider whether irony can be read into Cicero's written text.[14] There are passages of overt sarcasm like 26–8, where the 'constancy' of the prosecutor Tubero is exemplified by his desertion of the Republican cause. But even at the start (1) Cicero feigns *aporia* in the face of a powerful adversary. Thereafter we need to judge the spirit in which readers of the speech will have taken the references to Caesar's attitude to his vanquished foes. In (1), how would they take his 'pardon for their errors'? In 6 would they have appreciated his 'marvellous clemency' and 'light of his generosity'? The clause 'trusting not to the goodness of our cause but to Caesar's humanity' (13) was an implicit acknowledgement that Caesar was above the law. Elsewhere some readers might take a cynical view of the favourable reception supposed to have been accorded Caesar's triumph (15), and the measure of free speech enjoyed under his rule (23). Others, on the basis of their own experience, may have cringed when Cicero warned Tubero against overestimating the scope of Caesar's vindictiveness (29). Many will have detected irony in several of Cicero's observations, both in this speech and in *Pro Marc.,* on Caesar's character and behaviour. In conclusion, however, there is some evidence that Cicero was a more or less enthusiastic supporter of the new regime under Caesar, and that his praise of his *clementia* was sincere.[15] But this is a different issue from the effect that his oratory may have had upon others.

Nowhere is it more difficult to identify the line between raw *indignatio* and humour or ridicule than in the *Philippics.* After some brief excursions into urbane irony (2, 5, 21, 25, 34), Cicero's answer to Antony's invective against

[13] See J. P. Johnson's discussion (Ch.4 n. 25).

[14] If Plutarch (*Cic.* 39.6–7) is to be believed, the oration as delivered by Cicero affected Caesar profoundly.

[15] See H. C. Gotoff, *Caesar's Caesarian Speeches: A Stylistic Commentary* (Chapel Hill, 1993) xxvii–xxviii.

him (*Phil. II*) receives an injection of rough humour when he turns to Antony's early manhood (see p. 128). More serious is 'his fairest act' (84), his attempt to set a regal diadem on Caesar's head at the Lupercalia. Cicero captures the full outrage of the act, and especially its reception by onlookers. But Antony himself is also made to look ridiculous by his slavish persistence, and by his abuse of his consular office by making a speech while still in the semi-nude garb of the festival (86). Antony's funeral speech for Caesar, such a masterful display of sustained irony in Shakespeare's *Julius Caesar*, is merely framed in ironic terms here ('Yours was the beautiful panegyric...and, best thing of all, you abolished from the state for ever the title of dictator' (91)). Cicero takes every opportunity to represent Antony as an incompetent buffoon, as when he made a 'splendid excursion' to Campania (100–1). Similarly, in *III* 22, Cicero remarks: 'But on the saddest of topics what laughter does he excite!' Here the source of laughter is Antony's ineptitude in finding the correct wording for his edicts. In 26 the irony is strong, as the 'splendid decrees' described were actually illegal. In 31 the rapid rise of Antony's brother Lucius to eminence ('once a matador, now a commander – once a gladiator, now a general') reveals him to be of the same ilk. Here the very extremity of their behaviour makes them into the characters in a kind of grim comedy.

In *Phil. V* 12–13 Cicero comments on the quality of Antony's new jurymen, after describing him as 'this chaste and upright fellow, and supporter of the courts and of the law': 'What an eminent bench of jurymen, what a wonderfully dignified court', consisting of 'gamblers, exiles, and Greeks'. Individuals among these are characterized in similarly ironic terms. In *VI* 4 invective and humour sit side by side, as Cicero stresses the unlikelihood of Antony's complying with the Senate's demands:

> He will, no doubt, readily comply with this order to submit to the Conscript Fathers and your government – a man who has never governed himself! For what has that man ever done on his own initiative? He has always been dragged where lust, where caprice, where frenzy, where intoxication, have drawn him – two different classes of men have always held him in their grip, pimps and bandits; he so enjoys lechery at home and murders in the forum that he would sooner obey the most avaricious woman than the Senate and the Roman people.

The introduction of Antony's wife Fulvia as a dominant influence on his actions serves as the ultimate degradation of a would-be *macho*-man who claims leadership.

The occasion of *Phil.VIII* was a decision of the Senate, on the proposal of Calenus, but supported by the consul Pansa, to define Antony not as a *hostis* but as an *inimicus,* and the situation as one not of war, but of 'tumult', which would affect the measures that could be taken. Cicero argues the folly of this with the aid of irony (6):

> He is not a *hostis* whose garrison Hirtius [the other consul] has driven out of Claterna; he is not a *hostis* who is opposing in arms a consul, attacking a consul elect; nor are these the words of hostility or war that Pansa read out from his colleague's letter: 'I have driven out the garrison; I hold Claterna; the cavalry have been put to flight; a battle has taken place, some few have been killed'. What peace can be greater? Levies all over Italy have been decreed, exemptions from service withdrawn; military garb will be assumed from tomorrow; the consul has said he will come down to the forum with a bodyguard.

In 16 of the same speech Cicero congratulates Calenus on his opinion that Clodius had been 'incorrupt, reasonable, innocent, modest, and one to be kept and desired as a citizen', compared with his own view, that he had been 'a pernicious citizen, criminal, lascivious, disloyal, audacious, and villainous'. Returning to Antony, this time to examine the conditions under which he would undertake to meet the Senate's demands, Cicero introduces those conditions with irony (25): 'How modest are those conditions: we must be made of iron to refuse them!' Then, after noting some meaningless concessions, he describes Antony's exorbitant demands.

Cicero enjoys ridiculing the life-styles of Antony's friends in *XI* 13–14, which are depicted as ranging from the merely outrageous to the overtly criminal. Some his audience and readers will also have been entertained by his portrayal of Antony as a man of philosophical bent in *XIII* 45 (see also p. 150). Before that (4) there is an sarcastic outburst, and in the latter part of the speech, which is characterized by the use of vivid dialogue, occasional touches of irony (34, 37, 41). In the last speech there are further brief ironic comments (*XIV* 6, 7).

Instances of humour degenerating into bad taste are thus comparatively uncommon, so that Cicero may be said in general to have followed his own precepts. But when he crosses the boundary he does so in a memorable manner, as this example from *Phil. II* (63):[16]

[16] Interestingly, Quintilian (9. 4.23, 29, 44) quotes this passage for its word-order and other stylistic features. Fantham (*RWCO* 207 n. 35) suggests that it was 'a model passage assigned for memorization to students'.

With that voracious gullet and capacious lungs of yours, using that gladiatorial strength of your whole body, you swallowed so much wine at Hippias' wedding that you were forced to vomit in the sight of the Roman people the next day. At an assembly of the Roman people, while in the conduct of public business, a master of the horse, for whom it would be disgraceful even to belch, vomited and filled his own lap and the whole tribunal with fragments of food reeking of wine.

It may be assumed that Cicero knew his audience, and that they would recognize this description of Antony's behaviour. But other factors dictated his choice of targets for this kind of brutal burlesque. Antony had attacked Cicero violently in the tirade that prompted *Phil.II*. Similarly, Piso, Clodius, and Vatinius had, in their different ways, spoken and acted strongly and personally against him. Piso's statement that he 'disapproved of cruelty', referring to the execution without trial of the Catilinarian conspirators (*In Pis*. 14), rankled particularly with him, because it indicated Piso's intention to abandon his friend to Clodius. The latter, of course, had spoken frequently against Cicero and legislated for his exile. The bitterness Cicero showed against Vatinius (with whom he was later on friendly terms) is explained by his close connection with Caesar. A direct attack on Caesar would have been too dangerous, so his lieutenant became a surrogate victim on whom to vent his spleen.

A comprehensive study of humour in Cicero's speeches reveals a wide range of applications. Irony is certainly the most pervasive form of it.[17] But it is a somewhat blunt and limited weapon, and Cicero's fame for wit rests rather on argument, narrative, and imaginary dialogue, which could produce far more sustained entertainment for his audiences.

Finally, as we are about to consider emotional appeal, it is appropriate to observe that humour, and especially ridiculing invective, can act as a catalyst of it: an audience is as likely to be swayed by someone who can

[17] 17. Canter (op. cit. n. 5) writes (462): 'In many of the orations the use of irony in some form appears on average upon every other page'. A. Haury, *L'ironie et l'humeur chez Cicéron* (Leiden, 1955) takes a similar view of the pervasiveness of irony, but considers that humour takes longer to establish itself (111), and notes the confusion between them in theoretical discussions (49–51). For recent discussions, of the anatomy of invective, see J. Booth (ed.) *Cicero on the Attack : Invective, Abuse, and Ridicule in Action* (London, 2006); V. Arena, *Roman Oratorical Invective*, in Dominik and Hall (eds) *CRR* 149–160; and on the nature and scope of humour in Roman oratory, see A. Corbeill, *Controlling Laughter* (Princeton, 1996), and E. Rabbie, *Wit and Humour in Roman Rhetoric*, in *CRR* 207–17.

make them laugh at his opponent's faults or vices, as by one who can arouse
their sympathy for the speaker or for a third party.

(b) Emotional Appeal

Cicero's first reference to emotional appeal as a part of his ideal orator's
armoury is in *De Orat. I* 17, where he writes that the orator needs to have 'a
thorough acquaintance with all the emotions with which nature has endowed
the human race, because it is in soothing or in exciting the feelings of the
audience that the full power and science of oratory is to be brought into
play'. Here and in the *Brutus* (322), where he writes of the ability to 'sway
feelings in whatever direction the situation demanded', there is an emphasis
on *control* of the audience, using that control for a definite purpose, and
choosing which emotions to arouse with that purpose in view. They must
be 'reined back or spurred on... alternately swung round to hardness and
gentleness of heart, to melancholy and to gaiety' (*De Orat. 2. 72*). There
is a passing reference to humour, but it will be remembered that humour is
treated separately later in the *Brutus* passage, and Cicero is here interested
mainly in the arousal of passions.[18] He had the practical orator's knowledge
that reason and logic on their own cannot be guaranteed to win a court action,
and indeed, in a weak or difficult case, might even damage it. He knew that
it was more important to persuade his jury to respond to the feelings that he
engendered in them (*De Orat.* 2.178):

> For nothing is more important in oratory, Catulus, than for the orator to be
> regarded with favour by his audience, and for the audience itself to be moved
> in such a way as to be ruled by some strong emotional impulse rather than by
> reasoned judgement.

Cicero was well equipped to produce this effect. His own report and those of
others tell us that he was a very emotional speaker. Appeals for pity were one
of his specialities (*Orator* 130*)*; Plutarch (*Cic.* 3.7) writes of the 'vehemence
and passion' of his oratory, which made his friends apprehensive for his
health. Although he moderated this vehemence with training (*Brutus* 313–
4), it never left him entirely, as it was probably natural to him. His fellow-
advocates recognized this (*Pro Planc.* 83), and accorded him the task of
speaking last, after the routine facts and arguments had been presented, and

[18] As was Aristotle (*Rhet.* II 1.8 1378a – 11.7 1388b). Cicero's list of emotions is even longer
than Aristotle's (*Orator* 131).

when the stage was open for displays of pure eloquence. Even his most accomplished rival Hortensius gave way to Cicero on that stage (*Brutus* 190). The word *perorare* connects the two topics that follow. It denoted the act of presenting the final speech in a prosecution or defence, and also the closing section of an individual speech. Emotional appeal was a factor common to both, on the larger and the smaller scale. Hence its wide occurrence in his oratory. Its general character was also affected by another factor: nearly all Cicero's clients were defendants, so that pleas for pity, sympathy, and commiseration featured largely in his perorations.[19]

Missing from any modern assessment of emotional appeal is the contribution made to it by the orator's own performance. The variations in his tone (*De Orat.* 1. 17), his gestures and the movements of his body, including those of supplication, will have affected onlookers in a way which cannot be replicated in the written word alone.[20] It is through these physical manifestations of the orator's own feelings that he persuades his audience to share them; indeed, such persuasion may be impossible without this personal involvement (*Orator* 132). The ideal orator wore his heart on his sleeve when the occasion demanded, and thereby communicated his feelings (*De Orat.* 2.188):

> But I swear, Crassus, that I always shudder when you handle these matters in your cases: such mental vigour, such energy, such passion always show from your eyes, your face, your gestures, and even from your finger; so overwhelming is the flow of the best and most impressive words; so sincere, so true, so original are your sentiments, and so free of gaudy childish colouring, that it seems to me you are not just setting the jury on fire, but are actually ablaze yourself.

In the following sections, related aspects of the speaker's expressed commitment to his client's cause and to him personally are introduced. But above all it is his ability to act out the part of a man whose fate was totally bound up with the case and its outcome that will move the judges in his favour.

[19] 2. See M. Winterbottom, 'Perorations', in Powell and Paterson *CA* 223–4.

[20] 3. But see Winterbottom, op. cit. 220–2 for references in the speeches to actions evoking emotional responses, which would come not only from the jury, but also from the crowd of onlookers (*corona*), whose reactions could influence or even intimidate them. On the latter point, see M. C. Alexander, *Oratory, Rhetoric, and Politics in the Republic*, in *CRR* 104–5. On the influence of this crowd on the speaker's performance, see Cic. *De Or.* 2 338; Tac. *Dial.* 39; Quint. 10.7.17.

The most direct form of emotional appeal makes the speaker's own feelings the focus of attention. The First Person holds the stage. Typically, he describes pathetically his own pain, emotional and physical. But dwelling on this for too long without reference to his client and his predicament would have been counter-productive, so a balance must be struck. The operation of this balance is illustrated in *Pro Mil.* in an unusual way, because there he contrasts his own impassioned supplications with the stoical refusal of his client to plead for sympathy (95, 101, 105).[21] More straightforward is *Pro Quinct.* 10, where Cicero shows sympathy with the difficulties faced by his client, addressing himself to the presiding judge, C. Aquilius. The words *tot tantisque difficultatibus adfectus atque adflictus...misericordiam* describe Quinctius' feelings and his mental state. Later he implores Aquilius (22), and returns more fully to this direct pleading for *misericordia* with Aquilius in the peroration (90–9), emphasizing the unfairness of a situation in which a man without his opponent's resources and lack of scruple could be destroyed by him, with insult added to injury (*miserum est exturbari fortunis omnibus; acerbum est ab aliquo circumveniri, acerbius a propinquo* (95)). The build-up of emotion is assisted by the style, with *parison* and staccato short clauses introduced with etymological figure (*funestus...funestius; indignum..indignius* (95)) sustained until the final period (99). However, rhetorical question, elsewhere often a feature of emotional writing, is used here only briefly (94). The style found in this peroration closely matches that described by Cicero in *De Inv. I* 106 as suitable for the *conquestio* ('lament', 'complaint') in a peroration: the use of 'commonplaces...delivered gravely and sententiously' (*i.e.* in the succinct ('gnomic') style of a saying or generalization about the human condition).

The first emotional passage in *Pro Rosc.*, 8–9, has the same stylistic feature as that from *Pro Quinct.* 95 quoted above (*indignum...indignissimum*). Cicero is protesting vehemently that Roscius' accusers may, if successful, add his estate to the wealth that they have already criminally acquired. Less argumentative and more purely pathetic is the description of the mental state of the defendant when the chief prosecutor first went to Ameria to stake his claim (23):

> He forced his way into the defendant's farm when he was desolate with grief, and had not yet completed his father's funeral rites; ejected him unclothed

[21] See Quint. 6.1.27. But he seems to be criticizing Cicero's performance here when he warns that 'appeals to pity should always be brief, as there is good reason for the saying that nothing dries so quickly as tears' (28).

and headlong from his home, and drove him out from the paternal hearth, and from his household gods.

29–30 contains a good short example of aporistic rhetorical question being used to introduce an emotional passage deploring the prosecution's wickedness, but it also serves the purpose of focusing on Cicero's own resolve. In the long peroration (124–42) there is an unusual plea, to his client's chief persecutor, to let him live in the poverty which his depredations have caused (143–9). Such attempts to elicit pity must surely have been designed to move an audience and a readership, rather than appeal to Chrysogonus' better nature. His final appeal is naturally to the jury.

 After declaring in his claim to act as Verres' chief prosecutor that the Sicilians themselves wanted him, Cicero adds that they no longer have the protection of their gods because Verres has 'carried off their images from their holiest shrines'. Sharpened emotion is then coloured by his own intended part in the Sicilians' salvation: 'And they pray and beseech me not to spurn the appeal for help of men who, so long as I am alive, should have no need to appeal for help to anyone' (*In Caec.* 3). The prosecution of Verres himself, while containing vigorous oratory, becomes strongly emotional only under a limited number of stimuli, some of them relating to Cicero's own feelings. In 1 50, where he is reaching the end of his introductory remarks to the trial, he passionately affirms his commitment:

> I pray Heaven to justify the confidence I feel, that no man in this court will be detected in wrongdoing, save that one man whose crime has long since been discovered; and in the next place I declare to you, and, gentlemen, I declare to the people of Rome, that if there shall be other evil doers, I will, so God help me, sooner lose my life than lose the energy and the resolution that shall secure their punishment for the evil they have done.

Cicero's philhellenism provides some emotional material. The first example is *II* 1.47. Here he apostrophizes Verres for despoiling the Temple of Apollo on Delos:

> Is it possible that any reasonable hope of escaping can present itself to you, when you remember how impious and criminal and wicked your behaviour has been towards the gods in heaven? You dared to rob Apollo, Delian Apollo! Upon that temple, so ancient, so holy, so profoundly venerated, you sought to lay your sacrilegious hands?

In 1.58 he conveys his mixed feelings on surveying the art treasures plundered from Greece by Verres and displayed in the Forum, 'a decoration splendid to the eye, but painful and melancholy to the heart and mind'. In 1. 93–4 he briefly describes a pathetic court scene, a young heir cheated of his patrimony by Verres, accompanied by tearful grandparents and, in spirit, by his dead father, who is invoked in an *eidolopoiia*. In 2.46, there is the plight of Heraclius of Syracuse: 'No sooner had he fled than it [sc. his inheritance] was all carried off; and, God help us, with what shamelessness and cruelty! What a picture! Heraclius groaning under his calamity, Verres gloating over his profits, the Syracusans blushing with shame, men's hearts filled with distress!' Emotional appeal, aided by visualization, may have a specific function here. Cicero's effort to damage Verres by any means available may have been hampered in this case by the fact the Heraclius' wealth, and the fact that he was a son of the tyrant Hiero (35), would have attracted both envy and hostility from some people, including Romans. By representing his treatment by Verres as a kind of tragic *peripeteia* Cicero was perhaps trying to counter these prejudices. No doubt Cicero strengthened his friendship with some of the wealthy Sicilian victims of Verres by speaking emotionally about their fate; as he does in the case of Sthenius of Thermae (110–11).

Cicero seems to make a new start in the *Third Verrine,* by reaffirming, however disingenuously, his own disinterestedness in prosecuting Verres. But he becomes more emotional in 6, when he confesses to a personal enmity against a man who has 'attacked the property and the principles and damaged the interests and outraged the feelings of every honest man, and is loathed by the whole Roman nation'. In 22–3, the introduction of Verres' infamous tax-collector Apronius is framed in terms designed to animate what was, it will be remembered, an account that was written but not heard. Apronius is present, displaying his insolent countenance, and even his foul-smelling breath and body-odours. An even more striking simulation of the orator's presence is seen in 130–3, which begins with the plea: 'I ask your attention, gentlemen; I must strain every nerve, I must spare no kind of effort, to convince the world how brazen, how blatant, how fully admitted is the conduct for which he would use his money to buy himself acquittal'. The fear, dread, and loathing which the very name of Verres engendered in the stricken farmers is given emotional force by the style of the apostrophic questions that Cicero addresses to him (131). A later passage describing the sufferings of Sicilian farmers through Verres' crippling taxes plumbs even greater depths of pathos (198–9):

When the farmer's harvests were being swept off, and injustice of every kind
was tearing his property to shreds, he saw himself losing all the profit that
his own plough had brought him, his own toil won him, his own land and
crops borne for him. Yet, while suffering these terrible wrongs, he had at least
this pitiful consolation, that he saw himself losing what, under some other
governor, that same land would enable him to regain. But for a farmer to pay
money – something he cannot grow, nor his plough nor his toil procure him –
he must sell his oxen, even his plough, the whole of his equipment and stock.

The temperature rises to a similar level in 137, as Cicero asks the jury what
manner of man they are trying:

We see him plunging his hands deep into the revenues of Rome, into nothing
less than the harvests of our province of Sicily; we see this thief, I say,
embezzling before our eyes the whole of the corn and a vast sum of money as
well; we see him, I repeat, we see him so clearly that he cannot deny it.

Cicero finds much to stir emotions in the sorry fate of Sicily's farmers,
but even more when he comes to deplore Verres' art thefts in the *Fourth
Verrine*. The personification of the statue of Cupid in 7 may have moved
only the deeply religious among his readers; but more of them would have
been affected by the case of the Messanians. Verres had made their city his
'second home' and cultivated their friendship, so that they had 'assisted his
crimes, witnessed his debaucheries, and harboured the proceeds of his thefts
and robberies'. They had even sent an eminent citizen to the trial to praise
his administration. But this man, named Heius, had been a private victim
of Verres' rapacity, and now pleads with the court to help him recover his
sacred family heirlooms. Cicero turns to Verres (17–18):

It is the gods of his house and his fathers that he bids you give back to him.
Have you no sense of shame? No fear of God? No concern for your safety?
You have stayed at Messana in Heius' house, you have seen him perform
divine service in his own chapel before those gods almost every day.

It was important for Cicero to emphasize, where possible, the religious
significance of the artefacts plundered by Verres. The loss of merely rare
or valuable treasures would not have been a cause of pity or sympathy, but
rather, in some readers, of envy assuaged. But their religious feelings should
have been aroused when they were reminded that Jupiter himself (71) or
Diana (74, 77) had been affronted.

Verres requisitioned all the privately-owned silver plate in Haluntium, appointing their leading citizen to collect it at short notice. The scene is graphically recreated (52):

> How great do you imagine was the tumult in the town, the outcry, the wailing of women too? Any spectator would have thought that the Trojan Horse had been brought in, and that the city was in its enemy's hands. Here vessels, stripped of their coverings, were being carried out of doors, some of them forcibly torn from the hands of the womenfolk, while from many houses the locks were being torn off and the doors wrenched open. And can you wonder? Even when in some wartime emergency the houses of some private persons are ransacked for shields, their owners are reluctant to give them up; and you may be sure that the sharpest distress was felt by everyone who brought out his beautiful silver treasures for a stranger to rob him of them.

Such emotional scenes, when accompanying the fall of cities or the tidings of bad news, are staple fare in the historians. But Cicero adds an extra ingredient: he strives to involve his audience by inviting them to visualize the picture he is painting through the simple device of using the Second Person Plural. And of course here there is the additional point that this is not a wartime scene.

Sopater of Tyndaris stood up to Verres' demand for a civic treasure, a statue of Mercury. Verres had him flogged and exposed to the extreme winter weather. Cicero's description of this cruel punishment must surely have evoked pity and revulsion (86–7).

Until it is drawing to its close, the atmosphere of the *Fifth Verrine* is generally less highly-charged than that of the *Fourth,* as Cicero reviews Verres' military performance. But when he describes the treatment of Apollonius of Panhormus, who endured 'the tortures of being shut up, of being excluded from the sight of parent and child, nay, from drawing free breath and looking upon the common light of day' (24), we again witness the utter inhumanity of Verres in his endless pursuit of wealth. Later, his cruel treatment of Roman citizens on trumped-up charges of piracy is pathetically described (72–7). Then, after he had handed over command of the Roman fleet to Cleomenes of Syracuse (see p. 34), the pirates seem to have enjoyed free traffic on the seas. This prompts a surge of emotion from Cicero (100):

> Think of that pitiful, miserable scene! Think of the glory of Rome, the honour of the Roman people, the multitude of Roman citizens dwelling there, mocked

and insulted by that pirate galley! Think of that pirate celebrating his victory over the Roman fleet by a triumphal procession in the harbour of Syracuse, his oars dashing spray in the face of the indolent scoundrel of a governor.

It is difficult to pick out the highlights in a long emotional narrative, in which the sufferings of the leading Sicilians, who became scapegoats for Verres' disastrous handling of the pirate threat, are described (down to 128). It is uncertain whether the material Cicero has for this justifies such pathos. Perhaps it is meant to contribute to a climax for the whole Verrine pentad. Tearful and distressed Sicilians appear at every juncture of the story, but Roman citizens figure even more prominently – something to bring to the jury's minds as the case draws to its conclusion.

In *Pro Fonteio* emotion is restrained until its conventional place, the peroration. There (46–8) it is injected in a rather unusual way with the introduction of the defendant's mother and her sister, a Vestal Virgin, who, in a chaste embrace, 'casts her arms about the brother of her blood, imploring your protection, and that of the Roman people'. Cicero has been arguing about the unreliability of the evidence of foreigners, and this rounds the section off with a warming reminder of virtue and probity to be found in their midst.

In *Pro Cluentio* emotion is generated mostly in order to blacken the character of an opponent. It frequently arises naturally out of a narrative in which the lurid details of dastardly deeds are recounted, but occasionally, as part of the fevered atmosphere which Cicero seems deliberately to have fomented for this trial, he draws the jury aside to contemplate the enormity of what has been done (here by Sassia, his client's mother) (15):

> Oh! To think of the woman's crime, incredible, unheard of in all experience except for this single instance! To think of her wicked passion, unbridled, untamed! To think that she showed no fear, if not before the vengeance of heaven, of the scandal among men, at least before the night itself with its wedding-torches, the threshold of the bridal chamber, her daughter's bridal bed, or even the walls themselves that had witnessed that other union. The madness of passion broke through and laid low every obstacle: lust triumphed over modesty, wantonness over scruple, madness over sense.

In 29 he invites the jury even more directly to vent their emotions: 'I realize that your human hearts are wrung by this, my brief recital of his [the elder Oppianicus'] foul crimes. What then do you suppose were the feelings of

those who had not only to listen to such a story, but to pass judgement on it?' A gradual escalation of emotion may be detected in certain passages of extended narrative. Such climaxes are to be seen in 129, where the effect is assisted by rhetorical question, and in 136. Immediately prior to this (135), Cicero has spoken of being deeply troubled in dealing with a certain piece of evidence; and earlier (51) he has admitted being nervous at the beginning of a trial. Here he is referring to another occasion which shaped his frame of mind when approaching this trial: he had appeared at a previous defence of Oppianicus Senior's freedman Scamander, and lost. He was thus more personally involved than in many of his cases. Perhaps this explains the particular vehemence of the emotional appeal in the peroration (especially in 188, 195, and 199–202).

Invocation of the gods alongside earnest pleading to the jury is an effective way to arouse, as well as to express emotion. In *Pro Rab. Perd.* 5 Cicero gives this plea extra force by adding that the *salus reipublicae* depends on its being heard. In the *Catilinarians*, his consciousness that he was addressing two different audiences affects the amount of emotional writing that he employs. It is notably present in the *Second,* and especially the *Third,* both addressed to the People. In the opening periods of the former, the internal danger that Catiline had posed to them is matched by the relief that Cicero wants them to feel at its removal with his abrupt departure (1–2):

> He has gone, left us, got away, broken out. No longer will that misbegotten monster plan the destruction of our very walls within these walls; and we have overcome the one true leader of this civil war. No longer will that dagger be twisted in our sides; no longer shall we tremble in the Campus Martius, in the Forum, in the Senate-House, yes, in our very homes!

It is important for Cicero to make those in his popular audience who had sympathized with Catiline's aims see him as a wicked but now broken figure:

> Because he did not bear off a dagger stained with blood as he wished, because he left us still alive, because he left the city still standing and its citizens safe and sound – just think of the sense of desolation that weighed him down.

The speech ends with an exhortation to the citizens to pray to the gods, 'to worship them, to implore them to defend the city from criminal traitors' among them (29). The *Third Catilinarian* is pitched at a high emotional level throughout, so that it is difficult to choose individual passages. Cicero

feels that he can introduce a tone of triumphalism and self-congratulation that might be received less sympathetically by a Senatorial audience. The concluding sections (there is no clearly marked peroration) contain thanksgiving to the gods (22–3), and allusion to the horrors of previous civil wars (24–5), which because of his exertions have not been repeated (26); for which service he now asks for their protection (27–8).

Of the two senatorial speeches, the first is mostly (to 26) invective addressed to Catiline. Cicero's knowledge of his countrymen's predilection for the genre prompted him to choose this direct mode of attack, rather than attempting to arouse the feelings of senators by elaborating on his revolutionary plans, with which some of them may have been complicit, or at least sympathetic. But the *prosopopoiia* of the Fatherland, who upbraids Catiline for his lawless career (18), seems calculated to move even the most cynical audience; and some, at least, of them will have been impressed by the final invocation of Jupiter (33). In the *Fourth Catilinarian* too, rhetorical sophistication attains levels which might have been less appreciated by a popular audience. An example of this is the striking visualization in 11–12:

> A vision comes to me of this city, the light of the whole world and the citadel of all nations, suddenly collapsing in a sheet of flame. In my mind's eye I see the pitiful shapes of citizens lying unburied upon the grave of our fatherland; there passes before me the sight of Cethegus as he prances upon your corpses in his frenzied revels. Whenever I have pictured Lentulus as a potentate, as he hoped the fates would grant him and admitted as much, with Gabinius as his grand vizier, and Catiline there with his army, I shudder when I think of the mothers weeping, the boys and girls fleeing, and the vestal Virgins being violated; and it is because this vision arouses in me such strong feelings of pity and anguish that I am acting with such severity and vigour against those who have wanted to perpetrate such horrors.

Later (18) he sets himself in partnership with his fellow-senators, ready to answer the call of his country, who 'commends to you herself, the lives of all her citizens, the citadel and the Capitol, the altars of her household gods, the never-dying fire of Vesta, the temples and the shrines of all her gods, the walls and buildings of the city'. This is the orator's answer to the politician's critics: the rhetoricization of the present danger is the best way he knows of justifying to them the execution without trial of some of their most distinguished colleagues.

There are a few moments of emotional appeal in *Pro Murena*. The first

(1–2), a sustained plea to the gods, is designed to reinforce the argument that the confirmation of an experienced soldier in the consular office is vital for the safety of the Republic at the outset of a civil war. In 48 he refers to his own feeling – one of anxiety – at being the last speaker, and having 'to say what I feel is required by it [sc. the case] as a whole' He then proceeds to arouse the jury's sense of drama and danger by describing the fear that his opponent, Servius Sulpicius, had engendered by indecision, while Catiline, seen by everyone, made his preparations for revolution. 'The frenzy of his expression, the crime in his eyes, the insolence of his talk, were such that the consulship seemed already to have been confirmed as his' (49). Catiline's frenzy is the subject of another emotional passage (85), and this leads to the full-blooded broader appeal of the peroration. Beside a last return of the general topic of the dependence of the safety of the Republic on Murena's election, Cicero adds a potentially tragic idea, that of Murena's fall from triumph to abject despair (86–7):

> Today, gentlemen, clad in the garb of mourning, consumed with disease, worn out by his tears, he is your suppliant, he calls for your protection, implores your pity, and looks to your power and resources. Do not, gentlemen, in the name of the immortal gods, deprive him of this office which he thought would gain him greater distinction.

Cicero constructs a similar portrait of his client as the victim of a tragic *peripeteia* in the peroration of *Pro Sulla* (88–93), but the very fact of its occurrence in the same place as in his previous speech suggests a rather mechanical application of emotional appeal on his client's behalf. In only one other place is it clearly deployed: in 19, at a point where Cicero is doing all he can to portray himself as benign and forgiving, he describes how his unselfish concern for the plight of others made him set limits on his clemency towards Autronius, whose career had taken a similar course to that of Sulla (prosecution after election to the consulship, followed by implication in the Catilinarian Conspiracy). But the speech is much more about Cicero's reaffirmation of his own *auctoritas* than about defending Sulla, so that rhetorical *amplificatio* has a more prominent place in it than *pathos*.

Lucius Flaccus had held the praetorship when Cicero was consul and acted effectively against the danger posed by Catiline. Cicero begins *Pro Flacco* by alluding to this service, and returns to it at the end of the speech to evoke the scene at that perilous time in emotional terms. During the three years

which separated this speech from *Pro Murena* Cicero's personal position had become more precarious. Hence, whereas in the earlier speech the emotional writing had centred on the fear inspired by the madness of Catiline (49) and his client's ability to dispel it (83–4), in his defence of Flaccus, the dramatic scene ('Catiline was marching on Rome, the conspirators were reaching for their swords and torches') has consul and praetor in close concert (102):

> There were tears in the eyes of us both as I implored you, Flaccus, in the name of heaven and of that night, and entrusted to your well-tried loyalty the safety of the city and its citizens.

Cicero's graphic recital of Flaccus' services is skilfully coupled with his own part as leader, and hence author of the city's salvation. This was an urgent message for his potential supporters in the year of the Triumvirs. Shortly after this, Cicero has the defendant's son on the stage, appealing silently and tearfully to him to save his father, having apparently been coached to do so (106).

 After his return from exile, the recovery of Cicero's political position and his property were strong stimuli to his expression of feeling. His speech *Post Reditum Ad Senatum* opens with an impressively long period, not a normal vehicle for emotional writing; but through its main verb *maxime laetor* it probably conveyed the speaker's strong feelings to his audience, which will have been excited further by his fond references to his beloved family (2, 5), whose misery had been ended by his return (8). In *Post Reditum Ad Quirites* he appropriately dwells more on the joys and pleasures which all men have in common – family, children, friends – and again introduces his own parents and his brother, with thanks for his restoration (5–6). His pledge to resume his career as a statesman guarding and promoting the people's interests is couched in similarly emotional terms (18–19). His feelings are even closer to the surface in *De Domo Sua*. They are certainly expressed there in his outpourings against Clodius, but it is questionable whether some of these (46–7, 59, 98–9, 137) engender pathos rather than merely express anger. The sheer rhetorical virtuosity of passages like 24 (*Quid tandem... fuisset*) should have moved some hearers, but the exalted mood of gratitude at his restoration expressed in 75 is more calculated to arouse an audience's feelings:

> Why should I enlarge upon the heaven-inspired and never-to-be forgotten decrees of the municipalities and colonies, and indeed of the whole of Italy

– a ladder, for so I account them, whereby not only did I return to my country, but climbed to heaven.

Even here, however, the hyperbole might have seemed excessive to a live court, and more suited to reading in the studio or the schoolroom.

Recollection of his own recent tribulations prompts some of the emotional passages in *Pro Sestio* (32, 52–4, 76–7). The latter passage is a good illustration of how pathos could be generated through the medium of narrative. In it Cicero describes the proceedings (late January 57 BC) intended to lead to his recall, which end abortively in extreme violence, and a narrow escape from death or injury for his brother Quintus. On a larger scale but more remotely derived is the description of the theatrical performance at the Ludi Apollinares in July 57 BC. We hear (117–24) how good will towards him (in his absence – he was still in exile) was fervently expressed by the audience whenever anything was said that reminded them of him; and the actors played their part in underlining those allusions. More conventional emotional appeal is found in the peroration, where Cicero visualizes the distress of Sestius' family and friends at the prospect of his conviction (144–7). He does the same for Caelius in *Pro Caelio* 79–80.

Although we tend to associate that speech with urbanity and malicious humour, Cicero could find pathos in the death of Q. Metellus, who as praetor in 63 had taken the field against Catiline (59). In *Pro Balbo*, where the defendant owes Cicero's patronage to the latter's need to please Pompey, the only emotional passage in the speech (13) praises the man who left his mark on the remotest corners of Rome's empire. For Gnaeus Plancius, on the other hand, to whom he acknowledged a debt of gratitude for his show of friendship in the early days of his exile, he has a moving peroration (99–101):

> How bitter to me, gentlemen, is the memory of that time and that place, when he fell upon my neck, embraced me, bedewed me with his tears, and was dumb for very grief! It is a pitiful story to tell, but heartbreaking in the reality. Figure to yourselves all the days and nights that followed, when my client, never letting me out of his sight, saw me safely to Thessalonika...O the misery of your lonely watches, Plancius! O the dreariness and the torment of those sleepless nights... You took no rest, you never left my side.

Cicero expresses deep regret that he has not yet been able to reciprocate by saving Plancius in his present hour of danger. The speech ends with a

final plea to the jury, whom he represents as sharing his own distress (104). Another emotional expression of a debt of gratitude to a man who had shed tears on his exile is in *Pro Rab. Post.* 47.[22] In a speech modelled on classical lines, the peroration of *Pro Milone* is to be expected to contain most of its pathos, especially for another client who had been most active in securing his return. Prayer-like invocation of natural powers is a feature ('For to you now, O hills and groves of Alba I pray....It was you from your lofty hill, Jupiter Latiaris...' (85)), as their retribution has finally overtaken Clodius. So the man accused of killing him deserves only the tears of sympathy which he steadfastly refuses to shed on his own behalf (92–5).

Emotion is sustained to the end: 'O happy land, that shall give haven to this hero! Ungrateful this, if it shall cast him forth! Unhappy, if it shall lose him!' (105). Milo was probably already in Massilia when these words were penned.

It is difficult to measure the effectiveness of emotional oratory on the worldly, sophisticated one-man court which Cicero addressed in the *apud Caesarem* speeches. The appeals to him in the perorations of *Pro Marcello* (33–4) and *Pro Rege Deiotaro* (39) seem little different from many others, but in *Pro Ligario* there are three passages of heightened emotion. One, in 15–16, is enhanced by live speech. In 30 he pleads to Caesar 'as to a father'; and in 32–3 he implores him to look with sympathy on the dejection of Ligarius' distinguished friends at the prospect of his condemnation; and he ends (35–8) with warm sentiments surrounding the words 'in nothing do men more nearly approach divinity than in doing good to their fellow-men'. But the passage that is said to have affected Caesar himself (Plut. *Cic.* 39.7)[23] was the one in which Cicero mentioned the Battle of Pharsalus (9–10). Here memory is seen to be a stronger arouser of feelings than pure rhetoric.

After a brief allusion to his own mental turmoil on returning to Rome after Pharsalus (*Phil. I* 9), the next speech includes some emotional highpoints in its wide range of rhetorical virtuosity. Of course, it contains many passages of invective against Antony, but some of these seem to draw upon the speaker's deeper feelings: in face of Antony's abuses of the outward symbols of state

[22] See M. Winterbottom, 'Perorations', in Powell and Paterson *CA* 228, who remarks that Cicero 'at times gives the impression that the judges are honour bound themselves to repay what he owes to a client'.

[23] Plutarch, or his source, regarded the speech as extraordinarily invested with emotional appeal, affecting not only Caesar, whose 'face often changed colour and it was manifest that all the emotions of his soul were stirred', but all those who heard it.

authority (58), its day-to-day proceedings (63), and the memory of its greatest citizen (69). This is the expression of Cicero's feelings on Antony's acquisition of the house of Pompey:

> As for me, I pity those very walls and that roof. For what had that house ever seen but what was pure, what was sprung from the most perfect morals and the holiest discipline? For that man, as you know, was alike illustrious abroad and admirable at home, not more worthy of praise for his foreign achievements than for his domestic habits.

Cicero goes on to describe the likely activities there under Antony's tenancy. His appeal to Antony at the end of the speech to come to his senses (118) is made forcefully but without much conviction.

One of the most famous passages in the *Philippics* is an almost prayer-like effusion of emotion at the end of the *Sixth* (18–19):

> Therefore, through counsel exercised to the best of my ability, and with toil almost beyond my power, I will stand watch and ward on your behalf. Many great public meetings have I conducted as consul, and at many have I been present; but none has been so great as this meeting of yours. You have all one opinion, one object, to avert from the state the attacks of Marcus Antonius, to quench his frenzy, to crush his audacity.

This personal commitment and emphasis on unanimity is made against a background of the activities of an articulate and resourceful group of Antony's supporters, headed by Fufius Calenus. Those reading the *Philippics* as their only source for the history of these months would have a one-sided picture of it. But this passage admirably illustrates the principle of shouting loud in order to mask an unsound case. The ardour of Cicero's pledge also tells of his earnest desire to end his career as the dominant voice in Roman politics. This egocentric attitude appears again later, in the *Twelfth*, when he is opposing a second embassy to Antony, and, even more strongly, his own appointment to serve on it. Its pathos seems overdone (19):

> But if you are not concerned about Antonius, you ought, Conscript Fathers, at least to consider me. At any rate spare my eyes, and make allowance for just grief. For with what countenance will I be able to look – I do not say at the enemy of my country: my hatred against him on that account is common to you as well – but how shall I look on him who is my particular enemy as his most bitter harangues about me declare...?

Such passages as this seem to support a view that Cicero's chief aim in composing and publishing the *Philippics* was to establish himself in a position of primacy, undefined perhaps by an office of state, but universally recognized. He wanted to be like his ideal orator, *auctor publici consilii et regendae civitatis dux et sententiae atque eloquentiae princeps in senatu, in populo, in causis publicis (De Orat.* 3.17.63).

It is not possible to do full justice to the sheer amount of emotional content that the speeches contain without further reference to a prime ingredient of the examples discussed above – the pathetic *narratio*, in which the story of sad, desperate, harrowing and tragic events is told at length and in vivid detail. In such passages the reader's (or listener's) emotion is maintained at an elevated level without necessarily reaching a high point. Any change of fortune, stressful experience, or maltreatment suffered by a client or his dependant can be narrated with pathos. From the early speeches, to those already mentioned may be added *Pro Quinct.* 38–9, and several scenes in the *Verrines (II* 1.76, 2.74, 4.40–1, 5.128), where the treatment by Verres of some of the leading men of the Sicilian cities is deplored. Other pathetic passages arising out of narrative are *Pro Sulla* 19, *De Dom.* 59, *Phil. XI 7–8, XIII* 21.

The orator's ability to 'sway feelings in whatever direction the situation demanded' (*Brutus* 322) divides itself effectively into two – humour and pathos. These have been considered separately for practical reasons. In so far as they are susceptible to quantification, humour is the more pervasive of the two, being present in the greater number of individual speeches. But Cicero clearly believed that emotional appeal was necessary if success was to be achieved: in *Brutus* 277–8, he tells how, when the austere Atticist Calidius presented his case against Quintus Gallius, whom he accused of attempting to poison him, 'in a relaxed, smooth, yawning manner', he (Cicero), speaking for the defence, had been able to argue that Calidius' lack of indignation had in itself rendered his accusation incredible.

(c) Digression

When Cicero requires that his perfect orator should be able to 'charm the jury with a brief digression' in *Brutus* 322, he is summarily restating the view of it that he has taken in *De Oratore*. There it is seen to have a general and a particular function: to adorn and amplify (*ornandi et augendi causa* (2. 80)), and to arouse emotion (*permovendorum animorum causa* (2.311). It is

an additional instrument of persuasion, supplementing facts and arguments, and affording his ideal man of culture and eloquence the opportunity to spread his wings and delight his audience (*De Orat.* 3.303). But at the same time as he is regaling them he is manipulating them (*Orator* 137: 'he [the orator] diverts the thought' (*deflectat sententiam*). This practical purpose receives clearer articulation in Cicero's rhetorical works. In the early *De Inventione (I* 97) he is initially reluctant to place digression in a category of its own, because he disapproves of it in principle (perhaps influenced by Aristotelian thinking);[24] but then admits that it has a part to play in 'commonplaces' (*loci communes*). Later in that treatise commonplaces are linked with amplification and emotional appeal (*II* 48, 51, 108).

Some forty years separate *De Inventione* and *De Partitione Oratoria,* years during which Cicero applied and adapted theory to practice in many forensic and political speeches. In *Part. Or.* 5.15 digression has become a device for the defendant to use against the prosecutor, whose 'proofs are to be either done away with (*diluenda*), or thrown into the background (*obscuranda*), or covered up with digressions (*digressionibus obruenda*)'. This would seem to suggest a degree of flexibility for the location of a digression: it might be used wherever it could do most damage to the opponent's proofs. Now when this apparent freedom is confronted with digression's other associations – with amplification and emotional appeal – it is most likely to find its place near or in that part of the speech where these effects are always required; which is the peroration (*Part. Or.* 15.52). But the possibility that digression can find a place outside the peroration seems to be implied in *Part.Or.* 36. 128, where Cicero writes: 'The means available for amplification, which they [*i.e.* litigants, orators] will wish to employ *either* when making a digression from the case in hand, *or* in the peroration...' (*aut...aut,* which are mutually exclusive). This seems to dissociate digression from perorations, but this extreme view is modified in the contemporary *Brutus* and *Orator,* which affirm a multi-functional role for

[24] Aristotle's description of digression represents it as an aberration, even perhaps accidental (*apoplanesis* – 'wandering off the subject' (*Rhet.* 3.15.5 1415b)). Plato seems to have viewed it similarly (*Politicus* 263c). Practical orators of that time were more aware of its positive uses. In Isaeus 6 *Estate of Philoctemon* 59 the speaker Chaerestratus complains that his opponent Androcles is using digressions (*parekbaseis*) as a substitute for properly marshalled arguments and evidence, adding that 'he does not try to prove his point and deals with it only superficially'; and instead 'inveighs against us in a loud voice, saying that we are rich and he is poor'. Emotional appeal was clearly associated with digression at this time. It is surprising to find Albrecht (*CS* 161) regarding digression as the third 'standard division' of the speech alongside 'prooemium, narratio, and peroratio'.

234 CICERO'S SPEECHES

digression (see *Brutus* 322 and *Orator* 137, quoted above). Quintilian writes (4.3.1) of orators 'digressing (*excurrere*) to some pleasant and attractive topic with a view to securing the utmost favour from their audience', and adds (2) that the practice originated in the rhetorical schools and spread from there to the lawcourts. As a theorist he was inclined to base his teaching on a fairly strict observance of a *partitio oratoria,* so he allows digression 'only if it fits in well with the rest of the speech' (4), and it is brief (8). But he endorses the view expressed in the above Ciceronian passages that digression can be useful in other parts of a speech than the peroration (for example, at the end of the narrative (9), and he amplifies its applications later (15):

> Other occasions for digression on points not involved in the question at issue arise when we amplify or abridge a topic, make any kind of emotional appeal, or introduce any of these topics which add agreeable and artistic features to oratory, topics such as luxury, avarice, religion, and duty.

Quintilian thus follows Cicero in seeing digression as one of the manifestations of the accomplished speaker's art. But the task of identifying it is by no means easy. Canter has noted that, whereas Cicero usually marks the end of a digression clearly, when beginning one he 'in no case designates it specifically as such'.[25] There must also be an element of subjectivity when a critic has to decide whether the orator has digressed, or is simply confirming an argument or clarifying a statement of facts. Both these factors come into consideration when the speeches are examined for digressions. Another, more serious problem is that of overlap with other refinements, especially historical examples. Unlike Canter, I have taken the view that the latter do not generally constitute clear breaks from the surrounding subject-matter, but illustrate or expand it. Consequently his list of digressions (art. cit. 351–2) is much longer than mine. This difference is seen at the outset: first on Canter's list is *Pro Rosc.* 33–4, which is a comparison of an historical unjust prosecution with the present trial. But a comparative component does not rule out classification as a digression. *Pro Rosc.* 55–7 is a parable on the proper function of accusers. The proposition is that when accusers (who in Rome were private persons, not official appointees) make false charges, they are rightly liable to severe punishment. Yet it is useful that there should be plenty of potential accusers in the state, as a restraint on crime: an innocent

[25] So H. V. Canter, 'Digression in the Orations of Cicero', *AJP* 52 (1931) 359–60. For modification of Canter's general view of digression, see J. C. Davies, '*Reditus ad rem*: Observations on Cicero's Use of Digressio', *RhM* 131 (1988) 305–15.

man can refute their charges, while their existence in numbers would ensure that the guilty do not evade punishment. The analogy drawn by Cicero shows him at his most exuberant (56):

> Geese are fed at public expense on the Capitol, and dogs are kept there also, to signal the approach of robbers. But they cannot distinguish robbers; however, they raise the alarm when anyone approaches the Capitol at night, erring on the side of caution because their animal instinct informs them that it is suspicious. But if dogs bark in the daytime also when, for instance, people come to pay their respect to the gods, the practice is, I believe, to break their legs [*i.e.* destroy them], because they are over-zealous when there is no cause for suspicion. The case with you accusers is similar: some of you are the geese, who can only call out, but cannot cause injury, others are the dogs, who can both bark and bite. We see that sustenance is provided for you, but you are required to attack only those who deserve it: this is what the people find most satisfying.

In striving to demonstrate his knowledge and wit, Cicero has created an historically flawed and over-elaborate digression. The geese are surplus to his argument. Unlike the dogs, they lived on the Capitol as a privilege, because their alertness had famously saved it from the invading Gauls in 390 BC. Dogs were kept there as working guardians, whose employment naturally ceased when they performed that function inefficiently. The relevant accusers were comparable only with the dogs: they had only duties and were dispensable, like them, not privileges and permanent tenancy, like the geese. *Pro Rosc. Am.* contains several discursive passages, reflecting the style of Cicero's early oratorical period, but they are almost all linked to surrounding arguments or narratives.[26]

There are several narratives of Verres' depredations, some of which, like that in *In Verr. II* 4.22–24, appear to have the character of separate, self-contained tales, but on closer inspection are seen to form an integral, logically connected part of the speech, and consequently do not qualify as true digressions. In the same speech, however, is a passage which is a clear

[26] Canter (n. 2) 351 finds five digressions (33–4, 55–7.59–61, 61–73, 136–42). He logically suggests that their extensive use is understandable, because the case itself is 'an unreasonable accusation, unsupported by any proof, feebly presented by the prosecutor Erucius. Little effort was required for Cicero to show Roscius' innocence, so little that he soon turned to censure and ridicule of his adversaries, in strong, deliberate, and extensive emotional appeals. These conditions were favourable to digression' (356). This reflects his broad view of the nature of digression.

example of it, (and is identified as such by Quintilian (4.3.13)). Its length prevents its quotation in full (106–8), but selections from it can convey its leisurely tempo and enveloping mood:

> It is an ancient belief, gentlemen, established by the oldest Greek books and inscriptions, that the island of Sicily is sacred to Ceres and Libera. The belief is held by other peoples as well; and the Sicilians themselves are so sure of it that it seems implanted in their minds by Nature herself. They hold that these goddesses were born in Sicily, that corn was first brought to light in Sicilian soil, and that Libera, whom they also call Proserpine, was carried off from a wood near Henna, a place which, because it is situated in the middle of the island, is called the navel of Sicily. Ceres, the tale goes, in her eager search for traces of her lost daughter, lit her torches at the fires that burst forth from the peak of Etna, and roamed over the earth carrying these in her hands. Henna, the traditional scene of the event I speak of, is built on a lofty eminence, the top of which is a table-land, watered by perennial streams, and bounded in every direction by precipitous cliffs, round which are numerous lakes and copses, and flowers in all seasons in profusion: one feels that the landscape itself confirms the story, familiar to us from childhood, of how the maiden was carried off. There is indeed in the neighbourhood, facing north, a bottomless cave, from which, we are told, Father Dis suddenly came forth in his chariot. He seized the maiden, carried her away with him from that place, and suddenly, not far from Syracuse, plunged underground; and at that place a lake suddenly appeared, near which to this very day the Syracusans hold an annual festival which is attended by great throngs of men and women.

Cicero goes on to describe how these ancient beliefs, reinforced by modern portents and upheld by people in other countries, have made Sicily a peculiarly hallowed place. The story as he tells it has acquired an antiquarian and religious flavour, and at the same time reproduces the intense feeling of the people about their island. Elsewhere in the Verrines there are inchoate digressions which soon return to attacks on the defendant (*e.g. II* 3. 94–7, where he recalls the extortionate behaviour of equestrian governors in the past, but without reference to a particular historical period or event; then he turns on Verres).

In *Pro Cluent.* 139–40 there is an interesting digression in which Cicero explains the parameters within which advocates ply their profession:

> But it is the greatest possible mistake to suppose that the speeches we

barristers have made in court contain our considered and certified opinions; all those speeches reflect the demands of some particular case and emergency, not the individual personality of the advocate. For if a case could speak for itself, no one would employ a pleader. As it is, we are employed to express, not the conclusions warranted by our own judgement, but the deductions that can be made from the facts of the case. There is a story that the brilliant M. Antonius used to say that his reason for never having written any speech was that, should he have occasion to regret anything he had said, he might deny ever having said it; as if indeed men do not remember anything we have said or done unless we have committed it to writing.

Now this is a very different kind of digression from the almost poetic one discussed above. But it fulfils the same function of diverting the jury with *extra causam* material, while enlisting their sympathy for the stance he is taking at this particular time.[27]

The only true digression that I can find in *Pro Murena* is in 75–6, the second one that has the character of a parable:

Do not, Cato, condemn in too harsh terms the customs of our ancestors, which are vindicated by experience and the durability of our government. There was in our fathers' day a scholar and a Stoic like yourself, a fine man and an aristocrat, Quintus Tubero. When Quintus Maximus was giving a funeral banquet to the Roman people in honour of his uncle Publius Africanus, Tubero, who was the son of this same Africanus, was asked by Maximus to provide coverings for the coaches. Whereupon, being deeply versed in Stoicism, he covered the Punic coaches with shabby goatskins and set out Samian crockery more appropriate for the funeral of Diogenes the Cynic than a banquet to honour the death of the mighty Africanus. On the day of Africanus' funeral Maximus pronounced the funeral eulogy and gave thanks to the immortal gods that Africanus had been born to Rome and not elsewhere; for it was essential that the seat of the world's government should be where he was. The Roman people resented Tubero's ill-timed philosophy in the ceremony commemorating Africanus' death. These goatskins cost this most upright of men and best of citizens the praetorship, although he was the grandson of Lucius Paulus and, as I have said, the son of Publius Africanus' sister. The Roman people loathe private luxury, but they love public splendour.

[27] J. Paterson, 'Self-Reference in Cicero's Forensic Speeches', in Powell and Paterson *CA* 82 discusses the context, in which the prosecutor Attius has accused Cicero of inconsistency by adducing a passage from Verrine I.

The last sentence enunciates the moral of the story. Then Cicero criticizes Cato for taking too austere a view of how a public figure should behave, but not living up to his own guidelines.

Pro Archia is the first speech in which Cicero confesses to indulging freely in digression (18); and almost two-thirds of it (12–30) fall into that category. Berry has convincingly explained his approach.[28] After arguing that the digression is relevant in the sense that Cicero had set himself the task not only of establishing that Archias was legally a Roman citizen but that 'were he not a citizen, he ought to be one' (301), Berry draws attention to the prejudices of the average Roman juror which Cicero had to counter – xenophobia and suspicion of men of culture, especially Greeks (302–3). How well did he know his audience ? It seems clear that his defence was successful, as Archias was still resident in Rome some time after the trial (*Ad Att. I*.16.15). Again, defence based on character had long been recognized as a part of the advocate's armoury. The only features of the digression that are perhaps hard to explain are its length and complexity. Berry is careful to explain that its subject-matter and argument is designed not to display Cicero's intellectual superiority too blatantly and egotistically, but some of the speech, from its very beginning (particularly), could have had that effect on a jury. And when he signals the peculiar character of the speech in one of his most elaborately constructed periods (3 : *Sed ne cui vestrum... inusitato genere dicendi*), it is natural to wonder why he risks taxing an already impatient jury's patience by taking them on a cultural tour. On the other hand, later readers of the speech, especially students of rhetoric, would find it very rewarding. Perhaps it is towards this readership that the speech which has come down to us is aimed.

The same question arises in connection with the following digression in *Pro Flacco* 62–3:

> There are present men from Athens, where men think civilization, learning, religion, agriculture, justice, and laws were born and spread thence to every land. Tradition relates that even the gods competed for the possession of their city, so beautiful was it. It is so ancient that it is thought to have produced its own citizens, and the same soil is said to have been their mother, their nurse, and their home. Its prestige is so great that the present shattered and enfeebled reputation of Greece is sustained by the esteem in which this city is held. There are present men from Sparta, whose well-known and famous valour is

[28] See p. 67, n. 9.

thought to have derived its strength not only from their nature but also from their upbringing. They alone in the whole world have now lived for more than seven hundred years with one set of customs and without ever altering their laws.

Some of the philhellenes Cicero is addressing would have identified the sources of this material – the funeral orations in Thucydides, Lysias, Plato, and Hyperides, and the epideictic discourses of Isocrates, especially the *Panegyricus*. A few of them would recall sojourns in Athens, or longer educational stays like those experienced by Cicero and some of his friends. Here the digression is economical, and it is not allowed to interrupt the progress of the argument for too long.

Pro Sestio contains at least two digressions.[29] The first (91–2), has already been discussed (p. 82), and serves to illustrate a general but subsidiary point about the present political situation – that violence is inimical to civilization, and only the acceptance of the rule of law can guarantee continuance of peace. The second digression, remarkable for its scale and literary richness, was prompted by a question posed by the prosecutor, who (96) asked who were the men to whom Cicero had referred as 'The tribe of Aristocrats' (*natio optimatium*).[30] The subject is the nature of the classes which contended for power in the Roman state:

There have always been two classes of men in this state who have sought to engage in public affairs and to achieve primacy in them. Of these two classes, one aimed at being, in repute and in reality, 'friends of the people' (*populares*), the other 'aristocrats' (*optimates*). Those who wished everything they did and said to be agreeable to the masses were reckoned 'friends of the people', but those who acted so as to win by their policies the approval of all the best citizens were regarded as the 'aristocrats'. 'Who are, then, these 'best citizens' of yours?', you may ask. In number, if you ask me, they are infinite; for otherwise, we could not subsist. They include those who direct the policy of the state, those who follow their lead, and the very large number of men to whom membership of the Senate is open; and there are men living in the municipal towns and in the country, men of commerce, and even freedmen, who are called 'aristocrats'.

[29] Canter (n. 2 353) notes six.

[30] *natio* as used here was a derogatory term, though it is unclear whether Cicero used it first or was quoting from another speaker. At any rate, as will be seen, Cicero in the digression applies a wide definition to the term 'aristocrat'.

This wide definition of 'aristocrat' is explained a little later (97):

> All are aristocrats who are neither criminal nor vicious in disposition, nor
> insane, nor beset by troubles in their households. It follows, then, that those
> who are upright, sound in mind, and easy in their domestic circumstances
> are those you have called 'the tribe [of aristocrats]'. Those who serve the
> interests and principles of these men in the government of the state are called
> the champions of the 'aristocrats', and are themselves reckoned the most
> influential of the 'aristocrats', the most eminent of the citizens, and the leaders
> of the state. What, then, is the goal which those who take the helm of the state
> should set themselves, and on which they should set their eyes and direct their
> course? Peace with dignity (see p. 83)... To be a defender and advocate of so
> many and important interests requires an exalted spirit, great ability, and great
> resolution. For in so large a body of citizens, there are great numbers of men
> who, either from fear of punishment, being conscious of their crimes, seek
> to cause revolution and a change of government; or who, owing to some sort
> of revolutionary madness, feed upon civil discord and sedition; or who, on
> account of embarrassment in their finances, prefer a general conflagration to
> their own ruin.

In the opening sentences Cicero is arguing that being an 'aristocrat' is a moral
concept rather than one of mere wealth and inherited status. And it is these
moral qualities – uprightness, courage, and soundness of mind – that such a
man needs if he is to deal successfully with the forces of disruption that will
inevitably challenge the stability of the state. Cicero is drawing on his own
experience of contemporary politics, and his portrayal of the revolutionary
mind is very reminiscent of that which he has painted of Catiline, the
decadent scion of an eclipsed patrician family. Speaking here also is the
successful 'new man', who has ascended the political ladder through his
own *virtus*. And when he comes to write his own *De Republica* perhaps two
years after the trial of Sestius,[31] *virtus* is the one essential quality needed by
his ideal ruler (*De Rep. I* 51–2). The idea of replacing privilege by moral
worthiness as his primary qualification was also in harmony with Cicero's
aspirations to a *concordia ordinum*, since such a change would blur or even
remove the present distinction between the ruling and the subject classes.

 These two digressions seem to have a different purpose from those aimed
at delighting (*delectari*) and stimulating emotion. The words with which

[31] Cicero had completed an advance draft of the first two books by mid-54 BC (*Ad Quint.
Fratr.* III 5. 1), but they had been at a seminal stage some time before that.

Cicero introduces them suggest that purpose (96): 'You ask about a matter, which is most proper for the young to learn, while it is not difficult for me to offer full instruction'. Thus their purpose is to educate and indoctrinate the present and future generations of readers.[32] Their presence in a speech gave it the same intellectual authority as Cicero's philosophical and political treatises, and staked its claim to permanent value more strongly than any of the other refinements.

The view of digression propounded in this section emphasizes its clear separation from the main narrative, the evidence, and the arguments of the speech. It is a diversion from rather than a contribution to them, even when, as with the digressions in *Pro Sestio*, Cicero says that they have been prompted by a question of the prosecutor. Conversely, when he refers to a section of a speech as *extra causam*, it is unrealistic to regard it as a digression for that reason alone. Such is the case with *Pro Milone* 72–91, described as an *ethica digressio* by May.[33] He appeals to Cicero's admission (92), but the section is integral to Milo's defence, containing a review of Clodius' career leading to the thesis that his death had been deserved, and was beneficial to the state. It was thus, as May admits, supplementary to the *status iuridicialis* (question of legality), not a diversionary section designed to delight, educate, or even to move, a jury.

It is to be hoped that this last example clarifies beyond doubt the nature of digression, both as understood by Cicero and in accordance with its essential meaning. It is the least frequently used of the eight refinements.

(d) Dilatation

Cicero's description of this refinement in *Brutus* 322 raises difficult questions of meaning, scope, and practical application: '[No one who could] broaden his speech from a particular issue, limited to a single person and a single time, to embrace a general question of universal interest'. On initial inspection, this seems to locate it firmly in theory, and in the programme of the rhetorical schools. In *De Orat. I* 138, Cicero says that his teachers taught him that

[32] Demosthenes, following Thucydides (1.22), also hoped that his oratory would have permanent educational value. See S. Usher, *Greek Oratory: Tradition and Originality* (Oxford, 1999) 278.

[33] See J. M. May, 'The *Ethica Digressio* and Cicero's *Pro Milone*', *CJ* 74 (1989) 240–6; and *Trials of Character: the Eloquence of Ciceronian Ethos* (North Carolina Press, Chapel Hill and London, 1988) 28–9, 134.

'every question has to do either with the investigation of a general question (*de infinitae rei quaestione*), where no persons or occasions are indicated; or with a problem that is concerned with specific individuals and times (*de re certis in personis ac temporibus locata*)' (Cf. *Orator* 45–6; *Part. Or.* 18. 61). But in actual trials advocates are obliged to focus intensely on the latter – on 'specific individuals', their actions and circumstances. 'Dilatation' is the process of transition from this necessary particularity to a quasi-philosophical sphere, making it perhaps the most dispensable of the refinements: the orator normally has no practical reason to make the transition. Correspondingly, any search for instances of dilatation must exclude the major parts of most speeches – those in which 'single persons' are acting individually. This rules out all narrative and all apostrophic oratory, factual discussion of evidence, historical personages introduced for illustrative or exemplary purposes, and most of the material contained in exordia and perorations. In his rhetorical writings, Cicero does not acknowledge these practical restrictions. In *De Orat. II* 133 he argues that 'any debate whatever can be brought under the notion and quality of the general kind' , and he illustrates this (135):

> Even in those cases where the point in dispute is a fact, such as 'Did Publius Decius take money illegally?', both arguments supporting the prosecution and those supporting the defence must be referred to a general category, namely to the character of an entire class.

Later (*Orator* 45–6) he affirms that the broadening of the particular to the general was one of the techniques taught to students of rhetoric. But he does not say why this transition is desirable, and seems here to have lost touch with practicality in his quest for his ideal rhetoric.[34] Yet from his personal point of view, dilatation had obvious attractions. Like digression, it afforded him some opportunties to display his oratorical brilliance through amplification (*Orator* 125–6). But because it differs from digression in introducing subject-matter that arises directly from the case in question, dilatation can more readily be used to influence judgements both as to facts and as to their interpretation. It can clarify or obfuscate, as required; and in addition to entertaining an audience, it can subtly flatter a jury's understanding by projecting a philosophical tone.

[34] M. L. Clarke, *Rhetoric at Rome* (London, 1953) 78 observes that Cicero was aware that dilatation was rarely applicable in a real case, and opines that it 'was in fact of little relevance to his oratory'. Fantham (*RWCO* 258–9) concentrates on the view that Cicero propounds in *De Oratore,* viz. that 'the richest speeches are those which escape the confines of the private dispute and turn to the universal issues involved'.

The first dilatation is in *Pro Roscio Amerino* 62. The subject is the peculiar seriousness of the charge of patricide, which requires the adduction not only of motive, past character and circumstance, but of incontrovertible concrete evidence, not information which has been supplied by unreliable witnesses. In *Div. in Caecil.*, a brief example (7–9) is followed by a more substantial one (27–9), an excursus on the qualities necessary in a prosecutor, a subject which could scarcely have been avoided in a speech where he is arguing his own superiority in that role. Since his main contention is that Caecilius would be a collusive prosecutor, it is natural for him to dwell on the question of his probity. But since Caecilius has virtually no track record as a prosecutor, Cicero has to rely on generalities such as the poor opinion which the Sicilians have formed of him, and his previous friendship with Verres, two related matters. Here the dilatation is used as a device of insinuation.

The irregularities and corruption that have occurred since the transfer of the law-courts to the Senate give rise to brief dilatations in *In Verr I* 37 and *II* 1. 4. The link with the subject of the speech is Verres' own part in the corruption when he was *praetor urbanus*. Not unrelated to this, there is a dilatation on the theme of corruption in the extortion courts in *II* 3 94–7.

In Verr. II 4.117, a description of the city of Syracuse may be thought to be a digression. But it has the character of a dilatation because it focuses on those features of the city that establish it as a centre of power. This makes it an integral part of the surrounding discussion, and hence an amplification of the present argument. Cicero goes into details of the city's treasures in order to generate maximum contrast between the restraint shown by its conqueror Marcellus who, mindful of the reputation of Rome, saved all the city's buildings (120), and Verres, who systematically plundered religious artefacts (122–3).

In *In Verr. II* 5. 50, after Cicero has described how Verres has broken two treaties, with Tauromenium and Messana, he enlarges on the subject, addressing Verres:

> Well then, by this action of yours, which you have called a benefaction, but which the facts show to have been a piece of bribery and corruption, you have lowered the position of your country, lessened the resources of the Roman nation, weakened the forces procured for us by the valour and wisdom of our forefathers, annulled our imperial rights, the obligations of our allies, and the observance of our treaty with them.

Here a personal attack on Verres has developed into a dilatation, and it goes

further, taking the form of a description of the consequences of Verres' illegal action. At times, like much else in the *Verrines,* it has the flavour of an invective.

A dilatation may argue a bigger issue which has arisen from a particular case or instance. There is an example of this in *In Verr. II* 4. 113–4:

> The rights of our wronged allies, the authority of our laws, the reputation and honour of our courts, are here at stake; and these are all very great matters. But greater than all these is this, that the whole province is in the grip of such religious fear, the minds of the whole population of Sicily are seized by so fearful a panic because of this deed of Verres, that every public or private misfortune that befalls them is believed to have come about through his crime against heaven.

A similar transition to a broader issue occurs in *In Verr. II* 5. 139:

> It is now no longer a question of the preservation of our allies: it is a question of the life and existence of Roman citizens, or in other words, of each and every one of ourselves. Gentlemen, do not look to me to prove my statements on this matter, as if some part of them were open to doubt. All the facts which I shall give you are so notorious that I might as well have been making the whole of Sicily witness to their truth.

He then draws together some of the salient facts about Verres' governorship which confirm that it damaged Rome's interests in general, and also on an individual level by abusing the rights and the persons of Roman citizens in his province. Later (149) the general policy of Rome to avenge wrongs against her, and the value of Roman citizenship (167) are subjects of dilatation.

In *Pro Font.* 36–7, a transition is made from the consideration of evidence to the general subject of the influence exercised by witnesses. This would arise if a Roman court were 'influenced not by the evidence of the Gauls, but by their threats' (36). *Pro Cluent.* 115–6 adverts to the usual practice of juries not to concern themselves with the assessment of penalties after they have given their verdict. Later in the same speech (146–50), after Cicero has objected to an inconsistency in the application of the law, he introduces a broader discussion of the consequences of such departures from the course of justice:

> For law is the bond which secures these privileges of ours in the commonwealth, the foundation of our liberty, the fountain-head of justice. Within the law are

reposed the mind and heart, the judgement and the conviction of the state. The state without the law would be like the human body without the mind, unable to employ the parts which are to it as sinews, blood, and limbs. The magistrates who administer the law, the jurors who interpret it – all of us, in short – obey the law so that we may be free.

There is a shorter dilatation in 159 on the obligations of jurors. Such dilatations as these are characterized by their ethical content, and may also have an emotional component. This may be close to the surface in speeches like *Pro Rab. Perd. Reo,* where the morality of bringing to trial an aged senator on a thirty-six-year-old charge is highly questionable, and vexatious in origin. It also invited the adduction of parallels. A dilatation in that speech opens thus (25–6):

> For in bringing into court a case which was dead before you were born, a case in which you certainly would have been involved if you had been old enough, do you not realize in the first place who are the men, how distinguished are the citizens, whom you are accusing, now that they are dead, of a monstrous crime? And again, how many still alive you are bringing by this same charge into the utmost peril of their lives?

The list of those thus endangered includes some distinguished names, including ex-consuls. Another name, to be set aside from the rest, is that of Marius. He played a not altogether creditable part in the suppression of the rising, but Cicero always viewed him somewhat idealistically, and here allows himself the indulgence of a dilatation on Marius' unquenchable desire for glory (29–30):

> And so among the many reasons which lead us to think that the souls of men are divine and immortal, the chief is this, that the spirits of our best and wisest men look forward to the future with a gaze fixed solely upon eternity. Therefore do I call as witnesses the souls of Gaius Marius and all other wise and good citizens...

The invocation then broadens to include the whole class of men who have served the state with distinction.

In *Pro Caec.* 51 a thesis is discussed: that language is incapable of the precision needed to distinguish every nuance of meaning, so that recourse must be had to common sense as to the intention of the writer or legislator (*consilium autem eorum qui scripserunt et rationem et auctoritatem*). Later

(70) the broader consequences of the undermining of law by sophistry are described in general terms, followed by theoretical examples.

A well-defined dilatation develops in *Cat. II* 11–13, where the subject, one of urgent relevance, is 'the enemy within':

> There is no foreign people left for us to fear, no king able to make war on the Roman people. The sole remaining war is on our own soil: the plots, the danger, the enemy, are in our midst. The battles we have to fight are against luxury, folly, and crime. That is the war for which I offer myself as your leader, citizens. I accept the enmity of scoundrels. I shall find a way to cure what can be cured; what needs excising, I shall not allow to remain to destroy the state. Let them either go, then, or keep the peace. If they remain in Rome without a change of heart, they can expect their deserts.

The exigencies of the situation make this the wrong time to extend this dilatation to an analysis of the cause of Rome's moral degeneration. Moreover, the focus must be kept steadily on Catiline. Cicero goes on to describe his position as that of a pariah. Addressing the People in this speech, he can present Catiline's reception in the Senate with a degree of freedom. But he must not overdo this, because he wants to dilate also on the dangers that he has personally faced in his mission to root out this threat. Another dilatation on 'the enemy within' occurs in *Pro Mur.* 78. Earlier in that speech (22–5) Cicero dilates on the subject of the qualities necessary for a consul in order to disparage the claims of one of Murena's opponents for the consulship, the jurist and advocate Sulpicius Rufus. The qualifications of the serving soldier are to be compared with those of the man who spends his time in the lawcourts and with his clients. But this comparison is not straightforward, and in his dilatation on it Cicero needs to ascribe to his client qualities which are not automatically associated with his profession, while arguing that the professional jurist does not possess them (24–5). He presses home his attack on the legal profession by claiming that they had undermined their own reputation by jealously guarding their knowledge of legal rules and procedures. Obscure and arcane formulae were devised in order to perpetuate their monopoly. The dilatation multiplies examples of this, and its effect is to affirm the unsuitability of men who engage in this selfish kind of operation for the office of consul, whose greatest asset should be his ability to communicate, which he achieves by being a good orator. In another dilatation in this speech, 83–4, an appeal to the jury is used to emphasize the urgency of the situation.

Pro Sulla 78 is a rhetorical critique of the inefficacy of examination under torture as a means of obtaining reliable evidence. This discussion has a long history in Athenian oratory, where the rationale was that torture was necessary in order to obtain the truth from slave witnesses. A litigant's offer of his slave for this form of examination might be used as an indication of his confidence in his case, but no proved instance of the acceptance of such an offer exists. In Rome it receives occasional mention (*e.g.* Cic. *Pro Rosc. Am.* 78, *Pro Cluent.* 181–2), but the present passage is of interest because it emphasizes its weaknesses:

> The prosecutor threatens us with the examination of our slaves under torture. Although we do not foresee any danger under this procedure, still the course of examinations under torture is steered by pain, is controlled by the individual qualities of mind and body, is directed by the president of the court, is diverted by caprice, tainted by hope, invalidated by fear, and the result is that in all these straits there is no room left for the truth. Let the life of Publius Sulla be put to the torture. Let it be examined as to whether any lawlessness is concealed in it, any crime, any cruelty, any recklessness.

The metaphorical transition at the end strains the logic of the argument. If, as is implied by the first part of it, torture is an unreliable method of eliciting the truth, using it to examine the life of Sulla (whatever that means) is unlikely to reveal the truth about it. But perhaps this is Cicero's way of asserting that his speech has subjected Sulla's life to the closest possible scrutiny.

Pro Archia contains much digressive material, but 12 is rather in the nature of a dilatation, because it arises as a direct response to a request by the prosecutor for clarification, and, in spite of this personal angle, discusses a topic of general interest:

> You will no doubt ask me, Gratius, to account for the deep interest I feel in my friend. It is because he provides refreshment for my spirit after the clamour of the courts, and repose for senses jangled by their vulgar wrangling. Do you think that I could find inspiration for my daily speeches on so manifold a variety of topics, if I did not cultivate my mind with study; or that my mind could endure so great a strain, if study did not provide it with relaxation? I am a devotee of literature, and make the confession unashamed; shame belonging rather to the bookish recluse, who knows not how to apply his reading to the good of his fellows, or to manifest it to the eyes of all.

This passage seems to show that Cicero had already, several years before *De Oratore*, conceived his ideas on the all-embracing cultural associations of oratory; but it is also relevant to its immediate context, in that it shows how literature can, however indirectly, serve society. This in turn presents Archias in the most sympathetic light, as a desirable citizen, both to this jury and to the wider community.

The humorous reference to the unreliablility of Asiatics as witnesses in *Pro Flacc.* 65 has already been alluded to (p. 207), but its full context qualifies it as a dilatation, as it arises through a contrast with their illustrious co-witnesses, the Greeks (64). The dilatation reinforces this characterization by showing how not only the Greeks, but even the Asiatics themselves, affirm it. Two further dilatations in the speech (94 and 99) serve to underline that the welfare of the state is at issue in this trial.

In spite of the diffuse nature of *De Domo Sua* it is difficult to identify clear examples of dilatation in it. This is because of the intensely personal stance which Cicero assumes throughout the speech, and the almost constant focus on himself or on Clodius, which rules out almost all consideration of general themes or arguments. But the peroration begins with a dilatation (143):

> Since this is so, gentlemen, divert your minds at last from the minutiae of my argument to a broad survey of that republic, the responsibilities of which many gallant heroes in the past have helped you to bear, but which at the present juncture you have supported upon your own backs. It is to you that the perpetual authority of the Senate, to which you yourselves have throughout my case given a magnificent lead, it is to you that the magnanimous demonstrations of Italy and the united support of the corporate towns, it is to you that the Campus and the unopposed voice of all the Centuries, who have had you for their mentors and directors, it is to you that all associations, all classes, in a word, all those whose welfare has been realized or is in prospect of realization, think that all their good wishes and favourable opinions towards my merits have been, not merely committed, but commended.

The relentless *anaphora* ('it is to you...') underlines the final *captatio benevolentiae*. By broadening what was a very personal issue into one of public concern, in which all classes, but particularly the jury, had a part to play, Cicero tries to bind them to his cause.

In *Pro Sest.* 138–9 Cicero broadens his idealized characterization of the *optimates,* emphasizing their public-spiritedness and their protection of the state against demagogues.

The exordium of *Pro Caelio* contains a few passages which are somewhat widely focused, and the section as a whole is less well defined than in some other speeches, as Cicero tries to generalize the case. This broadens at one point into a dilatation on the education of young men (39–43). In it Cicero, while commending the strict asceticism of the traditional Roman education, argues that it cannot be maintained in the society of his own time. Austin (p. 83) reasonably describes the passage as an 'unusually long piece of doctrinaire lecturing'. There is an other shorter dilatation in 46 on the rigours of oratorical training.

Appropriate in the case of the ambitious and successful Balbus, a dilatation on the subject of worthy ambition and the warding off of envy serves a useful purpose (*Pro Balb.* 18):

If each of us, gentlemen, were bound to remain in the position in which he was born or, in whatever station of life he was established by fortune at his birth, to maintain it until old age; if all those whom luck has advanced, or their own labour and spirit of industry have rendered illustrious, were punished for it, the law and the condition of existence would not seem harder for Lucius Cornelius [Balbus] than for many good men and true. But if, in many cases, virtue, talent, and quality as a man, starting from the humblest origin and state of life, have procured not only friendships and abundant means, but also the highest praise, positions, glory, and rank, I do not understand why it seems more likely that jealousy will injure the merit of L. Cornelius than that your sense of justice will help a man of such modesty. Therefore, gentlemen, the request above all that I ought to make to you, I do not make for fear of appearing to doubt your wisdom and your human feelings. But I must ask you not to hate talent, not to show yourselves the enemies of industry, not to think that human feelings should be crushed and that talent should be penalized. And I do ask, if you see that my client's case is in itself sound and unshakeable, that you should prefer his own personal distinctions to be a help rather than a hindrance to his case.

This appeal to reason rather than prejudice and emotion may come from the heart, in so far as Cicero had something in common with Balbus, as a man who had made his way to the top through energy and ability.

Pro Planc. 8 is a dilatation on the electoral power of the people, in order to make the point that, although it was sometimes capriciously exercised, this should not render the candidate who had benefited from it liable to prosecution. Nor should a disappointed candidate take his defeat too much

to heart: in *Pro Planc.* 51–2, the prosecutor Laterensis, a previous holder of several state offices, is disgruntled at being defeated by Cicero's client. Cicero counsels him not to be mortified, citing similar instances of electoral disappointment. This develops into a dilatation, extending to instances of later success:

> But why this catalogue of failure to obtain this office? They have often occurred under circumstances which have led the defeated parties to believe that they had received a boon from the people. That eloquent noble, Lucius Philippus, was never elected tribune of the plebs, that renowned and gallant young man Gaius Caelius was never elected quaestor; Publius Rutilius Rufus, Gaius Fimbria, Gaius Cassius, Gnaeus Orestes, were never elected tribunes of the plebs, and yet, in spite of everything, were elected consuls.

By focusing on Laterensis' career, Cicero diverts attention from the charges made against his client, and also manages to mention an irregularity in Laterensis' earlier canvassing for the tribunate (52–3). Later (80–2) there is a dilatation on gratitude as the supreme virtue – a passage which strongly reminds Cicero's readers of the agency which cemented Roman political alliances.

A short background is needed to the dilatation in *Pro Rab. Post.* on the morality of the equestrian order. In 54 BC Gabinius was prosecuted for restoring Ptolemy Auletes to the Egyptian throne wthout the Senate's consent, and also for extortion. He could not pay the consequent fine and went into exile. Rabirius, a knight and a money-lender, became implicated because he had financed Ptolemy. He was now required to pay the damages adjudged against Gabinius. In his speech for him Cicero mounts a more general defence of the class of equites, beginning by adverting to his own attachment to that order (15). This expands into an imaginary dialogue between knights and senators on the privileges and advantages enjoyed respectively by the two orders. The knights' function as jurors, which enables them to ensure that public-spirited men like Rabirius receive fair treatment, is a precious one to them. The dialogue form of this dilatation adds to the variety of guises in which it can occur.

In *In Pis.* 68–72, the 'witty travesty' (Nisbet 133) of Piso's relationship with the Epicurean philosopher Philodemus qualifies as a dilatation because it broadens the picture of Piso's self-indulgent eclecticism. But the weighing of this against the constant presence of the personality of Piso in this invective perhaps makes this a marginal case. The same uncertainty arises in passages

like 76–81, in which Cicero tendentiously describes his own relationship with Pompey and Caesar.

In the fragmentary *Pro Scaur.* 42–5, a dilatation on the traditional treachery of the Phoenicians expands into a similar charge against their descendants in Carthage and Sardinia. There are exceptions to this generalization which undermine the argument, and it is not clear what part the whole topic plays in the overall plan of the speech. This kind of xenophobia is relatively more uncommon in Roman than in Greek writers, always excepting Carthage.

In *Pro Mil.* 18–19 Cicero deplores the fact that the killing of Clodius has evoked more adverse comment than that of Marcus Papirius, a worthy Roman knight, by Clodius. He adds to this an even more outrageous escape from justice. A slave of Clodius was caught lying in wait to assassinate Pompey, and was apprehended. The purpose of this dilatation seems to be to place the blame firmly and solely on Clodius, since Cicero avoids mentioning that the slave was killed (as he surely must have been) after he had confessed his mission, and concentrates on the political implications of the attempt on Pompey's life. A similarly obfuscating purpose is behind the dubious exercise of characterizing Milo as an altruistic tyrannicide, which produces a dilatation on the esteem in which the Athenian prototypes, Harmodius and Aristogeiton, were held (80):

> The Greeks accord divine honours to those men who have slain tyrants. What sights I have seen in Athens and other cities of Greece! What religious rites ordained in their honour! What magnificent musical compositions and odes! Their worship reaches almost to the observance and commemoration proper to immortal beings. And will you, so far from bestowing any distinctions upon the preserver of a great nation and the avenger of a great crime, even suffer him to be haled hence to a felon's death?

It is easy to forget for the moment that the subject of this hyperbolic comparative argument is being tried as the casual killer of a short-term demagogue. But the dilatation is a part of Cicero's plan of double insurance, as he goes on to argue that even if Milo admitted to the killing, he should be praised as the champion of Roman liberty.

Nearing the end of his tirade in *Phil. II* 116, Cicero reminds Antony of the fate of a greater man than he, who shared his aspirations to tyranny:

> And what a life is it, day and night to dread your own followers? Unless indeed you have men bound to you by greater favours than Caesar bestowed

on some of those who became his assassins, or indeed whether you yourself are in any way to be compared with him. In him there was genius, calculation, memory, letters, industry, thought, diligence; he had done things in war, however calamitous to the state, yet at least great. Having aimed for many years at the throne, he had by great labour, great dangers, achieved his object. By shows, buildings, largesse, banquets he had conciliated the ignorant crowd. His own followers he had bound to him by rewards, his adversaries by a show of clemency. In brief, he had already brought to a free community – partly by fear, partly by his forbearance – a habit of servitude.

This dilatation is an admirable example of Cicero's clarity of thought on the subject of domestic politics, summarizing as it does the essential instruments of Caesar's power, and explaining how his extraordinary energy was directed towards achieving a balance between ruthlessness and the cultivation of popularity. By thus portraying the hopelessness of any attempt by Antony to rival all this, Cicero can now adopt a conciliatory tone at the end of his most sustained invective: 'Recover your senses, I beseech you...' (118).

In *Phil. III* 9–11 the departure of Antony enables the heroism of Decimus Brutus to receive its due recognition; and this is most effectively embellished by drawing attention to his ancestor, who expelled the last tyrant, Tarquinius Superbus. 'Lucius Brutus did not tolerate a proud king: shall Decimus Brutus endure the reign of the accursed and impious Antonius?' The dilatation goes on to argue that Antony's brand of tyranny has been worse than that of the infamous Tarquin.

Most of the other *Philippics* (*IV, VI, VII, IX, X*) are too short to accommodate dilatations, or are addressed to a particular issue. They are also much concerned with the cut-and-thrust of argument between personalities

The above examples of dilatation in his speeches show how far Cicero has broadened the application of the theory of *quaestiones*. It is a radical departure from that theory in that it envisages the possibility of a transition from one kind of *quaestio* to the other in the same context, whereas in the rhetorical sources they are treated as separate and distinct.[35] In his practice, therefore,

[35] Cicero's brief reference to the question in *Orator* 45–6, *Latius enim de genere quam de parte disceptare licet,* derives from this received doctrine. The reference to dilatation in *Brutus* 322 specifies transition (*traducere*) from the particular to the general. M. L. Clarke in his important article 'The Thesis in the Roman Rhetorical Schools of the Republic', (*CQ* 45 [N.S.1] (1951) 159–66) is concerned with the relative development of the thesis (*quaestio infinita*) and hypothesis (*quaestio finita*) in Roman rhetorical theory. This leads him to set the teaching of the Greek rhetoricians, who concentrated on hypothesis (161) , beside the

dilatation embraces the widening of any theme, or any argument, or even in some cases emotional content.[36] Hence the varied character of the examples of it chosen for this chapter: some are informative, others argumentative, others express or seek to arouse feeling; and some are aimed at diversion or obfuscation. None exhibits the character of the rhetorical schools, and all have the individual stamp of a purely Ciceronian refinement.

tradition preserved in *Ad Herenn.*, where thesis has no place (162). Then, turning to Cicero, he notes that all the examples in cases cited by Crassus in *De Orat.* 2 are on particular rather than general themes (162), whereas Quintilian says (2.1.9, 2.4.41–2, 10.5.11) that Cicero was interested primarily in theseis, as Cicero himself seems to imply in *Ep. Ad Att. IX.* 4.1. But he notes that in *De Part. Orat.* 18.61, written around the same time as the above letter, Cicero says that the distinction between the general and the particular does not work in practice (61).

[36] This brings dilatation closer to Winterbottom's concept of 'widening', as applied in his chapter *Perorations* (Powell and Paterson *CA* 226–9), where emotional appeal is the primary feature of his examples.

CHAPTER SEVEN

CRITICISM AND PERFORMANCE:
SUMMARY AND CONCLUSIONS

In this concluding chapter I consider four closely related subjects. It begins with an examination of Cicero's views of his own oratory, which is a more elusive subject than the second, his assessment of other orators. For the third subject, Roman Oratory before Cicero, a more objective judgement can be made, since our material is drawn not from Cicero but solely from the surviving fragments of that oratory. Finally, a summary of Cicero's own deployment of the refinements in his speeches, drawn from the preceding chapters, leads to conclusions as to his realization of his own aims and ideals in his oratory.

(a) Self-Assessment

The elaborate subtlety of Cicero's presentation of the case for his primacy among orators is well worth examining. We may begin with his statement in *Orator* 100 that the ideal orator does not exist in the flesh, only in the imagination (*animo non manu*). Soon after this (102–3) he offers three of his own speeches (*Pro Caecina, Pro Lege Manilia,* and *Pro Rabirio Perduellionis Reo*) as exemplifying the Plain, Middle, and Grand styles respectively. By this juxtaposition he is implicitly setting himself up as a model for his readers to imitate. But he is also careful to temper his claims with qualified modesty, as when he says: 'There is no kind of oratorical merit which is not found in our speeches, if not in perfection, at least attempted and adumbrated. I have not reached the goal but I see what the proper goal is' (105). Yet when he says this he is surely inviting his readers to contradict him. He might have been looking for a similar reaction to his occasional self-depreciation: in addition to being critical of his own earlier oratory (*Orator* 108), he may refer to his own ability in neutral terms ('whatever ability I possess as an orator' (*Orator* 12), or 'whatever powers I possess, and I am sorry that they are not great' (*Orator* 130, a more equivocal statement than it looks, because he says *quanta,* not *quantula,* which would give the fullest possible force to a self-criticism; and the passage concerns his special powers in the arousal

of his audience's emotions)). A little earlier (129), beside a statement that his ability is 'mediocre or even less than that', he tells how he has worsted opponents with his vigorous style.

There is less qualification when he describes his early career in *Brutus* (305–316), where he stresses the thoroughness with which he sought and benefited from the best available training in civil law (306), dialectic (309), philosophy (315), and voice-training (313). He adds that he was already a well-known figure in the forum before he went abroad to put the finishing touches on his education (314); and says that he came back 'almost transformed' (316). But even then he was dissatisfied, because he was not yet recognized as the best. His most formidable rival was Hortensius, so he began by regarding him as the model to emulate (317). This rivalry did not last long, because Hortensius, overfed by success and preferment (he was elected consul in the year of the trial of Verres), went into a steady decline. Thus Cicero's rise to the top is made to seem like the conclusion of a natural process. He has also justified it, not by boasting his superior talent, but by continuing to stress that his position has been achieved not only by innate ability, but by arduous training and pure hard work (318); and he tells how he continued to 'increase such gifts as he had by every type of exercise, particularly by writing' as his political career approached its peak with his aedileship and his praetorship (321).

It is at this point that he chooses to turn disparagingly to other orators, and the full force of our key passage (322) becomes apparent. These 'others' (*ceteri* usually also has the sense of 'the rest', 'all the others') are his inferiors because they have not educated and trained themselves in the subjects which an orator should study, as he has done. It is therefore, for them as for him, a matter not so much of talent and ability as of application. Now his critics cannot accuse him of empty self-glorification, since any cause for complaint has been removed by the possibility that any of his rivals might have matched his achievement if they had matched his industry. While natural ability is important, and receives due attention in *De Oratore* (1.113–32), the ideal orator must apply himself to training, beginning with the study of rhetoric (137–46). This is a routine syllabus, which most of his rivals will have followed. What distinguishes Cicero from nearly all of them is the thoroughness of preparation that he demands. In his training, it is not enough for an orator to exercise his vocal chords: he must consider his words carefully, and to do this effectively he must write them down (*De Oratore* 1.150):

The pen is the best and most eminent producer and teacher of eloquence;

and that is reasonable. For if a speech which has been given prior thought easily defeats an impromptu and casual one, that speech in turn will surely be surpassed by what has been written with care and diligence. The whole gamut of the most brilliant thoughts and expressions must inevitably flow up in succession to the point of our pen. Then the ordering and arrangement of words is perfected by the act of writing, in a rhythm and measure suited to oratory and not poetry.

Here three stages or types of oratorical composition are envisaged, and Cicero makes it clear which type he favours, and which reflects his view of the proper nature and character of oratory. An orator should aim to produce a durable work of literature.[1] This is what Cicero did, and he believed that for such oratory to achieve this aim, it must contain subject-matter which his audience, after an initial hearing, would want read and contemplate.

Assiduous and wide-ranging study was thus necessary for the aspiring orator; and Cicero's rivals had conspicuously failed to recognize this necessity. The specific areas of study for the trainee orator are outlined initially in *De Oratore*. There Cicero speaks through the mouth of his famous teacher Crassus (with Antonius playing the part of antilogist or 'devil's advocate' at this stage of the dialogue). After an early summary of the 'very many subjects' of which the orator must have knowledge (*scientia rerum plurimarum*) (1.17–18), he makes Crassus analyse each in detail. Crassus' ideal orator is a man of letters and of broad culture, able to draw on the skill of a poet (1.69–73). He is thoroughly versed in common law (*ius civile*), and Crassus illustrates this need with examples (1.165–201). His discussion only impinges on the need for knowledge of philosophy, mainly in the form of morality and the understanding of human nature; but Antonius in his reply assumes that Crassus' orator has steeped himself in philosophy (1.223–33).

While it is easy to see how Cicero uses history at a practical level in his speeches, as a storehouse of examples for deployment in arguments and illustrations, the question of how he saw himself as a potential historian and his oratory as an historical medium should also be revisited, however briefly. The importance of history to the orator is shown in *De Oratore* by the fact that it is a subject of more general agreement than literary knowledge, law, and philosophy. Several speakers voice its praises: Catulus, Caesar,

[1] This opinion places Cicero firmly on one side of a long-standing controversy, in which the original antagonists were Isocrates and Alcidamas. Fantham (*RWCO* 86) describes that controversy succinctly: 'Cicero follows Isocrates' stress on the merits of written eloquence rather than Alcidamas' exaltation of the ability to talk on one's hind legs'.

and even the minimalist Antonius, who surprises his companions with his knowledge of historians (2.59). Nobody disagrees with him when he argues (62–3) that the writing of history demands the orator's skills as acutely as does forensic pleading and parliamentary deliberation. History is oratory's closest companion, and its most natural ally, and no serious orator can ignore it. Cicero was thoroughly acquainted with past and contemporary historians, and may even have considered writing history himself (see pp. 158–9, 174). Unlike the other three cultural refinements, historical knowledge needed to be on constant display, and Cicero had, in his own opinion, equipped himself to display it better than most other orators.

Evidence of Cicero's opinions about his own wit and humour is more difficult to find. In his oratory it is, of course, displayed, but he does not comment on its quality and effect. We have to turn to his letters for the little guidance that he provides. In *Ad Att. I* 16. 10 he gives a blow-by-blow account of an exchange between Clodius and himself, which ended in 'roars of applause' which 'were too much for him [Clodius] and he collapsed in silence'. But this encounter took place at a politically uncomfortable time for Cicero (61 BC), and it may perhaps be seen as a morale-booster for him when he was facing hostility, as the next paragraph of the letter shows. There is only one other reference in the letters to his wit and its reception, *Ad Quint. Fratr. II* 11. 1. There he tells his brother how he ridiculed the demands and pretensions of the potentate Antiochus of Commagene. It is interesting that this rare instance of Cicero's celebrating his own wit has a foreigner, not a Roman, as its subject. Many of his fellow-citizens (Clodius included) had been the enraged victims of his mordant wit, and he was sensitive enough to avoid antagonizing them further by gratuitous references to it. He seems to have left the recording of his witticisms largely to others. It is the sort of task that Tiro, his secretary, would have undertaken. Another assembler of his humorous utterances was Gaius Trebonius, now one of Caesar's lieutenants serving with him in Spain (46 BC), but also one of Cicero's long-standing supporters. In the letter thanking Trebonius for this work, (*Ad Fam. XV* 21. 2), Cicero implies that it consisted not merely of bare quotations, but that Trebonius had set each in its context. While thanking Trebonius for his labour of friendship, he does not congratulate himself on the richness of its content, but even suggests politely that Trebonius has found humour where none was intended

Cicero writes with a little more freedom in the letters on the less controversial subject of his ability to speak emotionally, though the references

to it are of a general character. He alludes to the reception of his high-flown oratory in *Ad Att. I* 14. 4, and to his appeal to his audience's emotions in the speech *De Domo Sua* in *Ad Att. IV* 2. 2. Of a speech which he made not long before the meeting of the Triumvirs at Luca, he writes that he 'spoke with great frankness and spirit', and that the speech 'caused a sensation'. In *Ad Fam. VII* 1. 3 he writes: 'I ruptured my lungs defending Caninius Gallus'; and in *Ad Fam. X* 28.1 he describes a speech in which he did not mince his words, but 'spoke with energy'. In the speeches, Cicero often shares his feelings with his audience, telling them how moved he is by his client's plight, or by the sufferings of the various worthy characters in his story. But this is an ingredient of his rhetorical strategy rather than a pronouncement about the place of emotion in his oratory. We must turn to his dialogues in order to learn about this. There he tells us that he saw himself as an orator who revelled in emotional speaking, as we have already seen (pp. 217–8).

How does Cicero justify his claim to primacy? In what ways was his oratory superior to that of other orators? The following clause describes the difference: *propter exquisitius et minime vulgare orationis genus animos hominum ad me dicendi novitate converteram.* ('[because] I had drawn men's attention towards me by the novelty of my style of oratory, which was more ingeniously composed and utterly unlike the common style of speaking' (*Brutus* 321). The chief significance of this is that it describes a literary style, conceiving oratory as a genre which attains its highest form on the written page.[2] Although he was proud enough of his performances on the rostrum, Cicero expected the ultimate appreciation to come from those who read his speeches, and these readers included budding students. Evidence that he established this readership for his speeches is to be found in his letters. As early as 60 BC he is writing of '...the little speeches which the enthusiasm of my young admirers prompts me to put on paper' (*Ad Att. II* 1. 3). A few years later, referring to his speech *De Domo Sua,* Cicero wrote (*Ad Att. IV* 2. 2): 'Our younger generation cannot be kept waiting for this speech'. These references to young students of oratory reading his speeches as part of their training seem to mark an advance in their education. The standard syllabus which they followed under the rhetoricians involved mainly the learning of the rules of composition from the handbooks; and special emphasis was laid on oral practice. When they turned to literature for models, Greek

[2] There is a close Isocratean parallel. In answer to critics of his style and the whole idea of the prepared speech, Isocrates writes (*Panegyricus* 11) of his 'speeches which are beyond the powers of ordinary men and have been elaborated with extreme care'. See also n. 1.

rather than Roman authors were used. When Cicero makes Crassus mention 'the reading of the ancient orators and poets' as a later stage in the orator's training (*De Orat.* 3. 48), the reference is to Greek authors. But Cicero wants to broaden this to include Roman oratory, especially his own. In the sequel to the passage in *Ad Att. II* 1 quoted above, he writes of following the example of Demosthenes in publishing some of his deliberative oratory. By doing this he would be providing students with topical Roman models to set beside, or even to replace, the speeches of long-dead Greek orators which students had been perusing hitherto, and thereby adding a new dimension to their training. The circulation of his speeches thus played a central part in his staking a claim to fame, enabling him to become an innovator in education, in addition to providing a conduit for the propagation of his thoughts about politics, and, not least, about the development of his political ideals in the course of his career.

(b) Cicero's Assessment of Other Orators

This subject is broached as part of the broader discussion in the Introduction. Here it is considered with more specific reference to individual orators and refinements. The dialogue *Brutus* remains the chief source, with its attendant problems. The main one of these is that it is concerned with other aspects of the history of Roman oratory, such as the debate between the Atticists and the Asianists, which tended to turn the main discussion towards matters of style and the orators' purely rhetorical prowess. Again, in his chronological treatment, Cicero restricts himself to summary judgements of individual orators and supplies little illustrative material.

The discussion begins (57) with Marcus Cornelius Cethegus, an otherwise minor figure (consul 204 BC), whose oratory had not survived; an unpromising start. The Elder Cato had fared better at the hands of posterity, but not at the hands of readers. Cicero claims to be one of the few who had read his speeches (though perhaps not all 150 of them) (65), but his interest centres on their purely stylistic features rather than the eight refinements (66–9). The next significant reference to an orator is to Sextus Aelius, 'the most learned man of his time in the civil law, but also a ready speaker' (78); and Sulpicius Gallus was 'of all the nobility, the profoundest student of Greek letters (ibid.). Amid many generalized critiques of styles, there is an isolated reference to the ability of Servius Galba to use digression effectively (82); and later (88–90) we read of his 'many moving appeals

to the mercy of the court' and 'stirring the pity of the people'. C. Carbo, who opposed the Gracchi, is the first orator credited with humour in *Brutus* (105). Subsequently, the most frequently attributed refinement is 'versed in Greek and Latin letters' (104, 107, 108, 114, 131, 167, 168, 175, 205, 214, 237, 247, 265, 283), with knowledge of the law in second place. Style and general tone remain the chief qualities described when philosophical affinities are discussed (116–21), with Stoicism to the fore, but primarily as a determinant of style, rather than as a philosophical doctrine.

Cicero marks arrival at Gaius Gracchus with a certain flourish (125): 'But now we have in our hands Gaius Gracchus, a man of outstanding talent, intense application, and training from childhood...' Yet his judgements on Gaius are equivocal: he is an orator whom students should read, but he lacks the final polish (126). The first of these judgements is at least unusual: subsequent orators are not so recommended, and receive summary treatment and lukewarm praise, as before based on style. It is only when Cicero comes to Antonius and Crassus that he offers distinctive and detailed critiques, though again style, and also performance, figure largely in these. In *De Oratore* Antonius is an enigmatic figure, understating the orator's art (1. 232, cf. Quint. 2 17.5–6), and denying that the orator needed knowledge of many things (1.213–8), including the law (1.248–55), yet himself displaying natural ability which enabled him to outstrip all rivals except Crassus (1.172). Cicero expands this portrayal in *Brutus*. There Antonius is seen to have the essential virtues of a practical orator: good memory, and the appearance of spontaneity and sincerity, through which he could arouse his audience's emotions (139, already noted in *De Orat.* 2.124, 185–96, 204). A certain lack of final polish seems concordant with these qualities (*Brutus*140), and even adds to the impression of naturalness.

Whereas Antonius is portrayed by Cicero as the prime exemplar of 'art concealing art', Crassus is the complete orator (*nihil statuo fieri potuisse perfectius* (*Brutus* 143)). He could match Antony in emotional appeal (*De Orat.* 2.188), and indeed the strain of speaking with passion cut short his last speech and led to his death (ibid. 3. 3–6). He was also endowed with wit, tastefully deployed (ibid. 2. 221–3; *Brutus* 197). In his knowledge of the law, he was inferior only to the legal specialists (*Brutus* 145 ('the ablest jurist in the ranks of the orators')); and he was adept at arguing for the spirit against the letter of the law (*Brutus* 197–8). But even he is not credited with all the refinements, and Cicero says much more about undefined virtues, like his 'dignity', and 'lucidity' (*Brutus* 143, 158).

Other contemporary orators predictably fare no better than Cicero's two favourites. Among those he highlights is Marcius Philippus, whose great popularity made him a strong contender for the crown. He was sharp-witted, but his humour could misfire (*De Orat.* 2. 245). Cicero places him next, though after a long interval, behind Crassus and Antonius (*Brutus* 173, 186). Mucius Scaevola is praised for his dexterity in interpreting the law, but is found to fall short in style (*Brutus* 194, 198). Aurelius Cotta (202) and P. Sulpicius Rufus (203) are likewise criticized in ambivalent terms, conditioned by Cicero's high regard for Antony and Crassus. Scribonius Curio could raise a laugh (216), as could Servilius Glaucia (224). Thus all the orators on whom Cicero passes judgement suffer weaknesses and fall short of perfection. In 161, he says that Latin eloquence reached a certain level with Antony and Crassus. Then he adds:

Henceforth no one could expect to add anything considerable to it [sc.Latin eloquence] unless he should become better equipped in philosophy, in law, and in history.

Thus it is the cultural refinements that are needed to make the complete orator, and they remain elusive. None of the orators whom he describes has more than one of them. In the end he has damned them all with faint praise, and the prize for ultimate excellence is still to be won. Even his most respected rival, Q. Hortensius Hortalus, does not receive that accolade. His name appears at the end of *De Oratore,* with a glowing prediction of his future greatness from Crassus. This may be taken at face value as an expression of Cicero's genuine admiration. The passage has long been traced to Plato, *Phaedrus* 279a, where Socrates is made to predict a bright future for Isocrates. It is suggested[3] that both Plato and Cicero are implying that Isocrates and Hortensius respectively failed to realize their early promise. This seems to be rejected, at least by Cicero, when he quotes the *Phaedrus* passage and affirms that Plato 'admired Isocrates alone of the rhetoricians' (*Orator* 42). As to Cicero's own relationship to Hortensius in stylistic matters, he saw at an early stage in his development that he was closer to Hortensius than to any other possible model (*Brutus* 317). In his opening assessment of Hortensius, however, Cicero singles out for praise his memory (301) and capacity for practice (302–3), hardly the most formative attributes of his ideal

[3] Most recently by Fantham *RWCO* 70, who writes that *De Orat.* 3.229 'may have been a transparent veil for Cicero's own reservations'. Further on Hortensius, see C. E. W. Steel, *Lost Orators of Rome,* in Dominik and Hall *CRR* 243–4.

orator. Returning to his subject later (317), he describes Hortensius' style as 'ornate and passionate' (*ornatus, acer*); later, 'fiery, animated, and sonorous' (perhaps pejorative: 'sing-song') (*incensum et agentem et canorum*). Unfortunately, in this part of the dialogue the main subject is Cicero's own career, which progressed *pari passu* with the decline of Hortensius, who was by this time looking forward to a more leisurely life (320). This mild but telling disparagement is seen in Cicero's parting comments on Hortensius. In 325–6, he says that Hortensius was an Asianist (see below) and adds that this style was suited to a younger man's oratory, so that his addiction to it became a cause of his decline in later life. More seriously for Cicero's portrayal of Hortensius, by introducing this addiction he was representing Hortensius' style as purely derivative and unoriginal. The contrived balance of clauses, and occasional impetuosity, were characteristics shared by other earlier writers who had been labelled Asianists. Finally, we read elsewhere (*Orator* 132) that Hortensius 'spoke better than he wrote', a significant criticism coming from Cicero, who, as has been shown, regarded the written speech as the highest expression of the orator's art.

By assigning to Hortensius a part in the Atticism/Asianism literary debate, Cicero focuses on style, and does not touch on the question of whether Hortensius had any of the cultural qualities of his ideal orator. That debate is deliberately used as a diversion, and makes no constructive contribution to the argument. This is unsurprising, since it had quickly become a sterile controversy. In Rome it had developed from the perception of two men, Calvus and Brutus, that oratorical style in the city was becoming too florid, bombastic, and bedecked with various forms of artifice. They called themselves Atticists, narrowly associating that name with plainness and austerity, and claiming Lysias as their model. Soon it had become centred on personalities. Not only was Hortensius called an Asianist, but that charge was levelled against Cicero himself (Quint. 12.10.13–15; Tac. *Dial.* 18). Cicero shows the consequence of the Atticists' extreme position, a style which suffers from 'meagreness, dryness, and general poverty' (*Brutus* 285). Moreover, he shows that their argument is historically flawed, because the Attic Orators represented a range of different styles, so that the character of an imitator's 'Atticism' depended on the particular passage of the particular orator he has chosen to imitate. But it must be remembered that Cicero has made Asianism/Atticism one of the topics of *Brutus* in order to defend himself against the critics of his style, and Hortensius' part in the discussion is incidental. The disparagement of his greatest rival is effected by other means.

(c) Roman Oratory Before Cicero

The examination of the texts of Cicero's predecessors, as distinct from his opinions of them, begins with the Elder Cato. He was a contradictory figure, claiming to despise rhetorical artifice while widely deploying it, like Sallust's Marius (*Bell. Jug.* 85. 31–2), and having a high enough opinion of his own oratory to include specimens of it in his history, the *Origines*. Both the style and the content of these speeches are in their different ways revealing. The speech *For the Rhodians* reflects some of the usages of contemporary literary speech: amplification through synonyms ('favourable and expansive and prospering...to grow and enlarge...disciplines and teaches... say and advise'), antithesis ('adversity...prosperity'), and anaphora. A major influence may be Plautus, but he in turn drew on popular speech. Perhaps more interesting is the argument, which is philosophical and psychological, reminiscent of Thucydides. The Rhodians had backed the wrong side when they allied themselves with King Perseus of Macedon against Rome in the Third Macedonian War. But Cato was concerned lest, after punishing the Rhodians, the Romans would engage in further conquest, and corrupt their own body-politic by bringing home plunder and creating luxury, the effect of which is encapsulated in the gnomic utterance 'adversity disciplines and teaches what needs to be done, prosperity is apt to turn men aside from right deliberation and understanding'. Alongside this is the deliberative topos of utility – that past friendship with the Rhodians has been useful, and therefore should not be abandoned. Also present is the quasi-legal concept of *mens rea*: the Rhodians have done no actual harm to Rome, and can be accused only of 'wishing' to become her enemy. Swiftly drawn parallels reduce this argument to absurdity; and there is even a touch of irony or cynicism as Cato throws it back in his audience's face by saying: 'They say that the Rhodians are insolent, alleging what I would not at all want to be said of me and my children. Let them be insolent. What business is it or ours? Are you angry if someone is more insolent than we are?' Several of the other fragments (*e.g.* Malcovati *ORF* 219–222) concern the laws and their interpretation, and this interest is confirmed by Livy (39.40) who, after praising his *versatile ingenium*, specifies his ability as a jurisconsult alongside his prowess as an advocate. Cato's ability to infuse emotion is apparent in narrative from two fragments of speeches against Q. Minucius Thermus (190 BC) (*ORF* 58–9), the first of which describes the maltreatment of local officials in Bruttium.[4]

[4] For stylistic analysis of this fragment, see E. Sciarrino, *Roman Oratory before Cicero: The*

Other fragments may have been preserved because of their wit, such as 217, where he quotes the proverb *inter os et offam multa intervenire* (cf. 'there's many a slip twixt cup and lip'). If one could judge from his entries in the text of *ORF* (82 pages), Cato would seem to have been the most frequently read and cited of the earlier orators. However, as has been observed, Cicero regards him as totally neglected in his own time (*Brutus* 65), and offers only a vague criticism of his style, that he is 'not yet sufficiently polished, and there is something more perfect to be desired' (*Brutus* 69). But the preserved passages show him to have deployed cultural refinements in addition to wit and emotional appeal.

Of three passages attributed to Scipio Aemilianus (*ORF* 21. 17, 19, 30), in the second he illustrates the difference between two kinds of wickedness, passive (*nequitia*) and active (*malitia*). He involves his audience with rhetorical questions and uses examples for illustration. The third passage is a description of debauched behaviour which he had witnessed, sufficiently detailed to form a scene or tableau. The point of the passage, and probably the reason for its preservation, was that the perpetrators were scions of his own class. He emerges as a thoughtful speaker, with an interest in public morals, but not notably witty or forceful.

Gaius Gracchus is second behind Cato in his entries in Malcovati *ORF*, though by a long way (22 pages). Of the several surviving fragments, one from *Against the Aufeian Law* (*ORF* 48.44) contains cynical comments on the mercenary motives of most politicians, in this case illustrated by their being in the pay of foreign princes, who wanted them to promote their interests. But the speaker tells us that he is not like those politicians: he is speaking because he wants to gain something – a good name, not money. A quotation from the Athenian orator Demades caps the argument: when a certain tragic poet boasted about receiving a talent for presenting a single play, Demades countered by saying that he had received ten talents for keeping his mouth shut. Before this speech, Gracchus delivered one denying that he had enjoyed an extravagant life-style while serving in Sardinia (*ORF* 48. 26–8). The style is that of a simple factual statement. But he is capable of instilling emotion, at least in an imaginative listener, into a quite bare narrative, as when he tells the story of the humiliating punishment inflicted on the local quaestor at Teanum Sidicinum by the visiting consul, whose wife was dissatisfied with the state of the public baths which she wanted to use. Gracchus makes the most of the spectacle of the unfortunate official being stripped and scourged

Elder Cato and Gaius Gracchus, in Dominik and Hall, *CRR* 58–9.

(*ORF* 48.48). Finally, on a more overtly emotional note, an outburst quoted by Cicero (*De Orat.* 3.214) combines aporia with hypophora:

> Where can I take refuge in my despair? Where can I turn? To the Capitol? But
> that is overbrimming with my brother's blood. To home? So that I can see my
> mother in grief and misery?

Hypophora (questions ('suggestions') answered by the speaker) had been used to stir up feeling in perorations by Greek orators at least since the time of Andocides (*Myst.* 148). Gaius Gracchus represents a more extrovert oratorical style, which included recourse to theatrical gesticulation (Val. Max. 8.10.1, Tac. *Dial.* 26, Plut. *T. Gracch. 2, C. Gracch.*4.1; see Sciarrino, n. 4, 60–2), than that which had hitherto been used in senatorial debates. This reflects his role as a *popularis* politician, and he is an early exemplar of a new course in Roman oratory. This gained momentum as the *populares* grew stronger with the rise of Marius, and more people wished to learn how to speak in public. This trend was opposed by the *optimates*, who saw the spread of popular rhetoric as an erosion of their power.[5] Aspirants to the novel style received help from new textbooks on rhetoric, of which the *Rhetorica Ad Herennium* is the most complete that has come down to us. Other preserved fragments, however, are from speeches by members of the ruling senatorial class, and are undistinguished in both style and content; with one exception. Helvius Mancia, the son of a freedman, is both the butt of humour and the purveyor of it in *De Oratore* (2. 266, 274) because of his bizarre appearance at an advanced age. When he accused Scribonius Libo before the censors in 55 BC, he was ridiculed for the same reason by Pompey, who enquired whether he had come back from the dead. His riposte, preserved by Valerius Maximus (6.2.8), is remarkable not only for its wit, but also for its extempore character, its emotional impact, and for its author's extraordinary courage in so confronting Pompey at the height of his power:

> You are not lying, Pompey, for I am indeed returning from the underworld. But
> while I tarried there I saw C. Domitius Ahenobarbus bloodied and bewailing
> the fact that he had been killed in the flower of his youth at your command –
> he who had been born into the most august family, and led the most blameless

[5] See. S. C. Stroup, *Greek Rhetoric Meets Rome* in Dominik and Hall *CRR* 28–36. Further on pre-Ciceronian oratory at Rome, see C. Steel, *Roman Oratory,* (Cambridge, 2006); and her 'Lost Orators of Rome' (in Dominik and Hall *CRR* (Oxford (Blackwell), 2007) 237–249; E. Sciarrino, n. 4 (above); E. Courtney, *Archaic Latin Prose* (Atlanta, 1999).

life of devotion to his country. I saw with equal clarity M. Brutus with ghastly
sword-wounds, complaining that this had happened initially through your
treachery, and subsequently through your cruelty. I saw Cn. Carbo, who had
defended you and your father's estate most zealously in your youth, enchained
while consul for the third time, in fetters which you had ordered to be placed
on him. He was protesting that he had been destroyed by you, a mere Roman
knight, contrary to all justice, when he was holding the supreme office. I
saw Perpenna, a man of praetorian rank, wearing the same garb and uttering
the same lament, cursing your cruelty; and the whole company of men, who
protested with one voice that they had died without trial at the hands of the
teenage executioner, yourself.

The vivid representation of Pompey's victims accusing him from beyond
the grave, with each of them displaying his anguish at his degradation from
eminence to humiliating death, is the work of no ordinary orator. And yet
Helvius Mancia is otherwise almost unknown today. How many others
of similar ability remained totally obscure? This is, of course, a constant
problem for those who try to assess the richness of a literary tradition.

It is clear from the foregoing survey that many of Cicero's predecessors
and contemporaries were capable of expressing and arousing emotion, both
by portraying their own feelings and by affectingly describing pathetic or
tragic events. Wit, and to a lesser extent irony and sarcasm, were the stock-
in-trade of some (often the same) orators. A philosophical tone and possible
philosophical interests are to be found in others, and learning, especially of
jurisprudence, is to be assumed from what we know of many public speakers.
On the negative side, there must be uncertainty as to the extent to which
these orators used examples from history; and it cannot be demonstrated that
any of them practised the arts of digression and dilatation.

(d) Cicero's Oratory: Summary and Conclusions

It seems likely that Cicero understated the amount of talent possessed by his
contemporaries, though we have too little of their oratory to form more than
a qualified opinion. This makes our final task, the assessment of Cicero's
performance when he tries to realize his ideals in his own speeches, all the
more important.. The eight refinements which he has desiderated in other
orators occur in his own speeches in the following numbers:

Speeches with all eight refinements: 4:
 (*Pro Roscio Amerino, In Verrem II* 3, *Pro Cluentio, Pro Murena*)
Speeches with seven refinements: 8:
 (*In Verrem II* 1, 4, *Pro Flacco, Pro Sestio, Pro Caelio, Pro Plancio, Pro Rabirio Postumo, Pro Milone*)
Speeches with six refinements: 8:
 (*In Caecilium, In Verrem II* 5, *De Domo Sua, De Haruspicum Responsis, Pro Balbo, In Pisonem, Pro Rege Deiotaro, Phillipic III*)
Speeches with five refinements: 8:
 (*In Verrem I, II* 2, *Pro Caecina, Pro Archia, Pro Scauro, Philippic II, V, XIII*)
Speeches with four refinements: 8:
 (*Pro Quinctio, Pro Fonteio, Pro Rabirio Perduellionis Reo, Pro Sulla, Post Reditum Ad Quirites, Pro Ligario, Philippic I, IV*)
Speeches with three refinements: 9:
 (*De Lege Agraria II, In Catilinam III, IV, In Vatinium, De Provinciis Consularibus, Philippic VIII, XI, XII, XIV*)
Speeches with two refinements: 9:
 (*Pro Lege Manilia, In Catilinam I, Post Reditum In Senatu, Pro Marcello, Philippic VI, VII, IX, X*)

The surviving fragments of *De Lege Agraria I* and *III*, which like the fragmentary *Pro Roscio Comoedo* and *Pro Tullio* are not discussed in chs. 2–4, each contain one refinement.

It is surprising to note that some of the most famous or admired speeches contain fewer than half the refinements: *Pro Lege Manilia*, the *Catilinarians*, *Pro Ligario*, and most of the *Philippics*. Perhaps more significant is the fact that most of the speeches in these lower categories are addressed to the Senate or the Popular Assembly rather than to a jury in the lawcourts. This phenomenon seems to accord with the observation of J. T. Ramsey, that these speeches were characterized by relative brevity and economy.[6]

Comparison of the relative incidence of the refinements themselves cannot take into full account the length of text which each example of the refinements occupies. This qualification applies particularly to history, digression, and dilatation, any of which may be lengthy, as the Table shows. The figures are:

Literary Allusion: 47

[6] *Roman Senatorial Oratory*, (in Dominik and Hall *CRR* 130–1).

Philosophy:	65 (33 Ethics, 32 Logic)
Law:	63
History:	160
Humour:	130
Emotion:	109
Digression:	16
Dilatation:	44

Like his rivals, Cicero deploys humour and emotional appeal widely, but, also like them, finds relatively fewer opportunities to display his literary, philosophical, and legal knowledge. He probably digressed and broadened his themes more than they did, but solid evidence for this is lacking. What distinguishes him from them above all, however, is the frequency of his use of history to illustrate and provide support and authority for his arguments, and to add extra colour.

If Cicero was arguing in *Brutus* 322 that his ideal orator should introduce all the refinements into all his oratory, it seems clear that he fell short of that ideal in most of his own speeches, and in some by a long way. This disparity between ideal and reality, theory and practice, is readily explained by the demands of actual lawsuits, where oratorical refinements had to take second place to the presentation of evidence forcefully but also clearly and succinctly. The results of our examination show that Cicero observed this requirement in the majority of his speeches. From those results we may draw another conclusion of considerable interest, which is that in preparing his speeches for circulation, he did not 'apply the curling-tongs' and embellish them as much as might have been expected.[7] This comparative paucity of the refinements which Cicero himself recommends is a contribution, albeit a modest one, to the discussion about the relationship between the speeches he delivered and their published form. By its very nature, this question cannot be answered decisively, but there is enough evidence to have generated controversy. This evidence has been assembled by Powell,[8] who rightly concludes that the differences between the live and the written speech have tended to be overemphasized. A good orator relied a great deal on his memory, and this faculty served him well when he came to write up (*conficere*) his speech. Missing from the written speech would be interruptions, some of the cross-examination of witnesses (57), and some of the more technical material which might sit uncomfortably in a published oration. It is more difficult to identify

[7] Brutus 262, Orator 78.
[8] *CA* 52–7.

what Cicero added to the delivered speech, but a criterion which he may have applied can perhaps be found in the word *conficere* itself. It connotes completing, finishing, perfecting, which suggests that the delivered speech needed such embellishment in order to convert it into a work of permanent interest to as many different kinds of reader as possible. Some speeches, and some trials, lent themselves more readily to such conversion than others. The most identifiable of these speeches is *Pro Sestio*. The case itself did not pose severe technical problems to the defence, and Sestius had powerful backers, who expressed their support during the trial. Hortensius spoke before Cicero and dealt with the central issues of the case, 'leaving nothing out' (3). The time was opportune for a review of the broader political situation and of the part which Cicero, continuing his rehabilitation after returning from exile, hoped to play in shaping its future development. The embellished version of the trial-speech that he composed for his readers contains seven of the refinements which he recommends.

Other explanations may be found for the high incidence of refinements elsewhere. *Pro Cluentio* was a case in which Cicero invested much time and effort. It was also an extremely difficult and complicated one on behalf of a very suspect client (see p. 44 n. 30). Focusing his reader's attention on his own virtuosity would have diverted attention in the most favourable possible direction. A similarly virtuosic display in *Pro Murena* met the exigencies of the political situation. Murena may have been guilty of electoral bribery as charged, but it was essential that the new consul should have had recent military experience. Moreover Cicero himself, flushed with the success (as he saw it) of his consulship, was sufficiently confident and relaxed to include a variety of extraneous subject-matter, much of which was designed to entertain or edify his readers rather than assist his client. The presence in *Pro Roscio* of all eight refinements is easily explained by the fact that it is the earliest of Cicero's published speeches, in which he felt he needed to display his all-round talents to the greatest advantage. It could be for the same reason that all the *Verrines* contain five or more refinements. The high incidence of refinements in *Pro Plancio* and *Pro Milone* (seven) is interesting for different reasons, the former for its personal content and Cicero's emotional involvement in the case,[9] the latter because he intended it to be regarded as a model speech embodying all the features which he wanted his readers (pupils) to imitate.

[9] Kennedy *ARRW* 205, referring to 86, remarks: 'It finally emerges that he regards the attack on Plancius as really an attack on himself'.

At first sight, the fact that over half of Cicero's extant speeches contain only half of the refinements which he recommends, or fewer, may seem surprising. But this relative sparsity only serves to confirm, for the majority of speeches, the view that the process of 'writing up' involved pruning down the spoken speech more than adding embellishments to it.[10] One may assume that assiduous preparation had gone into all Cicero's forensic and political speeches before their delivery, so that little titivation was needed before publication. This seems to be the case with one of Cicero's most admired and polished speeches, the *Pro Ligario*, which he circulated soon after its delivery, and said that he could not add to it thereafter (*Ad Att. XII.* 20. 2). The same reluctance to make changes may have applied to other carefully prepared and staged orations, like *Pro Lege Manilia*, the *Catilinarians*, and the *Philippics*. In all of these other factors came into play.

Speeches addressed to the People – *Pro Lege Manilia*, the *Second* and *Third Catilinarians*, the *Fourth* and *Sixth Philippics* – might be expected to contain fewer cultural refinements than those addressed to Cicero's senatorial colleagues. In the case of the *Philippics*, there may not have been much time for revision and embellishment; and it was always possible that pressure of time could curtail the process of preparing speeches for publication. We know that copies of the *Fifth, Seventh* and *Eleventh Philippics* were in M.Brutus' hands within three months of their delivery to the Senate,[11] and that in general Cicero was anxious not to keep his young admirers waiting to read his speeches.[12] But in a few instances delay may have been desirable for one reason or another: we know of one case where he asked Atticus to make the decision on the time of publication of a speech (the *Second Philippic*) (*Ad Att. XV* 13.1). Another factor which could have led Cicero to amend or embellish his speeches and hence delay their circulation was Atticus' role as his literary critic. In *Ad Att. I* 14. 3 he writes that Atticus is 'his Aristarchus', thus comparing him to the Alexandrian librarian and textual critic. Elsewhere Atticus is seen to have commented on subject-matter within his own particular areas of expertise, which included philosophy (*XIV* 17, *VI* 2.2). He is a respected critic in matters Greek, such

[10] Pliny *Ep.* 1. 20.6–7 reveals that the relation between the delivered speech and the published version was a matter of controversy in his day (his correspondent is Tacitus). He argues that Cicero 'said a great deal [in the trial] which he left out of the published speech' (*permulta dixisse, cum ederet, omisisse).*

[11] *Ad Fam.* 2.3.2; *Ad Fam.* 2.4..1.

[12] *Ad Att. IV* 2.2.

as Cicero's account of his own consulship in that language (*I* 19. *sub fin.*) and Greek geography (*VI* 2. 2). He even comments on an unfinished work, telling Cicero what he would like to see included in it (*XIV* 17. 3). Cicero, for his part, takes some pains to assure Atticus that he values his criticisms, even when they are adverse (*XVI* 11. 2). In the latter passage the subject is the *Second Philippic*, but there is little other evidence that Atticus suggests any changes or refinements to Cicero's speeches. Most of them, it seems, reached their readers not long after they were delivered, confirming that he regarded revision of them as a relatively simple process, consisting mainly of excision rather than addition.

The conclusion to be drawn from our whole examination of the speeches, and from other, extraneous evidence, is that the realization of Cicero's ideal in his own oratory was possible only in a certain set of circumstances, and that these had to contend with the practical requirements of a genre which operated in an exacting political, social, and intellectual environment. In such conditions ideals could not always be met. Cicero found more occasion to display his literary and philosophical knowledge in his correspondence than in his speeches. Humour found expression in both media, though it was harsher and more aggressive in the speeches than in the letters. Emotional appeal found its natural home in the theatre of the law-courts and the rostrum. But the most remarkable discovery of our study has been the importance of the place held by history in Cicero's oratory. He would have made a highly readable historian of his times, though not perhaps a wholly impartial one. As to his own assessment of his oratory, we may now take at its face value his confession (*Orator* 104): 'I have not reached the goal, but I see what the proper goal is'; and we can now gauge with some accuracy the extent to which he fell short of it.

TABLE:
REFINEMENTS IN THE SPEECHES

	Literature	History	Philosophy	Law
Pro Quinctio				30–1
Pro Rosc. Amerin.	46, 131, 140	33–4, 56, 62–6, 70, 90, 154	75	62–6, 111–2
Div. in Caecilium		62–3	*31, 45, 58, 60*	18, 35
In Verrem I	39	44		51–2
In Verrem II 1	53	48, 55, 70	38	17, 26–7, 106–7, 108–12, 115, 121–33, 142
In Verrem II 2	5, 191–2	2–11, 86, 109, 113, 123, 125		
In Verrem II 3	2–3	2, 81, 125, 185, 209	161–2	163, 193, 195
In Verrem II 4	39, 106–8	7, 9, 21, 56, 72, 115–51		41
In Verrem II 5	3	1, 84, 180		
Pro Fonteio		23–4, 38–9		
Pro Cluentio	84	95, 128–32, 134, 151, 153–6	*64, 66, 159, 171*	116, 120, 157
Pro Leg.Manilia	22	11, 54, 55, 60		
De Leg.Agraria I		5, 19–20		
De Leg.Agraria II		8, 18, 31, 64, 81, 83, 87, 90		21, 26–8, 30
De Leg.Agraria III			6–7	
Pro Rab. Perd.		15, 24–5		
Pro Caecina		53, 87	*48–9, 88–9*	40, 53, 66–8, 73, 80, 85
In Catilinam. I		3–4		
In Catilinam II		20		
In Catilinam III		18, 20, 24		

Ethical= Roman Logical= Italic

	Humour	*Emotion*	*Digression*	*Dilatation*
Pro Quinctio	19, 39, 80	10, 22, 91–9		33
Pro Rosc. Amerin.	6, 22, 23, 61, 100, 124, 147	8, 23, 28, 29–30	55–7	62
Div. in Caecilium	22, 27, 47, 50, 51, 57	3		9
In Verrem I		50, 58, 93–4		37
In Verrem II 1	106–7, 121	46, 76, 112		4
In Verrem II 2	13, 52, 54, 76, 115–6, 129, 132–3, 141, 154	43, 46, 76, 110–1		2–5
In Verrem II 3	16–17, 27–8, 34, 155, 187	6, 12–13, 130, 131, 137, 198–9	94–7, 122	207–8
In Verrem II 4	8, 51, 53–4, 59, 95	7, 17–18, 47, 52, 71, 74, 77, 86–7, 110–1	33–4, 106–9	113–4, 117–23
In Verrem II 5	2–3, 14, 26–7	23, 72–7, 100, 166–21, 128, 192	139, 149–57, 167–8	50
Pro Fonteio	21, 29, 30	46–8		36–7
Pro Cluentio	40, 58, 71–2, 141–2	12–16, 29, 136, 187–8, 195, 199	139–140	115–6, 146, 50, 159
Pro Leg.Manilia				
De Leg.Agraria I				
De Leg.Agraria II				76, 87
De Leg.Agraria III				
Pro Rab. Perd.	12–14	5		25–30
Pro Caecina	14, 18, 23, 28, 32			51, 70–7
In Catilinam. I		18, 33		27
In Catilinam II	22–4			11–15
In Catilinam III		passim		

	Literature	History	Philosophy	Law
In Catilinam IV		4, 20–1	3	
Pro Murena	60	31–4, 36, 58, 59, 66	*3, 8,* 15, 31, 61, 77	9, 27, 35, 36
Pro Sulla		23	*24, 31, 81*	
Pro Archia	12, 18	16, 19, 20, 21, 22, 24, 26, 27, 28		7
Pro Flacco	46, 65, 72	64, 98	*17, 39*	
Post Red.in Senatu		38–9		
Post Red.ad Quirites		6, 7, 11, 19–20	22, 23	
De Domo Sua		24, 64, 79, 86–7, 91, 101, 139	*46, 125, 140*	33–42, 43, 45, 51, 138
De Harusp. Resp.	39, 59	6, 16, 41, 43, 54–5		32
Pro Sestio, ,	102, 118, 120–1, 122, 123	37–9, 101–2, 107, 127, 140–2	23	
In Vatinium	14			37
De Prov. Cons.		18–23, 27, 32		46
Pro Caelio	36, 37, 38	34	*6, 30,* 41, 42, *52, 53*	
Pro Balbo		11, 25, 31, 34, 48, 55	3	19, 21, 22, 27, 28, 29, 33, 36
In Pisonem	43, 73, 82	22, 43, 44	41, 42	
Pro Plancio	59, 66	26, 33, 51–2, 69–70, 88	*8, 35, 46, 79,* 80–1	33, 40
Pro Scauro		III.1, 2, 3–4, 40	III.3	III.5
Pro Rab.Post.	4, 28, 29	4, 14, 16, 23–4, 26–7	11–12, *31–2*	9–11
Pro Milone	8	7, 8, 9, 14, 16, 80	17, 84	10
Pro Marcello			*21,* 27	
Pro Ligario		12	*23, 29*	
Pro Reg.Deiot.	25	19, 21–2, 36	*18*	3
Philippic I	34	11, 18	18, 23	
Philippic II	55, 66–7, 104	87, 114		

Ethical= Roman　　　　　　　　　　Logical= Italic

	Humour	*Emotion*	*Digression*	*Dilatation*
In Catilinam IV		11–12, 18		
Pro Murena	8, 19–29, 60–1	1, 49, 55–6, 85–7	75	24, 78
Pro Sulla		19, 88–93		78
Pro Archia			13–30	12
Pro Flacco	39, 47, 65, 76, 92	102–3, 106	62–3	64–5, 94
Post Red.in Senatu		1–2, 8		
Post Red.ad Quirites		5, 18–19		3–4
De Domo Sua	47, 60, 105, 110, 111, 127	24, 45–6, 75, 98–9, 137		143
De Harusp. Resp.	6, 8–9, 10–11, 44	25		
Pro Sestio, ,	116, 135	1, 3, 52–3, 76–7, 117–24, 144–7	91–2, 96–101	138–9
In Vatinium	1–9			
De Prov. Cons.	29			
Pro Caelio	34, 36, 61–9, 78	59, 79–80	4, 6	39–42, 46
Pro Balbo	22, 25, 27, 32	13		18
In Pisonem	13, 17, 22, 37, 39, 58–61, 73, 91		48–52	76–81
Pro Plancio	83, 85	99–101, 104–14		8, 80–2
Pro Scauro		47–8, 50		42–5
Pro Rab.Post.	21, 24, 38–9	43–7		16–17
Pro Milone	17, 20	85, 92, 102–4		80, 84
Pro Marcello		33–4		
Pro Ligario	1, 26–8	14–15, 32–3, 35–8		9–11
Pro Reg.Deiot.	6, 7, 21	39		
Philippic I		9		
Philippic II	2, 5, 21, 25, 34, 44–5, 84–6, 91, 100–1	58, 63, 69, 118		116

	Literature	*History*	*Philosophy*	*Law*
Philippic III	27	8–9	21–2	16
Philippic IV		13–15	13	
Philippic V		17, 24–5, 26, 48	31	8–10, 47–8
Philippic VI		13		
Philippic VII			9–15	
Philippic VIII		7, 13–15, 23, 31	2–4, 13, *16*	4
Philippic IX		4	3, 8	
Philippic X			20	
Philippic XI		9, 17, 18	7–9, 39	
Philippic XII			5, 25	
Philippic XIII	15, 49	1	1, 6, 45	
Philippic XIV		23–4		

Ethical= Roman　　　　　　　　Logical= Italic

	Humour	*Emotion*	*Digression*	*Dilatation*
Philippic III	22, 26, 31			9–11
Philippic IV		12–14		
Philippic V	12–14			
Philippic VI		18–19		
Philippic VII	23	7, 9, 17, 26		
Philippic VIII	6, 16, 25			
Philippic IX				
Philippic X		4		
Philippic XI	14			
Philippic XII		14, 19, 21		7
Philippic XIII	4, 27, 33–7, 41–2, 46–7	20–1		
Philippic XIV	6–7	34		

GLOSSARY

The following list contains the rhetorical and other technical terms used in this book. Most of them describe figures of language and thought, types of argument, features of style, and verbal devices which are designed to add force and emphasis to a phrase or clause. They are all listed in the index, from which examples may be located in the main text.

a fortiori **(comparative) argument***:* Reasoning from the greater to the lesser case, or *vice versa.*

amplificatio: Collocation of two or more synonyms, in order to expand and enrich a sentence.

anaphora: Repetition of the first word or word-group in co-ordinate clauses or phrases.

antithesis: Paired clauses or phrases containing contrasting or balanced thought.

aporia: A speaker's complaint of helplessness, usually posed as a question.

apostrophe: Turning away from an audience, judge, or jury in order to address another person, usually the speaker's opponent.

captatio benevolentiae: Topos (q.v.) of ingratiation (mostly used in the exordium).

chiasmus: Co-ordinate clauses or phrases with corresponding parts, in which the second clause is in reverse order to the first (AB>BA).

conquestio: Strong complaint about a situation or an opponent's behaviour. The term also applies to the general tone of a passage.

correctio: Clarifying a meaning by substituting a more accurate or stronger word.

dilemma **('double-catch')***:* An argument presenting two conditions, one of which must be fulfilled, though the fulfilment of either is detrimental to the speaker or his opponent.

eidolopoiia: A form of *prosopopoiia* (q.v.) in which dead persons, rather than merely absent persons, are represented.

enargeia: The description of a scene as if it is being enacted before the very eyes of the hearer. (Synonymous with *evidentia, repraesentatio, sub oculos subiectio*).

epideictic: Of oratory delivered for demonstration, display, and on

GLOSSARY 279

ceremonial occasions such as funerals and triumphs; of the style suited to such oratory.

etymological figure: The collocation of words derived from the same root, as in, for example, cognate accusative.

exordium: The opening section of a speech.

gnomic: Having the character of a saying, aphorism, or epigram, expressing a general truth; the context may make it almost synonymous with 'sententious'.

hyperbole: Exaggeration, usually in a whole passage rather than centring on a single word.

hypophora: Sequence of short anticipatory questions or suggestions alternating with short answers by the same speaker.

locus: Topic, theme, or subject. *locus communis* is a 'commonplace', or standard topic or argument.

metaphor: Transference of a word from one field of activity to another in order to add animation or colour to an expression. Cicero, like Demosthenes, was fond of this kind of imagery from the natural world, sailing, and medicine. But frequent metaphorical usage of a word caused the imagery to lose its force, so that its literal sense was no longer felt. Such a word became a 'dead metaphor'. This phenomenon seems to have gone largely unobserved by MacKendrick in his *The Speeches of Cicero* (London, 1995).

narratio: The statement of the facts on which a case is based, usually the second main division of a speech, theoretically placed between the exordium and the proof.

occultatio: Feigned omission: a device by which dubious facts or suspect arguments are presented under the pretence that the speaker does not attach importance to them. ('I shall not discuss the fact that ...'(details follow).

parable: Extended simile in the form of a short scene or story.

paradox: An unexpected turn or conclusion to an argument or sequence of events.

paratactic: Sentence structure consisting of co-ordinate clauses, not main and subordinate clauses.

parison: Co-ordinated clauses of equal length and corresponding parts.

pathos: Arousal or expression of emotion.

period: A complex sentence in which the full sense is not complete until the final words.

peripeteia: Change from good to bad fortune, as in tragedy.

peroration: The final section of a speech; also occasionally the final speech of a group delivered by the prosecutors or the defenders.

petitio principii: 'Begging the question': representing as agreed fact an unproved proposition.

praemunitio: Preliminary or anticipatory defence (*De Orat. III* 204).

principium a sua persona: In the exordium, when the speaker gives precedence to his own thoughts and feelings.

prodiegesis: Narrative of the background to the main events, including prior events.

prosopopoiia: Representation of absent or dead persons as interested observers of the present scene, or imagination of future scenes.

prothesis: The statement of a case.

rhetorical question: Question asked for effect, sometimes not addressed to a particular person, and not expecting a reply.

sermocinatio: Live conversation or dialogue.

simile: Explicit comparison, introduced by 'like...' or 'as...' See also *parable*.

status (constitutio): The issue of a case, raised by questions as to fact (Was the act committed?), the nature of the alleged act (*e.g.*Was it murder or manslaughter?), and its legality.

topos: A standard theme, either broad, as in epideictic and deliberative oratory the standard themes are *justice, expediency* and *possibility,* or specific, as in forensic oratory when the defence pleads for time in a capital charge, or the prosecutor argues that a verdict will serve as an example to others.

visualization: The creation of an imaginary scene, often in the future, and containing tragic events.

SELECT BIBLIOGRAPHY

Translations: The English translations are based on those by the editors of Cicero (vols.VI–XV) in the Loeb Classical Library (Harvard University Press): G. L. Hendrickson, H. M. Hubbell, L. H. G. Greenwood, H. G. Hodge, C. Macdonald, N. H. Watts, R. Gardner, W. C. A. Ker.

The following list of editions, monographs, articles and other studies is primarily intended to enable readers to study in further depth and detail the topics discussed in the book.

Adamietz, J., *M. Tullius Cicero Pro Murena* (Darmstadt, 1989).

Albrecht, M. von, *Cicero's Style : A Synopsis* (=*CS*) (Leiden, 2003).

Alexander, M. C., 'Hortensius' Speech in Defense of Verres', *Phoenix* 30 (1976) 46–53.

Alexander, M. C., *The Case for the Prosecution in the Ciceronian Era* (Ann Arbor, 2002).

Allen, W., 'Cicero's House and *Libertas*', *TAPA* 75 (1944) 1–9.

Austin, R. G., *M. Tulli Ciceronis Pro Caelio Oratio* (Oxford, 1960).

Badian, E., 'Waiting for Sulla', *JRS* 52 (1962) 47–61.

Balsdon, J. P. V. D., 'Auctoritas, Dignitas, Otium', *CQ* 10 (1960) 34–50.

Barwick, K., *Das rednerische Bildungsideal Ciceros* (Berlin, 1963).

Batstone, W.,'Cicero's Construction of Consular *Ethos* in the *First Catilinarian*', *TAPA* 124 (1994) 211–66.

Berry, D. H., *Cicero, Pro Sulla Oratio* (Cambridge, 1996).

Berry, D. H., *Cicero: Defence Speeches* (Oxford, 2000).

Bonner, S. F., *Education in Ancient Rome: From the Elder Cato to the Younger Pliny* (London, 1977.

Booth, J. (ed.), *Cicero on the Attack: Invective, Abuse and Ridicule in Action* (London, 2006).

Broughton, T. R. S.,'Was Sallust Fair to Cicero', *TAPA* 67 (1936) 34–46.

Brunt, P. A.,'The Legal Issue in Cicero *Pro Balbo*', *CQ* 32 (1982) 136–47.

Buchheit, V., 'Chrysogonus als Tyrane in Ciceros Rede für Roscius aus Ameria', *Chiron* 5 (1975) 193–211.

Butler, S., *The Hand of Cicero* (London, 2002).

Canter, H. V., '*Digressio* in the Orations of Cicero', *AJP* 52 (1931) 351–61.

Canter, H. V., 'Irony in the Orations of Cicero', *AJP* 57 (1936) 457–64.

Cape, R. W., 'The Rhetoric of Politics in the *Fourth Catilinarian*', *AJP* 116 (1995) 255–77.

Caplan, H., *Rhetorica ad Herennium* (Loeb: Harvard, 1954).

Ciaceri, E., *Cicero e i suoi tempi,* 2 vols. (Milan, 1930).

Clarke, M. L., 'The Thesis in the Roman Rhetorical Schools of the Republic', *CQ* 45.1 (1951) 159–66.

Clarke, M. L., *Rhetoric at Rome: A Historical Survey* (London, 1953; repr.1962, 1996).

Classen, C. J., *Recht – Rhetorik – Politik.* Darmstadt: Wissenschaftliche Buchgesellschaft, 1985.

Corbeill, A., *Controlling Laughter: Political Humour in the Late Republic* (Princeton, 1996).

Courtney, E.,'The Prosecution of Scaurus in 54BC', *Philologus* 105 (1961) 151–6.

Courtney, E., *Archaic Latin Prose* (Atlanta, 1999).

Cousin, J., 'Rhétorique dans le *Pro Caelio', Atti del I congresso internazionale di studi ciceroniani,* 2 (Roma, 1961) 91–8.

Craig, C. P., 'The *Accusator* as *Amicus*: An Original Roman Tactic of Ethical Argumentation', *TAPA* 111 (1981) 31–7.

Craig, C. P., 'The Central Argument of Cicero's Speech for Ligarius', *CJ* 79 (1984) 193–9.

Craig, C. P., 'Dilemma in Cicero's *Divinatio in Caecilium', AJP* 106 (1985) 442–6.

Craig, C. P., 'The Structural Pedigree of Cicero's Speeches *Pro Archia, Pro Milone* and *Pro Quinctio', CP* 80 (1985) 136–7.

Craig, C. P., 'Cato's Stoicism and the Understanding of Cicero's Speech *Pro Murena',* *TAPA* 116 (1986) 229–39.

Craig, C. P., *Form as Argument in Cicero's Speeches : A Study of Dilemma* (Atlanta, 1993).

Davies, J. C., 'Phrasal Abundantia in Cicero's Speeches', *CQ* 18 (1968) 142–8.

Davies, J. C., 'Molon's Influence on Cicero', *CQ* 18 (1968) 303–14.

Davies, J. C., 'Some Observations on the Early Development of Cicero's Plain Style', *Latomus* 39 (1970) 729–36.

Davies, J. C., '*Reditus ad Rem*: Observations on Cicero's Use of Digressio', *Rh.M* 131 (1988) 305–15.

De Lacy, P., 'Cicero's Invective against Piso', *TAPA* 72 (1941), 49–58.

Desmouliez, A., 'L'interpretation du *De Signis', RU* 58 (1949) 155–66.

Dominik, W., Hall, J.,(eds) *A Companion to Roman Rhetoric* (Oxford: Blackwell, 2007).

Donnelly, F. P., *Cicero's Milo. A Rhetorical Commentary* (New York, 1935).

Dorey, T. A., 'Cicero, Clodia, and the *Pro Caelio', G & R* 5 (1958) 175–80.

Dorey, T. A., (ed.) *Cicero* (London, 1965).

Douglas, A. E.,'A Ciceronian Contribution to Rhetorical Theory', *Eranos* 55 (1957) 18–26.

Douglas, A. E., *M. Tulli Ciceronis Brutus,* (Oxford, 1966).

Douglas, A. E., 'The Intellectual Background of Cicero's *Rhetorica', ANRW* 1, 3 (1973) 95–138

Dugan, J., *Making a New Man: Ciceronian Self-Fashioning in the Rhetorical Works* (Oxford, 2005).

Dyck, A. R., 'Narrative Obfuscation, Philosophical *Topoi,* and Tragic Patterning in Cicero's *Pro Milone', HSCP* 98 (1998) 219–241.

Dyck, A. R., 'Evidence and Rhetoric in Cicero's *Pro Roscio Amerino*: The Case against Sex. Roscius', *CQ* 53 (2003) 235–46.

Dyer, R. R., 'Rhetoric and Invention in Cicero's *Pro Marcello', JRS* 80 (1990) 17–30.

Fantham, E., *The Roman World of Cicero's De Oratore (=RWCO)* (Oxford, 2004).

Frank, T.,'The Background of the *Lex Manilia', CP* 9 (1914) 191–3;

Frier, B., *The Rise of the Roman Jurists: Studies in Cicero's* Pro Caecina, (Princeton, 1985).

Geffcken, K., *Comedy in the Pro Caelio,* Mnemosyne Suppl. 30 (Leiden, 1973).

Gelzer, M., *Cicero: ein Biographische Versuch* (Wiesbaden, 1969).

Gotoff, H. C., *Cicero's Elegant Style : An Analysis of the Pro Archia* (Urbana, 1979).

Gotoff, H. C., 'Cicero's Analysis of the Prosecution Speeches in the *Pro Caelio', CP* 81 (1986) 122–32.

Gotoff, H. C., *Cicero's Caesarian Speeches : A Stylistic Commentary* (Chapel Hill, 1993).

Gotoff, H C., 'Ciceronian Oratory: The Art of Illusion', *HSCP* 95 (1993) 289–313.

Hardy, E. G.,'Political and Legal Aspects of the Trial of Rabirius', *JPh* 34 (1915) 12–39.

Harries, J., *Cicero and the Jurists* (London, 2006).

Haury, A., *L'ironie et l'humeur chez Cicéron (= IHC)* (Leiden, 1955).

Heinze, R., 'Ciceros Rede *pro Caelio', Hermes* 60 (1925) 193–258.

Honigswald, G.,'The Murder Charges in Cicero's *Pro Cluentio', TAPA* 93 (1962) 109–23.

Humbert, J., 'Comment Cicéron mystifia les juges de Cluentius', *REL* 16 (1938) 275–96.

Johnson, W. R., *Luxuriance and Economy: Cicero and the Alien Style* (Berkeley, 1971).

Jonkers, E. J., *Social and Political Commentary on Cicero's De Imperio Gnaei Pompei (*Leiden, 1959).

Jouanique, P., 'Sur l'interprétation du *Pro Fonteio*', *REL* 38 (1960) 107–12.

Kennedy, G. A., *The Art of Persuasion in Greece* (Princeton, 1963).

Kennedy, G. A., *The Art of Rhetoric in the Roman World: 300 BC to AD 300* (Princeton, 1972).

Kinsey, T. E., *Cicero: Pro Quinctio* (Sydney, 1971).

Kinsey, T.E., 'Cicero's Case against Magnus, Capito and Chrysogonus in the *Pro Roscio Amerino* and its Use to the Historian', *L'Antiquité Classique* 49 (1980) 173–90; 54 (1985) 188– 96; 57 (1988) 296–7.

Kirby, J. T., *The Rhetoric of Cicero's Pro Cluentio* (Amsterdam, 1990).

Kroll, W., 'Ciceros Rede für Cluentius', *NJA* 53 (1924) 174–84.

Kumaniecki, K., 'Der Prozess des Q. Ligarius', *Hermes* 95 (1967) 434–57.

Lacey, W. C., 'Cicero, *Pro Sestio* 96–143', *CQ* 12 (1962) 67–70.

Laurand, L., *Études sur le style des discours de Cicéron avec un esquisse de l'histoire du 'cursus'*, (3 vols., 1st edn. (1907); 4th edn. (Paris, 1936–8); repr. Amsterdam, 1965).

Lausberg, H., *Handbook of Literary Rhetoric. Foreword by G. A. Kennedy.* (Leiden, 1998).

Leeman, A. D., *Orationis Ratio : The Stylistic Theories and Practice of the Roman Orators, Historians, and Philosophers,* 2 vols. (Amsterdam, 1963; repr. 1986).

Leeman, A. D., Pinkster, H., Nelson, H. L. W., Rabbie, E., Wisse, J.,(eds), *M. Tullius Cicero: De Oratore Libri III,* 5 vols. (Heidelberg, 1981–96 (vol.5 forthcoming)).

Leonard, J., 'Cicero als Redner und Schriftsteller', *Der Neue Pauly* 2 (1997) 1196–1202.

Ludwig, W., (ed.) *Éloquence et Rhétorique chez Cicéron.* Entretiens sur l'Antiquité Classique, Vol.28: Fondation Hardt, Geneva, 1982).

MacKendrick, P. L., *The Speeches of Cicero: Context, Law, Rhetoric (=SCCLR)* (London, 1995).

Malcovati, E., *Oratorum Romanorum Fragmenta Liberae Rei Publicae* (Turin, 1953; repr.1976).

Martin, J., 'Cicero und die zeitgenössischen Dichter', *Atti del I congresso internazionale di studi ciceroniani,* 2 (Roma, 1961), 185–93.

May, J. M., *Trials of Character : the Eloquence of Ciceronian Ethos (=TC)* (Chapel Hill, 1988).

May, J, M.,'The *Ethica Digressio* and Cicero's *Pro Milone*', *CJ* 74 (1989) 240–6.

May, J. M., Wisse J.,*Cicero On the Ideal Orator* (Oxford, 2001).

May, J. M. (ed.) *Brill's Companion to Cicero: Oratory and Rhetoric* (Leiden, 2002).

McDermott, W. C., 'In Ligarianam', *TAPA* 101 (1970) 317–47.

Michel, A., *Rhétorique et philosophie chez Cicéron* (Paris, 1960).

Mitchell, T. N., *Cicero: The Ascending Years* (New Haven, 1979).

Narducci, E., *Cicerone e l'eloquenza romana: Retorica e progetto culturale* (Rome, 1997).

Nicholson, J. H., *Cicero's Return from Exile: The Orations Post Reditum* (Bern, 1992).

Nisbet, R. G. M., *M. Tulli Ciceronis in Calpurnium Pisonem Oratio* (Oxford, 1961).

Nisbet, R. G. M., *Collected Papers on Latin Literature,* ed. S. J. Harrison (Oxford, 1995).

Norden, E., *Die antike Kunstprosa,* 2 vols. (Leipzig, 1898; 3rd.edn. Berlin, 1915; repr. Darmstadt, 1958).

North, H., 'The Use of Poetry in the Training of the Ancient Orator', *Traditio* 8 (1952) 1–33.

Porter, S. E., *Handbook of Classical Rhetoric in the Hellenistic Period 330 BC to AD 400* (Leiden, 1997).

Powell, J. G. F., (ed.) *Cicero the Philosopher: Twelve Papers* (Oxford, 1995).

Powell, J. G. F., Paterson, J. J.(eds), *Cicero the Advocate* (= *CA*), (Oxford, 2004).

Price, J. J., 'The Failure of Cicero's *First Catilinarian*', *Studies in Latin Literature and Roman History* 9 (1998) 106–28.

Rambaud, M., *Cicéron et l'histoire romaine* (Paris, 1953).

Ramsey, J. T., *Cicero: Philippics I-II* (Cambridge, 2003).

Rawson, E., 'Cicero the Historian and Cicero the Antiquarian', *JRS* 62 (1972) 33–45.

Rawson, E., *Cicero: A Portrait (=CP)* (London, 1975; repr.1983).

Reinhardt, T., *Marcus Tulllius Cicero: Topica* (Oxford, 2003).

Riggsby, A. M., 'Appropriation and Reversal as a Basis for Oratorical Proof',*CP* 90(1995) 245–56.

Riggsby, A. M., 'Did the Romans Believe in their Verdicts', *Rhetorica* 15 (1997) 235–51.

Riggsby, A. M., *Crime and Community in Ciceronian Rome* (Austin, 1999).

Rose, P., 'Cicero and the Rhetoric of Imperialism: Putting the Politics back into Political Rhetoric', *Rhetorica* 13 (1995) 359–99.

Sedgwick, W.B.,'Cicero's Conduct of the Case *Pro Roscio Amerino',* *CR* 48 (1934) 13.

Shackleton-Bailey, D. R., *Letters to Atticus,* 6 vols., (Cambridge, 1965–8); *Letters to his Friends; Letters to his Brother Quintus* (Cambridge, 1977).

Shackleton-Bailey, D. R., *Cicero* (London, 1971).

Siani-Davies, M., *Marcus Tullius Cicero Pro Rabirio Postumo* (Oxford, 2001).

Solmsen, F., 'Cicero's First Speeches : A Rhetorical Analysis', *TAPA* 69 (1938) 542–56.

Steel, C. E. M., *Cicero, Rhetoric, and Empire* (Oxford, 2001).

Steel, C. E. M., 'Cicero's *Brutus*: The End of Oratory and the Beginning of History?', *BICS* 46 (2003) 195–211.

Steel, C. E. M., *Reading Cicero: Genre and Performance in Late Republican Rome* (London, 2005).

Steel, C. E. M., *Roman Oratory,* (Cambridge, 2006);

Stockton, D., 'Cicero and the *Ager Campanus*', *TAPA* 93 (1962) 471–89.

Stockton, D., *Cicero: A Political Biography (= CPB)* (Oxford, 1971; repr.1978).

Stone, A. M., '*Pro Milone*: Cicero's Second Thoughts', *Antichthon* 14 (1980) 88–111.

Stroh, W., *Taxis und Taktik: Die advokatische Dispositionskunst in Ciceros Gerichtsreden* (Stuttgart, 1975).

Sumner, G. V., *The Orators in Cicero's Brutus: Prosopography and Chronology* (Toronto, 1973).

Tatum, W. J., 'Cicero and the *Bona Dea* Scandal', *CP* 85 (1990) 202–8.

Tatum, W. J., 'The *Lex Papiria de Dedicationibus*', *CP* 88 (1993) 319–328.

Taylor, J. H., 'Political Motives in Cicero's Defense of Archias', *AJP* 73 (1952) 62–70.

Ullman, B. L., 'History and Tragedy', *TAPA* 73 (1942) 25–53.

Usher, S., '*Occultatio* in Cicero's Speeches', *AJP* 86 (1965) 175–92.

Usher, S., *Greek Oratory: Tradition and Originality* (Oxford, 1999; pbk. 2001).

Vasaly, A., 'The Masks of Rhetoric: Cicero's *Pro Roscio Amerino*', *Rhetorica* 3 (1985) 1–20.

Vasaly, A., *Representations: Images of the World in Ciceronian Oratory* (Los Angeles & London, 1993).

Walser, G.,'Der Prozess gegen Ligarius im Jahr 46 v. Chr.', *Historia* 8 (1959) 90–6.

Webster, T. B. L., *Pro Flacco Oratio* (Oxford, 1931).

Wirszubski, C., 'Cicero's *Cum Dignitate Otium*: A Reconsideration', *JRS* 44 (1954) 1–13.

Woodley, E. C., 'Cicero's *Pro Cluentio*: an Ancient Cause Célèbre', *CJ* 42 (1946–7) 415–8.

Woodman, A. J., *Rhetoric in Classical Historiography: Four Studies* (London, 1988).

Wooten, C. W., *Cicero's Philippics and Their Demosthenic Model* (Chapel Hill, 1983).

Wooten, C. W., *Studies in Honor of George A. Kennedy* (Leiden, 2001).

Worthington, I., (ed.), *Persuasion* (London, 1994).

INDEX OF PASSAGES

GENERAL INDEX